IF PEOPLE WANT SACRED EXPERIENCES
THEY WILL FIND THEM HERE.
IF THEY WANT PROFANE EXPERIENCES
THEY'LL FIND THEM TOO.
I TAKE NO SIDES.

MARK ROTHKO

ROTHKO

Rothko: The Late Series
Edited by Achim Borchardt-Hume

With contributions by
Briony Fer
David Anfam
Morgan Thomas
Leslie Carlyle
Jaap Boon
Mary Bustin
Patricia Smithen

First published 2008 by order of the Tate Trustees
by Tate Publishing, a division of Tate Enterprises Ltd,
Millbank, London SW1P 4RG
www.tate.org.uk/publishing

on the occasion of the exhibition
Rothko: The Late Series

Tate Modern, London
26 September 2008 — 1 February 2009

Kawamura Memorial Museum of Art, Sakura
21 February — 14 June 2009

Exhibition at Tate Modern sponsored by FUJITSU

with additional support from ▲ ACCESS INDUSTRIES

With a donation from The Dedalus Foundation, New York

Exhibition organised by Tate Modern in association with Kawamura Memorial Museum of Art, Japan,
supported by Japan Airlines

ISBN 978 1 85437 788 3 (hbk)
ISBN 978 1 85437 737 1 (pbk)

Distributed in the United States and Canada by Harry N. Abrams, Inc., New York

Library of Congress Control Number: 2008930274

Designed by Why Not Associates
Printed in Italy by Conti Tipocolor

Front cover: Mark Rothko, *Untitled, Mural for End Wall* 1959 (see p. 135)
Back cover: Morton Levine, Rothko's Studio, 157 East 69th Street, New York, c.1970 (see fig. 16)

Measurements of artworks are given in centimetres, height before width

CONTENTS

Fujitsu Services is delighted to support Tate Modern in organising this unprecedented exploration of the later work of Mark Rothko, one of the world's best-loved artists.

We are particularly excited about the collaboration that has taken place between Tate Modern and the Kawamura Memorial Museum of Art in Sakura, Japan, to bring about this exhibition, since Fujitsu Services is the European IT services arm of the Japanese-based Fujitsu Group.

In our experience, great results come from such collaborations, and this exhibition is no exception. It challenges standard preconceptions that, as a painter, Rothko focused primarily on the effect of colour. This in-depth exploration of his late work will thus come as a revelation even to those familiar with his oeuvre.

Likewise, we in Fujitsu like to challenge; especially assumptions about how IT can be used to improve our lives at home and work. We've adapted Japanese 'lean manufacturing' techniques to reduce waste and provide continuously improving, more reliable services at a lower cost. A revelation to many of our customers — and one that leaves them with more time to enjoy the finer things in life!

I hope that you enjoy the unique opportunity afforded by this collaboration to gain greater insight into Rothko's extraordinary work.

Philip Oliver
Group Marketing Director, Fujitsu Services

SPONSOR'S FOREWORD
ACCESS INDUSTRIES

As Chairman of Access Industries, it is my great pleasure to congratulate Tate Modern on mounting this historic exhibition of Mark Rothko's late series. Emily and I have long been admirers of Rothko's unicue vision and we are delighted to provide our support to this exhibition.

Access Industries is particularly proud to be linked to Rothko's achievements. He is renowned as a creative artist whose influence has affected so deeply the history and direction of art throughout the world. We at Access Industries recognise the limitless value of fostering creativity, initiative and imagination to achieve the full potential of our employees and global holdings.

On behalf of Access Industries and our employees worldwide, Emily and I hope that your enjoyment of this important exhibition will match our pride in making it possible.

Len Blavatnik
Chairman, Access Industries

DIRECTOR'S FOREWORD AND ACKNOWLEDGEMENTS

VICENTE TODOLÍ

Tate's association with Mark Rothko dates back more than forty years. In the second half of the 1960s, the Tate Gallery's Director, Norman Reid, entered into a prolonged conversation with the artist to discuss how best to extend his representation in the Collection. It was Rothko's idea to select nine of his Seagram murals for Tate, a proposal that was enthusiastically welcomed by the Board of Trustees. Ever since its inauguration in 1970, the 'Rothko Room', as it has become popularly known, has been one of the iconic highlights of Tate's Collection, drawing visitors from near and far. Over the years, as Tate changed, so did the display of Rothko's murals, moving first from the nineteenth-century galleries on Millbank to the Linbury extension in the late 1970s, and in 2000 to the newly converted Tate Modern. However, what remained constant was Tate's commitment to honour the artist's wish that these powerful works should be shown as a single coherent environment.

Aside from the continuous presence of the Rothko Room, in 1987 Tate presented a major retrospective of the artist's work. Many still remember the extraordinary impact made by this exhibition of Rothko's unique painterly vision, especially that of his mature colour-field work. The following year, the newly inaugurated Tate Liverpool, under the guidance of Michael Compton, mounted an exhibition mapping the history of the Seagram murals for the first time.

The present exhibition builds on these earlier endeavours by foregrounding what is perhaps the least well-explored part of Rothko's career, his late work in series, and by presenting the Tate murals in a completely new context. In so doing it makes visible one of the museum's core functions, which often remains hidden behind the walls of the 'white cube', namely, the continuous research into works in its care by curators and conservators

It would not have been possible to realise this ambitious project without the help and support of many individuals and institutions. First among these are the artist's children, Kate Rothko Prizel and Christopher Rothko, who have generously shared important memories of their father as well as temporarily parted with much-treasured works from their collections. We could not have hoped for a more wholehearted endorsement, which made all the difference as the project took shape.

We are delighted to be collaborating on this exhibition with Kawamura Memorial Museum of Art, Sakura, Japan, whose collection contains a further seven Seagram murals. For the first time since they left Rothko's studio, five of these are being reunited with Tate's murals in London, and in turn, three of Tate's murals will be presented in Japan when the exhibition travels there in spring 2009. We thank Masashi Nakajima, Director, and Kenshi Nakagawa, former Director, for realising this historic opportunity. Special heartfelt thanks are due to Sumi Hayashi, Senior Curator, who has tirelessly worked with the Tate team on developing this project.

Exhibitions rely on the trust and generosity of their lenders and we are greatly indebted to those who have placed their works in our care. We would especially like

to thank Marion Kahan, Manager for the Collections of Christopher Rothko and Kate Rothko Prizel, who has facilitated the loan of numerous works with admirable patience and professionalism, providing much-appreciated advice on technical and logistical issues. Thanks are also due to Henry Mandell for his apt assistance behind the scenes.

The National Gallery of Art, Washington, has demonstrated an exemplary spirit of collegiality by providing vital information for research, enabling various visits by Tate staff and facilitating the loan of highly sensitive works. We would like to mention especially Harry Cooper, Curator of Modern and Contemporary Art; Judith Brodie, Curator of Modern Prints and Drawings; Jay Krueger, Senior Conservator of Modern Paintings; Ruth Fine, Curator of Special Projects in Modern Art; Janet Blyberg, Research Assistant, Special Projects in Modern Art; Laili Nasr, Research Associate, Mark Rothko Catalogue Raisonne; Alicia Thomas, Senior Loan Officer, and Judy Cline, Associate Registrar for Loans, all of whose contributions went far beyond the call of duty.

Others who have entrusted their fragile works into our care include The Menil Collection, Houston; the Whitney Museum of American Art, New York; the Kunstmuseum, Basel; the Los Angeles Museum of Contemporary Art and those who wish to remain anonymous. To all of them we express our deep gratitude for helping us to realise this extraordinary project.

We thank the MLA and DCMS for providing and administering British Government Indemnity for this exhibition, without which it would not be possible to mount exhibitions of such scope within the context of a public institution.

Many individuals have played an important role in bringing this project to fruition. Of these we would particularly like to thank His Excellency, Ambassador Robert Tuttle at the American Embassy in London and his wife, Maria Tuttle, for their personal support of the project. Oliver Wick, Curator, has generously shared aspects of his longstanding research into Rothko's work, leading us to rare studio photographs as well as allowing us to publish a note written by Rothko on the Seagram murals' genesis that he recently discovered in the artist's archives. Katy Spurrell, Director, Arthemisia Srl., was a steadily helpful font of information. A former colleague, Tom Learner, Senior Scientist, Getty Conservation Institute, first alerted us to the possibility of such a project between Tate and Kawamura Memorial Museum of Art.

Achim Borchardt-Hume, Curator for Modern and Contemporary Art at Tate Modern, developed the thought-provoking argument for this exhibition, bringing together a selection of works that will come as a surprise even to many of those who consider themselves familiar with Rothko's work. In this he was joined by Kerryn Greenberg, Assistant Curator, and Cliff Lauson, Curatorial Assistant, both of whom made vital contributions to all aspects of this project. Yu-Ching Liu, Curatorial Intern, provided much-appreciated additional support.

In preparation for this exhibition Tate's Conservation Department undertook a two-year long research project into the material history of Tate's group of Seagram murals. This research would not have been possible without the generous support of Tate's International Council, which has acted as Patron for the Rothko Room ever since it opened at Tate Modern. This project was overseen by Leslie Carlyle, Head of Conservation, together with Patricia Smithen, Head of Painting Conservation, and Joyce Townsend, Senior Conservation Scientist, who worked closely with Mary Bustin, Paintings Conservator, and Jaap Boon, University of Amsterdam and AMOLF. The fruits of their research form an integral part of both exhibition and catalogue.

This catalogue makes a significant contribution to the existing literature on Mark Rothko, exploring his late work from a number of vantage points. We would like to thank the authors Briony Fer, David Anfam, and Morgan Thomas for their contributions, which are scholarly, original, insightful and highly readable at the same time. Tate's philosophy of synthesising past and present is exemplified by the book's simultaneously classic and contemporary design expertly devised by Andrew Altmann and Geoff Williamson at Why Not Associates, who are also responsible for the exhibition's overall graphic identity. Melissa Larner has meticulously edited all text material. At Tate Publishing we would like to thank Alice Chasey, Project Editor; Emma Woodiwiss, Deputy Production Manager and Roz Young, Picture Researcher.

We are grateful to all our colleagues, too many to mention individually, for the boundless energy and personal sense of dedication without which Tate would not be able to operate. Sir Nicholas Serota, Director, was an early passionate advocate of this project as was Shenna Wagstaff, Chief Curator, Tate Modern. Hillary Taylor, Exhibitions Registrar, mastered the challenging task of orchestrating the transport of these large and delicate works with exemplary calm and attention to even the minutest detail. Phil Monk, Gary McDonald and Marcia Ceppo orchestrated the complex installation process together with Tate's experienced team of art handlers. Stephen Mellor and Helen Sainsbury helped with other logistical matters.

The challenges of realising this exhibition were manifold, not least financially, which is why our final thanks go to those who continuously enable Tate to realise its vision. We gratefully acknowledge the sponsors and supporters of this exhibition: Fujitsu, Access Industries and the Dedalus Foundation, New York. This is the first time that Fujitsu has undertaken a major arts sponsorship in the UK and we are delighted to welcome them as supporters of Tate. We would also like to thank Access Industries for their continued support of Tate, building on their sponsorship of the *Kandinsky* exhibition at Tate Modern in 2006. Finally, we thank the Dedalus Foundation, New York, for their donation to the exhibition.

Vicente Todolí
Director, Tate Modern

SHADOWS OF LIGHT: MARK ROTHKO'S LATE SERIES
ACHIM BORCHARDT-HUME

SHADOWS OF LIGHT: MARK ROTHKO'S LATE SERIES
ACHIM BORCHARDT-HUME

SHADOWS OF LIGHT: MARK ROTHKO'S LATE SERIES
ACHIM BORCHARDT-HUME

Between the conception
And the creation
Between the emotion
And the response
Falls the Shadow
T.S. Eliot, *The Hollow Men,* 1925[1]

What struck me, as I walked up and down the history of painting, was how much it was about fading light, and that the history of painting is also the history of the loss of light. For slowly but surely ... the light is squeezed out of painting to become finally a mere candle-flicker. A world once full of light becomes a world of shadows.
Ian McKeever, *In Praise of Painting*[2]

In 1961, the Museum of Modern Art in New York honoured the fifty-eight-year old Mark Rothko with a major retrospective exhibition spanning the last sixteen years of his career. A group of recent dark paintings, originally commissioned for Mies van der Rohe's iconic Seagram building on Park Avenue, formed an unexpected counterpoint to the chromatic exuberance of the rest of the show. The critic and art-historian Robert Goldwater described the experience of these brooding, burgundy canvases:

> [T]he most successful arrangement is the small chapel-like room in which have been hung three of the mural series of 1958–59. Partaking of the same somber mood, they reinforce each other, as they were designed to do. It is significant that at the entrance to this room one pauses, hesitating to enter. Its space seems both occupied and empty. One is a distant spectator, examining with a stranger's separateness decorations the centre of whose existence has been withdrawn, much as today we look (barred by a chain) at the frescoes of some no longer used ancient chapel in an Italian church. Only there we know that this was once an intimate and active place; here we have become our own admiring strangers. It is thus not surprising that Rothko should have decided against delivering these murals to the 'elegant private dining room' for which they had been commissioned.[3]

The convoluted history of Rothko's Seagram murals has become one of the enduring myths of twentieth-century art, with the solitary figure of the misunderstood artist defending the gravitas of his project at its centre. This myth has tended to overshadow a closer engagement with the actual works, which is why it is worth summarising what little factual information there is.[4]

When the architect Philip Johnson and Phyllis Lambert, heiress to the Seagram fortune and an architect in her own right, sought to appoint an artist to decorate a secluded dining room that formed part of The Four Seasons restaurant on the Seagram building's ground floor, they unhesitatingly opted for Rothko (fig. 1). The invitation having been formalised in June 1958, Rothko, according to Dan Rice, his studio assistant at the time, 'seized on the project with enthusiasm as though it

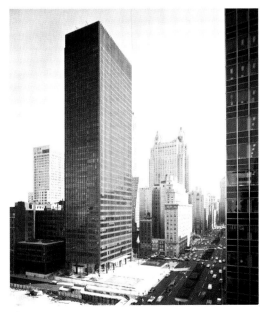

Fig. 1
Seagram Building, New York 1958

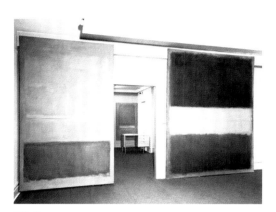

were a release.'[5] This is borne out by the fact that he spontaneously rented a new studio, a former basketball court on the first floor of a large building on 222, The Bowery. From circumstantial evidence it would appear that Rothko started work on the murals in earnest some time in autumn 1958, completing most of the project by early summer 1959, when he left New York for a family visit to Europe. On this journey, and even more so upon his return to New York, Rothko was plagued by doubt as to the continuing viability of the project. However, it was not until the following year that he irrevocably terminated his involvement, making use of a contractual escape clause to which he had attached great importance throughout, an indicator that he had felt ambiguous about the project from the very beginning.[6] Years later, in fact, he wrote of 'the self deception' he had laboured under throughout.[7]

Speculation about what led Rothko to abandon the commission is central to the myth surrounding the Seagram murals. Some claim that when he accepted the invitation Rothko had believed that it was not for an exclusive private dining room but for an employee's canteen, a function that appealed to his old left-wing sympathies.[8] Others have interpreted the paintings' oppressive darkness as a conscious affront to The Four Seasons' wealthy patrons.[9] One of the most frequently cited posthumous accounts, quotes Rothko as stating from the very start that he had 'accepted this assignment as a challenge, with strictly malicious intentions. I hope to paint something that will ruin the appetite of every son of a bitch who ever eats in that room.'[10] However, their popular appeal notwithstanding, these anecdotal narratives ignore the predicament in which Rothko found himself from the outset, namely that he, as Werner Haftmann rightly observed, 'wished to achieve much more than his client wanted and the plan inevitably failed because of this incompatibility'.[11] The key question, then, is what this 'much more' meant for Rothko.

Apart from recognition and financial stability, the Seagram commission afforded Rothko an unprecedented opportunity to create a unified painterly environment. As his style matured during the late 1940s and early 1950s, Rothko had come to realise that the impact of his paintings depended in no small amount on the interaction between the individual works and the surrounding space. With his work becoming the subject of a growing number of museum and gallery exhibitions, Rothko took increasing pains to control every aspect of its installation to create what he called 'a place'; that is, an all encompassing environment.[12] For this reason, he also declined to show his work next to that of other artists.[13] When looking at photographic documentation, what is perhaps most surprising is Rothko's preference for a very dense hang that prevented the viewer from 'stepping back'. For his exhibition at the Sidney Janis Gallery in 1955, for instance, Rothko placed two large canvases that barely fit into the space either side of a narrow doorway, forcing an unexpectedly intimate encounter between the viewer and his work (fig. 2). 'To paint a small picture is to place yourself outside your experience', Rothko had commented on one occasion. 'However you paint the larger picture, you are in it. It isn't something you command.'[14]

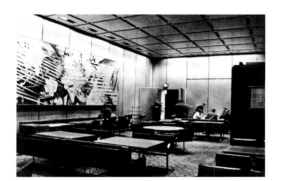

Fig. 3
The Four Seasons, West View c.1959

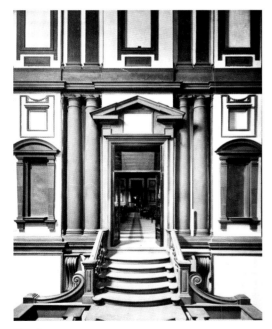

Fig. 4
Michelangelo, Laurentian Library, Florence 1524–34

Ultimately, Rothko aimed to recapture the experience of his own encounter with his work:

> Pictures must be miraculous: the instant one is completed the intimacy between the creation and the creator is ended. He is an outsider. The picture must be for him, as for anyone experiencing it later, a revelation, an unexpected and unprecedented resolution of an eternally familiar need.[15]

For the display of his work, Rothko therefore sought to create a position of empathy between the viewer and himself by emulating the conditions of his studio, which for him always remained the true spiritual home of his work.[16] Again, the show at Sidney Janis Gallery offers an instructive example. At this time, Rothko's studio formed part of the apartment on Sixth Avenue in which he and his family lived. Rice recalls that the domestic scale of this studio space made it impossible for Rothko to inspect his large formats from any distance.[17] There are obvious parallels here to the proximity that Rothko subsequently imposed on his gallery-going audience.[18]

This ambition to create an intimate encounter based on the studio setting had an important bearing on the Seagram project. Since this was a commission for a specific architectural context, the destined display space was a given: a room measuring 56 x 27 ft (fig. 3). Rothko's first course of action upon accepting the commission was to simulate this room in his new studio with the help of makeshift temporary walls. However, during this process of transference, a number of crucial discrepancies crept in. Whereas the dining room was twice as long as it was wide, the proportions of Rothko's studio were quite different, measuring 46 x 32 ft, with an astonishing 23 ft high ceiling (fig. 5). More crucially, whereas the dining room was perforated on two sides by a large window and sets of doors opening out onto the main restaurant, Rothko's Bowery studio was hermetically sealed, a row of windows high up on one wall so small and grimy that next to no daylight filtered through. It was this enclosed space to which Rothko's murals responded, not the airiness of The Four Seasons' dining room.

The floating frames, for instance, which mark such a departure in Rothko's work, can only be read as metaphorical windows and portals if they do not have to compete with actual wall openings. Rothko himself famously likened the effect he was after to Michelangelo's Laurentian Library famed for its calculated claustrophobic atmosphere (fig. 4).[19] Similar to Michelangelo's staircase and his rows of blind windows, Rothko's murals destabilise the architecture they inhabit by dematerialising the solidity of the walls on which they are hung. The ensuing drama between physical reality and its transcendence is not unlike that of Baroque architecture, for which the Laurentian Library is often cited as a prototype.

This drama was not lost on one of the early visitors to Rothko's studio, the German art historian and curator, Werner Haftmann:

> At a certain height, there was a darkly luminous frieze of pictures running round the whole room ... [Rothko] told me that he had regarded this commission as

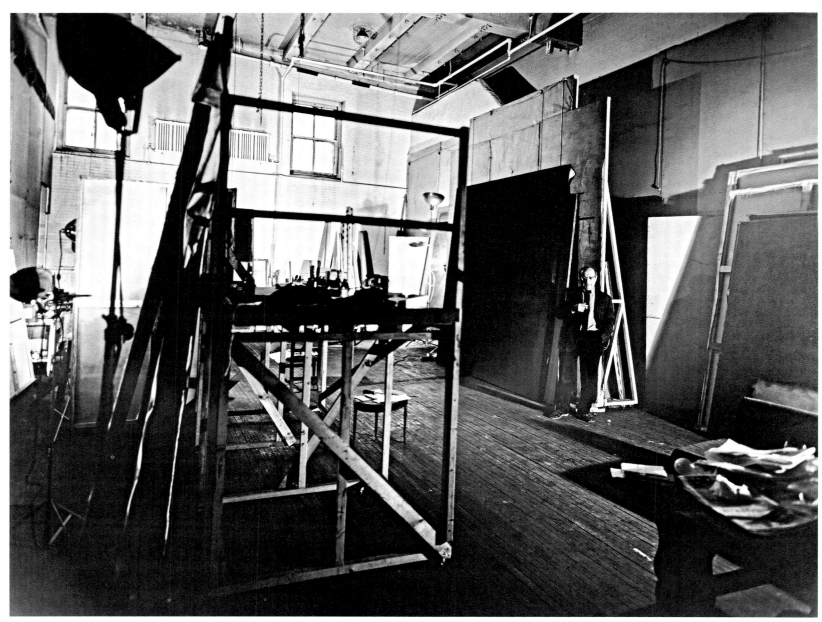

Fig. 5
Herbert Matter
Rothko in his 222 Bowery Street Studio,
New York 1960

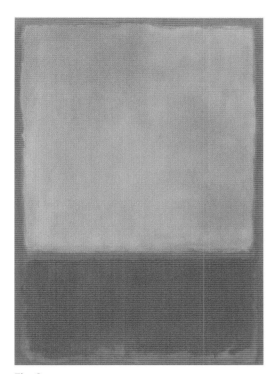

Fig. 6
Mark Rothko,
Ochre and Red on Red 1954
Oil on canvas
242.9 x 161.9
The Phillips Collection, Washington

a great and wonderful task that had finally been given him, that he had put everything in his power into its execution, and that here his work had reached a climax. In the zeal of his monologue, he did not hesitate to speak of the 'Sistine Chapel' ... Soon we were encompassed by these darkening walls of light. It was a very spiritual luminosity that emanated from these backgrounds. It was not a real light and did not suggest any perspective. It had no source. Without shadows or brightness, it shone out of the colored background as a still, pure light from within the picture. Here and there, a dark curve indicated a kind of gate. But the gate did not open. It was as though it were caught by a darkening plane of light that again veiled the opening. So in the upper part, into which the frieze broadened out, there arose a space that was breathing, quietly expanding and then contracting again. The expansion was only vaguely defined and devoid of any harshness, due to the diffusion of the planes and the fluorescence of the light.[20]

Haftmann's description vividly captures the symbiotic relationship between Rothko's murals and their architectural setting, a relationship that it would have been difficult to recapture within the refined elegance of The Four Seasons' wood-panelled dining room.

The Seagram murals not only represented Rothko's first painterly environment, but also his first body of work conceived and conceptualised as a series.[21] To avoid any misunderstanding, the use of the term 'series' here does not imply the 'serial' modular mode contemporaneously deployed by a younger generation of artists such as Frank Stella, Ellsworth Kelly or Donald Judd to critique the conspicuous uniqueness of a painting or sculpture. Instead, Rothko's late series, from the Seagram murals to his *Black on Gray* paintings, were rooted in the systematic exploration of a particular compositional scheme, their morphology leaving the aura of each individual work, however, intact.[22] It is worth stressing that the commissioning brief for the Seagram project had given Rothko carte blanche and that it was his personal choice to develop a series in response. Rice remembers: 'I believe he actually felt he had gone as far as he could in painting until the proposal for the Seagram murals was presented to him. It absolutely supplied him with a whole new dimension.'[23] Part of this new dimension was the paradoxically liberating effect of working within the self-imposed confines of the murals' compositional scheme by systematically varying the relationship of figure to ground, their respective proportions, and their distinction through surface sheen and tonal contrast; in other words, by following the internal logic of the series.

To some degree, all of Rothko's mature work had relied on strategies of repetition and variation. Rothko himself had commented: 'If a thing is worth doing once, it is worth doing over and over again — exploring it, probing it, demanding by this repetition that the public look at it.'[24] But the way the public looked at 'it', his work, had become increasingly problematic for Rothko by the late 1950s, especially the wide-spread perception that it was decorative, one of the key reasons for its rapidly soaring market value (fig. 6).[25] In the run-up to the Seagram project, Rothko's palette in works such as *Four Darks in Red* 1958 had already severely darkened

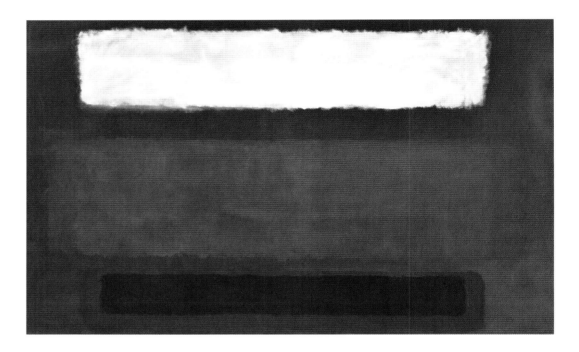

(p. 103). In the eyes of Dore Ashton, a critic and close friend of the artist, this was a sign that Rothko was striking out 'with exasperation at the general misinterpretation of his earlier work — especially the effusive yellow, orange and pinks of three years back. He seems to be saying in these new foreboding works that he was never painting luxe, calme, and volupté, if we had only known it!'[26] Consequently, Rothko, when he accepted the Seagram commission, rapidly side-stepped the commissioners' expectations for a set of sumptuous wall decorations, in favour of approaching the project as a highly visible platform from which to claim a critical revaluation of his work. Painters had deployed the conceptual endeavour implied in the series to this programmatic end from the onset of modernity, Monet's series of haystacks from 1890—91 being an early eloquent example.[27] Rothko wanted the murals' tragic grandeur to prove once and for all the existentialist endeavour underpinning his art and in so doing to vindicate the seriousness of all his work to date, which may be a further reason why the murals took centre stage at his 1961 retrospective.

The murals' architectonic monumentality and crepuscular intensity were hard won. *No. 9 (White and Black on Wine)* 1958, a majestic composition of three bands stretching across a vast landscape format, is generally assumed to be one of the few surviving examples from an early first set of murals, which the dissatisfied Rothko quickly disposed of (fig. 7). Rothko soon recognised that to safeguard the dynamic relationship between horizontal and vertical, which had been essential to much of his mature work, the murals' horizontal frieze had to be balanced by a vertical counterpoint. According to Rice, he found the solution via a 'creative accident' when he placed one of his canvases sideways, thereby inadvertently reversing the relationship of 'frame' and 'field'.

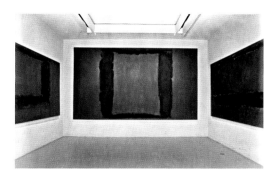

Fig. 8
Seagram murals, *Mark Rothko* retrospective,
Museum of Modern Art, New York 1961

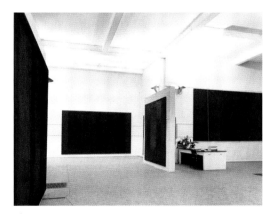

Fig. 9
Seagram murals, *Mark Rothko* retrospective,
Whitechapel Art Gallery 1961

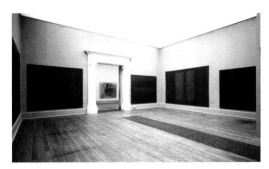

Fig. 10
Seagram murals, Tate Gallery, Millbank May 1970

Once Rothko had settled on the basic structure of the murals, the series generated its own momentum irrespective of the demands of the original commission. As Rice recalls:

> Mark moved from area to area in the painting with complete awareness and open-mindedness of what might happen even within the confines of what he had more or less laid out and as such, each painting was individual. And they were often interchanged, which is what led him on from series to series. They kept getting better and more clarified in his intent.[28]

Though the dining room would have offered room for a mere seven murals — three narrow landscapes above the folding doors, three large canvases on the long wall opposite, and a single canvas on the narrow side wall — Rothko over the course of a year elaborated over thirty canvases.[29] It would have been impossible, of course, for him to work on all of these at the same time, which opens up questions of sequence and subsets. Some canvases are clearly more closely related than others. *Sketch for "Mural No. 4"* 1958 and *Mural for End Wall* 1959, for instance, both stand out in their use of the same fiery orange, while *Mural, Section 2* 1959 and *Mural, Section 3* 1959 are compositionally almost identical, with the figure in the latter distinguished by colour, the one in the former by surface sheen alone (pp. 109, 135, 125, 127). However, as common as references to a second and third series of Seagram murals are in the literature, the dividing line along which one might distinguish these series remains obscure.[30]

An element of ambiguity was central to the Seagram project throughout. Hypothesising various models for the murals' presentation, including that of a continuous frieze, Rothko never determined a final selection. As Rice, who worked with Rothko at the time, recalls: 'While working on the exact mural series themselves he was very reflective, gathering all the paintings together again and jumbling them up. It would be very difficult to say that one was intended as part of the murals and one was not.'[31] Rothko's reluctance to fix any one scheme at the expense of other possible options was conceptually in keeping with the murals' serial mode (rather than the original commission), an argument that is substantiated by his continuous preoccupation with their changing displays over the next decade. At their first public showing at MoMA in 1961, a large canvas, *Mural Section 3* 1959, was flanked by two narrow landscape formats to create the 'chapel' that Goldwater described (fig. 8). When the show next travelled to London, provisions were made for the murals to be displayed in a separate room towards the rear of the Whitechapel Art Gallery, an arrangement not all that dissimilar to the 'Rothko Room' created several years later at the Tate. However, this plan was not executed and instead the paintings were installed in the open entrance room, interspersed with much earlier work (fig. 9).[32] At most of the subsequent touring venues, the murals were indeed presented as a separate entity, and were, at Rothko's suggestion, hung either surprisingly high or unusually low.[33] When Rothko, at the end of the 1960s, generously donated nine murals to the Tate Gallery, their arrangement was the subject of much debate between him and the gallery's Director, Norman Reid.[34] Eventually the latter furnished the artist with a scale-model of the designated

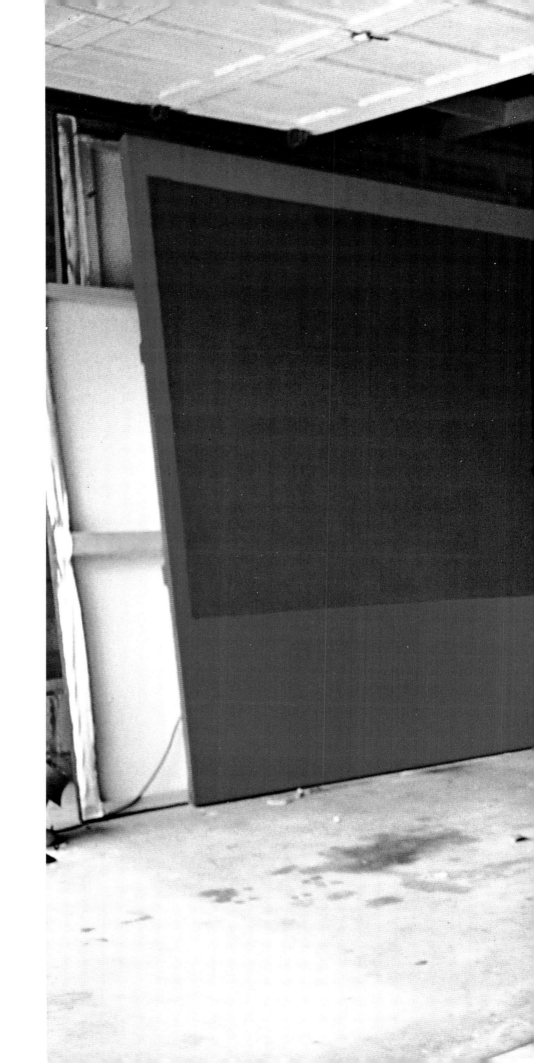

Fig. 11
Hans Namuth
Rothko in his East Hampton Studio 1964

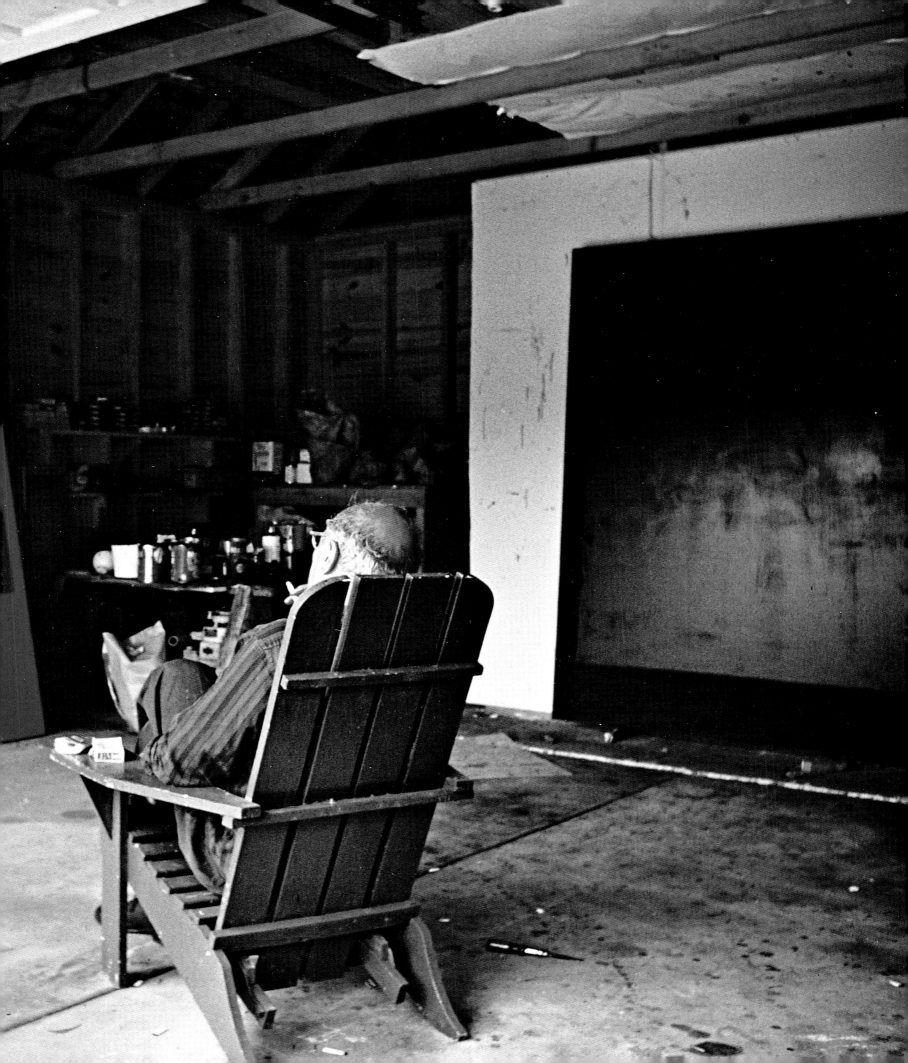

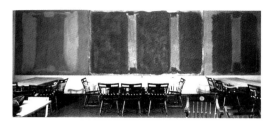

Fig. 12
Harvard Murals, Holyoke Center 1961–2

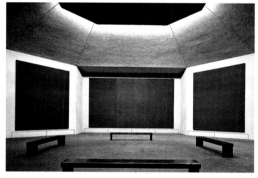

Fig.13
Rothko Chapel, Houston, North Walls

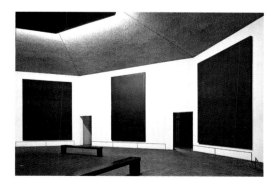

Fig. 14
Rothko Chapel, Houston, Entrance Wall

gallery space, for which Rothko produced small maquettes of his paintings (pp. 143–5). However, their numbers do not correspond, and while Rothko stated his ambition 'to give this space ... the greatest eloquence and poignancy of which my pictures are capable'[35] he ultimately shied away from prescribing a single definitive installation (fig. 10).[36]

* * *

When Haftmann viewed the Seagram murals in Rothko's studio, he invited the artist to take part in the *documenta* exhibition in Kassel in 1959. Rothko declined, reiterating his reservations about survey exhibitions and about showing his work in Germany. However, he nonetheless proposed a new series to Haftmann, to be housed in a temporary structure in memory of the victims of the Holocaust, a project that did not come to fruition.[37] Soon afterwards, the commission for a set of murals for the Holyoke Center at Harvard University, Cambridge, Massachusetts, allowed Rothko to expand on some of the issues raised by the Seagram murals. This was the only commission to be completed during his lifetime, though sadly the murals for a number of reasons rapidly faded and were taken off view, making their critical evaluation rather problematic (fig. 12).[38] Meanwhile, a visit by the French-American collector and arts patron Dominique de Menil yielded more lasting results, leading to what would become perhaps Rothko's best-known painting installation, a purpose-built Chapel for the newly founded University of St Thomas in Houston, Texas. De Menil had originally hoped to acquire part of the Seagram series for this project.[39] However, Rothko was keen to develop a new body of work. The Houston Chapel, including the various amendments to the building — like The Four Seasons designed by Philip Johnson — and to Rothko's mural scheme, have been the subject of extensive analysis elsewhere.[40] Suffice it to say that the basic plans were decided by the end of 1965, with most of the paintings completed by June 1966, though they were not installed until 1971, the year after Rothko's death (fig. 13).

As had been the case with his other commissions, including the Seagram and Harvard murals, Rothko executed significantly more canvases for the Chapel than fitted the space, proof of his continuous uncompromising attitude towards their designated architectural setting and his privileging of the series' inner momentum instead. Vast in scale, the Houston paintings are monochromatic expanses with either no internal differentiation or only a slightly lighter margin, the mural on the entrance wall being the exception (fig. 14). Here, as well as in a set of murals that did not find their way into the final scheme, the maroon ground frames a sharply defined black rectangle. The same hard-edged composition could already be found in a series of dark canvases from 1964. Rothko seems to have perceived nine of these as forming one coherent series.[41] These so-called *Black-Form* paintings share the radically paired-down compositional structure of a hard-edged, dark rectangle, set against an equally dark background, their tonal proximity creating a perceptual challenge that is without precedent in Rothko's work. Paradoxically, though the paintings are near black, they seem to emanate light, the central rectangle acting not unlike a blank cinema screen, its velvetiness suggesting a space of indeterminable depth.

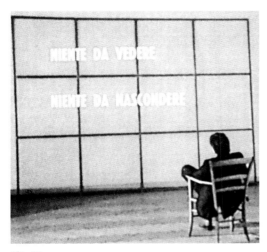

Untitled 1964 (p. 147), a unique work with no immediate counterparts, highlights the radical pictorial structure of the *Black-Form* paintings.[42] Within the rigour of this dual-tone composition, colour seems to cave in on itself, only to re-emerge a second later. Red here appears as colourless as black, leaving the viewer with a similar sense of delectable blindness. The appearance of *Untitled* 1964 in a carefully staged photograph of Rothko in his studio by Hans Namuth suggests that the artist recognised its seminal nature (fig. 11). The emphasis here, as in most photographs of Rothko, is on the act of looking rather than that of making (one only has to think of Namuth's famous photographs of Jackson Pollock 'dancing' across the canvas for contrast). In Namuth's photograph, Rothko appears 'as if he were the curator of a mystery which he could convey but to which he was not privy'.[43] Rothko's searching gaze spoke of his unwavering belief in art's potential to convey transcendental truths, a belief that by the 1960s ran a growing risk of appearing merely rhetorical, especially to a younger generation of artists. It is tempting, for instance, to read the mimicking of Rothko's pose in Alighiero Boetti's filmic representation of his own *Nothing to See, Nothing to Hide* 1969 as a sardonic comment on the older artist's metaphysical aspirations (fig. 15).[44]

By 1966, the year Rothko finished work on the Houston project, the cultural climate had dramatically changed compared to the post-war years during which his mature style had formed. To give but a flavour: between 1964 and 1966, the years Rothko worked on the *Black-Form* paintings and the Chapel commission, the Jewish Museum held a retrospective of the work of Jasper Johns (then thirty-four years old), Andy Warhol installed his *Thirteen Most Wanted* on the facade of the New York State Pavilion at the World Fair, Donald Judd theorised Minimalism in his 'Specific Objects' and Louise Bourgeois, Eva Hesse and Yayoi Kusama showed as part of the *Eccentric Abstraction* exhibition at the Fischbach Gallery in New York. The decision of the Los Angeles County Museum to take 1959 as the cut-off date for its 1965 survey of the New York School prompted Barnett Newman to comment that his generation was being 'treated as if we were all dead', a feeling that Rothko very much shared, even more so after a brief teaching stint on the West Coast during the summer of 1967.[45]

Meanwhile, the Chapel commission, not least due to the physical demands of working on such a large scale, had left Rothko — by now well into his sixties — exhausted, with his health steadily deteriorating, especially after he suffered an aneurism in April 1968. His marriage in turmoil and increasingly despairing at world affairs, Rothko was even more prone to long bouts of depression than he had been during previous decades. However, Brian O'Doherty has rightly warned that to see Rothko's late series of *Brown and Gray* works on paper and *Black on Gray* paintings, 'as records of psychic drama, is to make soap opera of something rare and hard-won'.[46] Rather, these extraordinary bodies of work mark a consciously radical point of departure in Rothko's late work and a brave revaluation of everything that had come before.

The most striking characteristic of the *Brown and Gray* works on paper and the *Black on Gray* paintings is, of course, that they do not look like 'Rothkos': no floating

colour fields, no atmospheric haze, no view into the 'beyond'. Instead, two horizontal fields of brown, black or grey, framed by a white edge, are thinly painted with the brushmarks clearly visible, their surface dryly confronting the viewer's gaze. Comparatively large in format, the *Brown and Gray* works on paper approximate the size of the viewer. Their upright format stands in sharp contrast to the horizontal division of the picture field into a dark upper and a light lower half. This inversion of dark and light, as much as Rothko's return to the emphatic 'portrait' format of his earlier work, counteracts any hypothetical reading of these works as referencing a landscape tradition.

The works' scale is in keeping with their new-found conceptual ambition. Rothko started the series after his return from a summer vacation in Provincetown where, following medical advice, he had largely concentrated on smaller works on paper. Back in his New York studio, he embarked on the *Brown and Grays* by instructing his assistants to attach large pre-cut sheets of paper to wooden boards with masking tape. Upon completion, the tape was removed, leaving an unpainted white border. However, what originally may have been the accidental by-product of a new experimental working process soon became an intentional and essential part of the works' pictorial structure, as Rothko himself became increasingly eager to assert to visitors to his studio.[47] As with the Seagram murals, the *Black-Form* and the Chapel paintings, the reduction of colour in the *Brown and Gray* works was intrinsic to Rothko's work in series; something that is all the more evident if one compares the many other works on paper executed during his final years and their often exuberant colour to Rothko's two final 'dark' series.

The uniform format of the *Brown and Gray* works on paper draws attention to even the slightest variation within their tight structural parameters, be it the rising or falling of the meeting line between the two fields, the differences of gestural intensity in the brush work, the varying degrees of opaqueness or translucence, or the nuanced tonal gradations within the light and dark areas. Every painterly decision taken by Rothko, no matter how small, commands the full attention of the viewer since it reveals itself as conscious and intentional, and thus within the conceptual framework of the series as 'meaningful'. Rothko's choice to pursue this exploration in a series of works on paper has frequently been attributed to the fact that working in this medium was less exertive than painting on canvas. However, while this may well have played a part, there might be other, and more pertinent, reasons for the choice. Working with acrylics on paper allowed Rothko to consider a greater number of variations at an accelerated pace; furthermore, and perhaps even more importantly, the intrinsic 'flatness' of paper precipitated Rothko's dramatic revaluation of the relationship between image and support as much as that between image, wall and viewer.

This much is suggested by the dynamic between the *Brown and Gray* works on paper and his final series on canvas, the *Black on Gray* paintings. Aside from the simple division into a black upper and a grey lower field, the single biggest departure from Rothko's other mature work is the painted white border, whose anti-illusionism underscores the materiality of the painted object. In his earlier work, Rothko had

Fig. 16
Morton Levine
Rothko's Studio, 157 East 69th Street,
New York c.1970

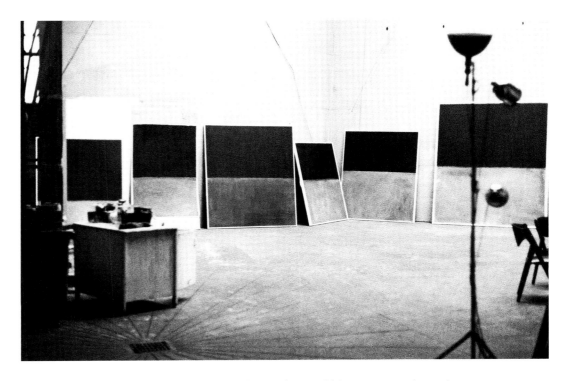

taken great pains to paint the stretcher edges of his canvases in order to transgress the material boundary of the picture surface and to create a continuum between pictorial space and the space inhabited by the viewer. In sharp contrast, space in the *Black on Gray* paintings does not extend beyond the painted surface. The white border does not frame a view. Rather, it acts as a zone of separation between real and pictorial space, exposing the painterly surface as an impenetrable membrane. The exceptional importance of the border is evidenced by its meticulous articulation and painstaking elaboration, with Rothko's typical attention to the effect of even its slightest widening or narrowing.[48]

Covering a far greater spectrum in terms of scale and orientation than the works on paper, what unites all the *Black on Gray* paintings is the continuous presence of the surface plane as a material, and consequently visual, barrier. Previously, Rothko had applied a mixture of rabbit-skin glue and pigment to his canvases to douse their surface in a first thin layer of colour thereby rendering the ground almost imperceptible. In the *Black on Gray* paintings there is no under-painting, the white primed canvas serving as a palpable foil to Rothko's brushwork, especially in the lighter fields. These paintings declare themselves as the physical objects they are, paint on canvas, and nowhere more so than around the central horizontal dividing line where the black and grey fields meet. There is a repeated tussle where black overlaps grey or vice versa, which highlights the fact that all this is material surface. Void of the atmospheric density and the painterly rhetoric of Rothko's preceding work, these last pictures, as Robert Goldwater noted, 'reject participation and withdraw into themselves.'[49]

One evening in December 1969, Rothko watched with trepidation as select members of New York's art world gathered in his studio on 69th street for a private view of his latest work, the first and only time he presented a series as such (fig. 16).[50] The choice of venue — by now not only his workspace but also his living quarters — was redolent with Rothko's growing feeling of isolation and world-weariness. He had always felt that it was 'a risky and unfeeling act to send it [his work] out into the world'.[51] It was this anxiety that gave rise to his growing preoccupation with the conditions in which his work was being shown, culminating in the Houston Chapel, which all but subsumed the physical environment to the demands of his art. Where Rothko felt such synergy was out of reach, as in the case of the Seagram murals, he preferred to withhold his work. While impressive for its integrity, by the late 1960s, Rothko's 'all-or-nothing' attitude also made for a burgeoning paradox; as his friend Dore Ashton observed: 'His craving to "control the situation" had grown more insistent, while "the situation" had become less and less clear.'[52]

It was perhaps this lack of clarity that led Rothko increasingly to withdraw into the private world of his studio. All of his earlier series had ultimately owed their existence to an external impetus in the form of a commission. And for all of them, Rothko's studio had primarily acted as simulacrum of the external situation to which they were expected to respond. For his final series, no such external referent existed any longer. Instead, their sole *raison d'être* lay in Rothko's existentialist struggle to test one more time the continuing possibilities of painting as a meaningful practice. Some ten years later, Daniel Buren, in his sensitive analysis of the relationship between a work of art and the locus of its making, observed that, 'it is in the studio and only in the studio that it [the work] is closest to its own reality, a reality from which it will continue to distance itself ... It is therefore only in the studio that the work may be said to belong.'[53] It seems that by the end of his life, Rothko too felt that there was no other place for him and his work to go.

SEEING IN THE DARK
BRIONY FER

SEEING IN THE DARK
BRIONY FER

SEEING IN THE DARK
BRIONY FER

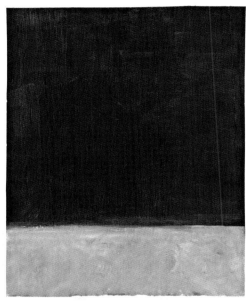

Fig. 17
Untitled (Brown and Gray) 1969
Acrylic on paper
152.8 x 122.3
National Gallery of Art, Washington
Gift of The Mark Rothko Foundation, Inc. 1986

Untitled (Brown and Gray) 1969 (p. 171 / fig. 17) shows the extreme point of reduction at which Rothko's work had arrived by 1969. A picture has become simply two parts, one dark, one light. It is striking how much of what went to make up one of his classic paintings of the 1950s has been removed. It is colour, of course, that is the most obvious extraction — but colour is only really the tip of the iceberg. There is something almost extravagant about the loss of everything that had apparently defined a Rothko painting. Thick, mainly vertical strokes of blackish-brown acrylic fill the upper section. The smaller bottom part is scumbled grey. The border line between them has none of the fraying and delicate spraying of the furrows between the colour bands of his earlier work — which never did seem that obvious, except now, by comparison. The join between the two halves is much harder now, its nuances still there but far less yielding. More interest is focused on the different ways in which the brushwork has been handled: the up-and-down of the brushstrokes of dark brown, the more open dabbing and raining of the grey brushwork become more like something to look at. And although the horizontal border is relatively plain, it also ends up looking more subtle and softer after a while. If there is nothing much there, it is an extraordinarily palpable void.

This is just one of many works in acrylic on paper that Rothko made towards the end of his life. All are variations on this arrangement, many of them in an achromatic range of greys through neutrals and browns to black, though by no means all. How Rothko came to this point is far from clear. Partly this has to do with the fact that less attention has been paid to the gradual unfolding and reversals of his final decade than to the earlier heroic years of what came to be labelled Abstract Expressionism. It is hard to reconcile these late works with the powerful emotional timbre that attaches to that movement in the critical imagination. Partly it has to do with the deliberate obscurity of the work itself.

As inappropriate as it might at first seem, the repeated eclipses and doublings of these late paintings remind me of the equally confounding first page of Charles Dickens' great realist novel *Bleak House* (1852—3) — not because of the detail of a particular scene that is described, but because of the lack of anything to see. The last thing I want to do is to suggest some literary comparison, still less some figurative basis to Rothko's work, which is without doubt relentlessly abstract. However, the first paragraphs of *Bleak House* not only describe what it is like to experience fog, but what it *feels* like for vision to be so thickly obscured; that modern vision is only a matter of the degree of density and opacity. Memorably, the word 'fog' appears no less than a dozen times in one paragraph, often twice or even three times in a single sentence — making, of course, a fog of words. The page descends in bands of non-colour, first a layer of mud-brown, then plunging down into grey-white. In a fantasy of colourlessness, smoke is 'soft black drizzle, with flakes of soot in it as full-grown snow-flakes — gone into mourning, one might imagine, for the death of the sun'.[1] The word fog seeps everywhere, repeated so often that it is all-engulfing with 'Fog in the eyes and throat.'[2] Light itself is eclipsed in the thickness. There is no scene surveyed — no outside to be outside of. Mud and fog meet in a mutual density and there is barely anything to distinguish one from the other.

Dickens's fog of words is a good deal more hallucinatory than we expect of a realist, just as Rothko is more of a materialist and less spiritual than is often thought. Both examine with almost anatomical precision a thin and sometimes barely perceptible border between materiality and immateriality. The fact that the novel is a product of modernity in astonishingly rapid formation and that Rothko is painting his final body of work at the moment of modernism's equally dramatic disintegration is not incidental. But I prefer to reverse the way we normally think about artistic causality and what makes a work of art look the way it does. Jorge Luis Borges held the view that artworks create their own precursors. Rather than cite a pattern of influences and tendencies, he maintained that a work of art 'modifies our conception of the past, as it will modify the future'.[3] Each work is a world within the world that an artist or writer makes. Taking the particular point of view, however opaque the lens that is offered, of the late work itself entirely transforms our sense of what comes before. This means taking a work of art as seriously as it demands to be taken. Far from seeing Rothko's work of the final decade in terms of a darkening mood, reflecting his own life, I aim to describe how the late work not only marks a departure from his classic canvases of the 1950s but also gradually dismantles their logic. Rather than revelling in pathos, Rothko's work of the 1960s takes a remarkable turn, regenerating itself at the very moment the whole aesthetic edifice upon which modernist painting was founded had seemed to reach a terminal state of collapse.

In retrospect, it is possible to see a major shift in Rothko's project occurring at the point of the Seagram commission at the end of the 1950s. To view this simply in terms of a darkening mood, because of the abandonment of colour, is a vast oversimplification. For a start, Rothko never does abandon colour but continues to swing between colour and non-colour in increasingly dramatic ways, which calls into question that very opposition. This is even clear in the Seagram murals themselves. Although most of the paintings that made up the gift to the Tate Gallery are very dark, with their dominant maroons and blacks, many others, including a number of those now in the Kawamura Memorial Museum of Art in Chiba and the National Gallery of Art in Washington, are much higher-pitched oranges and reds, which simmer brightly rather than darkly. To hook an entire reading on the dark sombre ones – whether it is a set of projections about Rothko's own melancholic state of mind or a larger sense of cultural depression – seems at the very least a partial gloss, one that no doubt answers to some desire in us to make of the artist a great tragic figure. Merleau-Ponty's remark on late Cézanne seems apposite here: 'If Cézanne's life seems to us to carry the seeds of his work within it, it is because we get to know his work first and see the circumstances of his life through it, charging them with a meaning borrowed from that work.'[4] This is not to say that there is no drama in the work, but that it is not that of the artist's own life; it is in each and every new encounter with the work. Although true of most abstract painting, one of the things that Rothko had always dramatised in his work was the fact that a picture animates not the space behind but the space in front of the painting – the space of the spectator's encounter. In the Seagram murals this becomes a pre-eminent consideration, not in the original restaurant commission, which failed, but in all the various ways in which Rothko grouped the murals from early exhibitions to the selection made for the Tate Gallery.

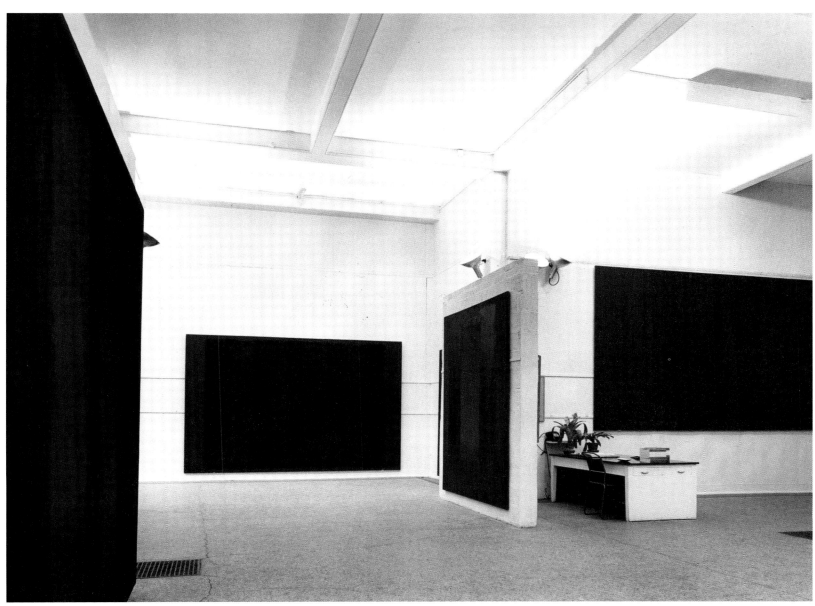

Fig. 18
Seagram murals, *Mark Rothko* retrospective,
Whitechapel Art Gallery 1961

At the artist's retrospective at the Museum of Modern Art in New York in 1961, three of the murals occupied a separate room. When the exhibition came to the Whitechapel Art Gallery in London later in the year, they were hung high up on the wall in the entrance, as if they were a kind of eye of the needle, or alternatively, the site of some kind of ambush, through which visitors had to pass (fig. 18). The height on the wall was stipulated by Rothko in a letter to Bryan Robertson, then director of the Whitechapel, distinguishing them from the others that were to be hung low, only about six inches off the floor. The height of the Seagram pictures explains David Sylvester's description of them when he imagined 'the gravity of one's body to be multiplied as if some weight borne down on one's shoulders were grinding one into the ground'. Sylvester describes his body struggling with and eventually 'rising against these pressures', ultimately to find 'exhilaration and release'.[5] The catharsis has the character of sexual ecstasy in Sylvester's rhetoric. There is a sense of melodrama too, which responds to something melodramatic in the need to test oneself against painting as a way of being fully immersed in the experience of painting. Rothko liked what Sylvester said.[6] But it is also worth noting that by 1961 this kind of desire for painting to create a great cathartic experience belonged to an expressive model of art that had exhausted itself and ran against the tide of new art. There is more to this than the obvious fact that by the early 1960s Rothko was of an older generation. More intriguing is why, working very much outside that contemporary context and through the logic of his own work, he makes paintings that speak so powerfully not only to that situation but to our own. At least in part, the serious claim of Rothko's late work is its own struggle against irrelevance, fuelled by his ambition to make work that counts, if only, in the first instance, to himself.

For an artist notorious for being difficult, Rothko wrote a most touching and appreciative letter to Robertson thanking him for his sympathy and cooperation 'with all the vagaries and uncertainties of hanging the pictures'.[7] From all the evidence, it seems that Rothko was certainly demanding, but only perhaps because he was so demanding of himself. He may well have felt resentment at being undervalued by younger generations, but mainly you get the sense of an artist pushing himself to the limit rather than resting on his laurels. So much so, in fact, that in the aftermath of the Seagram paintings he sets about making work that resists precisely the kind of affect or feeling that had become already formulaic by the mid-1950s. He makes paintings that create 'uncertainties and vagaries' for their viewers in figuring out how to look at them. The work transforms in the 1960s just as radically as it had at the end of the 1940s. The sea-change had begun with the Seagram series, but the break comes rather later, more precisely in 1964, at around the time he began work on the chapel in Houston. It is worth remembering that out of what have come to be known as Rothko's great set-pieces, only the Harvard murals were installed during his lifetime. In a cruel coincidence, the shipment of pictures for the Rothko Room at the Tate Gallery arrived in London the very same day in 1970 as did the news that Rothko had taken his own life, and the Chapel was finally completed after his death. That is to say, what we assume to be Rothko's great achievements were actually works in progress for much of the last decade of his life. If he was not engaged in actually painting the canvases, then he was

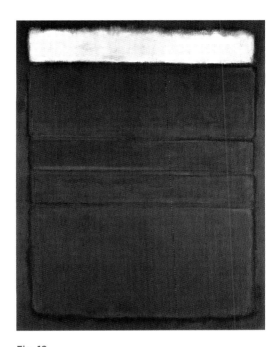

planning their installation. It is hardly surprising, then, that the work that he did alongside these big projects and which ultimately fed into them took risks, both with himself and with painting.

In the very early 1960s, Rothko was still working with the compositional arrangement of usually two or three rectangular bands that he had first proposed in 1949 and which had proved so elastic a format for so long. The vertical stack of colour blocks had proved incredibly flexible, allowing a disproportionate amount of attention to be paid to the subtleties of the edges and furrows and margins of painting. Now, after the Seagrams, he continued to layer veils of paint but they tended to be very dark — browns, blues, maroons and blacks — all in the deepest possible tones. If the preponderance of dark was lifted at all it was often with white, as for example in the work from 1963 now in Zurich (fig. 19), with its stack of rectangular blocks of black rising to the thinner, brushy band of white that forms an incomplete edge at the top. The starkness of the opposition between black and white — the two poles of non-colour — is dramatised but also dissolves in that frayed edge of white. It is as if the classic format is now cast in shadow and reiterated in a complex game of doublings and negations. In fact, there are always other colours layered beneath the surface that give to the dark colours, and especially the blacks, a fullness and a depth. For instance, here, several layers of black and grey are layered over maroon.[8] As you look at these works the complexities of surface slowly reveal themselves. Rather than lighter rectangles laid over a darker ground, darker blocks are laid over an already dark ground. Only by obscuring the layers beneath does the work emerge and come into being. As opposed to reflecting a darkening mood, the works that Rothko produces in the wake of the Seagrams are like sombre but sensual doubles of the layout of his earlier paintings.

The more radical transition would occur in 1964, and the painting that would mark it is a vivid cadmium red (p. 147). Just as darkening his palette in such an extreme and sustained way had allowed him to break into something new, now, in yet another somersault, it is as if just an extreme red painting can break the pattern again. Rather than a neat turning point, it is one of a group of works that edge towards a very different way of organising the canvas. In *Untitled* 1964 the broad blocks of colour still form a vertical stack, but now with a narrow margin on either side of the central section. Rather than evacuating colour from the picture whilst remaining within the terms of the older format, one brown rectangle is simply superimposed over the larger red rectangle that is the shape of the whole painting. The edges are much harder and the space much shallower. You can see its prehistory through the layers — first a very loose red coat, where the paint has been allowed to drip; then the red and brown rectangles painted over again. Colours never come singly. Another painting of identical size, *No.5* 1964, repeats the same format in a black rectangle over brown (p. 151). Others, on a much larger scale, relate closely to those in the Chapel in Houston. *No 6* 1964 (p. 153) is differentiated only by a very slight shift in the register of black that he used. Their darkness is demanding: you have to look for some time for the different blacks and near-blacks to reveal themselves. The eyes must adjust to the dark, not unlike those of an insomniac settling into a wakeful night. The paintings require concentration, so that the perceptual process can be

Fig. 20
Ad Reinhardt
Abstract Painting No 5 1962
Oil on canvas
152.4 x 152.4
Tate

set in train. To look cursorily will only show an all-over black painting; looking takes time. As you look, depths of colour emerge in the black; different textures of brushwork, sometimes very subtle ones, unfold; in some, the under-layers of colour show through; in others, the ground is totally obscured. Rothko makes an experience not just a painting. And that experience is not only spatial but also temporal. This is what he had discovered so powerfully in the Seagram murals.[9] Stipulating a grey wall enhanced these effects, allowing the rich colour of the maroons and reds to emerge slowly, to prolong the aesthetic experience. The black paintings from 1964 look more severe, but they dramatise, to my mind even more powerfully, this sense that the encounter with a painting is a kind of waiting with your eyes wide open.

Ad Reinhardt had also made black paintings that initially seem monochrome but which, as you look, unfold into barely perceptible geometric forms like a square or a cross (see fig. 20). The perceptual facts make it impossible to see what you saw before you saw the subtle configuration. Reinhardt had got rid not only of colour, as he saw it, but also of what he termed the 'clichés of brushwork' in the mid-1950s.[10] The brushwork was 'brushed out to remove brushwork' and the surface was matte and 'glossless' and 'textureless'.[11] Even the way in which Reinhardt set out his aphoristic notes was compelling, especially for artists of the Minimalist generation, but so were his ideas — for instance, that black could be 'a medium of mind'.[12] It is as if for Reinhardt all art's paradoxes were played out through black. Black could be both a symbol and a void, positive and negative, a colour and a non-colour. Under the heading 'Black as color' he noted 'shiny black on matt black, texture, scumble'.[13] In the end it comes down to this: Reinhardt used black as a non-colour, whereas Rothko used it as a colour. In so doing he was working within an illustrious tradition within the history of art. Matisse once described the velvet jacket that Manet gave to Zacharie Astruc as 'expressed in blunt, luminous black' and stated that his own use of black in his *Morrocains* was 'as luminous as the other colours in the painting'.[14] From the point of view of Borge's claim that artworks create their own precursors, Manet and Matisse are much more meaningfully connected to Rothko than is Reinhardt.

Rothko made his blacks and darks resonate across a full range of possibilities from the most austere to the most sensual, from the most light-filled to the most lightless. One of the many ways in which he did this was by using a shiny black together with a matt black. He had already made a shiny red appear to project forwards and a matt red appear to recede in the subtle but still startling spatial gradations of the Seagram murals. There is also an unfinished and little-known study from that series that experiments with the same combination in black, which Rothko ended up leaving aside (fig.21). It was only some years later that the potential of matt-shiny all-black painting came good as a way of organising two distinct zones within a painting with the barest of markers. The subtle shine or reflectiveness picks up the lighting conditions of the place in which it is installed. All colour is sensitive to light, but here the painting itself becomes purely and simply a light-sensitive surface, like a huge and ghostly rayogram. The differentiations of the surface are slight, but the effects, once you notice them, radically change how you see the painting. The surface ends up bearing the imprint of its environment — which is also, of course,

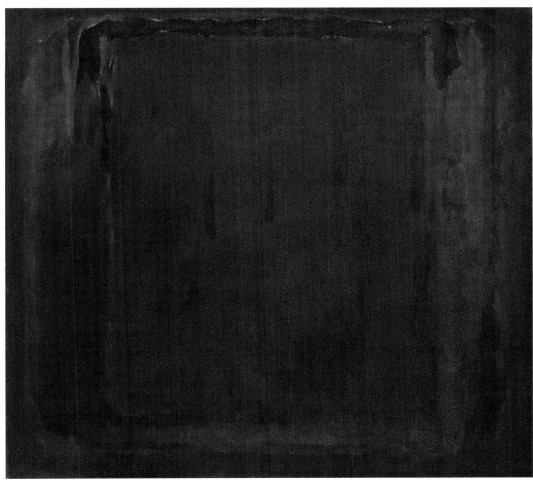

Fig. 21
Mark Rothko
Untitled 1959
Oil on canvas
267.2 x 289.2
National Gallery of Art, Washington
Gift of The Mark Rothko Foundation, Inc. 1985.38.4

our environment. These effects are transient and change depending on how far you stand away from the painting and at what angle. Further away, it may look blankly monochromatic; close up, the experience telescopes into a surface that ricochets between the lightness and darkness of black. Nothing more than a barely perceptible shine can reorganise both the spatial and temporal coordinates of painting. Again, the problems of how to hang the works were a direct consequence of the 'uncertainties and vagaries' that were so essential a part of them from the outset.

Black is a very powerful cultural symbol, but that does not mean that everything in a culture adheres to its symbolism. Most critical commentaries of Rothko's late paintings accept as given their symbolic currency of tragedy and foreboding.[15] Yet the evidence of the paintings themselves suggest, I think, a struggle against the legibility of any such symbolic reading. There may inevitably be a level of friction with cultural convention, but it is simply too easy to see black as a funerary colour. There is a pathos that attaches to the rhetoric surrounding Rothko's work that is not to be confused with the work itself. If you think of Robert Ryman and his all-white paintings (fig. 22), you do not automatically see them as symbols of purity or whatever traditional meaning white might have held, because Ryman makes white paint an intense material rather than an expressive deposit. Rothko may not be Ryman, or indeed Stella, or a painter of monochromes. But the point is that the history of modern colour had since the early twentieth century been engaged in a battle with precisely that kind of symbolic or iconographical approach. After all, Malevich's *Black Square* 1915 functioned not as a symbol of death but as a clean slate proclaiming the birth of the new. The death of colour had been at the hand of colour itself — ready-made colour, the kind that came straight from the can or the colour-chart.[16] Rothko's black is the opposite of ready-made; instead, by layering and mixing, he creates colour *through* it. And like any other colour, black has to emerge in the process of painting just as for the viewer it comes into being in experience.

Theodor Adorno, one of the last century's great diagnosticians, argued that an ideal of blackness was one of the few means for art to 'survive in the context of extremity and darkness, which is social reality' while acknowledging that 'blackness too — the antithesis of the fraudulent sensuality of culture's façade — has a sensuous appeal'.[17] The presupposition is that bright colour is fraudulent, while black holds some mimetic power critically to engage with those same lamentable conditions that make art so nearly impossible to salvage. Rothko does not so much fail to fit this model as put pressure on it by proposing an even more extreme stance: that black is no less fraudulent than the most vivid red, but nor is its sensuality simply a means to escape into some comfort zone outside of those conditions. Slowing vision down may not seem to amount to very much. It may not sound as heroic as making black the symbol of the death-knell of an entire culture. But if we set aside for a moment our desire for totalities, realising that in art, the greatest struggles are often more piece-meal and hard-won, then Rothko's late work seems a less likely but in the end greater achievement. The challenge becomes not to create symbols but to explore the opacity (or the fog) of vision itself. Each painting, rather than an escape into contemplation, requires of us the same kind of hard looking that

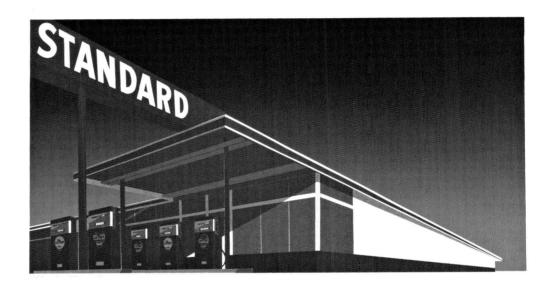

Rothko demanded of himself. Perhaps, after all, the turn against the work of the 1950s was necessary in the end precisely because it came too easily to him and his viewers. Extreme measures were necessary to test out how painting could not only survive but stand its ground in a culture that was – and is – predisposed to devalue it or treat it simply as spectacle.

One of the hardest aspects of Rothko's late work is how to situate it in relation to the problem of affect. By the word 'affect' I do not mean the mood a painting reflects or creates, but the feeling that a painting produces in the viewer. Affect is what hits you, often viscerally and often in a first instant, when you look at a painting. Rothko's reputation is as one of the great painters of affect, capable of moving us, but I want to propose that in his late work in particular this is not at all straightforward. David Sylvester was describing the affect of Rothko's paintings in that charged account of being borne down on followed by the exhilaration of release in a cathartic moment. As a counter, I quote the critic and poet David Antin, who suggests that the dark paintings create a sense of anxiety. He starts from the eyestrain caused by looking hard. In Reinhardt, he says, the slight feverishness that comes from the strain 'becomes an analog for a kind of transcendence', while the Rothkos 'produce a similar eyestrain but they don't produce a feeling of exaltation'.[18] Their slowness involves, I think, a kind of withholding of affect. This entails a deferral in time, but also more than that, as if deliberately to court disappointment. This does not mean they fail as paintings. It has nothing to do with an impoverishment of painting or a depletion of the artist's powers. On the contrary, it is a high-risk way of making a painting, which it had taken Rothko some thirty years to be able to reach.

We tend to think of 1960s art such as Pop or Minimalism as having firmly rejected the kind of emotion that was supposed to drip from every bit of bravura brushwork in an Abstract Expressionist painting, not least Rothko's own expressive touch. From the mid-1950s Jasper Johns had been systematically dismantling that myth with the achromaticity of grey as one of his lethal weapons of choice (fig. 23). Ed Ruscha developed a rhetoric of extreme indifference that is both extravagant and comic in his images of gasoline stations such as his dark screenprint *Mocha Standard* 1969 (fig. 24). He would go on to alternate between registers of colour and black and white, as if it would be absurd to think that either one offered any more possibility of emotional affect than the other. It is perhaps inappropriate to call this the context for Rothko's late work because it is so alien to his sensibility. Yet it does provide a larger frame of reference for the work that, however initially unpromising, gives a different kind of perspective on it. For instance, J.G. Ballard, the writer of dystopian fantasies admired by a younger generation of artists than Rothko's, made his own diagnosis of the 1960s as a time when 'emotion, and emotional sympathy, had drained out of everything'.[19] He has said that his own writing — books like *Crash* or *The Atrocity Museum* — was an attempt to awaken some kind of feeling by going to extremes, through violent and sexual images, to counter the general anaesthesia. Rothko's radical experiments in *chroma* could not be further removed from Ballard's fantasies in gleaming chrome. Yet there is a bizarre symmetry to their polar positions at each end of a spectrum of feeling — each marking some kind of extreme measure in response to a mid-point that is entirely affectless and indifferent.

I began with one of the works on paper done in the last year of his life, reduced now to a surface divided into two blocks of dark and light. Rothko also produced a series of much larger paintings in acrylic on canvas using the same simple format, all of which draw on the grisaille colours of white, grey, neutral, brown and black. These works are striking in part, as I said at the start, because of what has been extricated from them, but I did not even begin to describe the full impact of the turn-around involved. Most striking of all, here we have Rothko reintroducing one of the main taboos that had haunted abstract painting from the outset: a line that runs across the picture as if it were a horizon line. Most abstract painting, including Rothko's own, had been predicated on the suppression of anything that could be seen as redolent of figuration in a landscape format. Yet these paintings never become landscapes, even when their format is horizontal (the fact that the term 'landscape format' is still often used to describe the orientation of abstract paintings shows how language holds to an archaeology of viewing habits). If Rothko much admired the late paintings of Turner, which were shown in a major retrospective at the Museum of Modern Art in New York in 1966, it must surely have been because their centrifugal arrangements and complete chromatic dissolution so exceeded landscape as a genre, even though they were produced in the mid-nineteenth century (contemporaneously, of course, with Dickens). Rothko continues in this spirit of self-contradiction when he leaves a border a little short of the framing edge, creating a white surround, whereas before, his custom had been to paint all the way around the sides of the stretcher. Having used masking tape around the edges when making the work on paper, he chose to use the same technique when making the paintings on canvas. He often adapted it by hand, making it slightly narrower or

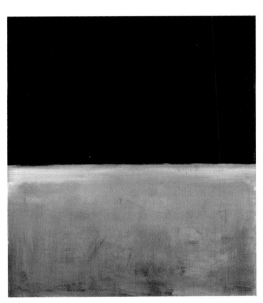

Fig. 25
Mark Rothko
Untitled 1969
Acrylic on canvas
233.7 x 200.3
Collection of Christopher Rothko

wider. It is not inconceivable that this was some kind of delayed response to his other old rival Barnett Newman, who used masking tape to make his vertical zips, a comparison that makes all the more anomalous and even scandalous the fact that Rothko should use it in the way that he does. He does not simply draw attention to a framing edge, but makes a more definite frame, of the kind that conventionally separated the imaginary content of painting off from the wall and the world outside it. Given all that has gone before, not least the drive to immerse the spectator in the work, it makes one wonder at Rothko's remarkable capacity to question himself in a way that proved generative of new work.

On the surface, these paintings look 'minimal', but it turns out that they are anything but, at least as that term became synonymous with art that rejected a certain kind of feeling or affect. Although initially they appear empty, with time they open onto a different kind of amplitude. Their sparseness — the simple doubling of the surface, the barely stated condition of enframement — is offset by the way the surfaces become capacious as they unfold in the course of looking at them over time. First, the lighter whites and greys more obviously let the light through in patches, the open brushwork often suggesting mini-vortexes or more intricate passages of veils and drips of liquid acrylic. The dark blocks are more intransigent, but they too end up yielding more than they look as if they should. In *Untitled 1969* (fig. 25 / p. 193), Rothko painted over the narrow white border where the masking tape had been, but left the side of the stretcher white, thereby making us pay attention to painting as a surface rather than as an object. The lower half is filled with horizontal strokes of grey layered over a lighter white, with drips beneath the vaporous surface, even tiny spatters of red. But then the top half turns out to be full of incident too, with a reddish-brown pressed into the mass of dark, an under-painted layer of brown showing through the black. There is a luminosity in dark and an opacity to light that tends to throw our expectations — as well as any lexicon of symbols — into disarray. It is as if the slow process of looking demanded of us claws back something from painting's dying affects: a kind of lustre that is all the more intense because it does not get delivered up that easily. Rothko does so not by making art more complicated, but by asking fundamental questions like what is the very least that can hold a painting together. The horizontal that divides the surface into two is not in fact a line but a join or hinge. It hovers just a little below the level of our own eyes, corresponding with our line of sight, as if whatever we might think of as a horizon is not something out in a landscape so much as inside our eyes. It is what holds a picture together because it is what conjoins it with us, like a spirit-level that registers not only our presence but also our precarious equilibrium in front of the paintings.

THE WORLD IN A FRAME
DAVID ANFAM

THE WORLD IN A FRAME
DAVID ANFAM

I realize that historically the function of painting very large pictures is ... grandiose and pompous. The reason I paint them however ... is precisely because I want to be intimate and human.
Mark Rothko

As the archaeology of our thought easily shows, man is an invention of recent date. And one perhaps nearing its end.
Michel Foucault

At the time when Mark Rothko was tackling and recovering from the Houston Chapel project, the American cinema twice serendipitously echoed certain recurrent themes of his art. John Frankenheimer's *Seconds* (1966) featured a banker who fakes his own death, alters his appearance with radical plastic surgery and is 'reborn' into a second life as an artist, before coming to an untoward end. Fundamentally, *Seconds* delved the darkness at the heart of identity, its effacement and the personae that the self may assume, concerns that had long preoccupied Rothko.[1] Later, in the year Rothko suffered an aneurysm linked to the duress of realising the huge Chapel paintings, Stanley Kubrick's *2001: A Space Odyssey* (1968) presented a black monolith strikingly similar, again coincidentally, to the dark forms in the artist's images.[2] Kubrick's enigma symbolised some transcendent absolute, maybe even a negation, countering human consciousness. Both films posed similar questions: what does the 'human' mean and where might selfhood reside in an antagonistic age? During his ultimate decade or so, Rothko recast these issues with the studiousness of an endgame.[3]

On the one hand, Rothko's artistic moves appear entwined with his biography, inviting romanticised interpretations. From this standpoint, as the 1950s drew to a close, the artist's moodiness, his disillusion with the responses to his work, and his incipient physical ailments conspired to produce what may resemble, for want of a better phrase, gloomy pictures.[4] Indeed, Rothko fostered readings in this *vie romancée* vein: 'I can only say that the dark pictures began in 1957 and have persisted almost compulsively to this day.'[5] The remark suggests an inner drive, implying that the artist must externalise it, as though emotion can be 'ex-pressed', like paints from a tube, onto canvas (a fallacy that E.H. Gombrich and others have demolished. Communication relies upon shared conventions, schema, language and other sign systems).[6]

Undeniably, too, Rothko's predilections meshed with the typology of melancholia.[7] This repertoire included shadow (a leitmotif from his *Sketch in the Shade*, painted in July 1925, onwards),[8] solitude or stasis ('for me the great achievements of the centuries in which the artist accepted the probable and familiar as his subjects were the pictures of the single human figure — alone in a moment of utter immobility')[9] and mortality ('there must be a clear preoccupation with death').[10] Then again, as Julia Kristeva has argued, the mind may be unable to countenance death, and the difference between clinical depression and an art born of melancholia is that the latter sublimates the former into eloquent speech.[11] Here, Rothko's purpose when donating a group of the Seagram murals — those putatively silent set pieces — to

the Tate Gallery is pertinent. He wrote to that institution's director in 1966: 'It seems to me that the heart of the matter ... is how to give this space you propose the greatest eloquence and poignancy of which my pictures are capable.'[12] This pronouncement came from the painter who elsewhere declared that 'silence is so accurate'.[13] In short, Rothko was antinomic to the core of his being — an exponent of silent speech.

On the other hand, Rothko's conflicted sensibility matched that of the 1960s against which his conclusive artistic strategies unfolded. It was an almost schizophrenic decade. Alongside the euphoric ecstasy that the 'Summer of Love' (1967) epitomised, apocalypse was in the air — from such bellwethers as Andy Warhol's 'Death and Disasters' series (1962 onwards), to the dystopia of 1968 and The Rolling Stones' hit song, 'Paint It Black':

> I wanna see it painted, painted black,
> Black as night, black as coal
> I wanna see the sun blotted out from the sky.
> I wanna see it painted, painted, painted black.

Mick Jagger and Keith Richards wrote these lyrics the year (1966) before Rothko completed the Houston Chapel scheme, in which black reigns — either as the obdurate mass blocking the centre of two of the three triptychs and of the south entrance wall painting, or as the pigment mixed with red that yields the sombre all-pervasive purple tone. Coincidence again? Doubtless, yes.[14] However, The Rolling Stones' and Rothko's joint address to blackness signals his canny parallelism with wider avant-garde developments in the 1960s.

Black is double-edged. Associated in Western eyes with mourning and negation, it also carries more positive overtones: consider black as a newly chic fashion statement in the 1960s (hearkening back to its nineteenth-century role as *de rigeur* for formal wear and the dandy) as well as the advent, in the racial sphere, of black consciousness. If the comparisons sound fanciful, then we have the old truism that it is to black (or monochrome) that modern artists have gravitated at moments of special concentration, high drama or innovation. The manoeuvre has ranged from the grisaille of 'analytical' Cubism, Kasimir Malevich's canonical *Black Square* 1915, Henri Matisse's orchestration of black as light during the First World War years (fig.26),[15] Pablo Picasso's *Guernica* 1937, Robert Motherwell's paens to blackness in his 'Elegies to the Spanish Republic', Ad Reinhardt's testing of black from the early 1950s onwards to Frank Stella's paintings of 1958—9.[16] The last heralded trends that proved widespread during the 1960s. The tendency that dealt most intensively with these was Minimalism.

Balancing the bright colours that Donald Judd, Dan Flavin and others explored, Minimalism elsewhere evinced a streak of chromophobia not altogether dissimilar to Rothko's aversion, around 1957, to his luscious palette of the first half of the decade and his drift towards a direction that reached a point of no return in the Chapel's subfusc tonalities and the still severer ones of the *Brown and Gray* acrylics

Fig. 26
Henri Matisse
Porte-Fenêtre à Collioure 1914
Oil on canvas
116 x 89
Musée National d'Art Moderne,
Centre Georges Pompidou, Paris

and *Black on Gray* canvases of 1969–70. Likewise, the studies for the Chapel triptychs are done on black paper, as though anything else could distract from their graph-like plotting (intriguingly, Cy Twombly's first dark-ground, blackboard-like paintings happened in the same year, 1966, as Rothko's studies). As the artist David Batchelor has demonstrated, common perception ties bright colours to irrationality, unsophistication, the superficial and base physicality: 'Colour threatens disorder — but also promises liberty.'[17] Scant wonder that the Seagram murals should foreground monochrome.[18] Rather than promising 'liberty' in them, Rothko is routinely cited as having averred that they should entrap:

> I realized that I was much influenced subconsciously by Michelangelo's walls in the staircase room of the Medicean Library in Florence. He achieved just the kind of feeling I'm after — he makes the viewers feel that they are trapped in a room where all the doors and windows are bricked up, so that all they can do is butt their heads forever against the wall.[19]

As for black signifying cerebration in contrast to action or frivolous *matière*, Hans Namuth's photograph of Rothko pondering two canvases speaks volumes (see fig.11). It portrays a thinker rather than a doer, someone who suppressed the reds of even the unprecedentedly stark composition at left for the shiny/matte blacks of that on his right. True, Rothko distinguished between his dark pictures and those of Ad Reinhardt, propounding that 'the difference between me and Reinhardt is that he's a mystic. By that I mean that his paintings are immaterial. Mine are *here*. Materially. The surfaces, the work of the brush and so on. His are untouchable.'[20] Notwithstanding this disclaimer,[21] Reinhardt penned a notion that pinpoints Rothko's later use of black: 'Black, *"medium of the mind"*'.[22] Why? Because Rothko was an inveterate Platonist, a philosophical idealist who earlier proclaimed that 'all of art is the portrait of an idea' and, later, was delighted when a friend said that one of his paintings represented 'pure mind'.[23]

Blackness, materiality, entrapment and ruling ideas happen to have coalesced — in step with Rothko's commissions for Harvard's Holyoke Center (1961–2) and the Chapel — in Minimalism. Despite vast divergences in media and intention between, say, Tony Smith's black cube, *Die* 1962, Eva Hesse's black frame *Washer Table* 1967, the obsidian of Robert Smithson's *Double Non-Site, California and Nevada* 1968 and Richard Serra's monolithic, dark grey lead *One Ton Prop (House of Cards)* 1969, each abnegated colour with a resolve as stern as Rothko's in the same period. There are more parallels. For example, Carl Andre's parodistic sculpture, *The Maze and Snares of Minimalism* 1993, retroactively highlighted the cage-like structures and enclosures that Robert Morris and, subsequently, others beyond Minimalism (Bruce Nauman's *Green Light Corridor* 1971) had earlier employed to frame the spectator and straiten his/her space.[24] The enclosure of Morris's *I-Box* 1962 is almost the same configuration as the internal 'I' motifs — architectonic ciphers or figural surrogates — in at least six of Rothko's canvases and related oil sketches for Harvard. Both engage human presence and its envelopment. As the *I-Box's* case fits the photograph of the naked artist inside it, so Rothko was fascinated — in the verticality of his signature style — with rectangles that metaphorically articulate a human scale.

What Morris made ironic, Rothko had rhapsodised. To quote Rothko's credo, 'since there are no gods man must measure himself'.[25] This dictum underwrote the 'measures' that parse his abstract fields into a human-like upright stance. When the collector Duncan Phillips asked, 'Am I right that in your approach to your work, *color* means *more* to you than any other element?', Rothko answered, 'No, not color, but *measures*.'[26] By this logic, Rothko's hallmark image sprang from Leonardo's 'Vitruvian Man' — metamorphosed into an altogether different species of vaporous, outspread presence.[27]

However, the humanist-cum-Renaissance Rothko had another side. To paraphrase Franz Kafka, Rothko was adept at taking sides against himself. Never did he do so more than after 1957. Whereas hitherto his paintings frequently had a soft haziness that invited the gaze to enter and immerse itself in their brightness, henceforth the contours hardened; their overall refulgence dimmed; the values became polarised until, in 1969, they reached black poised above inchoate greyness; and either they congregated in wraparound ensembles (the mural sequences)[28] or they retreated from the spectator. In his light-toned acrylics on paper of 1969, Rothko even feigned to recapitulate his pre-1957 lyricism.[29] By contrast, with their white borders and dry acrylic textures, the *Black on Gray* paintings are very specific, slightly impersonal, objects.[30] To be sure, they are not two-dimensional equivalents to Judd's boxes; nor were they ever meant to be.[31] Yet they affect to approach a whole climate of literalness, thought and practice in the 1960s (and we must remember too that 'Minimalism' was as much a set of debates as of actual art practice) towards which Rothko might otherwise be taken for a complete outsider or even an adversary.[32]

Rothko stated of the Seagrams, 'I have made a place' and that it was 'a *place contained*'.[33] Equally site-specific were the Harvard paintings, which also ultimately failed to find their rightful place of belonging (in this case due to conservation hazards) and instead became displaced entities (as were, in a quite different semantic context, Smithson's 'Non-Sites'). When Rothko found a site that his art could inhabit with acute specificity, the Houston Chapel, the irony was that he never saw the installation (nor even visited the place). A less bitter cut concerns the ambiguities of the entire endeavour, which was, in a sense, acutely modernist and current: modernist insofar as it was 'the most ambitious attempt at the integration of painting and architecture in the twentieth century';[34] current insofar as here were site-specific and installation art *avant la lettre*, albeit idiosyncratically conceived, and taken to an uncommon extreme. By another token, though, the Chapel remains a conservative anachronism, a throwback to the Renaissance and even more distant antecedents. If, as Arthur Danto posits, the Chapel went beyond painting to foretell a later era, our own, where artists 'strive to encompass their audiences in a relationship more intimate than vision alone permits',[35] it was also as regressive as Chartres or Stonehenge.

Countermanding this ultra-traditionalism — symptomatic of a reactionary, if noble, urge to re-enchant painting with the powers of ritual or magic so that it might enthral the beholder — was a strong streak of no-nonsense objectivity that could

verge on bloody-mindedness. Thus, Rothko said of the Chapel that 'I'm only interested in precision now'; that it was 'all a study in proportion'; entrusted the execution of most of the paintings to the hands of assistants; and, anyway, had already decided, *à propos* the Seagram cycle, that he was 'pretty much of a plumber at heart'.[36] Again, we might be reminded of a 1960s sensibility akin to that of Judd, the young Stella, Sol LeWitt and Robert Mangold. Judd asserted, 'Yes. The whole's it. The big problem is to maintain the sense of the whole thing.'[37] *Mutatis mutandis*, Rothko held that his entire output should be regarded as a single whole.[38] In particular, on what do his three mural series — wherein no single component functions alone or apart from the total effect — pivot if not 'the sense of the whole thing'? Similarly pragmatic was Rothko's resolution in his talk at the Pratt Institute that: 'Truth must strip itself of self which can be very deceptive.'[39]

Going further, mordancy marked Rothko's reported oft-cited remarks that the Seagram Building was 'a place where the richest bastards in New York come to feed and show off ... I accepted this assignment as a challenge, with strictly malicious intentions. I hope to paint something that will ruin the appetite of every son of a bitch who ever eats in that room.'[40] That a strain of ostentatious malice bordering on nihilism comprised the flip side of Abstract Expressionism's spiritual aspirations is predictable. For a start, we can trace its ancestry to Rothko's sometime friend, Clyfford Still. Writing in 1949 about an invitation to participate in a drawings show in San Francisco, Still anticipated Rothko's spleen by nearly a decade:

> OK. I'll give you a picture. After all, this show to an artist of integrity can only be a gesture ... I will give you my gesture, my respect for the public art gallery working in these terms. I will give you my contempt for the whole business: a six-by-ten foot canvas blank as the fabric comes from the factory.[41]

Like Rothko's derring-do aim to ruin the appetites of those in The Four Seasons restaurant, Still's was the last-ditch response of a humanist, someone who believes in the integrity of the self, when confronted with an inimical age. By the time Rothko died in February 1970, he was on the cusp of a new paradigm. Simply stated, it was a post-human mentality for which Michel Foucault's voice, that year, spoke bluntly: 'As the archaeology of our thought easily shows, man is an invention of recent date. And one perhaps nearing its end.'[42]

Rothko's eschatology was still darker. As Dore Ashton recounted, 'When he asked me three months before his death whether I thought the world would last another ten years, I know he was serious.'[43] Crucially, the size of the Seagram and Chapel canvases abrogated Rothko's previous attitude to scale, as when in 1951 he explained that his reason for painting large pictures was 'precisely because I want to be intimate and human'.[44] Once the beholder had faced Rothko's compositions as if meeting another personage. Now, surrounded by the multitude of rectangles mirroring the rectangularity of the Seagram paintings themselves, the classic format segued into something more disturbing: darkly tinctured nothingness extended by repetition so that the spectator in their midst might as well be in a room without a view, a *huis clos*. Moreover, Rothko's claim to have executed three distinct series

Fig. 27
Mark Rothko
Thru the Window 1938–9
Oil on gesso board
25.1 x 17.5
National Gallery of Art, Washington

Fig. 28
Jan Vermeer
Officer and a Laughing Girl 1655–1660
Oil on canvas
50.4 x 46.4
Frick Collection, New York

smacks of narrative over-determination and his ingrained penchant à la Nietzsche for being systematically unsystematic. Rather, the Seagrams are more akin to a *Gesamtkunstwerk*, of which the very point is to deny any easy entry or exit — bleak stage scenery for a theatre of the absurd. Jean-Paul Sartre anticipated its repetitive seriality in 1946 when he wrote of Manhattan that it was akin to everywhere and nowhere: 'You never lose your way, and you are always lost.'[45] The mood is that which would also permeate Alain Resnais's film *Last Year at Marienbad* (1961), with its endless corridors, puzzling spaces and figures as still as the architecture that dominates them (while the camera itself relentlessly shifts, just as Rothko's murals and the small yet panoramic studies on paper that preceded them adumbrate the panning motion of a lens and/or an ambulatory subject).[46] Divulging a rare glimpse of his motives, Rothko described this atmosphere to David Sylvester: 'Often, towards nightfall, there's a feeling in the air of mystery, threat, frustration — all of these at once. I would like my painting to have the quality of such moments.'[47] In the Houston Chapel, such feelings dig deeper. Despite an aura of premonitory *Stimmung*, there is little to see — except slate-like black shapes; formless maroon-purple fields hovering in the manner of some inexplicable, enveloping ether; the repetitive axes that arise between the placement of the images around the angles of the octagon, like sight-lines without a vanishing-point; and the doorways of the architecture, apertures that ape the compositions' rectangles.[48] Of this dark fugue, a veritable *camera obscura*, Rothko insisted that he intended to create 'something *you don't want to look at*'.[49] This resembles a despairing humanist's negative rejoinder to Judd's matter-of-fact Yankee pragmatism when, in 1964, the latter critiqued one of Robert Rauschenberg's early monochromes: 'There isn't anything to look at.'[50]

Looking and not wanting to look, gazing and seeing nothing, the very act of framing a view or a subject — these all have a history in Rothko's lengthy career. As early as the small but prophetic panel *Thru the Window* 1938–9 (fig. 27), the true subject is the matrix of the pictorial *mis-en-scène*. Put another way, both *Thru the Window's* title and its diminutive drama enact one of painting's originary gambits, that of a window frame.[51] Given the perspectival window and the otherwise weird rectangular frame-within-the-picture, this fantasia hints that somewhere in its lineage lurks Leon Battista Alberti's famous passage on painting:

> Let me tell you what I do when I am painting. First of all, on the surface on which I am going to paint, I draw a rectangle of whatever size I want, which I regard as an open window through which the subject to be painted is to be seen; and I decide how large I wish the human figures in the painting to be. I divide the height of this man into three parts, which will be proportional to the measure commonly called a *braccia*; for, as may be seen from the relationship of his limbs, three *braccia* is just about the average height of a man's body. With this measure I divide the bottom line of my rectangle into as many parts as it will hold.[52]

Not only might Alberti's mention of bodily measure have caught Rothko's attention, but also this text touches one of his *idées fixes*: art's reckoning with the world's spaces and their translation into planes, surfaces at once flat and illusory. This is also why *Thru the Window* may make passing allusion to Jan Vermeer, especially his

Fig. 29
Mark Rothko
Untitled #12 1936—8
Oil on canvas
50.8 x 40.6
Neuberger Museum of Art

Fig. 30
Marcel Duchamp
Fresh Widow 1920 replica 1964
Mixed media
78.9 x 53.2 x 9.9
Tate

Officer and a Laughing Girl 1655—60 (fig. 28). Each juxtaposes large and relatively dwarfed figures, the officer's bright red garment chimes with Rothko's red painting on an easel and both have leftward windows in sharp perspective.[53] Vermeer in general also anticipates a Rothkoesque play between luminosity and abstract, often rectilinear, design[54] (as well as a theme that, to reiterate Rothko's words of 1947, involved 'the single human figure, alone in a moment of utter immobility').

Elsewhere, the early Rothko grappled with spatiality, already a central topic in his thought, yet one that burgeoned into the *sine qua non* of his mature art. In turn, the reduction of means that the sexagenarian Rothko essayed left space — near-empty, full of nebulous colour or abruptly truncated, as in the cut-and-dried facticity of the 1969—70 canvases and acrylics on paper — as almost all that remained. In teaching notes written in the 1930s, Rothko mused, 'a child may limit space arbitrarily and then heroify his objects. Or he may infinitize space, dwarfing the importance of objects, causing them to merge and become a part of the space world.'[55] Much later, infinity morphed into another dimension. When questioned about the content of the Chapel paintings, Rothko replied, 'the infinite eternity of death'.[56] Mortality spatialised.[57]

Perspective generates infinities.[58] Significantly, Rothko's paintings of the 1930s alternate frontal/flat passages (where often the figure predominates) and plunging vanishing points. In the most bizarre instances, such as a tableau in which two nudes gesture, respectively, before a partly closed door (a near-flat rectangle) and a partly open one (a recessive plane revealing emptiness), the dialectic looks almost programmatic (fig. 29).[59] Whatever its pictorial guise, the underlying scenario entails a dilemma that has pervaded modern existence and ideology since the late nineteenth century: where to position the beleaguered self and its surfaces? This begs the question of frames, the tropes or figures of placement.

One modernist tradition has made cynical retorts to the problematic self and its sites. In sum, these subversions annihilated subjectivity and/or replaced it with surrogates, frequently mechanomorphic or sub-human. Marcel Duchamp exemplified such iconoclasm. His *Fresh Widow* 1920 is the framework that was left when half a millennium of Alberti's Renaissance art-as-a-window frame was emptied out (fig. 30). Duchamp's 'widow' mourns with her black leather windows for a lost transparency. In an analogous spirit and closer to the last-ditch tastes of the present day, so will Damien Hirst's shark in *The Physical Impossibility of Death in the Mind of Someone Living* 1991 stand proxy, in its all too-transparent display container, for a human subject *in extremis*. Yet, for the most part, Rothko took another route.

As Rothko admitted, 'I belong to a generation that was preoccupied with the human figure ... It was with the utmost reluctance that I found that it did not meet my needs. Whoever used it mutilated it. No one could paint the figure as it was and feel that he could produce something that could express the world.'[60] Rothko's many distorted perspectives in his earlier work bespeak his figures' self-awareness migrating into their ambience. A major precursor here — and one unquestionably known to Rothko — was Edvard Munch.[61] Munch's *The Scream* 1893 (fig. 32) is the

Fig. 31
Mark Rothko
Untitled (Figure Standing at a Portal) c.1938–9
Gouache on paper
23.2 x 15.5
National Gallery of Art, Washington

modern *locus classicus* for an emotional tide flooding from the self into its surroundings, with a head-on figure opposed by plummeting space. Reverberations of *The Scream's* ordonnance run through diverse compositions by the young Rothko, such as *Street Scene* 1936—7 and two subway paintings of 1939.[62] Indeed, perhaps the expanses with little except blood-red, purple and maroon shades that the Seagram murals initiate are a last way stage in the progress of the 'pathetic fallacy' — that is, empathy pushed to a pitch at which we inject ourselves into erstwhile insentient space.[63] The result is to immerse the beholder in a wilderness of empty, though deeply tinted or shadowed, mirrors. It is a foretaste of sorts to the conditions of our own era, overwhelmed by the 'windows' or frames of cyberspace, computer screens, mobile phones and a myriad other technologies employing virtual portals to structure everyday consciousness.[64]

As Michel Butor observed, when Rothko turned his classic format on its side to create the horizontal disposition that first emerged in the Seagram murals, the margins that had hitherto defined his colour fields accordingly moved inside the paintings.[65] This climaxed a lengthy rhetoric of mirroring and framing in Rothko's stagecraft. In the Namuth photograph of 1964 (fig. 11), the dark painting stands in relation to the red one as though it were a black mirror, while Rothko's scrying of the pair hints at his odd habit of both recognising and effacing his self in his works. Thus, he claimed on one occasion, 'when I recognize myself in a work, then I realize it's completed'; on another, 'I don't express myself in painting. I express my *not-self*.'[66] From such remarks, we might almost suppose that Rothko proleptically rehearsed Jacques Lacan's concept of the 'mirror stage' of identity formation.[67] Be that as it may, the stacked rectangles of Rothko's signature style evolved from the doubling of the upper and lower halves of his compositions of the mid-1940s, which approximate reflections in water (hence, too, the various titular references, such as *Slow Swirl at the Edge of the Sea* 1944 and *Figure in Archaic Sea* 1946) and also, possibly, refer to the arrangement of Pierre Bonnard's death-haunted *Self-Portrait in the Mirror* 1945 with its simulacrum of the figure reduced to tinted shadow.[68] While the mirror *topos* may derive from such prototypes as Picasso's *Girl Before a Mirror* 1932, its roots go back to an extraordinary early watercolour and gouache on paper (fig. 31).[69] There, everything comes together — the doubling of light and dark onlookers in profile, a fixation with seeing and, in turn, the enigmatic object of the gaze: this evokes a mirror, a portal and an abstract canvas (note the row of white marks along its edge, reminiscent of both the light bulbs that surround theatrical makeup mirrors and of the tacking margin of a canvas).[70] Lest the interpretation should sound extravagant, Rothko's own notebooks testify to a probable source for these mirrorings and acts of framing the self: 'The story by Vasari of the painter who painted himself from a reflection of an infinite number of mirrors.'[71] The reference is almost certainly to Giorgio Vasari's account of Parmigianino's *Self-Portrait* c.1523—4 (fig. 33) in the second volume of his *Lives of the Artists*, wherein the painter is said to have rendered himself in a convex barber's mirror in which he 'set himself to counterfeit or it all that he saw in the mirror'.[72] That Rothko, already conversant with Vasari's *Lives* in the 1930s,[73] wrote this note around 1954 when he was well advanced into abstraction stresses the continuity of his thinking over many years.

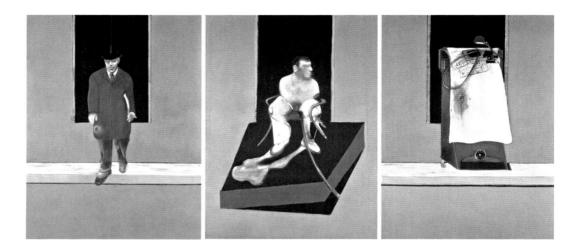

Fig. 34
Francis Bacon
Triptych 1986—87
Oil on canvas
Each panel 198 x 147.5
Private collection

Flash forward from the watercolour of the late 1930s and everything that it typified, to Rothko's note in the 1950s on Parmigianino, who 'painted himself from a reflection of an infinite number of mirrors' and whose spirit haunts the repetitions of the classic abstractions, to the last, post-1957 phase. Where are we? By one reckoning, the doublings and empty inner frames of the Seagram murals, the modular serialism of the large oil and smaller pencil studies for the Chapel, and the black or brown areas that replicate the grey ones below in the acrylics from 1969—70 suggest that we might be in the so-called culture of the copy.[74] In other words, a pictorial counterpart to the rationale that yielded Andy Warhol's conundrum: 'People are always calling me a mirror and if a mirror looks into a mirror, what is there to see?'[75]

In the same breath, however, we also remain in the land that Rothko had long made his own — except that its terrain had grown irremediably starker. Arguably, the late Rothko's mental geography was somewhat akin to 'the area of bare uniqueness' and the Spartan mechanics of the thoroughly 'dismantled image' that the philosopher Richard Wollheim was then outlining as criteria for Minimalism,[76] or else to the ethos of a systemic artist such as Howard Mehring: 'I am using the same basic composition over and over again. I never seem to exhaust its possibilities.'[77] Certainly, we are in the darkling theatre of late twentieth-century Existentialism. Why else would Francis Bacon have perceived Rothko's abstract stage clearly enough to mimic it in the blank black rectangles that sometimes frame his desperate protagonists (fig. 34).[78] The Rothko who claimed to express his 'not-self' in painting matched the Samuel Beckett of *Not I* (1970). And the stripped-to-the-bone rigour of the artist's late visual syntax, the Seagrams' imagery of blocked windows and the sepulchral light of the 1969—70 paintings, match the setting of the same writer's *Endgame* (1957):

> Bare interior.
> Grey light.
> Left and right back, high up, two small windows, curtains drawn.[79]

As with Beckett, every detail is carefully calibrated.[80] Beckett's comment in 1949 about the artist's fate applies *a fortiori* to the late Rothko: 'the expression that there is nothing to express ... together with the obligation to express'.[81] If Rothko's claim that the Chapel encapsulated 'the infinite eternity of death' rang, like a ground bass, through the rest of his activity in those years, it also revived the words of Beckett's character Hamm:

> You'll look at the wall a while, then you'll say, I'll close my eyes, perhaps have a little sleep, after that I'll feel better, and you'll close them. And when you open them again there'll be no wall any more. [*Pause*.] Infinite emptiness will be all around you, all the resurrected dead of all the ages wouldn't fill it.[82]

Above all, Rothko's endgame was a deliberated campaign to frame a certain obsession. He loved to recall the Italian film director Michelangelo Antonioni telling him in late 1962 that they shared the same subject matter — 'nothingness'.[83] Having reached this terminal world, the last stage in a prolonged shift from a previous and relatively optimistic humanism to a downbeat existentialism, Rothko nevertheless made of it a disciplined art.[84] And what is art, if not the world in a frame?[85]

ROTHKO AND THE CINEMATIC IMAGINATION

MORGAN THOMAS

ROTHKO AND THE CINEMATIC IMAGINATION
MORGAN THOMAS

Maybe you have noticed two characteristics exist in my paintings; either their surfaces are expansive and push outward in all directions, or their surfaces contract and rush inward in all directions. Between these two poles you can find everything I want to say.
Mark Rothko in conversation with Alfred Jensen, 1953[1]

A [picture] frame is centripetal, the screen centrifugal. Whence it follows that if we reverse the pictorial process and place the screen within the picture frame, that is if we show a section of a painting on a screen, the space of the painting loses its orientation and its limits and is presented to the imagination as without any boundaries. Without losing its other characteristics the painting thus takes on the spatial properties of cinema and becomes part of that 'picturable' world. ... It is in pulling the work apart, in breaking up its component parts, in making an assault on its very essence that the film compels it to deliver up some of its hidden powers.
André Bazin, 'Painting and Cinema'[2]

In his later serial work, Rothko moves into a visual terrain that is distinctively, and errantly, cinematic. The cinematic current running through his later work, beginning with the Seagram mural project and continuing in his subsequent series, correlates with his systematic adoption of the 'framework of a permutational unfolding' — a peculiarly cinematic framework — in his painting.[3] Three elements contribute to the cinematic quality of these later paintings: the use of illusion, the solicitation of the viewer as part of the work, and, following from these considerations, the work's capacity to conjure an uncanny sense of the lived experience of time, space, light and movement.

One place where Rothko's use of a cinematic framework, and its implications for his painting, becomes strikingly evident is in his use of darkness and indistinctness — both qualities central to his later work. There is evidently much common ground between Rothko's darkness and that of many of his contemporaries in the late 1950s and early 1960s — the general interest in real or 'literal' presence and the persistent pull of formalist notions of 'pure' painting leave their mark. Yet Rothko's later paintings never look completely at home next to the work made around this time by artists like Ad Reinhardt, Frank Stella, Robert Rauschenberg or Pierre Soulages. Their difference lies, perhaps, in how they function cinematically and appear made to function cinematically.

Nowhere are darkness and indistinctness more visible in Rothko's work than in his series of *Black-Form* paintings of 1964. Just preceding his work for the Houston Chapel in Texas and leading directly into the paintings known as the 'Chapel out-takes', this series suggests how the framework of a cinematic unfolding comes into effect in Rothko's work and the level of intensity it brings to it.

Rothko's paintings of 1964 invite comparison with Reinhardt's black paintings of the 1960s (fig. 20). Both Rothko and Reinhardt use thin paint and finely differentiated variations of black and near black. These marked similarities do not efface the

Fig. 35
Georges Seurat
Promenade c.1883
Pen and ink
29.8 x 22.4
Von der Heydt-Museum, Wuppertal

differences in their approaches, however. Reinhardt's square, matte, evenly painted surfaces, often enclosed in thin black wooden frames, appear self-contained, committed to their own rigorous internal order. They impeccably register Reinhardt's tautological idea of 'art as art' and nothing else. Rothko's surfaces, by contrast, are full of micro-inflections, material traces of the painting process that remain visible — if just faintly so. Rothko distanced his work from Reinhardt's, distinguishing what he saw as the 'mystic' character, or idealism, of Reinhardt's paintings from his own paintings' way of being 'here' — 'materially'.[4] As his comments indicate, Rothko's nuanced darkness conveys some sense of volume and reinforces his paintings' object-like physicality, yet curiously, as Stephanie Rosenthal has noted, it is also more 'atmospheric', more outwardly oriented, than Reinhardt's.[5] This darkness is also a foil for the elision of contraries in the paintings — their weaving of materiality and ephemerality, continuity and discontinuity, darkness and light. Rothko cultivates the dynamic relationships that Reinhardt did not want in his paintings. If you keep looking at these inflected surfaces, the perceptual blackout that may be their first effect opens onto an aesthetics of indeterminacy and movement.

Like the passers-by in Georges Seurat's drawings of the 1880s, the central figures (or zones) in Rothko's 1964 series are not just part of the atmosphere around them, but are themselves atmospheric (fig. 35). Rothko's figures, even more than Seurat's, fade in and out of the spaces surrounding them. Seurat draws volume and space together in an infinitely flexible mesh of lines. In Rothko's case, what brings the picture surface and the central dark zone into communication with one another is his treatment of them as screens, that is, as open yet delimited surfaces through or onto which light and colour pass. The surface screens the figure and vice versa. To use a phrase with a currency extending across many visual media, the computer and television as well as film, the 'screen effect' in Rothko continues beyond the limits of the pictures.[6] Even as they subtract themselves from the viewer's space, the picture surface (physically) and its single figure (illusionistically) project out into it. The modulated light that inhabits darkness in the paintings — coming mostly from the translucency of Rothko's layered passages of paint and sometimes from his glossing of regions of the surface — is pivotal to this double-movement. In time, the paintings seem to fluctuate between stillness and movement, proximity and distance; they appear and disappear. Rothko's way of dissolving or almost dissolving the distinction between darkness and light is above all destabilising, but it is also what holds the viewer who keeps looking.

Rothko approximates effects frequently used in both popular and experimental cinema. A similar enfolding of light in darkness occurs at moments in Alfred Hitchcock's *Psycho* (1960) and in Stan Brakhage's *Crack Glass Eulogy* (1992), for example (figs. 36, 37). Paralleling Rothko's screen effects, Hitchcock and Brakhage set up movements of dark and light through screening devices that echo, from within the body of the film, the function of the cinema screen itself. A rain-drenched car windscreen obscures the view of the road outside in *Psycho*. In Brakhage's *Crack Glass Eulogy*, the dissolve that superimposes an aerial shot of a city at night onto footage of a pool of liquid is effectively a screen, as is the light-reflecting surface of the liquid as it spills across the frame.

In these films, as with Rothko's paintings, the loss of visibility is visually compelling. What emerges in each case is a heightened sense of the heterogeneous fabric of the visual field, with its precisions and imprecisions, its multiple textures, depths and densities, yet also an awareness of the ungraspability of these appearances — and of the ungraspability of these very moments of looking. Such moments come and go quickly, and indelibly, in *Psycho* and *Crack Glass Eulogy*. With Rothko, they stay and pass from painting to painting.

Film, Samuel Weber remarks, 'doubles the reality of everyday perception, our visual and auditory perceptions'. [7] The experience of cinema is uncanny, both familiar and strange, because, as Weber notes, it 'demonstrates that one's bodily senses are not simply one's "own"'. [8] In these phenomenological terms, with regard to the question of the kind of bodily and visual encounter that it sets up the complex machinery that is film plays with our senses (as does the machinery of Rothko's paintings). It displaces and overtakes them. It is not just the projection of the image that interpolates vivid traces of another time and another place into the 'here and now' of the movie theatre. The viewer in the audience, while retaining a sense of the separation between the film and what is outside it, invests the projected image with a certain reality, projects life onto it, and for a while perhaps even lives this borrowed life. [9] The power of cinema to affect the spectator in a physical way, to provoke tears and laughter, for example, reflects how it produces a viewer whose position is also double; a viewer who is at a remove from what is happening on screen but who is also captured by this other vision, this other 'reality', and in a certain way a participant in it. The doubling of perception that occurs in Rothko's later paintings produces the same uncanny effect. With its capacity to elicit intense involvement from its audience, and as itself an interval made up of other intervals, cinema may also — like Rothko's work — disturb the premise of a 'living present' and that of a natural perception that would regulate our encounters with the world.

The extended meaning of the word 'cinematic' is relevant here. If I say that an event or a moment in life is cinematic, I accent the affective power of this moment that imprints it on my memory and makes it like the movies. I mean that I lived it with a special intensity, yet also that I stepped back from it, like a camera filming it from a certain distance. I was both in the moment and outside it. Similarly, 'cinema' is a word for both the apparatus or medium of film and for the darkened place where films are seen by a public. These usages indicate how central the spectator and the act of viewing are to cinema's production, as well as the strangeness of this apparatus of which the body and its senses are a part. They also show how cinema's effects pass into everyday life, imparting this characteristic feeling of strangeness, this sense of a heightened reality that is also an unreality, to all kinds of occurrences.

For André Bazin, the difference between cinema's 'perfect illusion' and the illusions of painting lies in its objective existence as a material trace of the 'continuum of reality', its place as the outcome of a process scarcely requiring creative intervention. [10] Before being an art, cinema, as Bazin sees it, is a technical apparatus, an automatically regulated mode of contact with the world of appearances. The seamless modulation

of the moving image in this way reflects the camera's 'impassive' registration of light in time.[11] Conversely, from Edgar Morin to Gilles Deleuze, cinema's time-based image has been seen as an image of thought, sense and imagination, an invention that, in time, creates new perceptions of time and its relation to thought. Cinema incarnates a connection between the human and the world beyond the human; it also embodies the break in this connection. Bazin, too, touches on this duplicity, this cinematic interplay of subjectivity and objectivity. In the essay 'The Ontology of the Photographic Image' (1945), he describes the photographic image — and, by extension cinema — as a 'hallucination that is also a fact'.[12]

A hallucination that is also a fact: Bazin could be describing Rothko's *Black-Form* paintings — or his other serial paintings. The cinematic effect of these paintings makes itself visible in the luminous modulations that affect their surfaces, as well as in the modulation of a recurrent structure that, within each series, unfolds from painting to painting. For the spectator, the modulation of the cinematic image imparts to cinema its appearance of movement and its feeling of 'life'. In Rothko's work, the screening of modulation functions in the same way.[13] The modulations in his paintings emerge from the surface in a slow release. The work in this way implies a spectator who is at once in the work and outside it, registering how it affects the space that the work makes for itself and the space on all sides of it; it calls for a durational viewing that spans interruptions and delays. Floating clear of any specific reference, Rothko's modulations produce a strangely self-sufficient and tactile illusionism.

This is a surface that is physically and materially here, a 'fact', but one that, in its recurring suggestion of the effects of light in time and space, conveys something else: an unfamiliar, refracted sense of the look of things in the world that brings forward the starkest and most enigmatic aspects of this look. The cinematic gleam that coincides with darkness in Rothko's *Black-Form* paintings, attracting and deflecting the viewer's look, exemplifies a strategy that is constantly pursued in Rothko's later work: that of accelerating painting's quasi-cinematic capacity to bring life — or the illusion of life — to a picturing of the very point at which powers of vision and imagination seem to extend yet also to fall away.

Cinema is not an overt, locatable point of reference in Rothko's paintings as it is in the work of many painters before and after him. It is rather something in play in the paintings. It is a quality that flows from Rothko's conception and treatment of their surfaces, in particular his deployment of correlating mechanisms of screening and modulation and the indeterminate illusionism they produce; it is an effect that occurs in the uncertain interval between the work and the viewer. Most tellingly, it is an uncanniness that persists in the way the paintings appear always on the verge of disappearing — not into cinema, but into an uncontainable movement, a kind of flicker, that could be called cinematic.

Individually and as a series, Rothko's *Black-Form* paintings of 1964 convey with particular clarity the forces in play in the cinematic transformation of painting running through his later work, from the Seagram series of 1958—9, to the spiralling

spatial and pictorial displacements of the Chapel installation in Houston, up to the last series of paintings and works on paper of 1969–1970. The *Black-Form* paintings, coming in the middle of this sequence, distil the cinematic effect that takes place in the work — or takes it over — in this period. An attention to other moments and manifestations of this effect may elucidate how it unfolds and what it entails for Rothko's painting.

Something of this cinematic effect already makes itself felt in Rothko's 'classic' or signature paintings of the early to mid-1950s. The close-up and the (mediated) image of catastrophe are two signs of this effect in operation. In an essay of 1974, Brian O'Doherty links the magnetism and intimacy of the cinematic close-up, exemplified in the 'magnified vagueness' of Greta Garbo's face as it becomes identified with the screen, to the general look of Rothko's paintings.[14] For O'Doherty, Rothko's figuration replays the new facial geography opened up by the close-up, giving any slight movement of an eye, brow, or mouth 'immediate impact'.[15] Reviewing Rothko's solo exhibition held in Chicago in 1954, the critic Hubert Crehan comments that the tension between the colours in Rothko's paintings reaches 'such a shrill pitch that one begins to feel in [the paintings] a fission might happen, that they might also detonate.'[16] The image is of nuclear terror. According to Crehan, the paintings create 'a symbol of contemporary experience' which resonates with the 'dislocations of recent history.'[17]

These reflections, indexing the permutability of Rothko's paintings and projecting a kind of image onto them, open ways to think about his move into seriality — both into series of paintings framed in relation to architecture as installational ensembles, and into series without defined destinations or occasions. Here Rothko's series may look like means by which the cinematic tension or (for Crehan) 'immanent' movement that builds in his single-panel paintings can be released: Rothko gives the paintings time and space to unfold.[18] Yet the series go further than this. More than relieving this tension, Rothko's serial paintings, in installation or otherwise, sustain and multiply it. The serial extension of the work does not merely situate it in an 'expanded field' or time-frame. Seriality, and the installational questions that accompany it, provide Rothko not only with a new scale, or place, but also with an occasion for a play on and with time and space as the very conditions in which paintings are made present. This play — involving a certain suspension of situation — becomes apparent in the spatial ambiguities of the Seagram series. It also emerges in Rothko's treatment of time and duration in his last series, his *Black on Gray* paintings.

In his work for the Seagram mural project, Rothko's use of a single framing figure in each painting is a corollary of his serial conception of the paintings, of the co-presence of other paintings, like it but unlike it, in a single space (actual or imagined). Rothko disperses the effect of the counterposed shapes in his signature paintings. Multiple figures now face and conceal themselves from anyone who comes into this room from all sides, inside and outside or peripheral to the visual field available from any one place in it. The frame-by-frame movement may suggest a closed circuit between the paintings, making only an indirect address to the viewer

Fig. 38
Michelangelo Merisi da Caravaggio
The Calling of Saint Matthew 1599–1600
Oil on canvas
322 x 340
Church of San Luigi dei Francesi, Rome

or no address at all. At the same time, however, the paintings in situ face and surround the viewer who has to move around in response to their excess of address. The viewer, sliding between these modes of address and non-address, becomes the connective thread between the frames.

Rothko's mobilisation of physical and pictorial space in the Seagram series can be allied to the treatment of space and movement in baroque art. For Bazin, it was through its 'cataleptic' movement and powerful illusionism that baroque painting situated itself as painting's most cinematic moment. Baroque painting, from this perspective, would belong to the history of the cinematic apparatus. Rothko's procedures in making these paintings — relating, for example, to the role of the figure, the function of the studio, and his use of materials — suggest his reworking of a proto-cinematic, baroque pictorialism and, along with this, a rethinking of the space of paintings and the spaces of their viewing.

In his book *Working Space* (1986), Frank Stella writes of the 'miraculous' — and cinematic — interlocking of spatial self-containment and outward movement in Caravaggio's paintings. He argues that Caravaggio arrives at a 'projective displacement of space' that is neither dependent on the architecture around it nor cut off from the viewer.[19] For Stella, Caravaggio's transformation of pictorial space is in part traceable to his innovations in the studio, starting with *The Calling of Saint Matthew* 1599–1600, his first public commission (fig. 38). Caravaggio makes his models 'perform', not just pose; he directs them like a film director. Using a closed room, probably a cellar, and a single elevated light, he restricts the field of visibility in his paintings to a glowing frontal plane that reaches out. All the drama happens in the controlled 'frame' of the studio. First in this theatrical studio space, then elsewhere, the painting displaces and projects this frame. This use of space, Stella writes, gives paintings like Caravaggio's *Saint John the Baptist* 1602 the 'close-up realism we prize so often in motion pictures.'[20]

Although Rothko's applications of paint were usually quick, according to his assistant for the Seagram project, Dan Rice, at various points he would spend extremely long intervals, hours and sometimes days, sitting and looking at the paintings. Rothko once described the shapes in his paintings as 'performers' that would have to be capable of making gestures with 'passion'.[21] Rothko, as he looks, takes up a position not unlike the one Stella imagines Caravaggio taking up in his studio — that of one who, from a certain distance, choreographs the drama taking place before his eyes. Here, however, the figure plays itself. As if by default, the contained elasticity that Stella speaks of in Caravaggio's painting turns into a figural principle in the Seagram series. Its recurrent frame-figure sometimes looks like an immensely imposing presence, sometimes like a flimsy trace of a form disappearing into the fluid atmosphere in which it is suspended. It simultaneously manifests thing-like qualities and a subjective, flesh-like vitality (apparent when the sides of the frame bulge or bend). It also conveys something else: the impression of a non-localisable force that exceeds these polarities — shadow falling, something burning, a sheen of light catching a surface. The studio, where Rothko looks as these permutations unfold, functions like a private cinema.

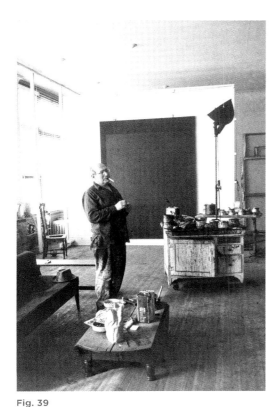

Fig. 39
Alexander Liberman
Rothko in his studio, New York 1964

The relation between Rothko's treatment of pictorial space and his use of the studio for the Seagram project, a former half-basketball court on the Bowery, is again strangely similar to Caravaggio's set-up as described by Stella It is also a radicalisation of this theatrical staging (and framing) of the studio and the space it delivers. Rothko set up his studio with movable walls, made it darker, with a partition that blocked out the windows on one side of the room, leaving a small pair of windows set high on another wall, and introduced a pulley system allowing him to modify the hanging height of the paintings. Rothko also became 'enamoured' of photographer's lights, according to his friend Herbert Ferber — referring, perhaps, to the spotlights, which he would point toward the ceiling, or to the incandescent hot lights on rollers seen, with and without aluminium reflectors, in some photographs of his later studios (fig. 39).[22] His reconfiguration of the studio went some way towards simulating the dimensions of the dining room in The Four Seasons where the paintings were meant to go. The reconfigured Bowery studio, like the East 69th Street studio where Rothko worked on the Chapel commission (fig. 40), takes on the properties of the film-set. Everything in this definitively provisional space — as with the Seagram paintings themselves — has to do with framing, but also with the mobility, adjustability and contingency of frames. (An extension of this is Rothko's habit of moving studios — the moves coinciding with each of his commissioned series of paintings — and of having more than one studio at once.)

Aspects of Rothko's working processes in the studio, like the way he constructs the support for his paintings (without frames), his thinning of paint and his choice of lighting, can also be seen in these terms. The absence of the frame, and Rothko's practice of painting around the sides of the pictures, opens them to their surrounding space, like a screen, yet it is a kind of non-action, a side-effect. His thinning of paint produces fluid surfaces made up of a series of delicate and translucent paint films, muting a sense of the painter and of the painter's hand.[23] The paint looks literally filmic, scarcely the result of someone's actions. The glow and shadowiness of the Seagram paintings surely draws some of its character from the studio's controlled lighting. Rothko appears to have favoured partial and oblique lighting, yet the relatively high colour temperature of the lights he sometimes used perhaps carries over into these paintings.[24] These procedures are off screen, part of the studio routine, yet they are also places where a baroque illusionism leaves its mark on Rothko's work, and means by which the fugitive elements in the paintings find a material support.

The work that comes out of Rothko's Bowery studio extrapolates from the theatre of transformation and dislocation that is the studio itself. Rothko associated the 'feeling' he was after in the Seagram series with the atmosphere of Michelangelo's vestibule for the Medici Library in Florence.[25] For Heinrich Wöfflin, it was Michelangelo who set baroque aesthetics in motion by making matter lose its rigidity, turning it 'supple and soft'.[26] For Wöfflin, the Florence vestibule, with its 'unending process of impassioned struggle between form and mass', is a singular case of the baroque and its new, chaotic conception of matter.[27] Like Michelangelo's room, the Seagram series, in installation, displays a proto-cinematic capacity to stage itself and draw the viewer into the centre of a vortex of forces.

Fig. 40
Hans Namuth
Alterations to Rothko's Studio, 157 East 69th
Street, New York December 1964

Fig. 41
Henri Matisse
The Red Studio, Issy-les Molineaux 1911
Oil on canvas
181 x 219.1
Museum of Modern Art, New York
Gift of Mrs Simon Guggenheim

As if adopting an ironic posture with regard to the place where they are, everything in the paintings, and in the spaces between them, conspires toward movements of disorientation and dislocation. The painting pits its plasticity against the stability of the architecture that frames it. But this, too, is contradictory. The paintings fill this space, give it a purpose, animate it. More than this, according to their logic of a movement running 'in all directions' (to use Rothko's phrase), they reframe this architecture. They place the room — imagine it — as another provisional structure, another 'momentary stasis'.[28] The red that travels through the paintings like an electric current, gaining and losing force along the way, could in this sense be seen as a distant refraction of the red field that displaces the wall, hanging in the gaps between an assortment of paintings, in Matisse's *Red Studio* 1911 (fig. 41).[29] (Rothko remembered his viewing of this painting at the end of the 1940s as a turning-point in his work.) With his Seagram series, Rothko spatialises his work only to de-spatialise it all the more.

Rothko's *Black on Gray* paintings of 1969—1970, like his 1964 *Black-Form* paintings, do not perform or provide a scenography in the theatrical manner of his Seagram paintings. The paintings, which are without figures in any conventional sense, instead appear and recur like a series of apparitions, or like 'facts'. Rothko's work, over time, draws nearer to the conjunction of factuality and unreality that characterises the virtual (or doubled) space-time of cinema.

Two features stand out: the narrow outer white border and Rothko's unpredictable placements of the interval where the light and dark areas meet. The white border, made by taping over and then untaping and retouching the paintings' outer margins, makes the paintings' surfaces appear to float slightly in front of the wall. The white curls around from the wall to the surface, leaving a fine margin of white bordering the two fields and continuous with them on the picture plane. This white border tends to disappear, like the masking that produces the sharp division separating the film image on the screen from the space around it. It seems to imply a section of time and space that continues past this limit. In Bazin's terms, the border orients the paintings centrifugally, making them work cinematically, like screens. When the *Black on Gray* paintings are shown together, the border, along with the other similarities in the paintings, strengthens the impression of a continuity running from one painting to the next.

The horizontal interval between the light and dark areas in each work cuts into this equation. This interval works in two ways. Within each painting, it installs a 'momentary stasis', or stillness, in the visual field. When the paintings appear together, it turns into a capricious element, breaking their continuity. (The unpredictable movement of this interval is one way this series differs from the *Black-Form* paintings, where the sense of a recurring structure predominates.) The white borders operate cinematically to suggest a flow of time connecting the paintings to one another and to the durational time of the viewer's engagement with them; the horizontal intervals, again cinematically, work like jump cuts, introducing sudden moments of disorientation in this engagement.

The paintings crystallise a sense of time as a shuddering that runs 'in all directions', to use Rothko's phrase — at once lingering and catastrophic. The catastrophic aspect of this picturing of time hinges on a non-successive and indeterminate conception of its unfolding. Time oscillates: it appears as a moving limit and as an aleatory movement with no set sequence and no end. The lingering 'play element' that Rothko spoke of in his work lies in the rhythms of continuity and discontinuity that open up in and between the paintings. The relation between painting and the cinematic folds over in a paradoxical way. Bazin's idea, prompted by seeing Alain Resnais's *Van Gogh*, that 'if we show a section of a painting on a screen, the space of the painting loses its orientation and its limits', reverses itself.[30] Here, instead, the time of cinema loses its bearings in a translation of cinematic effects in painting. Rothko uses continuity and comes close to a kind of montage, yet the temporal situation of these paintings is elastic in a way that filmic time is not. Rothko's serial paintings approach the errant, disorderly framing of time that, for Roland Barthes, made the experience of looking at film stills more pleasurable than being caught in the predetermined time-sequence of films themselves. They work upon a time of viewing that is radically unfixed.[31] Rothko effectively places the viewer as the work's camera-projector, as if imagining it as a film that is not yet made.

In Rothko's *Brown on Gray* works on paper, painting's errancy acts as a counterforce to the cinematic currents in the work in another way. These paintings, the starting-point for the works on canvas, mostly follow the same structure — the white border, the contrasting areas, the uncertain interval between them. In many of these works, however, the application of the paint is vigorous, unlike Rothko's usually understated mode of applying paint, yet also unreadable as expressive or gestural in the familiar sense. The path of the brush, like other aspects of the paintings, is erratic, disconcertingly chance-like. (The same thing recurs, more elliptically, in the works on canvas.) Rothko's indistinct colours bleed out over the white border; sometimes the white paint of the border intrudes on the inner fields. Rothko reinscribes his picturing of time with the disorderly 'now' of that picturing as it happens, the 'now' that makes it happen.

Speaking to William Seitz in 1952, Rothko said: 'I live on Sixth Avenue, paint on 63rd Street, am affected by the television, etc. etc. ... My paintings are part of that life.'[32] Such a life — mobile, mediated, routine — in turn works its way into the paintings. What makes Rothko's later series look out of place next to the work of his contemporaries may be, from this perspective, their intertwining of the technique and fiction of painting with a materialism that confounds the logic of 'what you see is what you see'.[33] The complexity of this engagement becomes apparent. Interviewed by Bruce Glaser in 1964, Dan Flavin, Frank Stella and Donald Judd raised the question of whether the painted sides of Rothko's paintings make them more object-like or more pictorial, but left it hanging.[34] For Barnett Newman and Clyfford Still in 1955, Rothko's technique — his reliance on 'devices' of painting, visual 'seduction', a supposed 'virtuosity' and 'ease' — made his work seem retrograde.[35] Rothko's painting alters dramatically in the wake of Abstract Expressionism but there is no elimination of techniques. Rothko's approach to technique in his later series verges on the ironic.[36]

These series invariably involve a manipulation of the procedures and materials of painting and of the conditions in which paintings are seen. The cinematic effect of this manipulation, in the paintings and in the visual and corporeal encounter they set up, is to open a series of intervals that disable any sure sense of the difference between the illusionistic and the literal, or the human and the inhuman, or the virtual and the real. This is to point to the negative momentum, and obstinate contrariness, of the paintings. Yet these surfaces are also fluid, tactile, open, life-like. Bazin's remarks on painting and cinema are again relevant. The basis of Rothko's later paintings, and the basis of their contact with the viewer, is the sensuous 'picturability' of these intervals of disorientation and intense uncertainty. These series produce a 'presence', a 'situation', a 'world', that is at once familiar and insistently strange. Rothko's late work eludes the terms of any fixed opposition of fiction and fact, instead playing on the unmasterable relation between one and the other. The 'cinema' of this unmasterability — a density dissolving before our eyes, a light that fades as it approaches, a distance that draws nearer — brings to the paintings their capacity to shock and to fascinate.

THE SUBSTANCE OF THINGS

LESLIE CARLYLE, JAAP BOON,
MARY BUSTIN, PATRICIA SMITHEN

THE SUBSTANCE OF THINGS

LESLIE CARLYLE, JAAP BOON, MARY BUSTIN, PATRICIA SMITHEN

I adhere to the material reality of the world and the substance of the things ... For art to me is an anecdote of the spirit, and the only means of making concrete the purpose of its varied quickness and stillness.
Mark Rothko[1]

The compelling surfaces that Rothko creates in his Seagram murals result from overlapping translucent and opaque paints, gradually building to a continually interactive play between the background and the figure. Rothko's success is that he found a way to work his paints over very large surfaces without losing the distinction between layers. Depth is created by allowing paint beneath to shimmer through; even the seemingly solid figures result from the partial exposure of a series of delicate layers. Oil paint alone could not be successfully manipulated to achieve these effects because it would not easily preserve evidence of previous layers or subtle variations in brushwork once successive coatings were applied. To create such an engaging interplay of surface characteristics, Rothko had to find his own technique.

How he worked has been difficult to discover since he did not provide details himself, and his thin layers have proved hard to detect and visualise through conventional means. To unlock his complex surfaces we carried out an advanced scientific study of the Seagram murals in Tate's Collection and worked with first-hand information from interviews with his studio assistant Dan Rice.[2]

Pigments and media were investigated by taking micro-samples of paint from Tate's murals.[3] The latest scientific methods were applied to view and analyse both his surfaces and paint samples in a selection of the paintings (Table).[4] As a result, we are able to explore his technique in more detail than ever before.

Fundamental to the concept of Rothko's mural series is the direct relationship of each painting to the others and to their intended location. To try to visualise this location, in 1958 Rothko, with the help of Dan Rice, built a simulation of The Four Seasons' room plan within his studio in an old YMCA basketball court.[5]

Rice recalled that Rothko kept three very large paintings up at one time, 'so that he could see the fullness of the concept. He didn't work on them singly, in the sense of having only one painting in front of him ... the changes took place within each set as a whole entity.'[6]

Between episodes of painting he took time to reflect, to evaluate the consequences of each step. Rice remarked, 'he sat and considered the paintings for long long periods of time, sometimes hours, sometimes days. I think it was this that led him to working on more than one painting at a time.'[7]

William Scharf, Rothko's studio assistant for the Houston Chapel paintings (1964–7), described some of the difficulties when working over the large surfaces that characterised Rothko's mural series from the late 1950s onwards. In order to maintain uniformity, the paint had to be applied swiftly and:

Fig. 42a
T01165 High resolution microscope image (see note 4) of the paint surface showing red-coloured canvas fibres (diameter 20 microns) at the surface of the painting.

Fig. 42b
T01165 3D image of the painting surface showing close confirmation of paint with the canvas such that the fabric's texture is clearly evident. This allows conservators to relate cracking in the paint with surface topography which is not always as clearly evident with conventional stereomicroscopy.

as beautifully as you might plan, you never really knew how a surface was going to dry, how it was going to turn out. And if it ever did dry uniform, you might decide you wanted it two colors lighter or two colors darker. It could be a perfectly magnificent black or deep wine surface but after a few days he might decide, no, its not right, beautiful as it is tactically. Then it has to be reapplied.[8]

Amongst the practical considerations in creating his monumental paintings was the need to create great expanses of paint without his efforts resulting in mechanical flat surfaces. As we shall see, Rothko developed a means to control his paint layering, but first he had to address the preparation of the canvas. Commercially prepared grounds can present a relentlessly uniform surface and any traditional ground, whether machine-or artist-applied, would form a physical and visual barrier between the canvas and the paint.

Rothko created an intimate relationship between his paint and canvas by avoiding a traditional ground, and by using a priming method that he had developed in previous works.[9] For the Tate murals, he stained his canvases with transparent reddish-blue coloured-glue layers. He chose heavy cotton duck that was meant for awnings.[10] Unlike conventional canvas prepared for artists, which is shaved to remove surface fibres (nap),[11] top fibres sit proud of the surface on his raw canvases. Indeed, high-resolution photography of T01165 (p. 129) reveals his red-coloured fibres at the surface intermingling with surrounding paint (fig. 42a & b). A canvas thread from T01170 (p. 113) viewed under the microscope in ultraviolet light (fig. 43) shows cotton fibres in a matrix of animal glue with synthetic red and blue pigments.[12] Rather than forming a discrete layer on top, Rothko's thin priming partially soaked into the canvas and became an integral part of the fabric.

Rice's description of preparing the canvas gives us a graphic image of the pure physical exertion that working with such large canvases entailed.[13] First, the fabric was stretched onto very basic strainers in 'batches of about half a dozen'. Rothko and Rice would then coat each with rabbit-skin glue tinted with powdered pigments. Dried sheets of glue were melted in hot water with the pigments stirred in:

> [W]e had a hot plate, because you know if it [the glue] gets too cold it gets gelatinous and just won't penetrate, and if it's too hot it goes straight through, ... [and the canvas] is like a piece of glass then. So we had to get it at the right temperature and then work furiously to cover one of these enormous things ... We began with Mark on top of the ladder doing the top half and me underneath doing the bottom half ... the fella working underneath got absolutely drenched because it's like water this stuff.[14]

Protein (from the animal glue) was confirmed by analysis in most of the paintings (Table). However, the reverse of T01168 (p. 125) shows three separate sections where paint has penetrated the canvas to differing extents, with acrylic alone found in two of these sections (fig. 44). This suggests that on this painting Rothko was experimenting with different priming options.

Fig. 43
T01170 Canvas thread (20 micron diameter) under ultraviolet light. The paint, composed of animal glue with synthetic ultramarine, lithol red (PR49:1) and a paint extender barytes (natural barium sulphate) sits amongst the cotton fibres. This image is constructed from ten microscope images taken at different focal lengths.

Fig. 44
T01168 Reverse of the painting showing three broad sections exhibiting different penetration of paint through to the back of the canvas, suggesting that Rothko was experimenting with his priming layer.

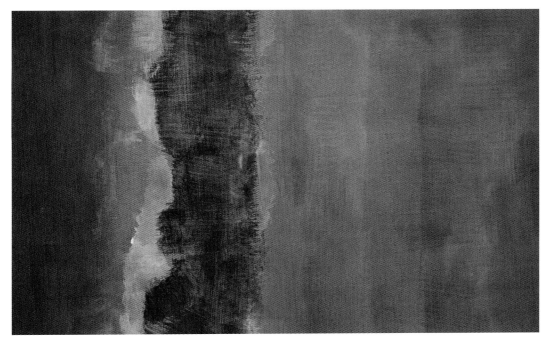

Fig. 45
T01167 Detail in ultraviolet light. Media fluoresces differently according to its composition thus enhancing our appreciation of Rothko's brushwork. In normal light these layers are visible, but only barely.

The pigmented size acted as a sealing layer, keeping the canvas from absorbing further paint. Highly dilute, it coated the fibres but did not disguise or flatten their textural effect. This tinted base formed the beginning of Rothko's subsequent layers of subtle colour and gloss variations.

Rice described what came next: first a 'field' of a base colour, then a series of thin paint layers, varied in colour or tone. Throughout application of these top layers 'he would sort of feather it [the paint] so that the dark or lighter color would show through; he would isolate this so that the two didn't intermix on the surface as he feathered it in.' Rice explained how Rothko would isolate the layers: 'the first one would be fairly dry but if you try to put a wet paint on top of that they would tend to mix, so then to isolate one from the other, you would cover it with an egg mix ... sometimes he'd put a powdered pigment into the egg mix.'[15] The overall effect of layering in this way 'would be so minuscule on the surface that you would have the effect of luminosity without seeing the layers'.[16]

An ultraviolet light image (fig. 45) from one of Tate's paintings offers enchanting testimony of Rothko's working method, showing the rich layering sequence and variety of materials he used, since each fluoresces differently according to the pigment or medium. Through chemical analyses[17] six different media were identified

in Tate's mural paintings: oil-modified alkyd, acrylic resin (*n*-butylmethacrylate), phenol formaldehyde resin, a natural resin (dammar), egg and oil. Evidence of oil was only ever found in mixtures with other media. The same media combinations were not used for every painting. The table indicates where each was found.

All of these materials, except the oil, are fast drying: they would be touch-dry in a matter of hours rather than the days or even months that traditional oil paint can require. All the synthetic materials contain prepolymers,[18] which increases their viscosity and allows thinning of the paint well beyond the point where regular artist oil paints would have failed (oil paint diluted too far loses its coherence and powders off when dry). An additional feature, certainly of the acrylic-resin-based paint, is that it retains its strong colour even when very dilute.[19] Rothko's choice of materials, then, was highly suitable for a painting method where top layers had to be thin and translucent while still preserving their independence and thereby contributing to the final appearance of the work.

Little is known about Rothko's paint preparation, although Rice recalls, 'We used one of those kitchen pots about [2 feet] around and just tube after tube, after tube, after tube, after tube would go in with the turpentine (fig. 46).'[20] In a different interview, Rice had said that Rothko used 'very good quality paint — top grade Bocour oil' mixed with a lot of turpentine,[21] which suggests the tubes were oil paint, although, as noted below, artists' acrylic-resin paints soluble in turpentine were also supplied in tubes at that time.

Samples of paint from Tate's works show different ratios of the various constituents (binder, pigments, extenders), supporting Rice's descriptions of Rothko mixing the paint himself or adding his own selection of materials to prepared paint.[22]

The question of the degree to which Rothko used artists' paint or relied on commercial paint or a combination of both, is as yet unanswered. Each scenario fits our most recent analytical information. In terms of the synthetic media, in the 1950s oil-modified alkyd resin and oil paint with phenol formaldehyde resin were only available as commercial products such as unpigmented lacquers and house paint (the former) and printing inks (the latter).[23] Therefore our analysis showing the presence of these materials is a clear indication that Rothko used at least some commercial paint products.

As for the use of acrylic resin, in the 1950s it was being purchased directly from raw materials suppliers (for example, Rohm and Haas and DuPont) to be added by artists to their oil paint[24] and it was also available in the form of clear medium or as a fully developed 'plastic paint' under the trade name 'Magna' from the artists' colourman, Leonard Bocour. Bocour recounted that he supplied artists in Rothko's circle and includes Rothko himself.[25] Rice confirmed that Bocour stopped by the studio on occasion for 'some happy conversation' and that Rothko was getting paint from him directly,[26] possibly for free, since Bocour was known to hand out free paint at this time as part of his marketing strategy.

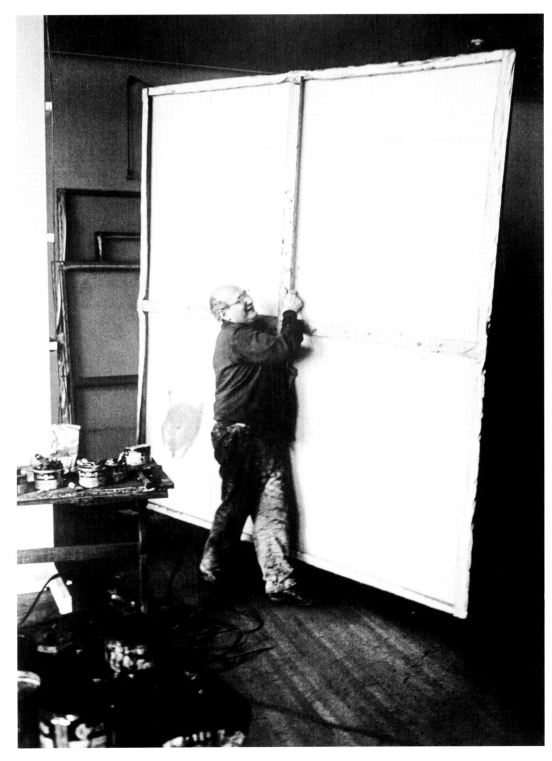

Fig. 46
Alexander Liberman
Rothko in his studio in 1964. Paint cans and various
painting materials can be seen. The proximity of
Rothko's paint stained overalls as he carries his
painting explains why paint found on the reverse
does not always match that found on the front.

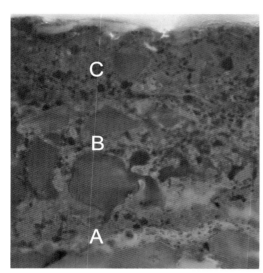

Fig. 47
T01170 Microscopic paint sample in cross-section photographed using ultraviolet light. The paint layers are difficult to see under conventional preparation methods, but with ion polishing and the aid of ultraviolet light it is possible to see three layers: A — the transparent glue ground with synthetic ultramarine blue and and lithol red, superimposed by paint layers; B and C — containing alkyd and phenol formaldehyde resins and oil coloured by lithol red, synthetic ultramarine, bone black and large natural barytes particles.

Thin pigmented layers including dammar resin or egg were detected at the surfaces of some of Tate's murals (Table). These binders were both capable of a wide range of gloss/matt effects: when only lightly tinted they would have imparted a soft gloss, or with the addition of a high volume of pigment or extenders they could appear matt. The detail from T01167 (p. 133 / fig. 45) in ultraviolet light enhances what we can already see in normal light: Rothko's energetic brushwork in the figure set against a series of thin washes in the background. In several of Tate's murals (T01163 (p. 127), T01166 (p. 117), T01168, T01170) this was achieved with pigment bound in egg, dammar, or a combination of both.

To understand Rothko's layering sequence we looked in detail at tiny paint samples in cross-section using a special technique for enhancing the surface of the sample[27]. We were hoping to gain, for the first time, a clear image of Rothko's multiple layering technique. However, unlike many traditional paintings where paint layers follow in a consistent sequence from ground, underpainting, finishing and varnish, samples from Rothko's paintings revealed little demarcation between layers or a clear sense of the layer sequence (fig. 47). In previous work with painting reconstructions, it was demonstrated that multiple layers of the same material are not necessarily easily distinguished in cross-section; rather, layers are visible primarily when the paint formulation changes (either by media or by different pigments or pigment mixtures)[28]. Therefore it is not surprising that there are difficulties in finding visual evidence of multiple layers of the same paint in micro-samples from Rothko's paintings.

Throughout Tate's murals, the first layer (with only one exception) consisted of the maroon-tinted glue priming, but the next layers varied significantly. While we found a consistent base paint with lithol red pigment,[29] to achieve variety in the maroon hue, the colour was pushed towards or away from red or blue by the addition of differing proportions of cadmium red and synthetic ultramarine blue pigment. In some areas, Rothko's paint appears to have been highly dilute since it has flowed freely in a thin film leaving a trail of drips (apparently defying gravity since some now run horizontally or even upwards due to the fact that the paintings were turned to a new orientation) (fig. 48).[30] On T01031 (p. 115) a consequence of his brushwork and the use of dilute paint is that the uppermost threads of his red-coloured canvas fabric are exposed, creating liveliness and variation at the surface. According to Rice, 'Every detail was important to him … [He] worked always with a housepainter's brush, but as he dipped it in the paint he would only get a tiny bit on the end of the brush, allowing what was underneath to come through.'[31]

Robert Motherwell reflected that 'One year sometime in the sixties, I bought a couple [of housepainters' brushes] when I was working on huge pictures, to be able to cover more of an area: and had to give them up because I couldn't help but make a Rothko edge. I mean it's intrinsic in the spring of the brush … there is no way to use a brush like that without doing it, so I had to quit using it.'[32]

Rothko's figures sometimes lie on top of the background, and sometimes they have been painted over with background paint, then reinforced again. In T01031 the black

Fig. 49 (right)
T01031 Detail in ultraviolet light showing Rothko's feathered edges achieved by light brushing with a house painter's brush.

rectangular figure lies on top of maroon egg-based paint. Rothko scumbled on the black paint and brushed it out to create a thin film with his characteristic feathered edges (fig. 49).

Throughout Tate's series, Rothko departed from classic mural paintings where 'a dead flat (mat) finish' was recommended that 'may be viewed from all angles without undue glare or reflections'.[33] Instead, he introduced changeable subtle surfaces by creating a play of matt and gloss. T01168, for example, relies on the viewer's movement to reveal or to hide the figure (fig. 5C). If light catches it, the figure seems to hover in the reflected light; if the viewer moves to the side, the colour shifts dramatically, slipping back into deep red, with the matt field lightened by comparison.

In T01168 Rothko painted the background in acrylic paint pigmented with synthetic ultramarine and various reds (lithol red, iron oxides, and cadmium, Table). The figure was painted with a similar mixture; however, it differs from the background through the addition of finer cadmium red pigments without any ultramarine (fig. 51a). The figure was then coated with a glossy pigmented glaze made with whole egg binder.[34] The complex layering on the figures is enhanced in ultraviolet light. (fig. 51b). Once alerted to their presence, it is possible to go back and pick out these layer variations under normal light. It is the small differences in pigment combinations, and the play of matt and gloss, that create Rothko's subtle but dynamic effect.

Fig. 48
T01164 Drips in the paint show how the canvas orientation was changed during the process of painting.

Although most of Tate's works appear to have stood up well, there are indications of change in the series[35] with T01165 in particular exhibiting a significant surface

Fig. 50
T01168 This image, photographed at an oblique angle, illustrates the gloss of the figure contrasting with a matt background.

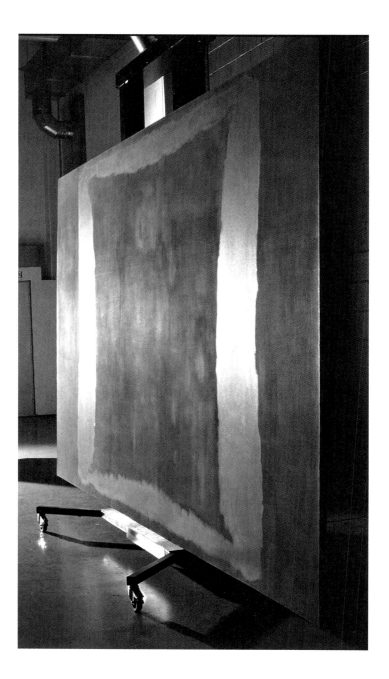

Fig. 51a
T01168 A detail in normal light of the lower left corner showing the subtle contrast in red on the figure and in the background.

Fig. 51b
T01168 The same detail in ultraviolet light reveals Rothko changing his media to create the gloss/matt contrast. The media in the top layer was identified as whole egg.

Fig. 52a
T01165 High magnification at the surface shows the dammar film broken up with predominantly blue colorant where there would originally have been red and blue.

Fig. 52b
T01165 Microscope image in ultraviolet light of a paint cross-section from the painting's surface. The uppermost layer originally contained lithol red pigment. This layer now consists of transparent barytes and synthetic ultramarine blue with only slight remnants of reds as practically all the lithol red has faded. The darker cloudy material is thought to be degraded dammar resin and surface dirt.

alteration in the form of a white haze. Ironically, this development enhances the soft dreamy ephemeral quality of the background in this work. That the haze is in fact a function of colour fading became evident through comparing an old restoration from 1973 on the surface, which had been colour matched at the time to the surrounding paint. When the painting was treated again in 1999, the old retouching needed to be readjusted because it showed up as a brighter pink colour against an otherwise unbroken white surface. The cause and the extent of this change has only come to light as a result of our most recent research.[36]

Analysis of T01165 reveals that over his usual tinted-glue priming, Rothko brushed well-bodied alkyd paint overall then coated it with a glaze containing dammar, egg and oil coloured with lithol red and synthetic ultramarine (Table). While lithol red is notorious for fading,[37] the mechanism for change in this case may not simply be a matter of its losing colour. The dammar in the film itself is showing striking visual and chemical evidence of degradation (compare figs. 52a–d).[38] Studies at the Institute for Atomic and Molecular Physics in Amsterdam are suggesting that the synthetic ultramarine blue pigment in the film has catalysed the breakdown of the natural resin and greatly accelerated the fading of the lithol red pigment.[39]

A similar slight haze is present on other paintings in Tate's series, probably due to the same mechanism (T01031, T01166). The impact of the loss of colour in this surface layer varies according to the thickness of the layer and the materials present. It is particularly noticeable where the layer has collected and pooled or dripped, and where the vehicle is predominantly dammar resin. On T01031, where the haze is much less visible, reduced levels of dammar resin were identified through analysis.[40]

The present trend in conservation is to understand, accept and monitor such change where possible rather than to take action to eliminate its effects. Therefore there are no plans to remove or adjust the haze on T01165 (nor on the other paintings where it is visible), since this would mean removing or covering an original layer of paint, albeit degraded, which would not leave us with an original surface. Replacing Rothko's glaze, even using the same materials, could never reproduce the exact colour, sheen and distribution of pigmented glaze that he applied.[41]

We recognize that in any course of action we will have to live with a distortion of his original, whether by leaving his current surface intact, or by creating a new distortion of our own in an attempt to 'restore' his surface. For the time being, recognising the change, understanding it, and seeing it for what it is, is a way to appreciate Rothko in the most authentic way possible.

The challenge of coating vast expanses of canvas while retaining visual interaction between layers required Rothko to make careful adjustments in his media according to solubility and drying time. Using a range of both traditional natural materials and the relatively new synthetic media, he mastered a technique to achieve his pictorial aims with elegance. While his aesthetic required an interplay between thin translucent and opaque layers of paint, his technical solutions resulted in paintings

Fig. 52c
T01165 Edge of the stretcher (tacking margin)
shows paint drips that washed over the side
when the background layers were applied.
This is presumably closer to the original
background colour however the drips are much
deeper in tone since the paint is concentrated.

Fig. 52d
T01165 Microscope image of paint sample
from the drips where the red pigment is still
present (compare with the uppermost surface of
paint in Fig. 52b).

that are not robust. Rothko's delicate surfaces are physically fragile and subject to change due to the chemical interactions of the components within the paint and due to exterior agents of deterioration. Given Rothko's materials and technique, Tate's paintings are lasting remarkably well. Despite the evidence of change in some, the murals still provide us with what Rothko intended: rich and varied surfaces that engage and interact with the viewer.

TABLE

PAINTING

	FI	glue	alkyd	PF	n-BMA	oil	egg	D-mar	Ulmar	PR49:1	Fe-ox	Earth	clay	Barytes	Cd-pigm	Black	Note
T01163																	RL
ground		•															
field			•	•	•	•		•	•	•				•	•		
figure			•	••	•	•		•	•		nd	nd	nd	nd	nd	nd	PR1
glaze figure	•					••	•										
T01164																	RL
ground		•															
field				•j	•	•	•		—	•	•	•	•		•	bone	PR1
figure			•		•j	•			—	•		•	•		•	bone	PR1
glaze figure	•						•										
T01165																	
ground		•						•	•				•	•			
field			•	•		•		•	•								
glaze figure	•					•	•	•		(•)				•			
figure			•			•		•			•				• orange	bone	PR1
T01166																	
ground		•						•	•								
field					•			•	••	•	•				• red	carbon	
glaze field								•									
figure				••	•			•			•	•	•				
glaze figure	•						•										
T01167																	
ground		•			•?												
field					•	•		•					•				PR1
figure			•		•	•					•			•	• orange		chalk
glaze figure	•				•?												

PAINTING

	Fl	glue	alkyd	PF	n-BMA	oil	egg	D-mar	Ulmar	PR49:1	Fe-ox	Earth	clay	Barytes	Cd-pigm	Black	Note
T01168																	
ground		•?				•			••	•		•	•				
field						•	(•)		•	•		•	•		• red		
figure						•			•			•	•		• red		
glaze figure	•				•	•											

	Fl	glue	alkyd	PF	n-BMA	oil	egg	D-mar	Ulmar	PR49:1	Fe-ox	Earth	clay	Barytes	Cd-pigm	Black	Note
T01169																	RL PVA
ground		•															
field			•	••i	•				•	•		•	•	•		bone	PVA
figure			•	••i	•				•	••	•	•	•	•		bone	PVA
glaze figure	•							•									

	Fl	glue	alkyd	PF	n-BMA	oil	egg	D-mar	Ulmar	PR49:1	Fe-ox	Earth	clay	Barytes	Cd-pigm	Black	Note
T01170																	
ground		•						•	•								
field			•	••	(•)				•	•	•		•	•	• red	bone	
glaze field								•									
figure			•	••	(•)					•	•	•	•			bone	
glaze figure	•								•	•							

	Fl	glue	alkyd	PF	n-BMA	oil	egg	D-mar	Ulmar	PR49:1	Fe-ox	Earth	clay	Barytes	Cd-pigm	Black	Note
T01031																	
ground		•						•	•								
field			•			•			•	•	•	•	•	•	• red		
glaze field	•							•	•	•	(•)						
figure			•			•					•	•	•	•		bone	

KEY

Fl	fluorescent	**Clay**	aluminum silicates	**RL**	restored / lined before arrival at Tate in 1970
Glue	animal skin glue	**Barytes**	natural barium sulphate		
Alkyd	oil modified alkyd paint (medium to long oil)	**Cd-pigments**	red or orange cadmium sulphoselenides	**Field**	area inside and outside the figure (so includes the edges)
PF	phenol formaldehyde resin oil paint	**Black**	organic black pigment	**Glaze field**	thin glaze layer inside the figure (usually fluorescent)
n-BMA	n-butyl methacrylate resin (i = isobutyl isomer)	**Carbon**	carbon black		
oil	fatty acids detected ranging from C12-C18	**Bone**	bone black	**Figure**	the form that outlines the window
		Note	special feature	**Glaze figure**	thin glaze layer over the figure form
egg	egg yolk and/or egg protein	**PR1**	Pigment Red 1 or para-red	**Number**	Tate accession number.
D-mar	dammar triterpencid resin	**PVA**	polyvinylacetate, suspected to be restoration material		
Ulmar	synthetic ultramarine				
PR49:1	lithol red colourant	**•**	present		
Fe-ox	Iron oxides	**••**	abundantly present		
Earth	earth pigments including umber	**(•)**	very small amount		
		—	certainly absent		
		nd	not determined		

STATEMENTS BY MARK ROTHKO

STATEMENTS BY MARK ROTHKO

ADDRESS TO PRATT INSTITUTE
NOVEMBER 1958

I began painting rather late in life; therefore my vocabulary was formed a good time before my painting vocabulary was formed, and it still persists in my talking about painting. I would like to talk about painting a picture. I have never thought that painting a picture has anything to do with self-expression. It is a communication about the world to someone else. After the world is convinced about this communication it changes. The world was never the same after Picasso or Miró. Theirs was a view of the world which transformed our vision of things. All teaching about self-expression is erroneous in art; it has to do with therapy. Knowing yourself is valuable so that the self can be removed from the process. I emphasize this because there is an idea that the process of self-expression itself has many values. But producing a work of art is another thing and I speak of art as a trade.

The recipe of a work of art — its ingredients — how to make it — the formula.

1. There must be a clear preoccupation with death — intimations of mortality ... Tragic art, romantic art, etc., deals with the knowledge of death.
2. Sensuality. Our basis of being concrete about the world. It is a lustful relationship to things that exist.
3. Tension. Either conflict or curbed desire.
4. Irony. This is a modern ingredient — the self-effacement and examination by which a man for an instant can go on to something else.
5. Wit and play ... for the human element.
6. The ephemeral and chance ... for the human element.
7. Hope. 10% to make the tragic concept more endurable.

I measure these ingredients very carefully when I paint a picture. It is always the form that follows these elements and the picture results from the proportions of these elements.

I want to mention a marvelous book: Kierkegaard's *Fear and Trembling*, which deals with the sacrifice of Isaac by Abraham. Abraham's act was absolutely unique. There are other examples of sacrifice: in the Greek, the Agamemnon story (state or daughter); also Brutus who had both of his sons put to death. But what Abraham did was un-understandable; there was no universal law that condones such an act as Abraham had to carry out. As soon as an act is made by an individual, it becomes universal. This is like the role of the artist. Another problem of Abraham was whether to tell Sarah. This is a problem of reticence. Some artists want to tell all like at a confessional. I as a craftsman prefer to tell little. My pictures are indeed facades (as they have been called). Sometimes I open one door and one window or two doors and two windows. I do this only through shrewdness. There is more power in telling little than in telling all. Two things that painting is involved with: the uniqueness and clarity of image and how much does one have to tell. Art is a shrewdly contrived article containing seven ingredients combined for the utmost power and concreteness.

The problem of the civilization of the artist. There has been an exploitation of primitiveness, the subconscious, the primordial. This has affected our thinking.

People ask me if I am a Zen Buddhist. I am not. I am not interested in any civilization except this one. Then whole problem in art is how to establish human values in this specific civilization.

I belong to a generation that was preoccupied with the human figure and I studied it. It was with the most reluctance that I found that it did not meet my needs. Whoever used it mutilated it. No one could paint the figure as it was and feel that he could produce something that could express the world. I refuse to mutilate and had to find another way of expression. I used mythology for a while, substituting various creatures who were able to make intense gestures without embarrassment. I began to use morphological forms in order to paint gestures that I could not make people do. But this was unsatisfactory.

My current pictures are involved with the *scale* of human feelings the human drama, as much of it as I can express.

Q. Don't you feel that we have made a new contribution in terms of light and color, ambience?
A. I suppose we have made such a contribution in the use of light and color, but I don't understand what ambience means. But these contributions were made in relation to the seven points. I may have used colors and shapes in the way that painters before have not used them, but this was not my purpose. The picture took the shape of what I was involved in. People have asked me if I was involved with color. Yes, that's all there is, but I am not against line. I don't use it because it would have detracted from the clarity of what I had to say. The form follows the necessity of what we have to say. When you have a new view of the world, you will have to find new ways to say it.

Q. How does wit and play enter your work?
A. In a way my paintings are very exact, but in that exactitude there is a shimmer, a play ... in weighing the edges to introduce a less rigorous, play element.

Q. Death?
A. The tragic notion of the image is always present in my mind when I paint and I know when it is achieved, but I couldn't point it out, show where it is illustrated. There are no skill and bones. (I am an abstract painter.)

Q. On philosophy?
A. If you have a philosophical mind you will find that nearly all paintings can be spoken of in philosophical terms.

Q. Shouldn't the young try to say is [sic] all ... question of control?
A. I don't think the question of control is a matter of youth or age. It is a matter of decision. The decision is: is there anything to control. I think that a freer, wilder kind of painting is not more natural with youth than with gray old men. It isn't a question of age; it is a question of choice. This (idea) has to do with fashion. Today, there is an implication that a painter improves if he gets more free. This has to do with fashion.

Q. Self-expression ... communication versus expression. Cannot they be reconciled? Personal message and self-expression.
A. What a personal message means is that you have been thinking for yourself. It is different from self-expression. You may communicate about yourself; I prefer to communicate a view of the world that is not all of myself. Self-expression is boring. I want to talk of nothing outside of myself — a great scope of experience.

Q. Can you define abstract expressionism?
A. I never read a definition and to this day I don't know what it means. In a recent article I was called an action painter. I don't get it and I don't think my work has anything to do with Expressionism, abstract or any other. I am an antiexpressionist.

Q. Large pictures?
A. Habit or fashion. Many times I see large pictures whose meaning I do not understand. Seeing that I was one of the first criminals, I found this useful. Since I am involved with the human element, I want to create a state of intimacy — an immediate transaction. Large pictures take you into them. Scale is of tremendous importance to me — human scale. Feelings have different weights; I prefer the weight of Mozart to Beethoven because of Mozart's wit and irony and I like his scale. Beethoven has a farmyard wit. How can a man be ponderable without being heroic? This is my problem. My pictures are involved with these human values. This is always what I think about. When I went to Europe and saw the old masters, I was involved with the credibility of the drama. Would Christ on the cross if he opened his eyes believe the spectators? I think that small pictures since the Renaissance are like novels; large pictures are like dramas in which one participates in a direct way. The different subject necessitates different means.

Q. How can you express human values without self-expression?
A. Self-expression often results in inhuman values. It has been confused with feelings of violence. Perhaps the word *self-expression* is not clear. Anyone who makes a statement about the world must be involved with self-expression but not in stripping yourself of will, intelligence, civilization. My emphasis is upon deliberateness. Truth must strip itself of self which can be very deceptive.

The drive to be a public man — universal drive for a community

The solitude

unmitigated by success, rather sharpened

The ideal situation of a commission

Neither the place nor the pictures yet exist

The self deception that drives the project

to conclusion in the hope of a miracle

~~the~~ that the two can coincide

In the spring of 1958 I received a phone call. It proved to be a commission to ~~fill a~~ space which was to be used as a ~~pub~~ private room. ~~My~~ My one condition that the place be an enclosed space. As far as I have always maintained that if I should be given an ~~private~~ enclosed space which I could surround with my work it would be ~~the~~ realization of a dream that I have always held.

The question of the dining room was always appealing to me for I immediately envisioned the refectory of the San Marco Church

NOTES ON THE SEAGRAM MURAL COMMISSION

This untitled manuscript on four loose sheets of paper forms part of a larger portfolio of notes and reflections drawn up during preparations for the retrospective at MoMA in New York. As some of these sheets contain inventory lists and selections, it is assumed that they were compiled in the autumn of 1960. The text may have been intended originally for publication in the catalogue as a comment by the artist, given that Rothko presented for the first time publicly a fairly large selection of works from the Seagram murals cycle in that exhibition. It is reproduced here in its original draft form. Only three crossed-out words, which can be regarded as Freudian slips in connection with the question of the public or private nature of the space, have been reinserted. In any case, Rothko was aware from the very outset of the fact that the place concerned was a restaurant and not only an ideal space for his art. Rothko himself is responsible for underscoring the expression "place contained".

We gratefully acknowledge Oliver Wick who rediscovered this manuscript in the Rothko family archives. This manuscript was first published in the exhibition catalogue *Mark Rothko*, Palazzo delle Esposizioni, Rome 2007 and subsequently translated into German and published in *Mark Rothko, Die Retrospektive*, Kunsthalle der Hypo-Kulturstiftung, München and Hamburger Kunsthalle, Hamburg 2008.

The drive to be a public man — universal drive for a community
The solitude unmitigated by success, rather sharpened
The ideal situation of a commission
Neither the place nor the pictures yet exist.
The self-deception that drives the project to conclusion in the
hope of a miracle that the two can coincide.

In the spring of 1958 I received a phone call. It proved to be a commission to fill a ~~pu~~[blic] space which was to be used as a ~~pub~~[lic] private room. My one condition that the place be an enclosed space. In so far as I have always maintained that if I should be given an ~~private~~ enclosed space which I could surround with my work it would be the realization of a dream that I have always held. The question of the dining room was always appealing to me for I immediately envisioned the refectory of the San Marco church with the wall painting by Fra Angelico.

My first instinct was the general distrust of all dealing promises of this sort. Therefore the first item of the contract was a provision that in the event of a desire on the part of my patrons to dispose of the pictures that they must be resold to me. Already was the hope that I would paint something which they could not endure. In this wish was embodied of the horror of the great maw which had developed which had a mouth and teeth anything that was offered. Nothing could any longer shock or repel. But on the basis of the aesthetic everything could be consumed.

What was obvious that there was in me the need to undertake a conception of a <u>place contained</u> and absolutely mine.

The first pictures I made were in my old style. But soon I discovered that the old image would not serve the purpose. It became clear that to be a public man required a different attitude. Other pictures are made for nowhere. But once a specific place and permanence and the heterogeneousness of a public situation were involved a new image would have to be evolved.

There followed a series of steps in which every step was further and further reduced and at the last the extent of reduction was acceptable. In an age which has found no myths and symbols to express itself, the final image had to be free of interior connotations. The problem was to image an image which was whole and extraneous to the several images themselves. In short to make a place rather than pictorial vestiges. When the project was achieved I realised that I had never forgotten M. A. [Michelangelo's] room which contained the stairway leading to the Lorenzo Library wherein the false bricked-in windows toward the top of the unrelieved brick walls made an interior world wholly pervasive and awesome.

I locked the door and did not see the pictures for the next two months. When I saw them again their conviction persisted. By this time the place and the spirit for which they were made was functioning. Then I saw the completed destination. It was obvious that the two were not for each other.

Then if not for this place, what other places. Banks, lobbys, chapels.

INSTRUCTIONS FOR EXHIBITION AT THE WHITECHAPEL ART GALLERY, 1961
SUGGESTIONS FROM MR. MARK ROTHKO REGARDING INSTALLATION OF HIS PAINTINGS

Wall color

Walls should be made considerably off-white with umber and warmed by a little red. If the walls are too white, they are always fighting against the pictures which turn greenish because of the predominance of red in the pictures.

Lighting

The light, whether natural or artificial, should not be too strong: the pictures have their own inner light and if there is too much light, the color in the picture is washed out and a distortion of their look occurs. The ideal situation would be to hang them in a normally lit room — that is the way they were painted. They should not be over-lit or romanticized by spots; this results in a distortion of their meaning. They should either be lighted from a great distance or indirectly by casting lights at the ceiling or the floor. Above all, the entire picture should be evenly lighted and not strongly.

Hanging height from the floor

The larger pictures should all be hung as close to the floor as possible, ideally not more than six inches above it. In the case of the small pictures, they should be somewhat raised but not "skyed" (never hung towards the ceiling). Again this is the way the pictures were painted. If this is not observed, the proportions of the rectangles become distorted and the pictures changes.

The exceptions to this are the pictures which are enumerated below which were painted as murals actually to be hung at a greater height. These are:

1. *Sketch for Mural, No. 1*, 1958

2. *Mural Sections 2,3,4,5*, and *7*, 1958—9

3. *White and Black on Wine*, 1958

The murals were painted at a height of 4'6" above the floor. If it is not possible to raise them to that extent, any raising above three feet would contribute to their advantage and original effect.

Grouping

In the Museum of Modern Art's exhibition all works from the earliest in the show of 1949 inclusive were hung as a unit, the watercolors separated from the others. The murals were hung as a second unit, all together. The only exception to this grouping of the murals is the picture owned by Mr. Rubin, *White and Black on Wine* 1958, which could take its place, but with a raised hanging among the other works since it is a transitional piece between the earlier pictures of that year and the mural series. In the remaining works, it is best not to follow a chronological order but to arrange them according to their best effect upon each other. For instance, in the exhibition at the Museum the very light pictures were grouped together — yellows, oranges, etc. — and contributed greatly to the effect produced.

In considering your installation, it might be of interest that with [sic] three murals (*Mural Section No. 3*, 1959 in center, *Mural Section No. 5*, and *Mural Section No. 7*, each on flanking walls) were hung in a separate gallery in our Museum. The dimensions of this gallery were 16 1/2' x 20' which Rothko felt were very good proportions and gave an excellent indication of the way in which the murals were intended to function. If a similar room could be devised, it would be highly desirable.

Whitechapel Art Gallery Archive, London

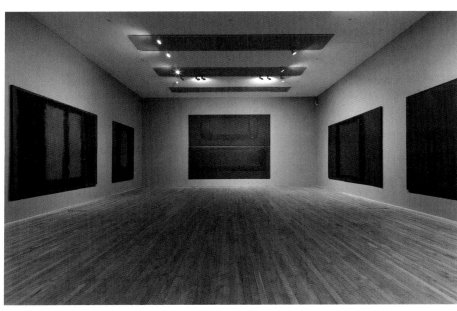

Seagrams murals, Tate Modern, London 2008

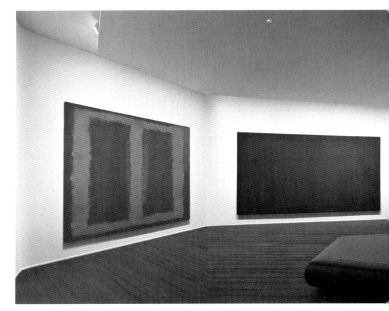

Seagrams murals, Kawamura Memorial Museum of Art, Sakura 2008

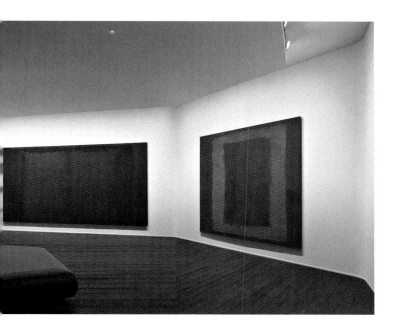
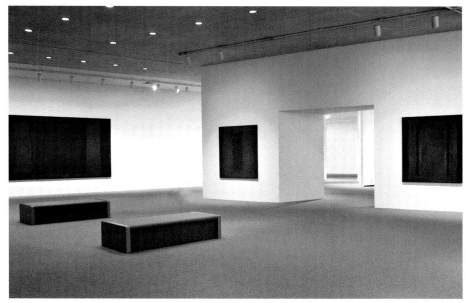

Seagrams murals, National Gallery of Art, Washington 2005

PLATES

Four Darks in Red
1958
Oil on canvas
259.1 x 294.6
Whitney Museum of American Art, New York
Purchase, with funds from the Friends of the
Whitney Museum of American Art, Mr. and Mrs
Eugene M. Schwartz, Mrs. Samuel A. Seaver
and Charles Simon

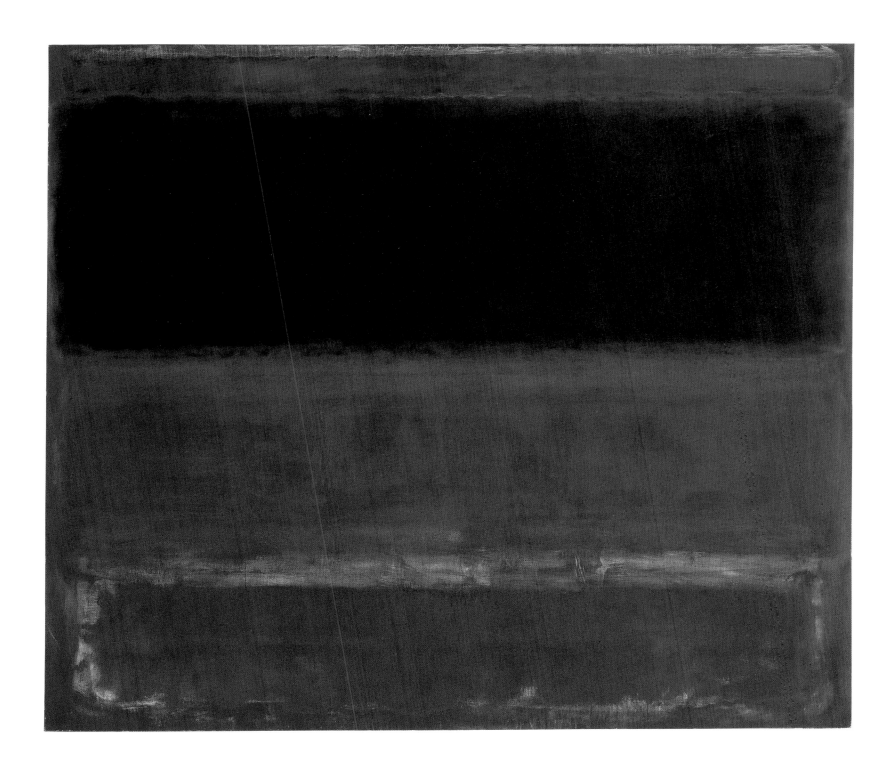

Untitled
1958–9
Coloured crayons with graphite and touches
of pastel on red construction paper
9.9 x 45.8
National Gallery of Art, Washington
Gift of The Mark Rothko Foundation, Inc. 1986

Untitled
1958–9
Coloured crayons and traces of
pastel on red construction paper
10.6 x 45.7
National Gallery of Art, Washington
Gift of The Mark Rothko Foundation, Inc. 1986

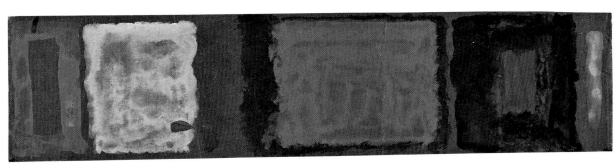

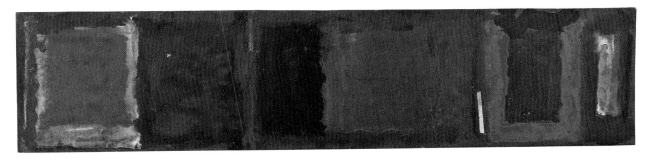

Untitled
1958–9
Gouache on red construction paper
11.9 x 51
National Gallery of Art, Washington
Gift of The Mark Rothko Foundation, Inc. 1986

Untitled
1958–9
Gouache and watercolour on wove paper
10.7 x 42.9
National Gallery of Art, Washington
Gift of The Mark Rothko Foundation, Inc. 1986

Untitled
1958–9
Gouache and watercolour on red
construction paper
12.1 x 51.1
National Gallery of Art, Washington
Gift of The Mark Rothko Foundation, Inc. 1986

Sketch for "Mural No. 1"
1958
Mixed media on canvas
266.7 x 304.8
Kawamura Memorial Museum of Art,
Sakura

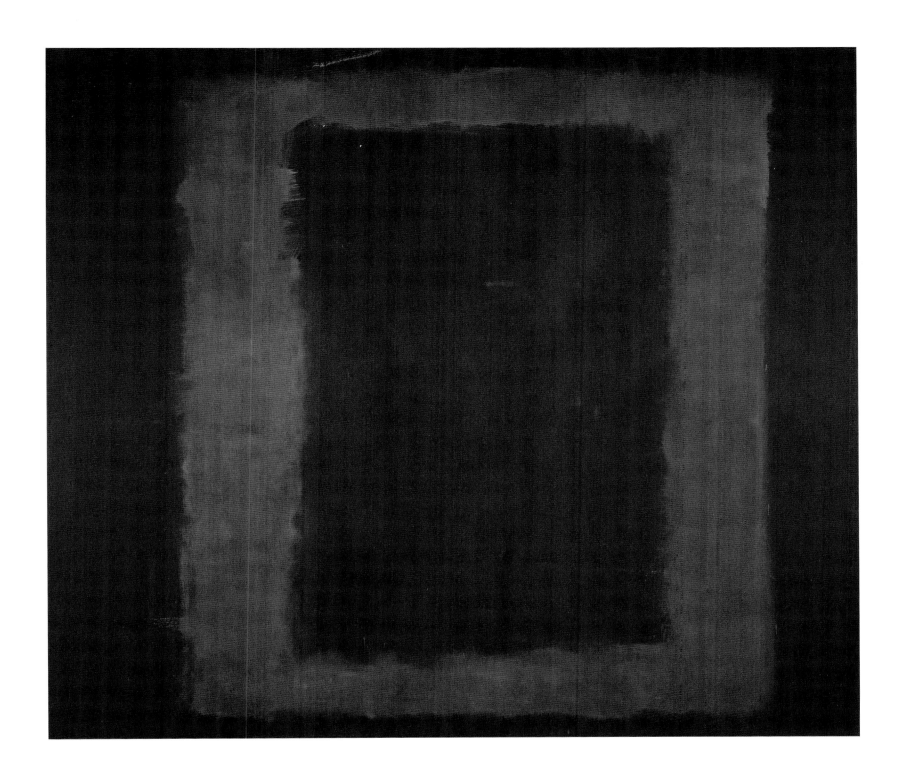

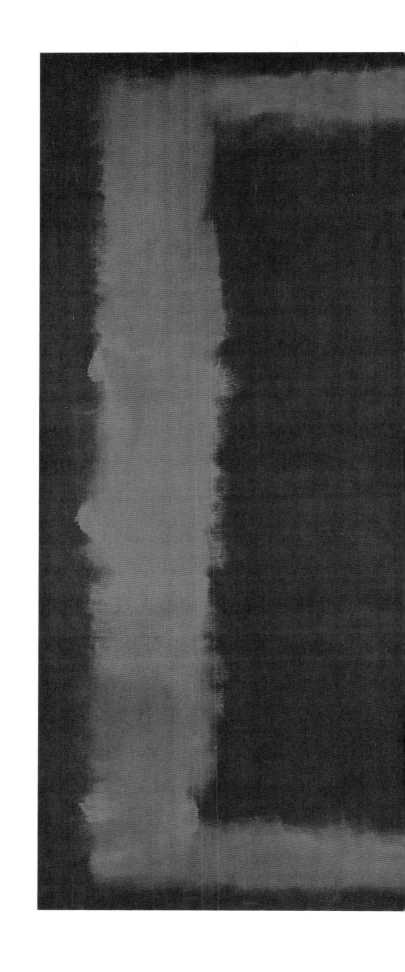

Sketch for "Mural No. 4"
1958
Mixed media on canvas
265.8 x 379.4
Kawamura Memorial Museum of Art, Sakura

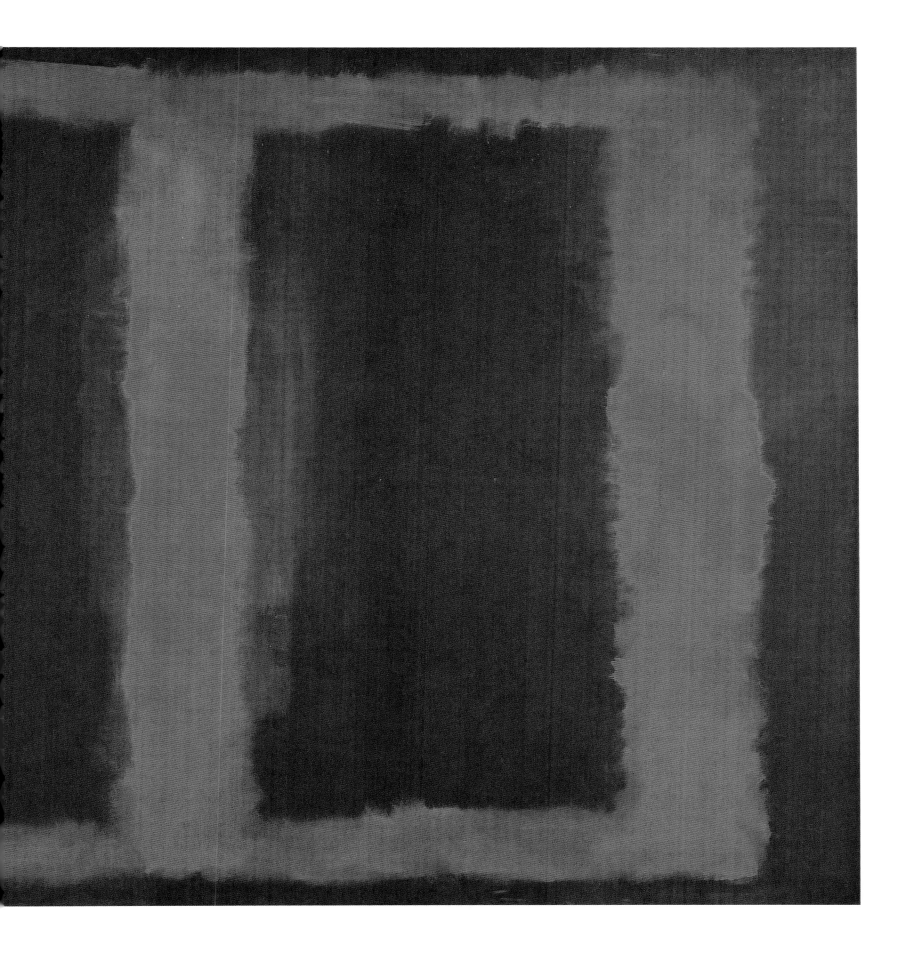

Untitled
1958
Mixed media on canvas
264.8 x 252.1
Kawamura Memorial Museum of Art, Sakura

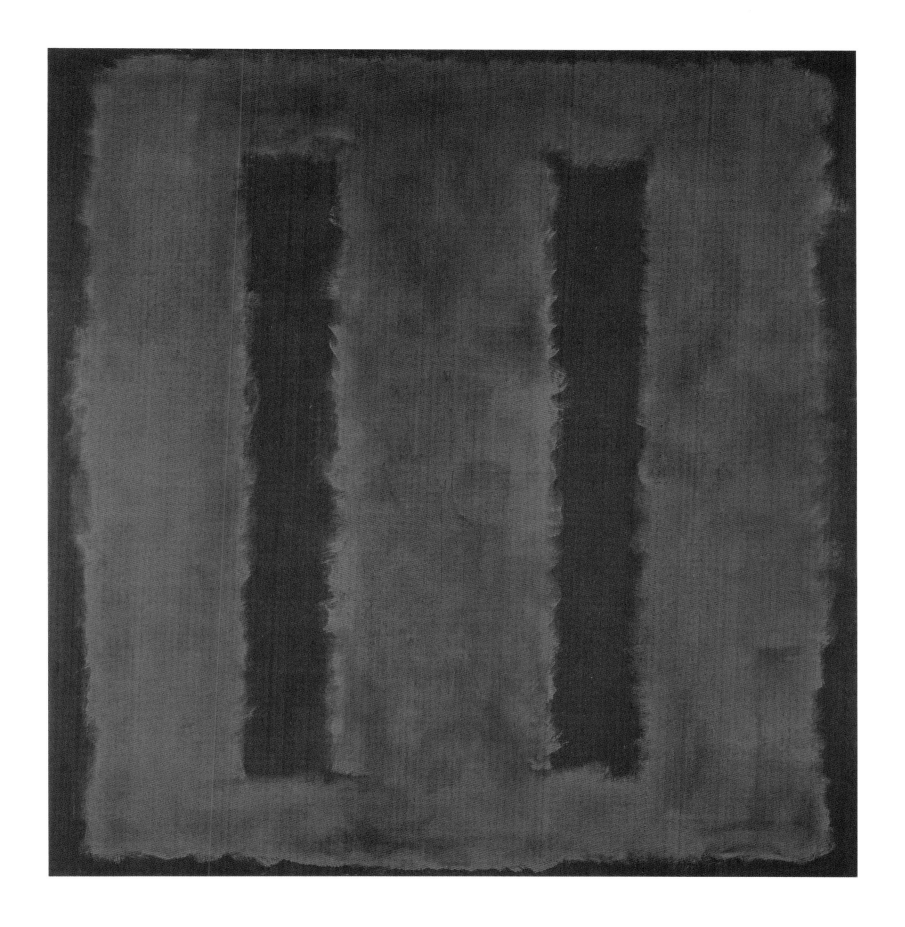

Black on Maroon
1958
Mixed media on canvas
228.6 x 207
Tate. Presented by the artist through
the American Federation of Arts 1969

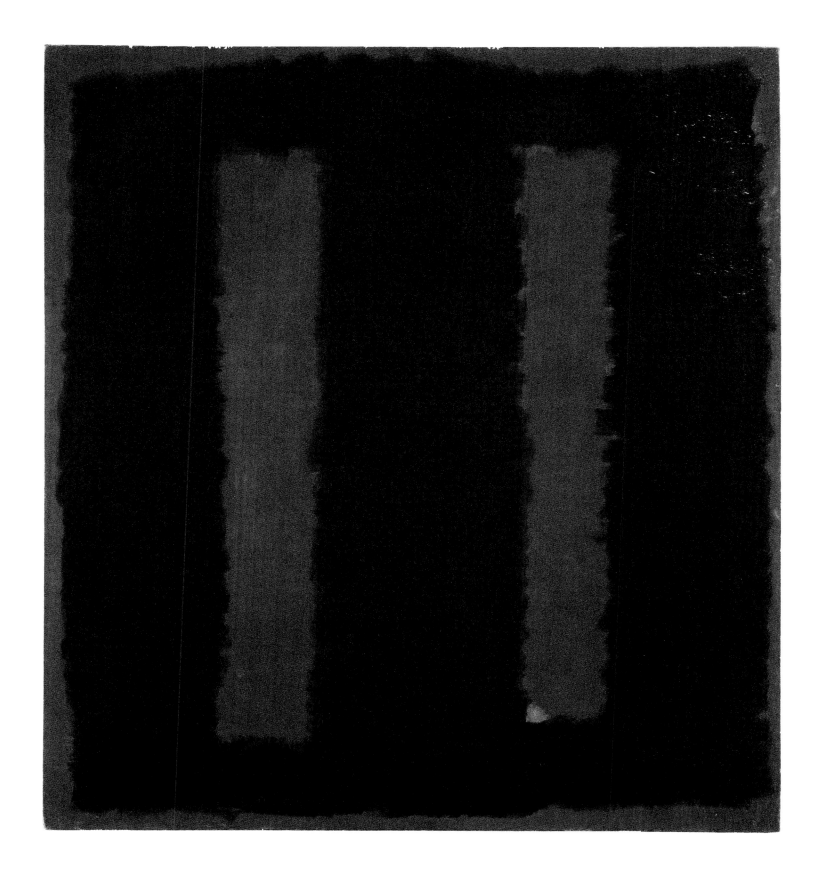

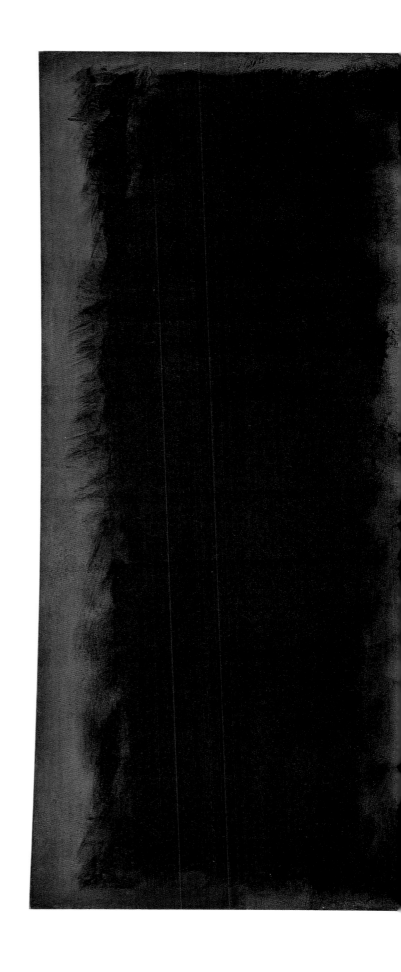

Black on Maroon
Sketch for "Mural No. 6"
1958
Mixed media on canvas
266.7 x 381.2
Tate. Presented by the artist through
the American Federation of Arts 1968

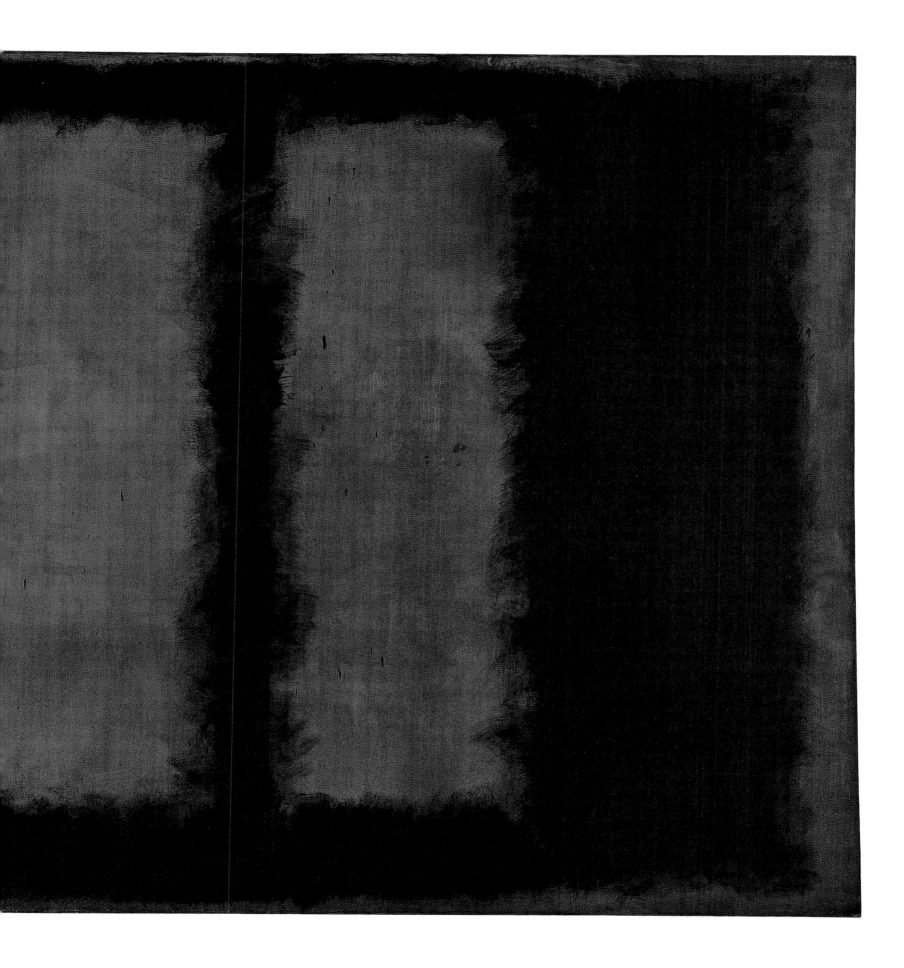

Black on Maroon
1958
Mixed media on canvas
266.7 x 241.3
Tate. Presented by the artist through
the American Federation of Arts 1969

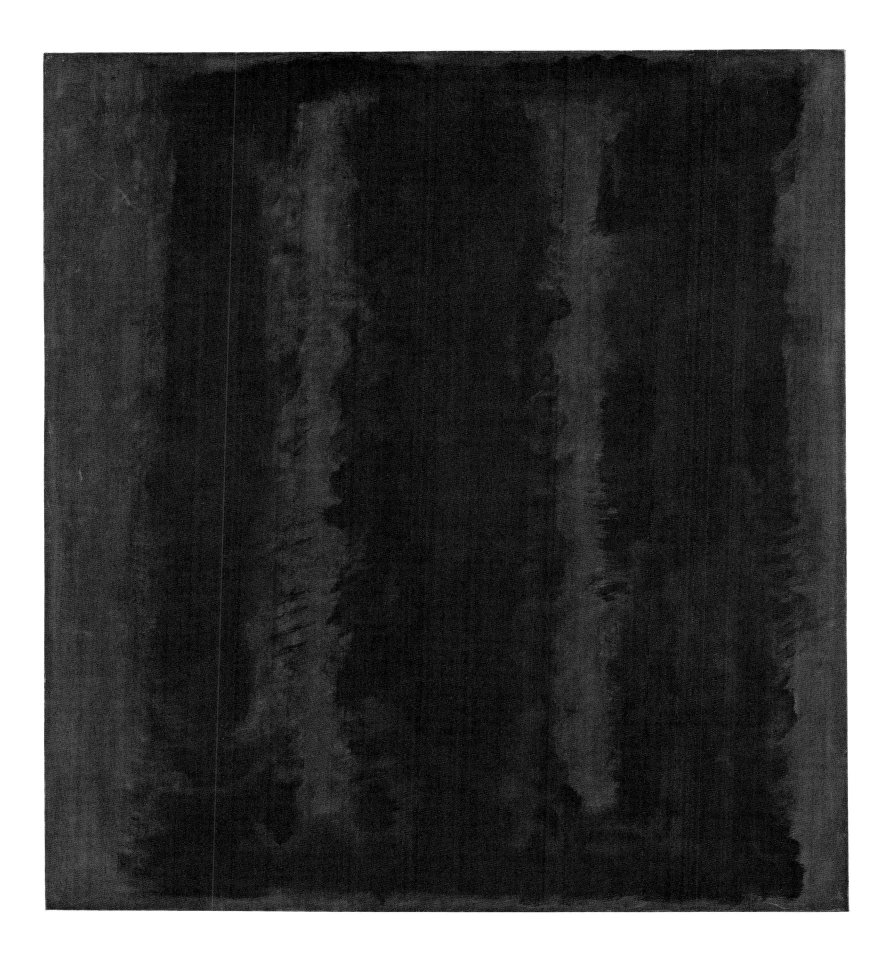

Black on Maroon
1959
Mixed media on canvas
266.7 x 228.6
Tate. Presented by the artist through
the American Federation of Arts 1969

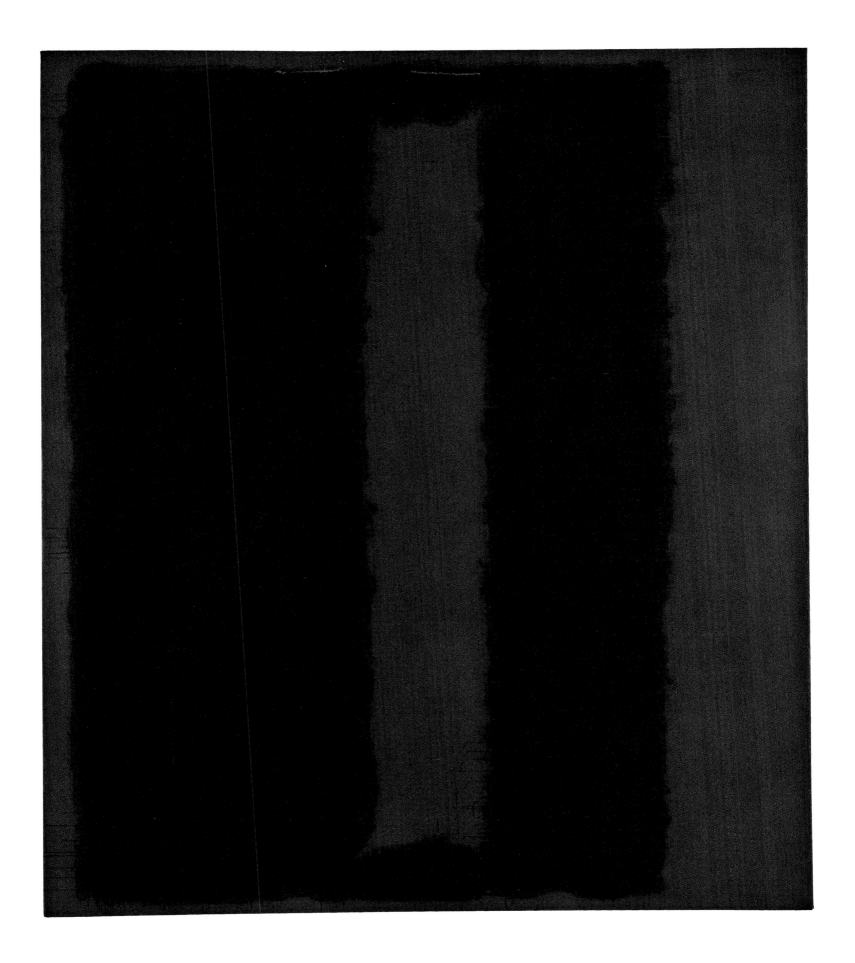

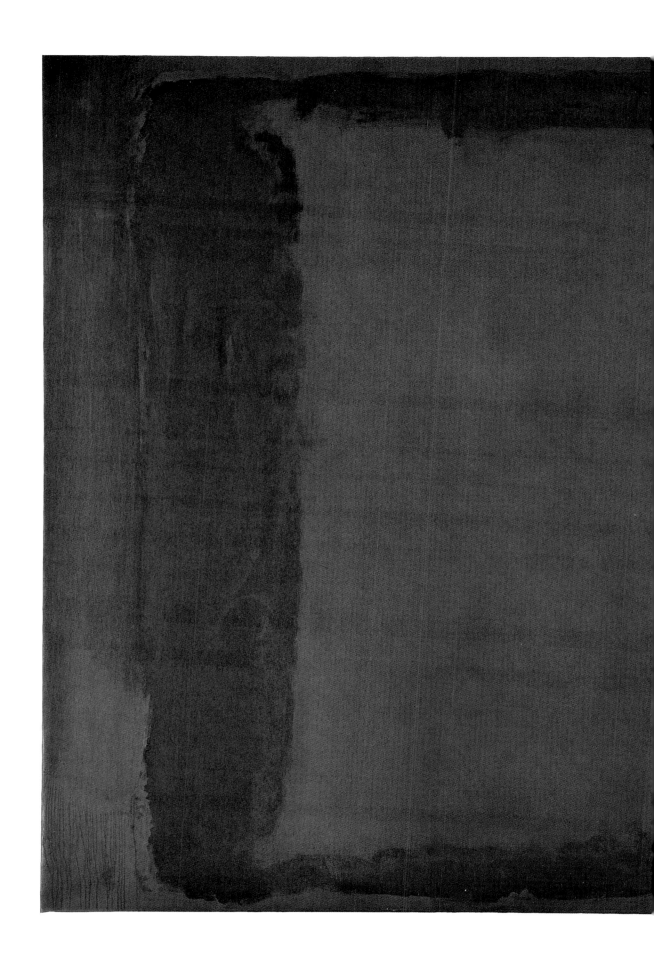

Untitled
1959
Mixed media on canvas
266.7 x 455.9
Kawamura Memorial Museum of Art,
Sakura

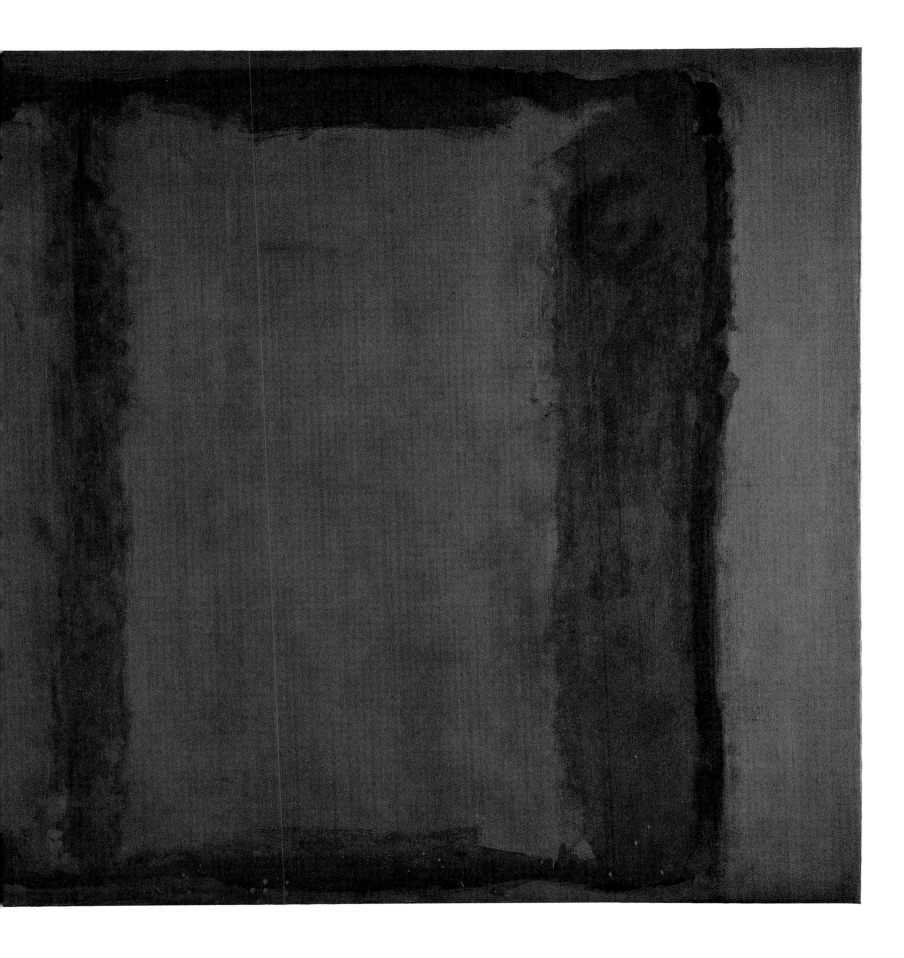

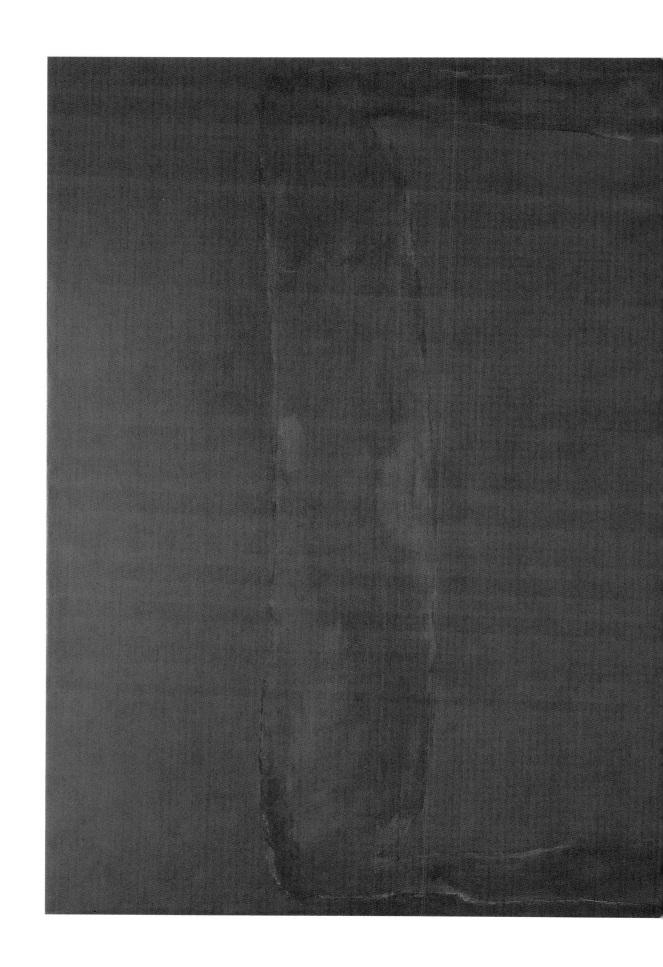

Untitled
1959
Mixed media on canvas
266.1 x 453.8
Kawamura Memorial Museum of Art,
Sakura

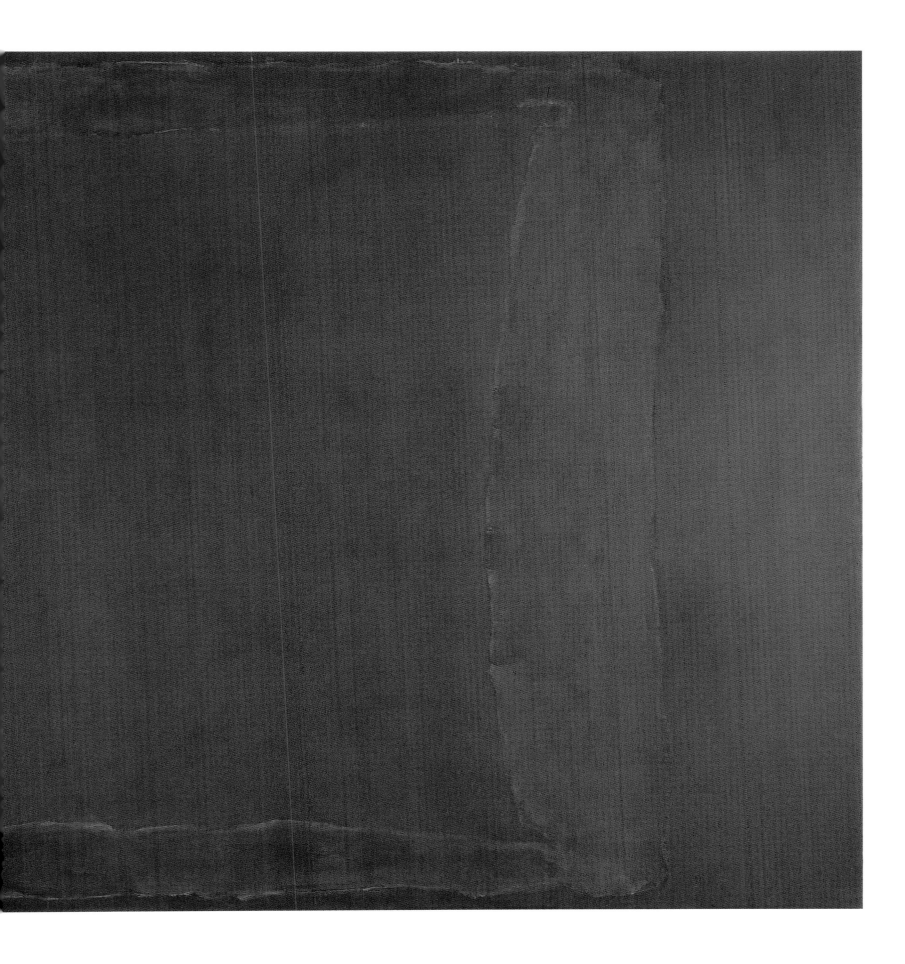

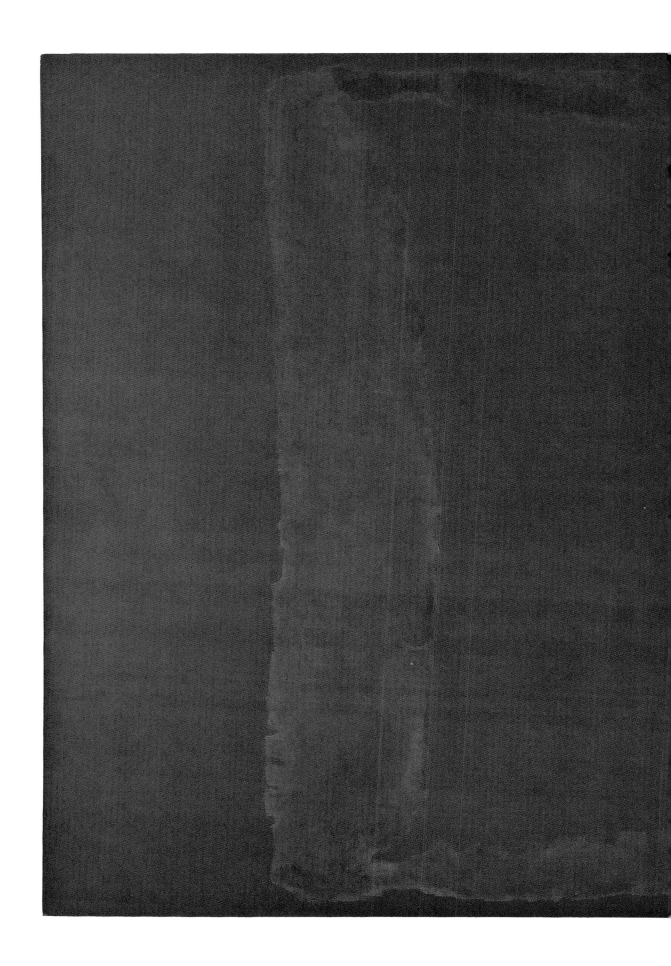

Red on Maroon
Mural, Section 2
1959
Mixed media on canvas
266.7 x 457.2
Tate. Presented by the artist through
the American Federation of Arts 1969

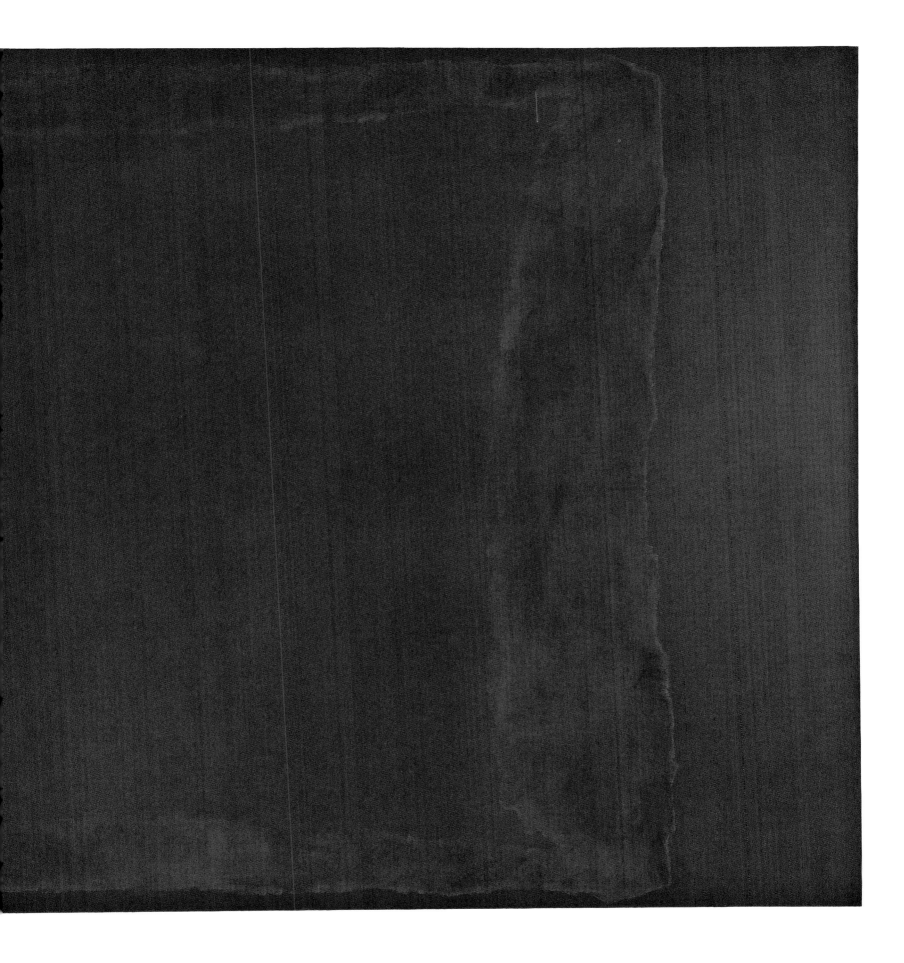

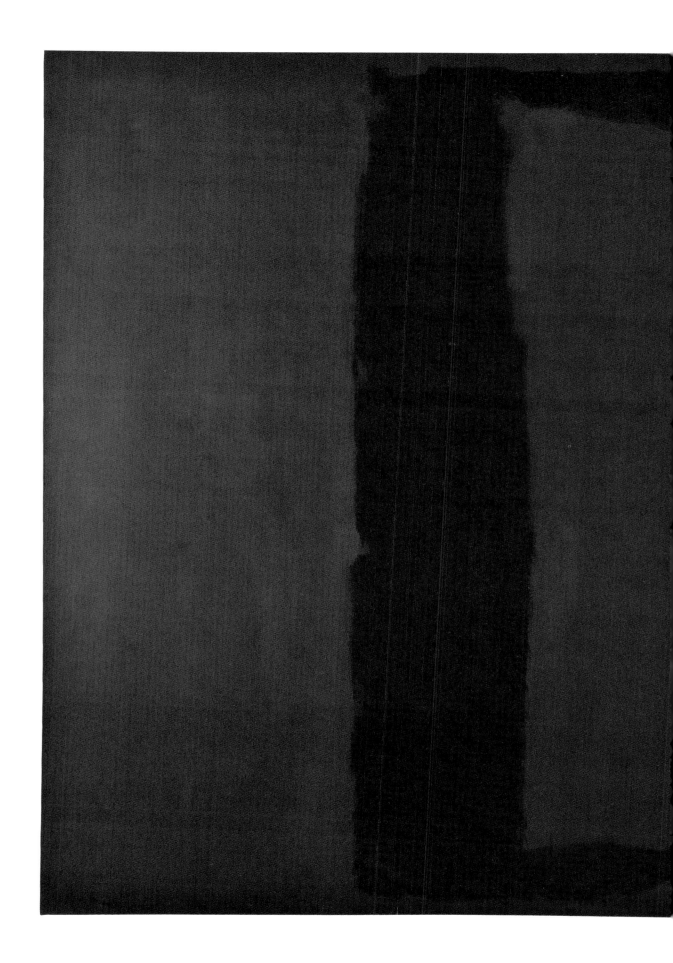

Black on Maroon
Mural, Section 3
1959
Mixed media on canvas
266.7 x 457.2
Tate Presented by the artist through
the American Federation of Arts 1969

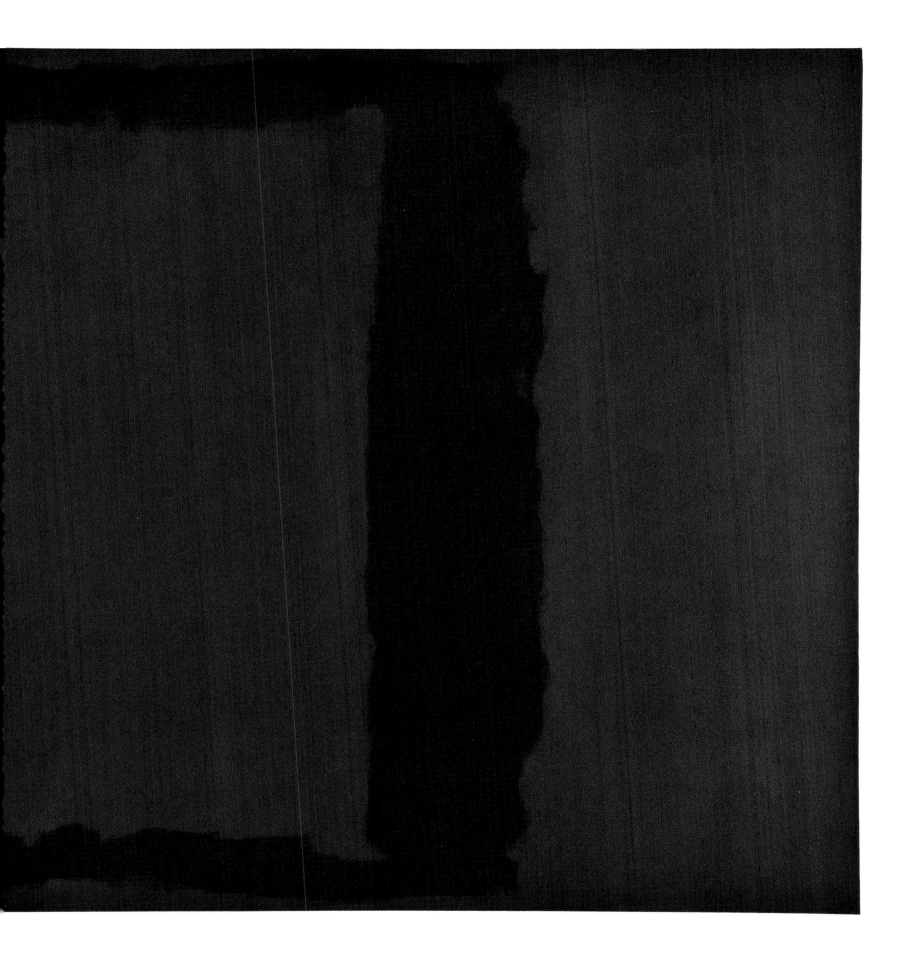

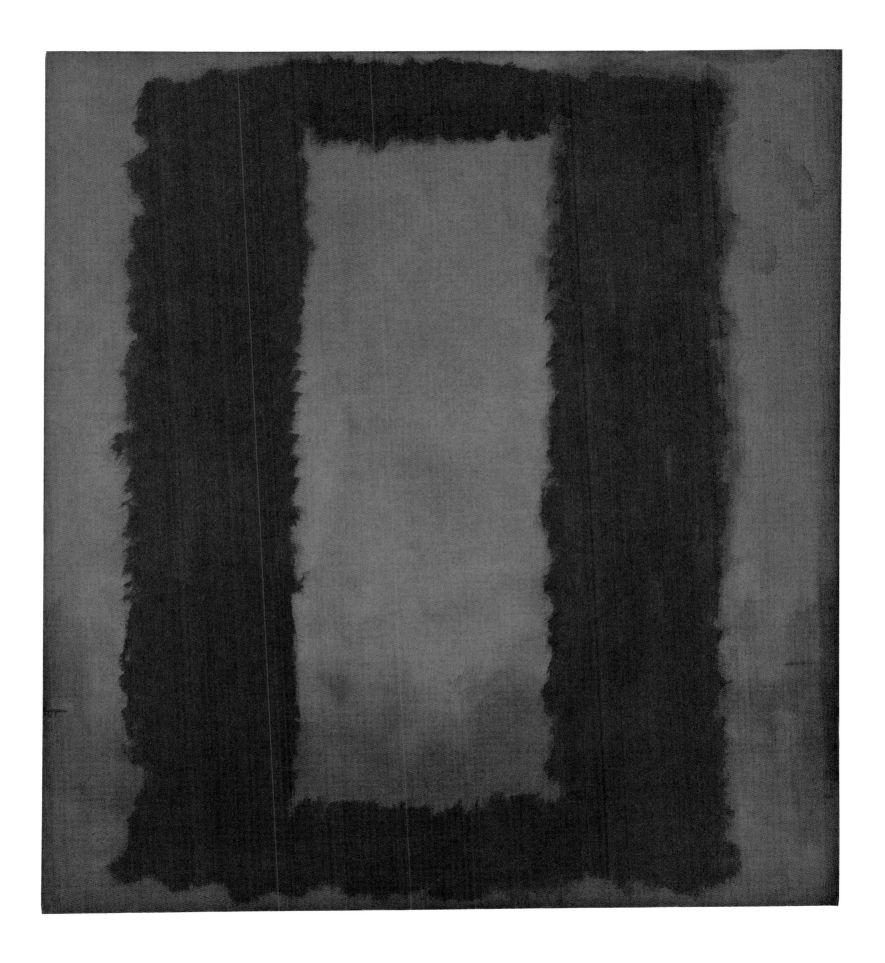

129

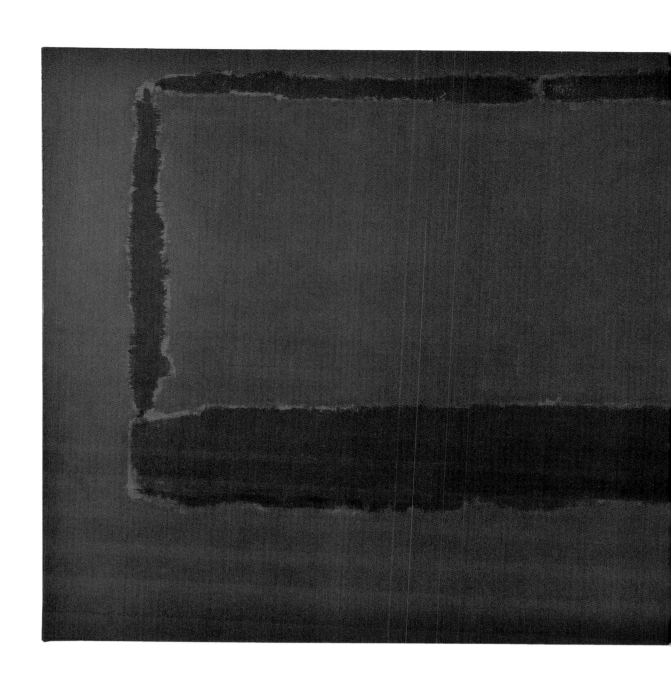

Red on Maroon
Mural, Section 5
1959
Mixed media on canvas
182.9 x 457.2
Tate. Presented by the artist through
the American Federation of Arts 1969

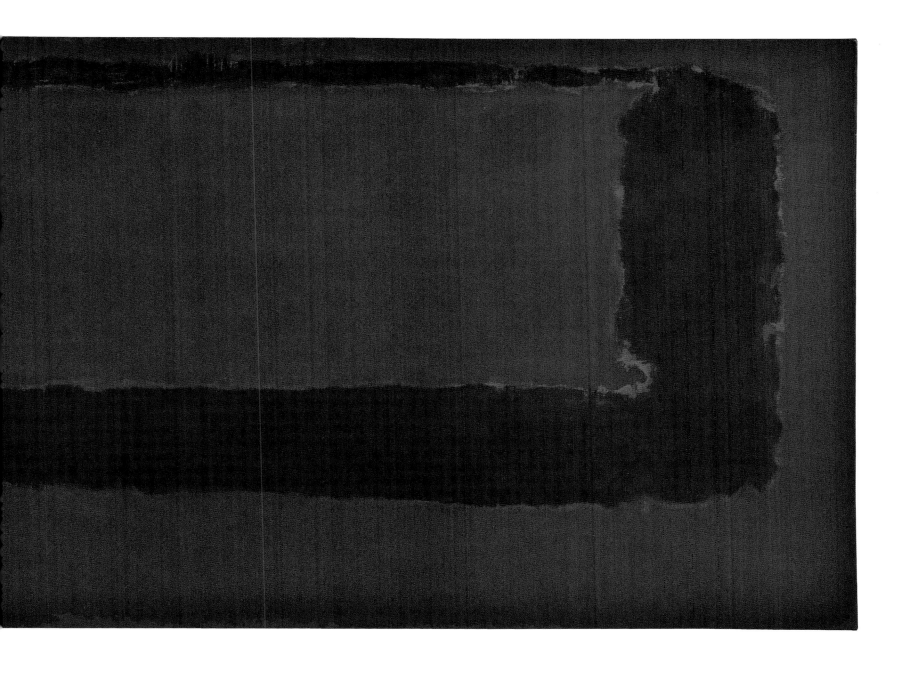

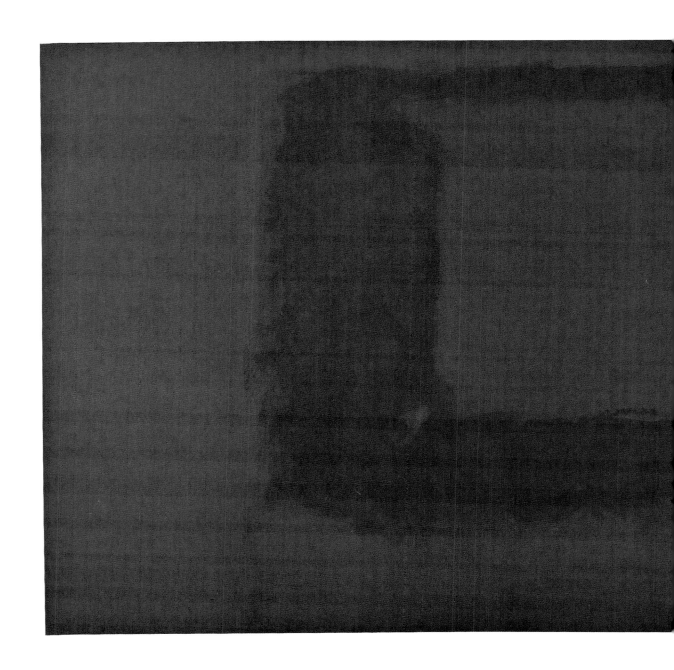

Red on Maroon
Mural, Section 7
1959
Mixed media on canvas
182.9 x 457.2
Tate. Presented by the artist through
the American Federation of Arts 1969

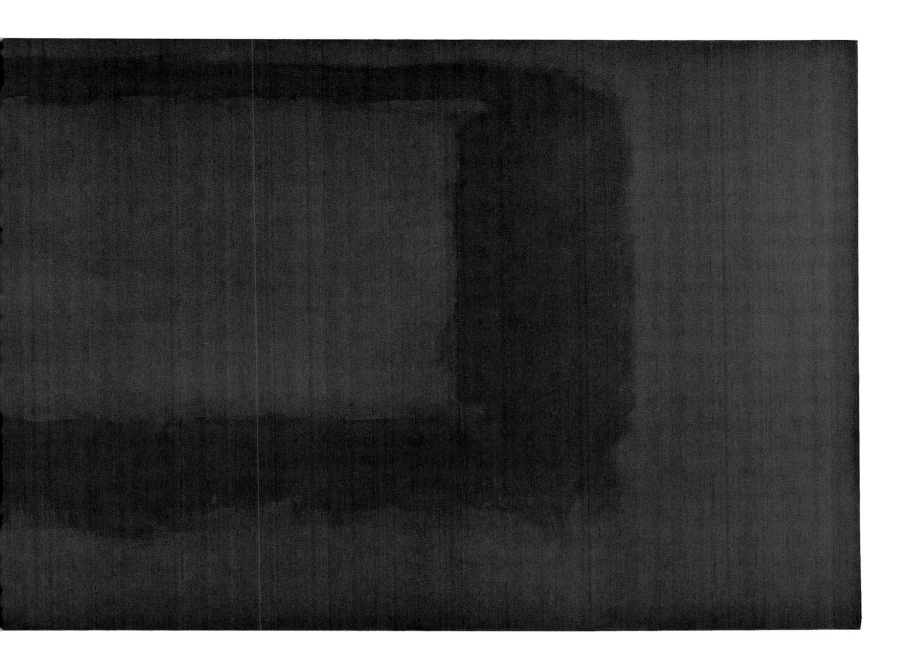

Untitled
Mural for End Wall
1959
Mixed media on canvas
265.4 x 288.3
National Gallery of Art, Washington
Gift of The Mark Rothko Foundation, Inc. 1985.38.5

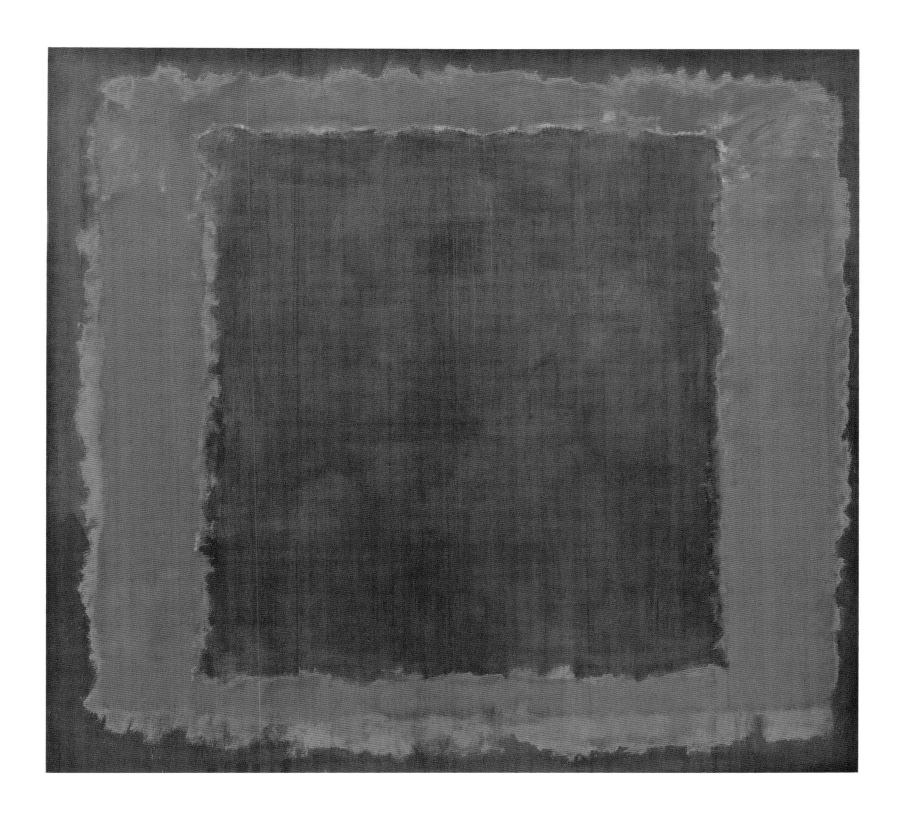

Untitled (Study for Seagram Mural)
1958–9
Gouache on paper
63.5 x 96.5
Collection of Christopher Rothko

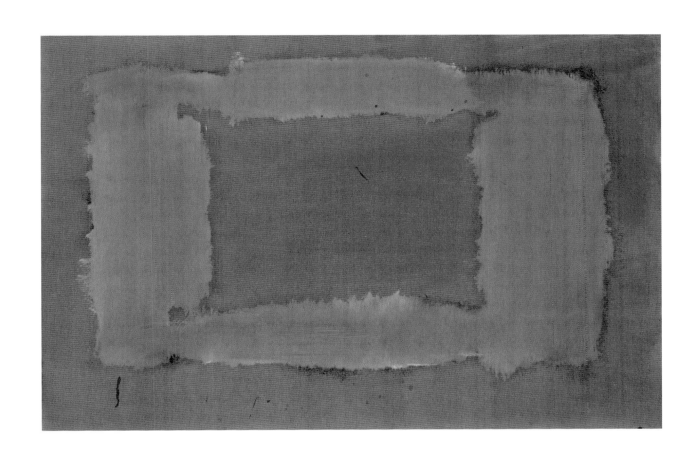

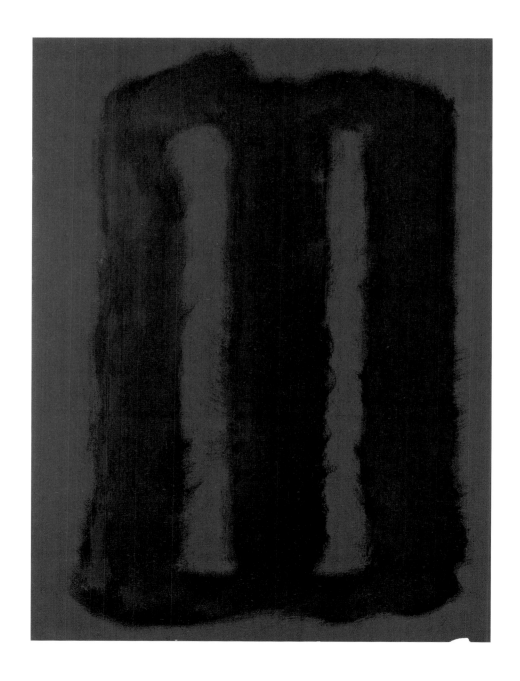

Untitled (Study for Seagram Mural)
1958—9
Gouache on paper
76.2 x 56
Collection of Kate Rothko Prizel

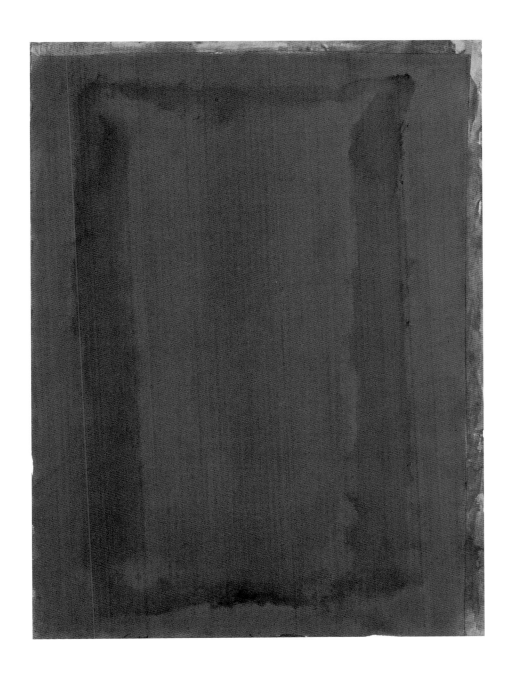

Untitled (Study for Seagram Mural)
1958–9
Gouache on paper
76.2 x 56
Collection of Christopher Rothko

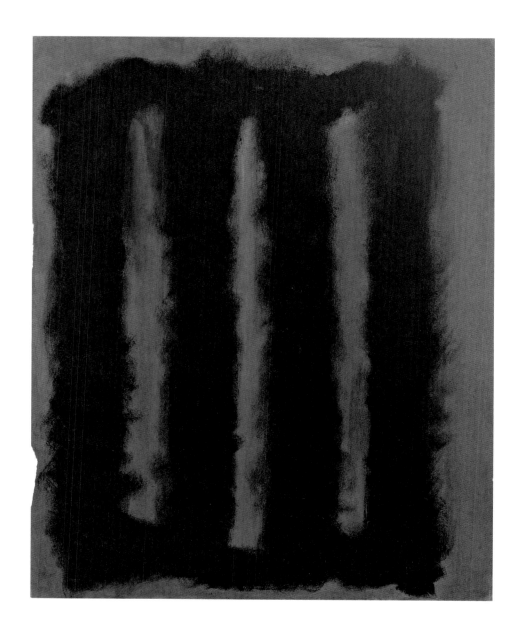

Untitled (Study for Seagram Mural)
1958—9
Gouache on paper
60.3 x 47.6
Collection of Kate Rothko Prizel

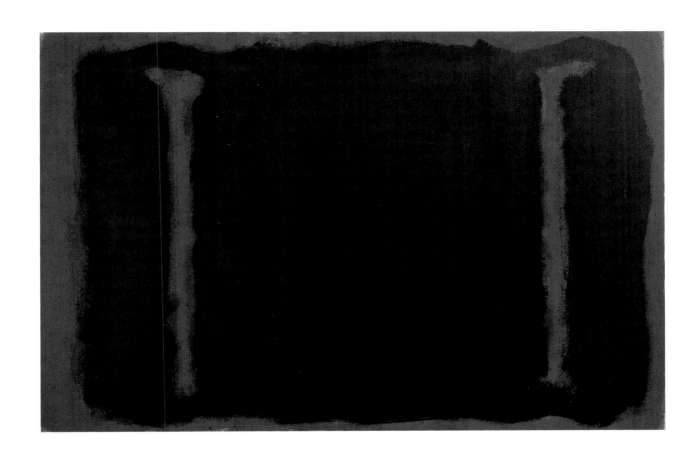

Untitled (Study for Seagram Mural)
1958–9
Gouache on paper
63.5 x 96.5
Collection of Kate Rothko Prizel

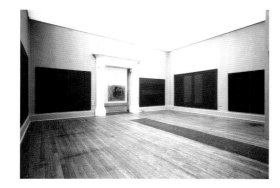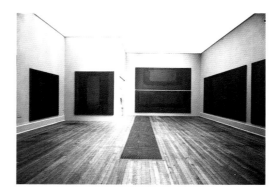

Seagram murals, Tate Gallery, Millbank May 1970

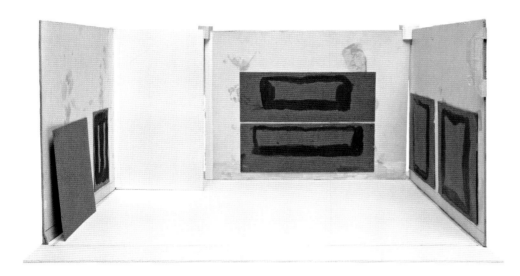
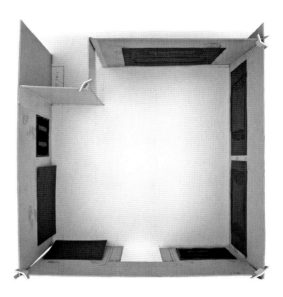

**Maquette for installation of
Seagram murals at Tate Gallery**
1969
Cardboard
19.4 x 46.1 x 50.1
Tate Archive Collection

The arrangement of the maquettes reflects the first
installation of the murals at the Tate Gallery in 1970

A second blank maquette is not an accurate match for either T01164 or T01165

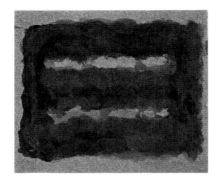

Maquette of *Black on Maroon* 1959 (T01166)
1969
Tempera on purple construction paper
10 x 8.5
Tate Archive Collection
Hung sideways

No maquette for *Black on Maroon* 1959 (T01164)

No maquette for *Red on Maroon*
1959 (T01165)

Maquette of *Red on Maroon* 1959 (T01167)
1969
Tempera on purple construction paper
6.5 x 17
Tate Archive Collection

Maquette of *Black on Maroon* 1959 (T01169)
1969
Tempera on purple construction paper
6.5 x 17
Tate Archive Collection

Blank maquette of approximate size for
Black on Maroon **1958 (T01031)**
1969
Purple construction paper
10 x 14.2
Tate Archive Collection

Maquette of *Black on Maroon* **1959 (T01170)**
1969
Tempera on purple construction paper
9 x 7.5
Tate Archive Collection

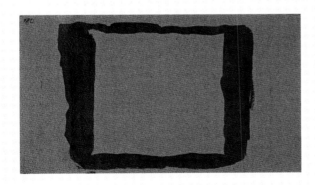

Maquette of *Red on Maroon* **1959 (T01163)**
1969
Tempera on purple construction paper
10 x 17
Tate Archive Collection

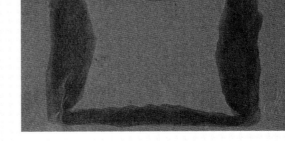

Maquette of *Red on Maroon* **1959 (T01168)**
1969
Tempera on purple construction paper
10 x 17
Tate Archive Collection

Untitled
1964
Oil on canvas
228.6 x 175.3
Collection of Kate Rothko Prizel

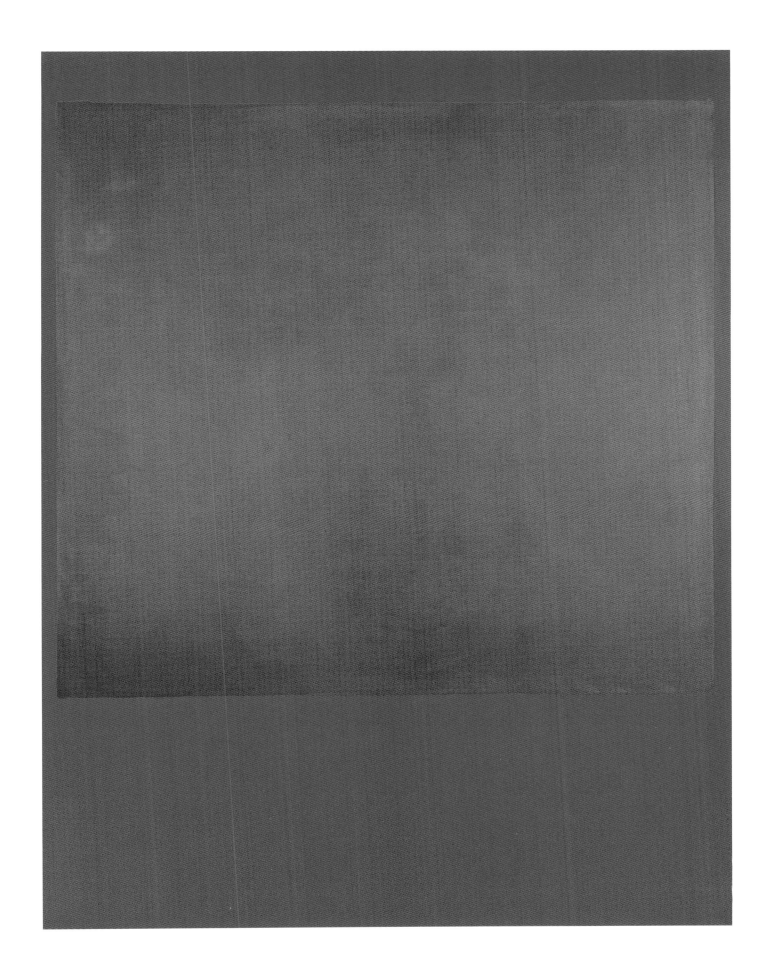

No. 1
1964
Mixed media on canvas
266.7 x 203.2
Kunstmuseum Basel

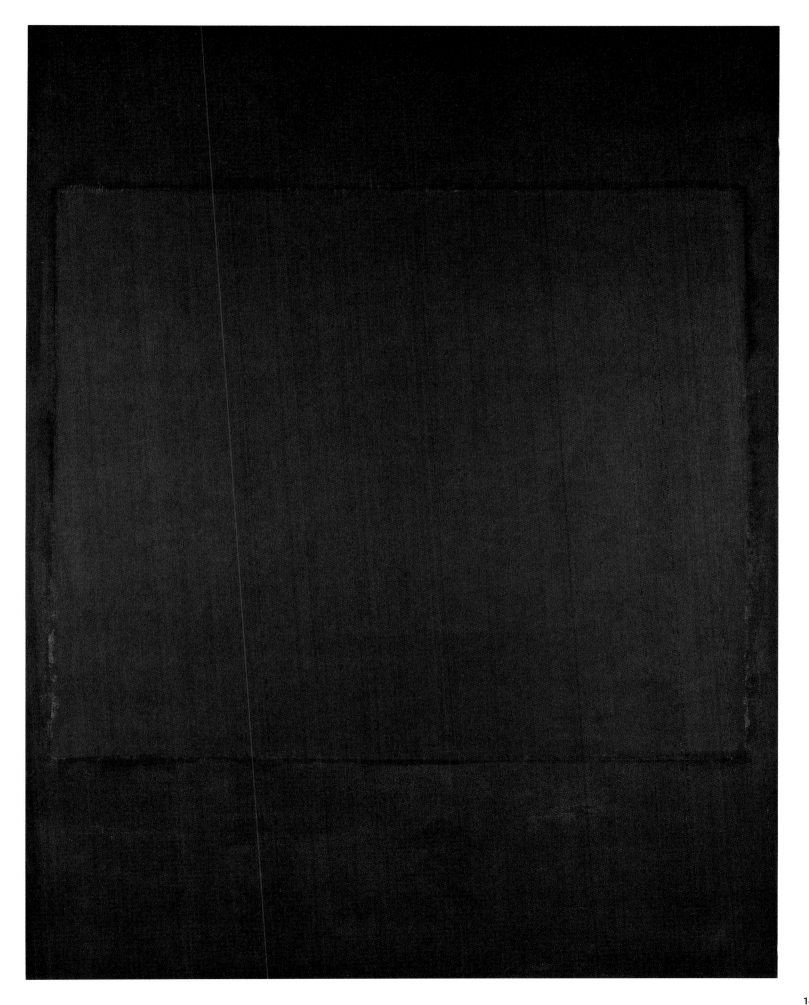

No. 5
1964
Mixed media on canvas
228.6 x 175.3
Collection of Christopher Rothko

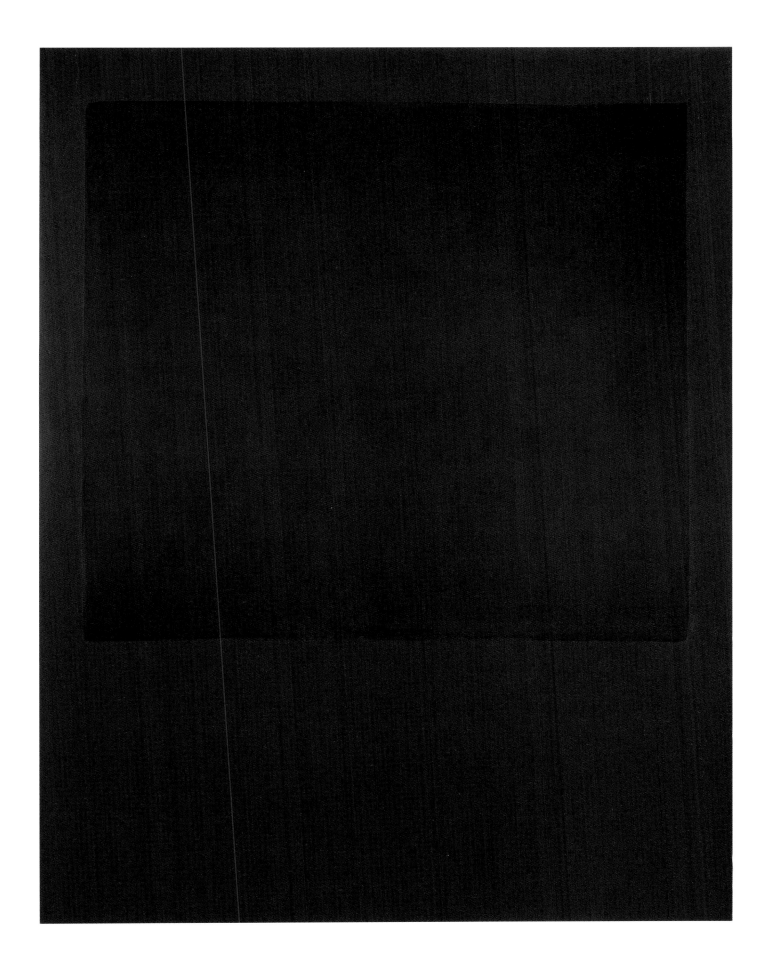

151

No. 6 (?)
1964
Mixed media on canvas
236.2 x 193
Naticnal Gallery of Art, Washington
Gift of The Mark Rothko Foundation, Inc. 1986.43.140

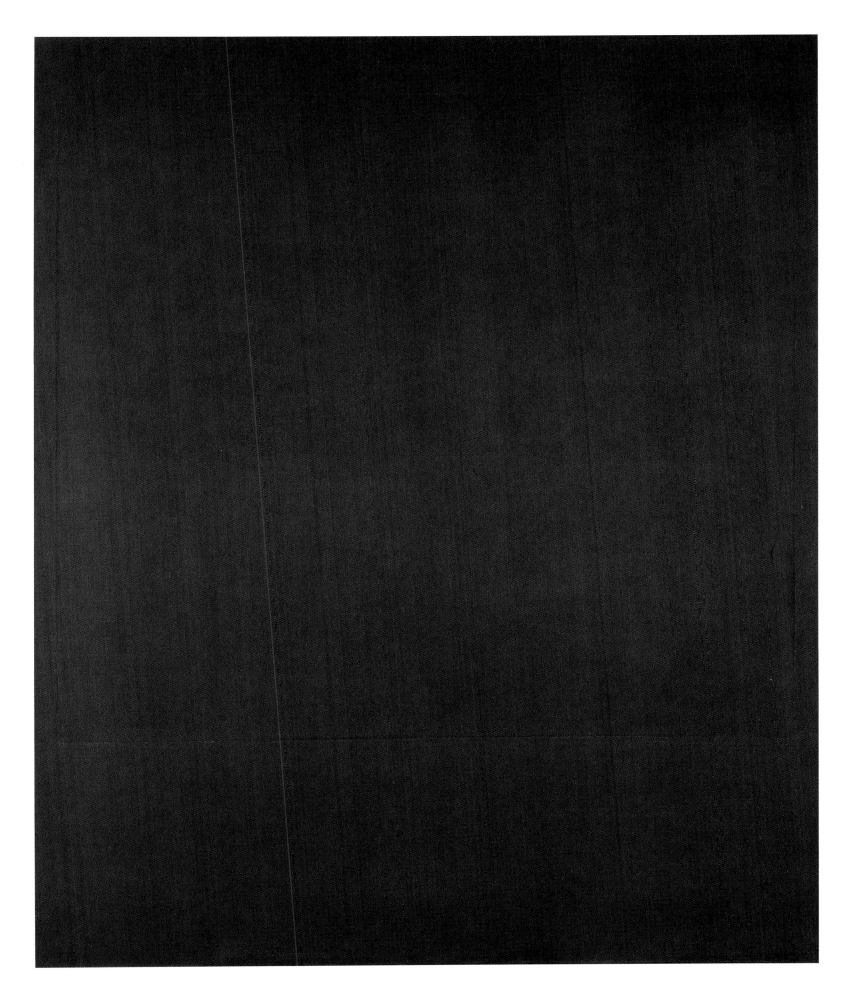

No. 7
1964
Mixed media on canvas
236.4 x 193.6
National Gallery of Art, Washington
Gift of The Mark Rothko Foundation, Inc. 1986.43.134

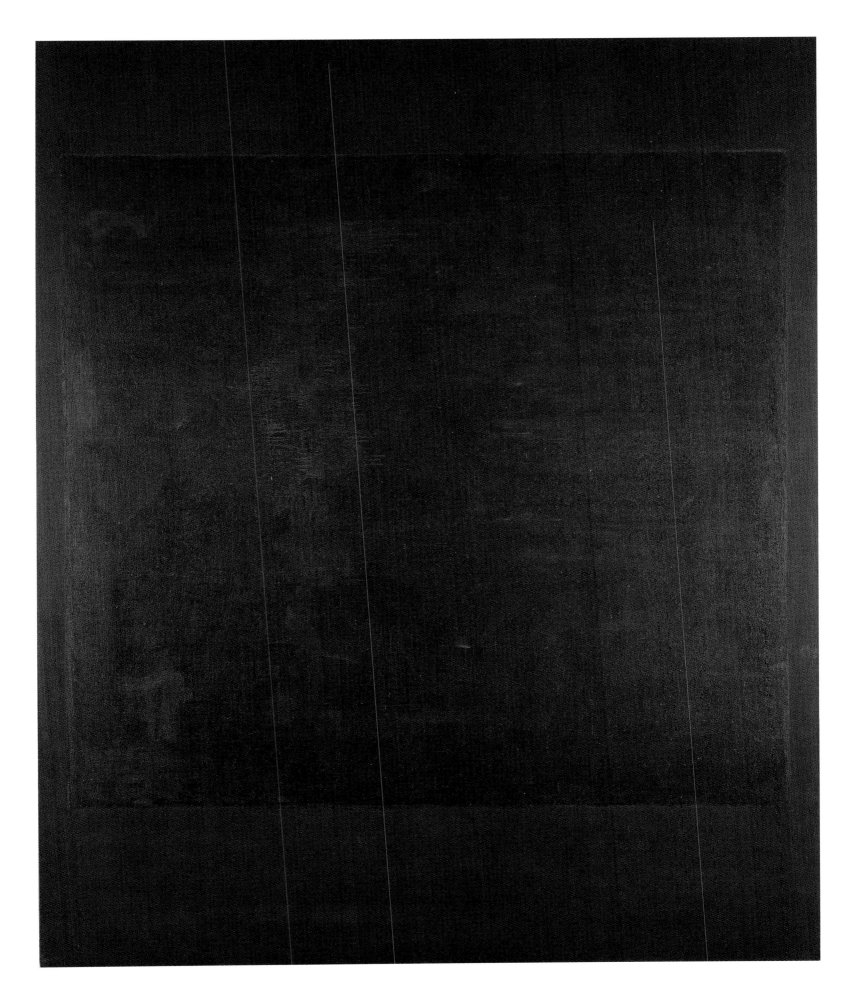

No. 8
1964
Mixed media on canvas
266.7 x 203.2
National Gallery of Art, Washington
Gift of The Mark Rothko Foundation, Inc. 1986.43.139

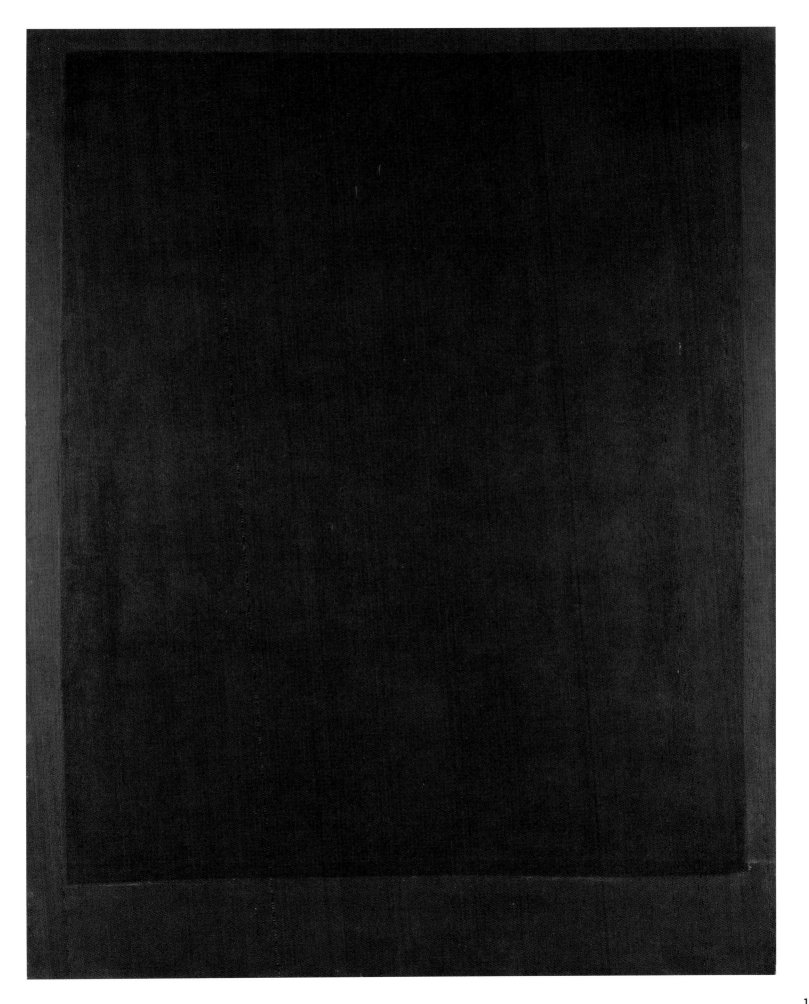

Study for side-wall triptychs
1966
Graphite pencil on black paper
with traces of red crayon
16.5 x 26.4
The Menil Collection, Houston
Gift of The Mark Rothko Foundation, Inc.

**Miniature model for entrance-wall
replacement panel**
c.1966
Collage of gouache on black paper
mounted on gouache on board
19.4 x 8.3
The Menil Collection, Houston
Gift of The Mark Rothko Foundation, Inc.

Study for side-wall triptychs
1966
Graphite pencil on black paper
17.1 x 26.4
The Menil Collection, Houston
Gift of The Mark Rothko Foundation, Inc.

Study for side-wall triptychs
1966
Graphite pencil on black paper
22.9 x 30.5
The Menil Collection, Houston
Gift of The Mark Rothko Foundation, Inc.

Study for side-wall triptychs
1966
Graphite pencil on black paper
16.5 x 26
The Menil Collection, Houston
Gift of The Mark Rothko Foundation, Inc.

Study for side-wall triptychs
1966
Graphite pencil on black paper
16.5 x 26
The Menil Collection, Houston
Gift of The Mark Rothko Foundation, Inc.

Untitled (Brown and Gray)
1969
Acrylic on paper
182.8 x 121.9
National Gallery of Art, Washington
Gift of The Mark Rothko Foundation, Inc. 1986

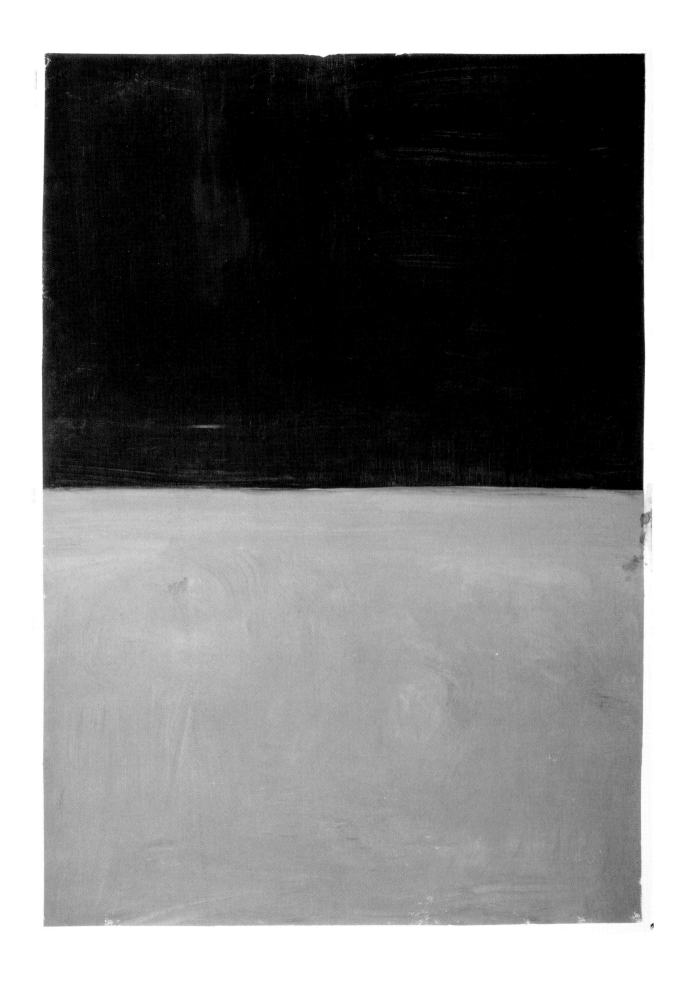

Untitled (Brown and Gray)
1969
Acrylic on paper
152.9 x 122.2
National Gallery of Art, Washington
Gift of The Mark Rothko Foundation, Inc. 1986

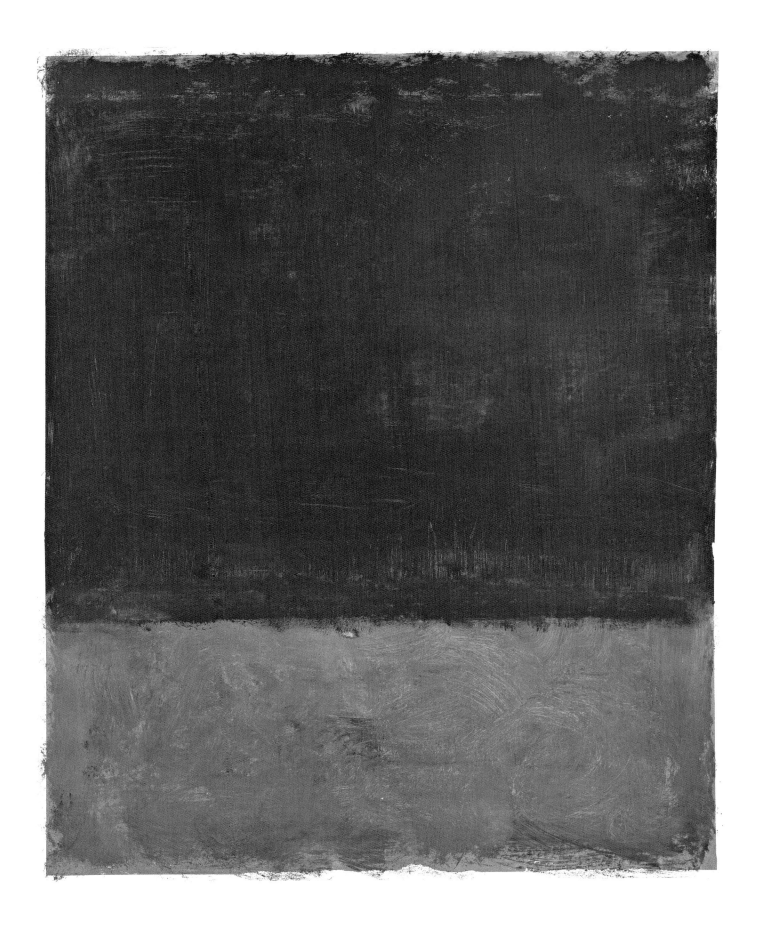

Untitled (Brown and Gray)
1969
Acrylic on paper
152 x 122.2
National Gallery of Art, Washington
Gift of The Mark Rothko Foundation, Inc. 1986

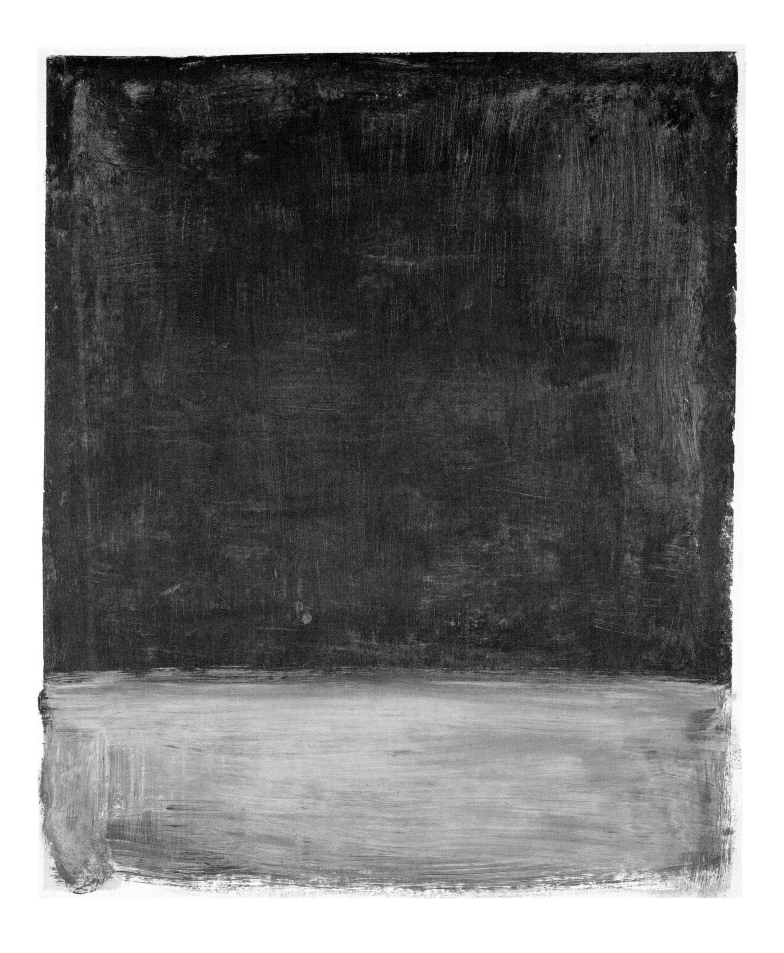

Untitled (Brown and Gray)
1969
Acrylic on paper
152.8 x 122.3
National Gallery of Art, Washington
Gift of The Mark Rothko Foundation, Inc. 1986

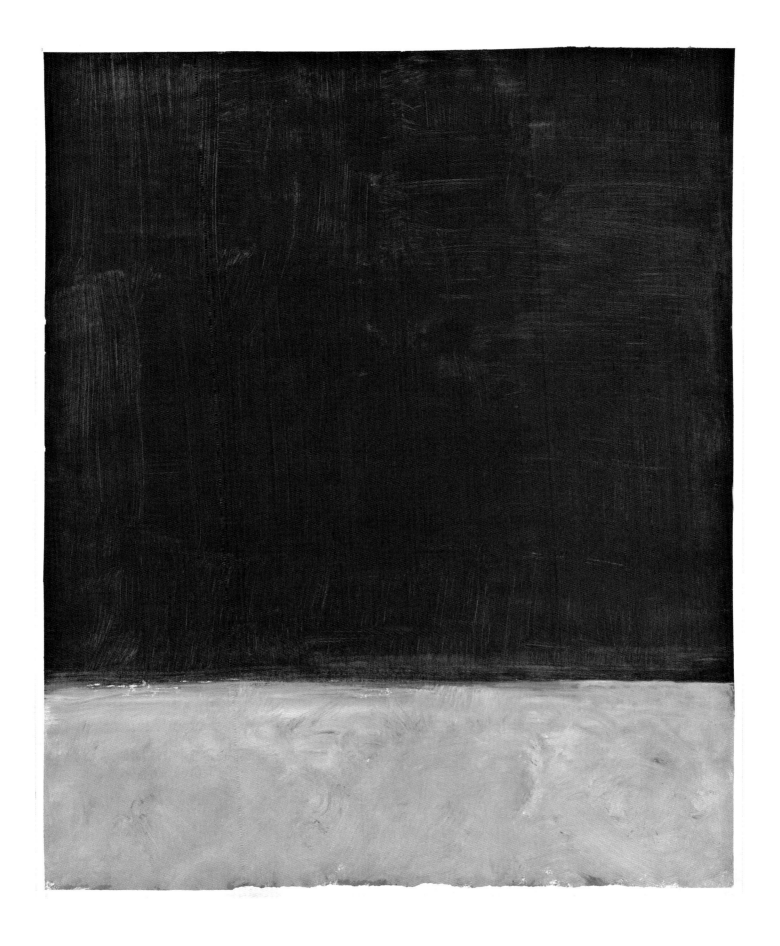

Untitled (Brown and Gray)
1969
Acrylic on paper
182.7 x 122.2
National Gallery of Art, Washington
Gift of The Mark Rothko Foundation, Inc. 1986

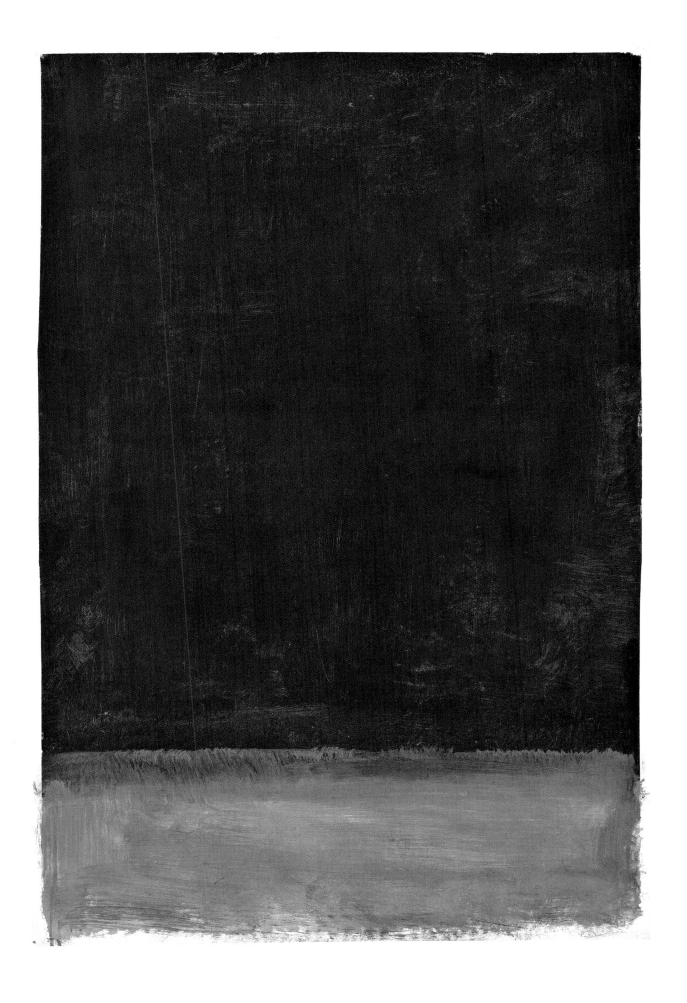

Untitled (Brown and Gray)
1969
Acrylic on paper
182.5 x 122.2
National Gallery of Art, Washington
Gift cf The Mark Rothko Foundation, Inc. 1986

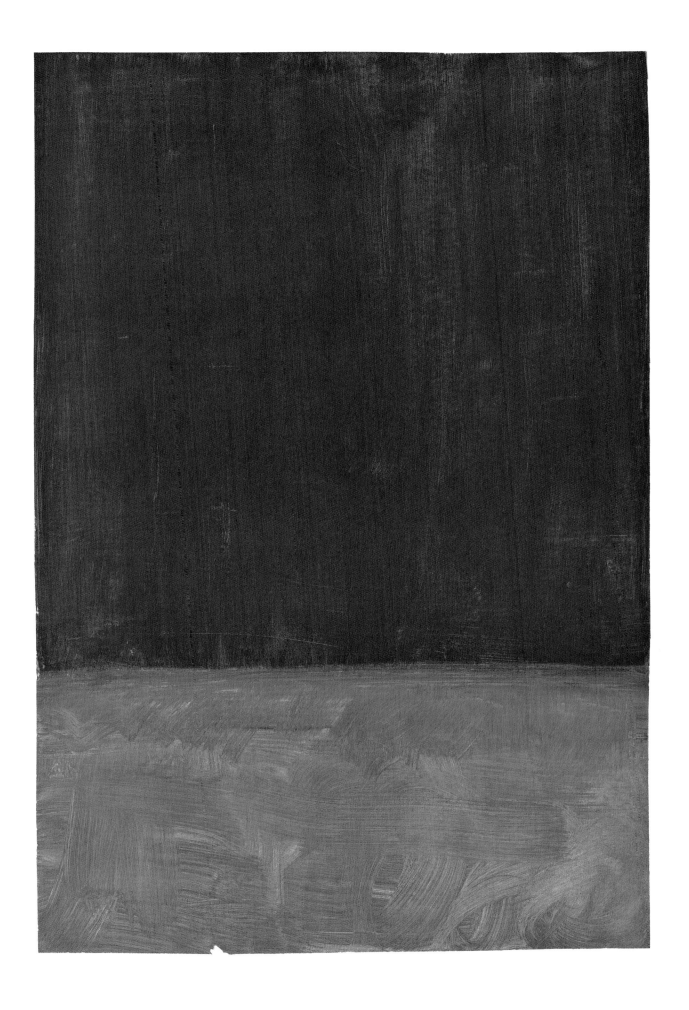

Untitled (Brown and Gray)
1969
Acrylic on paper
173 x 123.5
Tate. Presented by The Mark Rothko Foundation, Inc. 1986

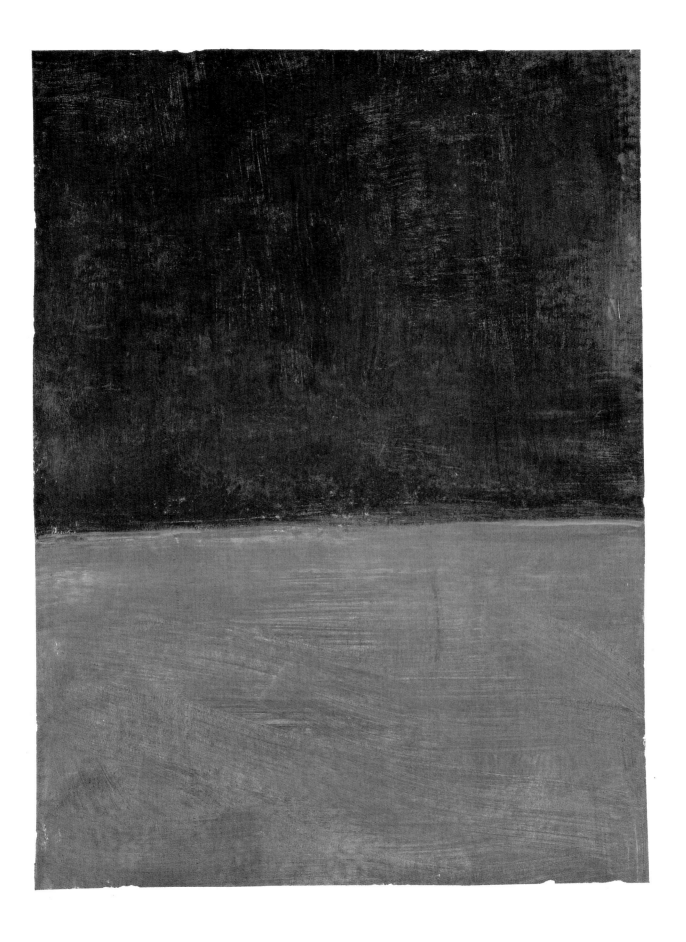

Untitled (Brown and Gray)
1969
Acrylic on paper
183.6 x 122.2
National Gallery of Art, Washington
Gift of The Mark Rothko Foundation, Inc. 1986

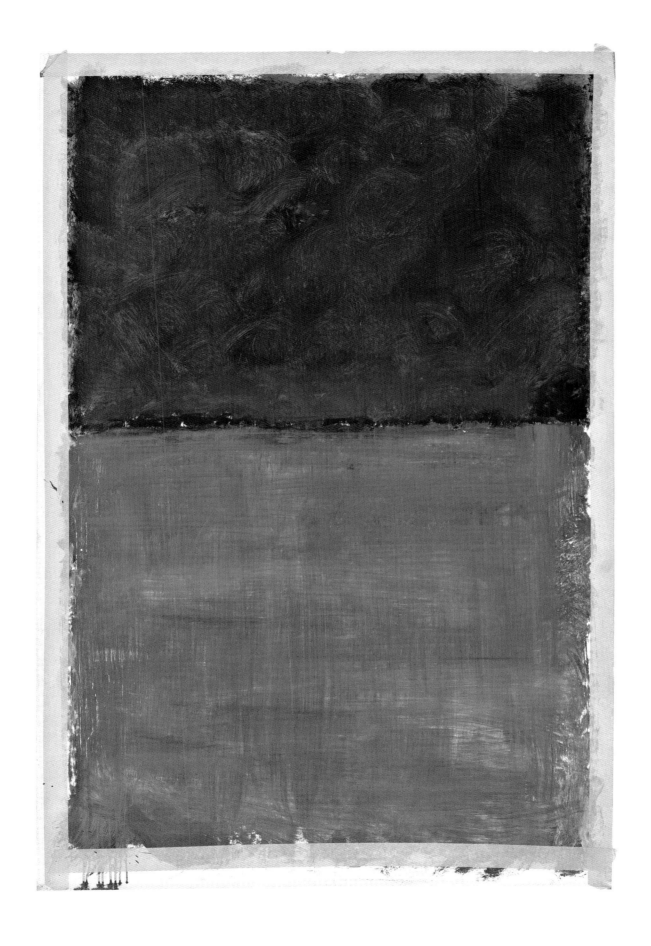

Untitled
1969
Acrylic on canvas
137.8 x 173.4
National Gallery of Art, Washington
Gift of The Mark Rothko Foundation, Inc. 1986.43.165

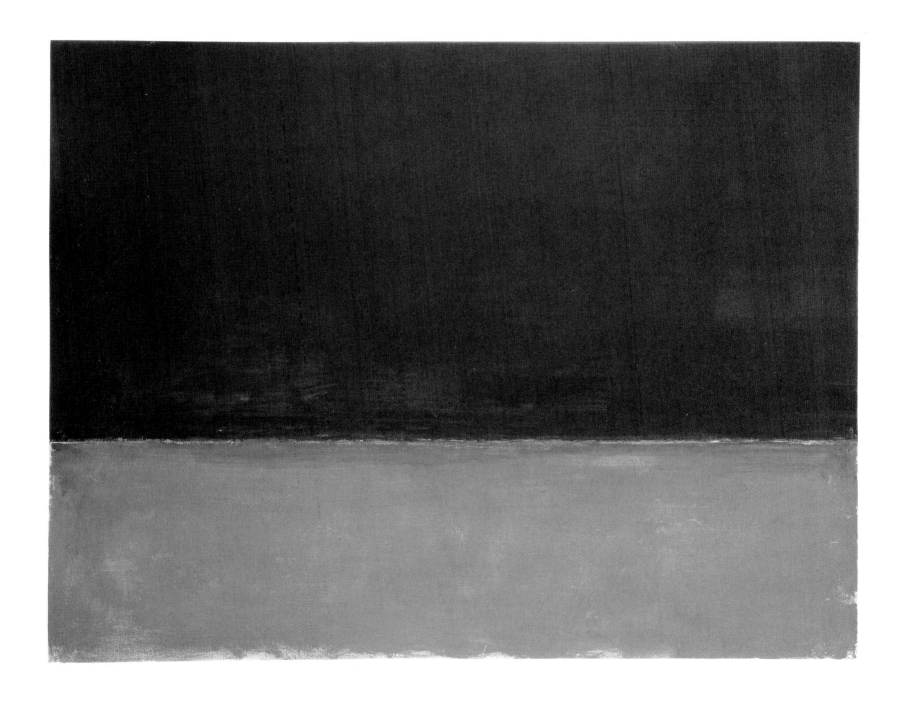

Untitled
1969
Acrylic on canvas
229.6 x 175.9
National Gallery of Art, Washington
Gift of The Mark Rothko Foundation, Inc. 1986.43.164

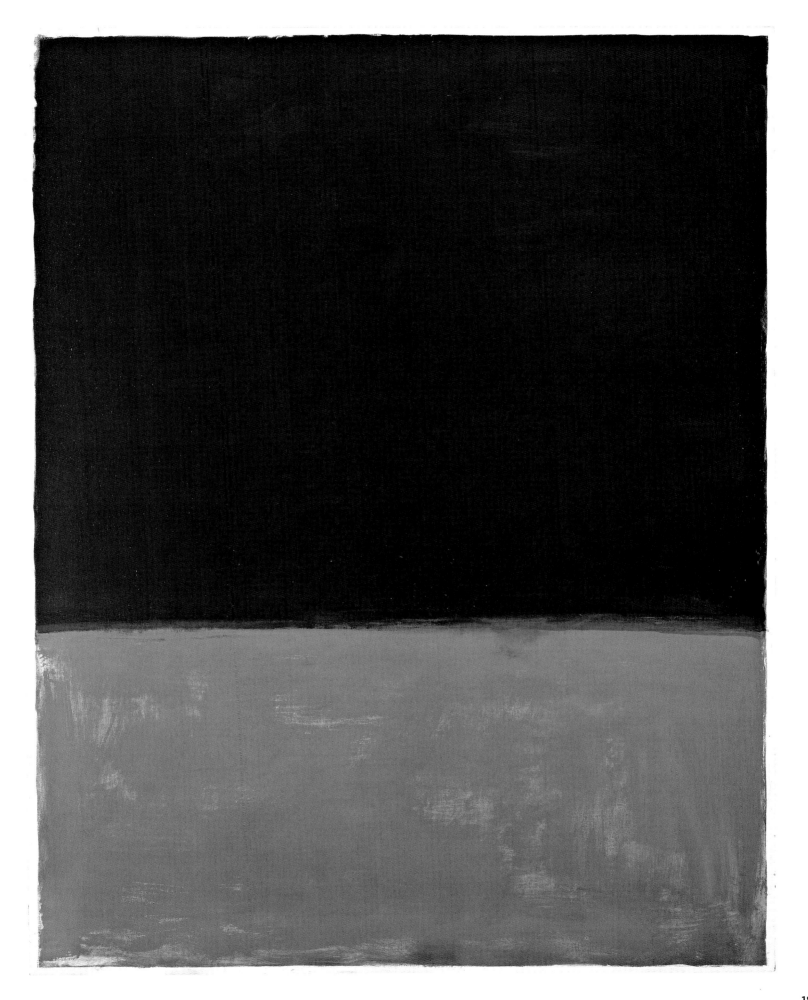

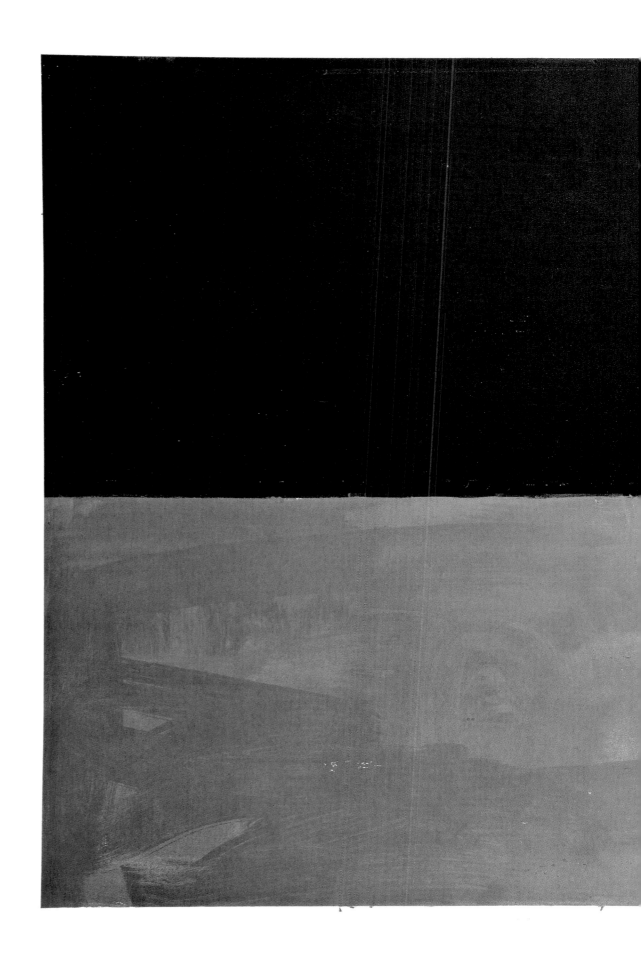

Untitled
1969
Acrylic on canvas
177.2 x 297.2
Collection of Christopher Rothko

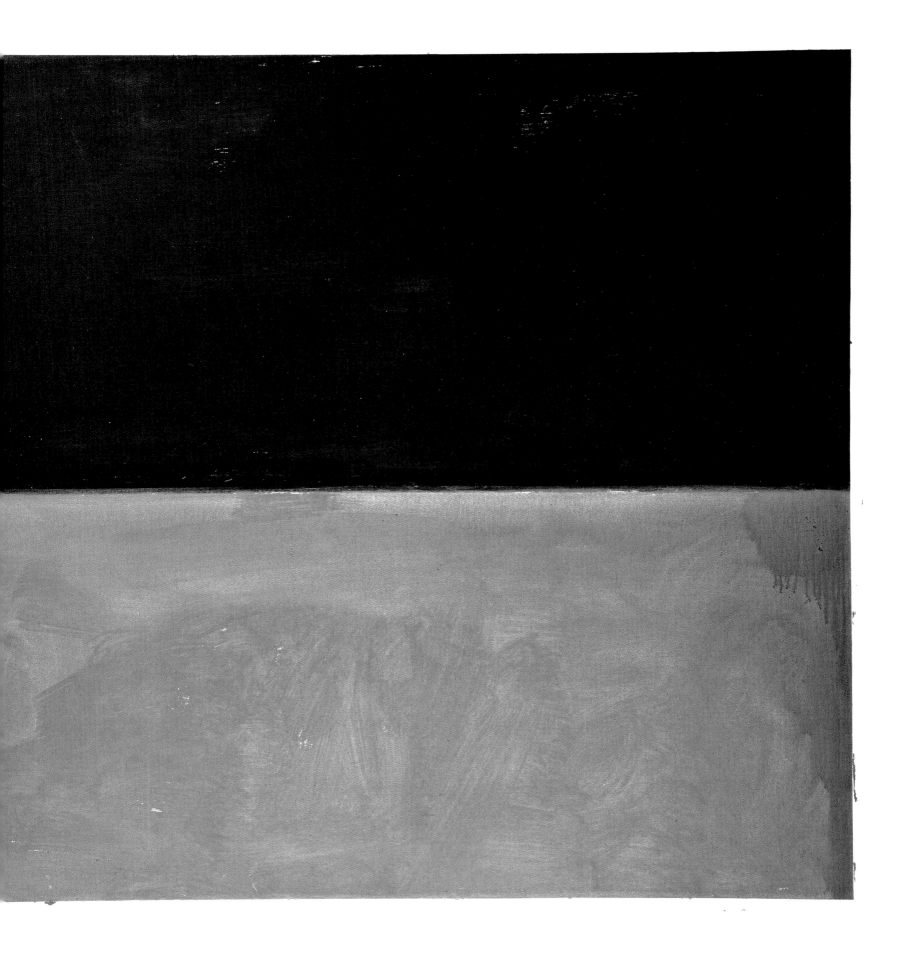

Untitled
1970
Acrylic on canvas
172.7 x 152.4
The Museum of Contemporary Art, Los Angeles
Gift of The Mark Rothko Foundation, Inc.

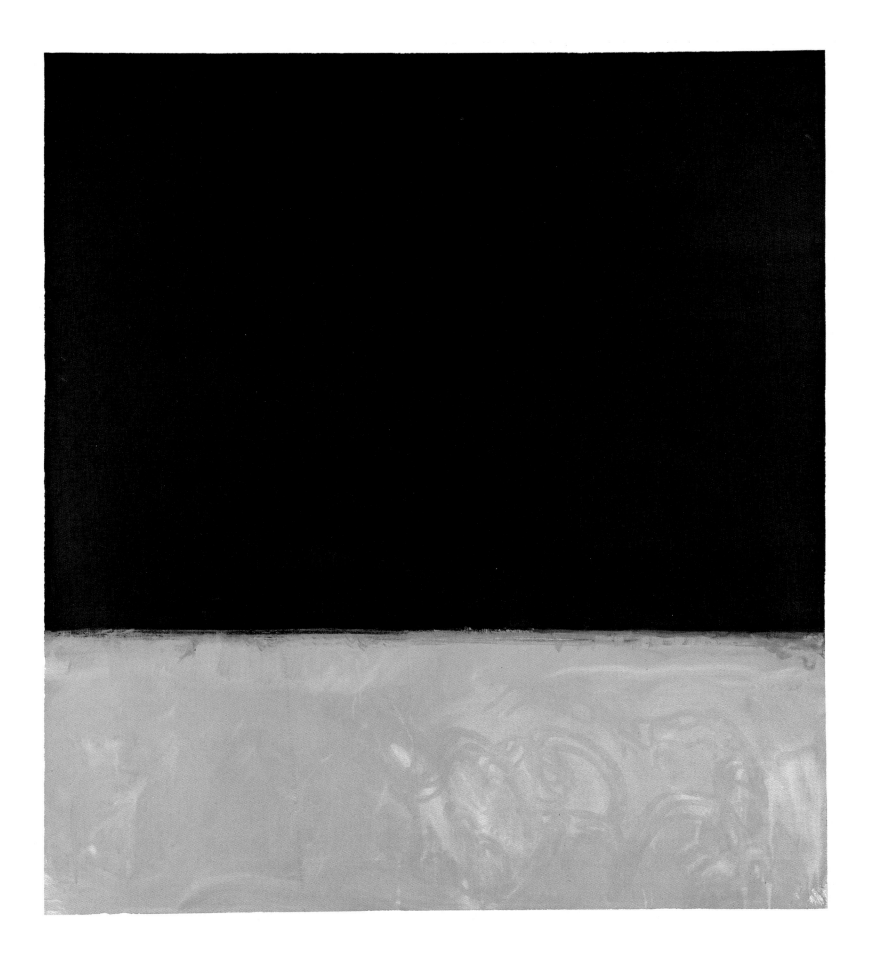

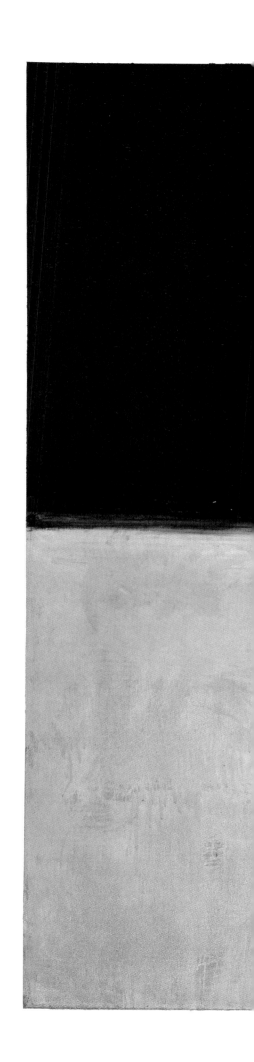

Untitled
1969
Acrylic on canvas
206.4 x 236.2
Collection of Kate Rothko Prizel

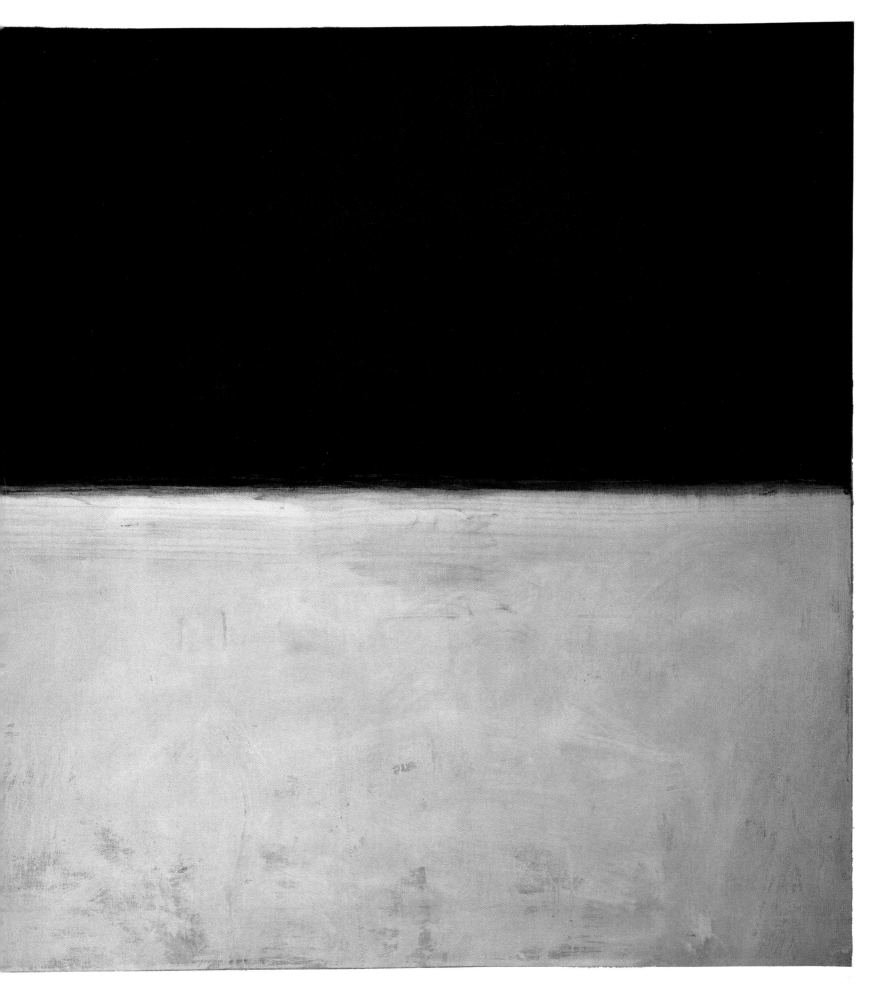

Untitled
1969
Acrylic on canvas
172.7 x 152.7
Private Collection

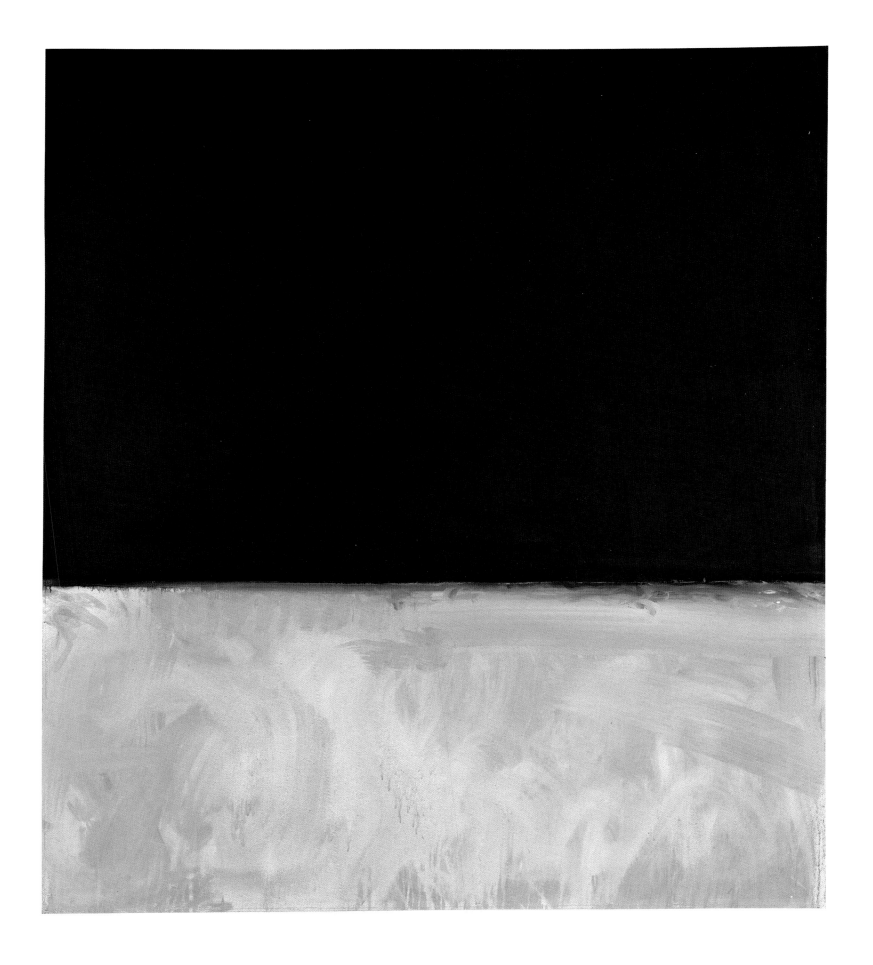

Untitled
1969
Acrylic on canvas
233.7 x 200.3
Collection of Christopher Rothko

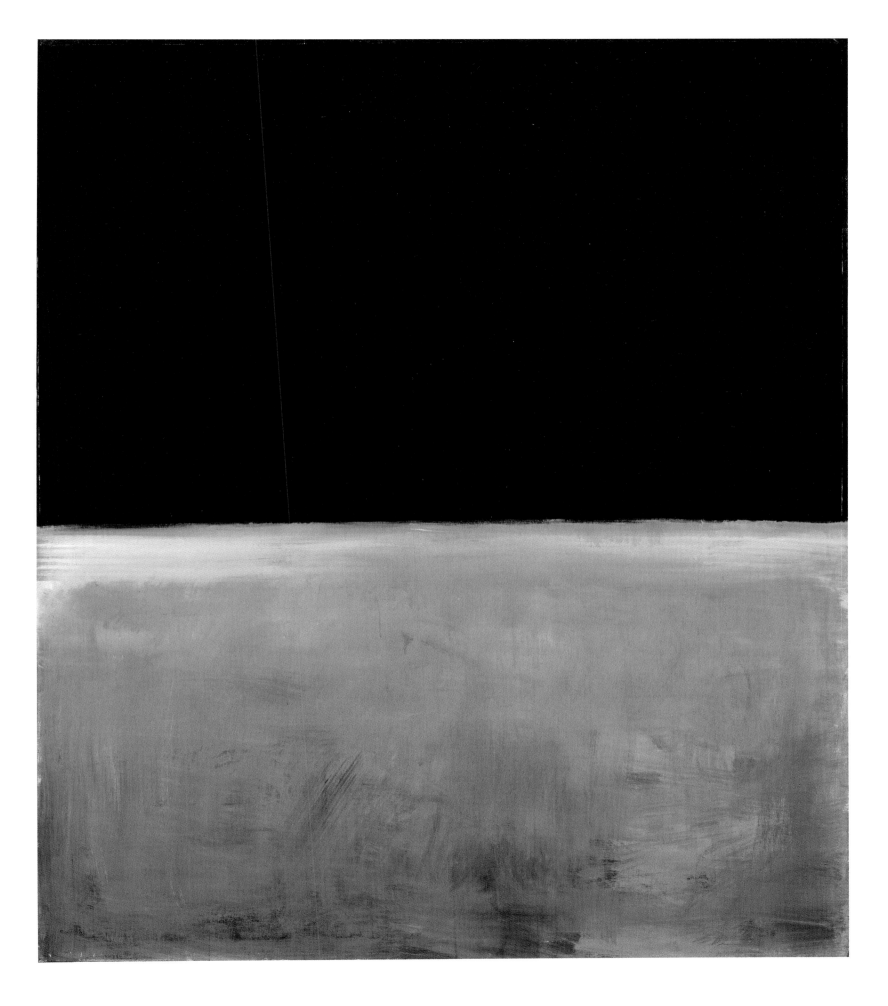

Alexander Liberman
Rothko in his studio, New York 1964

26 September 1903 Born as Marcus Rothkowitz in Dvinsk, Russia (now Daugavpils, Latvia)

1957

ART

Robert Rauschenberg, *Factum I and II*

Robert Ryman begins painting white monochrome works.

Frank Stella moves to New York.

Agnes Martin returns to New York from New Mexico.

John Cage teaches *Experimental Composition* at the New School for Social Research in New York and influences the Fluxus generation.

Leo Castelli Gallery opens on East 77th Street, New York.

Francis Bacon, *Screaming Nurse*

Henry Moore, *UNESCO Reclining Figure*

6 JANUARY—26 FEBRUARY
Paintings by Rothko, Tomlin, Okada at the Phillips Collection, Washington

10 MARCH—28 APRIL
The New York School Second Generation: Paintings by Twenty-Three Artists at the Jewish Museum, New York

ROTHKO

This year marks Rothko's move toward a darker palette, which he later acknowledges, 'I can only say that the dark pictures began in 1957 and have persisted almost compulsively to this day.'

FEBRUARY—MARCH
Rothko serves as a visiting artist at the Newcomb Art School, Tulane University, New Orleans, resulting in a small show of his work.

The Rothko family spend the summer in Provincetown, Massachusetts.

WORLD

Elvis Presley, *All Shook Up*

Jack Kerouac, *On the Road*

Samuel Beckett, *Endgame*

10 JANUARY
Harold Macmillan becomes the Prime Minister of the United Kingdom.

20 JANUARY
Dwight D. Eisenhower is inaugurated for a second term as the President of the United States.

6 MARCH
Ghana is the first sub-Saharan country to gain independence from Britain. Other colonies follow suit.

25 MARCH
The Treaty of Rome establishes the European Economic Community (ECC).

1—20 APRIL
Eight Americans at Sidney Janis Gallery, including de Kooning, Gorky, Guston, Kline, Motherwell, Pollock, Rothko and Albers

24 APRIL—16 JUNE
Hans Hofmann Retrospective at the Whitney Museum of American Art, New York

18 JUNE—1 SEPTEMBER
American Paintings, 1945—1957 at the Minneapolis Institute of Arts, including Baziotes, Gorky, Gottlieb, Guston, Hofmann, Kline, de Kooning, Motherwell, Newman, Pollock and Reinhardt

17 NOVEMBER—31 DECEMBER
Adolph Gottlieb at the Jewish Museum

5 SEPTEMBER—6 OCTOBER
Mark Rothko at the Contemporary Art Museum, Houston, Texas. Rothko disagrees with Elaine de Kooning's essay for the catalogue, which associates him with action painting.

12 APRIL
Allen Ginsberg's volume *Howl and Other Poems* is seized by United States customs officials on the grounds of obscenity.

28 JULY
The Situationist International is formed in Italy.

30 SEPTEMBER
The BBC begins broadcasting Network Three.

24 SEPTEMBER
President Eisenhower sends federal troops to Little Rock, Arkansas, to provide safe passage into Central High School for African-American students.

4 OCTOBER
The Soviet Union launches Sputnik I, the first space satellite.

20 DECEMBER
The first flight of the Boeing 707 airliner

1958

Jasper Johns, *Three Flags*

Barnett Newman, *The Stations of the Cross* (1958–66)

Morris Louis, *Blue Veil* (1958–9)

Piero Manzoni begins his Achrome paintings.

Yves Klein, *The Void*

Richard Hamilton, *$he* (1958–61)

14 JANUARY–16 MARCH
Nature in Abstraction: The Relation of Abstract Painting and Sculpture to Nature in Twentieth Century American Art at the Whitney Museum of American Art

26 FEBRUARY–22 MARCH
Lee Krasner, Recent Paintings at the Martha Jackson Gallery

1 MARCH 1958–15 JANUARY 1959
Jackson Pollock 1912–1956 organised by the International Council of the Museum of Modern Art. The exhibition tours extensively in Europe.

ROTHKO

Rothko enters into discussions with Phyllis Lambert to paint murals for The Four Seasons restaurant in the Seagram Building designed by Mies van der Rohe and Philip Johnson in New York.

Rothko moves to a new studio at 222, the Bowery, a former YMCA gymnasium.

27 JANUARY–22 FEBRUARY
New Paintings by Mark Rothko at the Sydney Janis Gallery presents Rothko's new palette of rich reds and blacks, including *Light Red over Black* (1957) and *Four Darks in Red* (1958).

18 MAY
Rothko, Motherwell, de Kooning, Guston and Kline sign an agreement with Bernard Reis for him to represent them in their dealings with the Sidney Janis Gallery.

25 JUNE
Rothko is officially commissioned to paint a mural sequence for The Four Seasons restaurant.

WORLD

Hannah Arendt, *The Human Condition*

Claude Lévi-Strauss, *Structural Anthropology*

The first stereo records are sold.

The United States ends military aid to Cuba in 1958 and on 1 January 1959 General Fulgencio Batista flees into exile.

13 JANUARY
9,235 scientists publish a plea to stop nuclear-bomb tests.

31 JANUARY
The first successful American satellite, *Explorer 1*, is launched into orbit.

1 FEBRUARY
Syria and Egypt establish the United Arab Republic.

19 APRIL 1958—8 SEPTEMBER 1959
The New American Painting, including work by Baziotes, Brooks, Francis, Gorky, Gottlieb, Guston, Hartigan, Kline, de Kooning, Motherwell, Newman, Pollock, Rothko, Stamos, Still, Tomlin and Tworkov. Opens in Basel and tours internationally before ending at the Museum of Modern Art in New York.

4—24 MAY
Barnett Newman First Retrospective at Bennington College

14 JUNE—19 OCTOBER
Rothko, along with Lipton, Smith and Tobey represent the United States at the XXIX Venice Biennale.

JULY
Rothko begins work on the Seagram murals.

Without Rothko's knowledge, Janis submits *No. 14* (1957) to the Solomon R. Guggenheim Museum's International Award competition. When the work wins the United States National Selection Award in August, Rothko refuses to lend to the exhibition and declines the $1,000 prize.

27 OCTOBER
Rothko delivers his final public lecture at the Pratt Institute, New York, in which he disassociates himself from Abstract Expressionism.

14 JULY
The Iraqi monarchy is overthrown by Arab nationalists, King Faisal II is murdered and Abdul Karim Qassim assumes power.

29 JULY
National Aeronautics and Space Administration (NASA) is established in the United States.

8—9 SEPTEMBER
Major race riots in Notting Hill, London

30 SEPTEMBER
USSR resumes nuclear testing.

4 OCTOBER
First transatlantic jet travels between New York and London.

21 DECEMBER
General Charles de Gaulle is elected President of France.

1959

ART

Allan Kaprow, Red Grooms, Robert Whitman, Claes Oldenburg, George Brecht and Jim Dine organise *18 Happenings in 6 Parts*.

Nam June Paik, *Hommage à Cage*

Frank Stella, *Die Fahne Hoch!*

David Smith begins *Cubi* series.

16 JANUARY–8 FEBRUARY
New York and Paris: Painting in the Fifties at the Museum of Fine Arts, Houston

11 MARCH–5 APRIL
Barnett Newman: A Selection 1946–1952, French and Co.

24 APRIL–23 MAY
Robert Motherwell Retrospective at Bennington College

23 APRIL–31 MAY
The Romantic Agony: From Goya to de Kooning at the Contemporary Arts Museum, Houston

28 MAY–8 SEPTEMBER
The New American Painting exhibition at the Museum of Modern Art, showing works by seventeen painters, including Rothko.

ROTHKO

Art-historian and curator Werner Haftmann visits Rothko in the spring to propose that he participates in the second *documenta* exhibition in Kassel, Germany. Rothko has reservations about taking part because he feels that his work has no place in survey exhibitions and, as a Jew, he feels uneasy about exhibiting in Germany.

However, he suggests to Haftmann the idea of a new body of work to be shown in a separate temporary structure that could act as a memorial to the victims of the Holocaust. This project does not come to fruition though three paintings by Rothko are included in *documenta 2*.

16 MAY
Rothko legally changes his name from Marcus Rothkowitz to Mark Rothko in the process of obtaining a passport for his trip to Europe.

WORLD

The first known human with The first known human with HIV dies in Congo.

IBM builds the first commercial transistorised computer.

United Nations General Assembly passes a resolution condemning racism.

2 JANUARY
Fidel Castro takes power in Cuba, backed by Soviet military aid.

3 JANUARY
Alaska becomes the 49th State of the United States.

23 FEBRUARY
The first meeting of the European Court of Human Rights at Strasbourg.

9 MARCH
The Barbie doll debuts.

11 JULY—11 OCTOBER
documenta 2, Kassel, curated by Arnold Bode and Werner Haftmann, including three works by Rothko

25 JULY—5 SEPTEMBER
American National Exhibition, Moscow, co-ordinated by the United States Information Agency to implement the cultural exchange agreement signed by the United States and the Soviet Union in 1958. Includes Motherwell, Pollock, de Kooning, Gorky, Guston, Hopper and Rothko

25 SEPTEMBER—25 OCTOBER
Recent American Painting from the Collections of the Museum of Modern Art and Institute of History and Art, Albany

21 OCTOBER
The Solomon R. Guggenheim Museum, designed by Frank Lloyd Wright, opens in New York.

5 NOVEMBER—13 DECEMBER
Clyfford Still Retrospective at the Albright Art Gallery, Buffalo

15 JUNE
Rothko sails to Naples with his wife Mell and daughter Kate. He sees the wall of paintings in the Villa of Mysteries in Pompeii and feels a deep affinity with his own works. They also visit Peggy Guggenheim in Venice and Tarquinia to see the Etruscan murals. While in Florence, Michelangelo's Laurentian Library and Fra Angelico's murals in the convent of San Marco make a great impact on him.

15 JULY
The Rothkos travel to Paris, then to Brussels, Antwerp and Amsterdam. Finally, they visit England, where Rothko considers purchasing a chapel in St Ives to convert into a private museum. The family leaves for home on 20 August.

Upon their return, Rothko and his wife have dinner at The Four Seasons, an experience that further feeds Rothko's doubts about the appropriateness of the setting for his murals.

17 MARCH
Dalai Lama flees Tibet and sets up the Government of Tibet in exile in Dharamsala, India.

9 APRIL
Frank Lloyd Wright dies.

17 JULY
The first skull of *Australopithecus* is discovered by the Leakeys in the Olduvai Gorge, Tanzania.

21 AUGUST
Hawaii becomes the 50th State of the United States.

22 SEPTEMBER
The United Nations declines admission to the People's Republic of China.

1 DECEMBER
The Antarctic Treaty is signed, setting aside Antarctica as a scientific preserve and banning military activity.

1960

Ad Reinhardt starts making black paintings.

Kenneth Noland, *Bloom*

Jasper Johns, *Painting with Two Balls*

Yves Klein, *The Painter of Space Hurls Himself into The Void* and *Anthropométries*

Lucio Fontana, *Concetto Spaziale*

Arman, *Full Up*

Jean Tinguely, *Homage to New York*

Marcel Duchamp, *The Green Box* (1934) is published in English.

Clement Greenberg, 'Modernist Painting'

ROTHKO

Duncan and Marjorie Phillips visit Rothko's studio to select works for *Paintings by Mark Rothko* and acquire two.

Bernard Reis becomes Rothko's financial adviser, accountant and lawyer.

John and Dominique de Menil, who will later commission a series of murals for a chapel in Houston, Texas, meet Rothko for the first time and visit his studio.

WORLD

The first laser is developed.

Michelangelo Antonioni, *L'Avventura*

Federico Fellini, *La Dolce Vita*

10 JANUARY
British Prime Minister Harold Macmillan makes his 'Wind of Change' speech.

19 JANUARY
The Treaty of Mutual Co-operation and Security is signed between the United States and Japan.

18 FEBRUARY
Seven Latin American countries establish the Latin American Free Trade Association.

6 MARCH
The United States announces that 3,500 American troops will be sent to Vietnam.

21 MARCH
The Sharpeville Massacre occurs and a State of Emergency is declared in South Africa.

3 APRIL–8 MAY
60 American Painters at the
Walker Art Center, Minneapolis

4–23 APRIL
Nine American Painters at the Sidney Janis
Gallery, including de Kooning, Gorky,
Guston, Kline, Motherwell, Pollock, Rothko,
Albers and Baziotes

17 OCTOBER–5 NOVEMBER
*Ad Reinhardt. Twenty-Five Years of
Abstract Painting* at the Betty Parsons
Gallery, New York

SPRING
Rothko withdraws from the Seagram
commission, returning the money and
retaining the murals.

4–31 MAY
Paintings by Mark Rothko at the
Phillips Collection, Washington

NOVEMBER
The Phillips Collection becomes the
first institution to install a permanent
'Rothko Room'.

18 APRIL
The Campaign for Nuclear Disarmament
rally in Trafalgar Square in London attracts
up to 100,000 supporters.

21 APRIL
Brasilia is inaugurated as Brazil's capital.

9 MAY
The United States Food and
Drug Administration approves the
birth-control pill.

6 AUGUST
In response to a United States embargo,
Cuba nationalises American and foreign-
owned property.

29 OCTOBER
Cassius Clay (later Muhammad Ali)
wins his first professional fight in
Louisville, Kentucky.

8 NOVEMBER
In a close race, John F. Kennedy is elected
over Richard M. Nixon and at forty-three
becomes the youngest president of the
United States.

1961

George Maciunas coins the term 'Fluxus'.

Allan Kaprow, *Yard*

Nam June Paik, *One for Violin Solo*

Robert Morris, *Box with the Sound of Its Own Making*

Dan Flavin makes his first light *Icons*.

Adolph Gottlieb, *Coalescence*

Piero Manzoni, *Artist's Shit*

Bridget Riley, *Movement in Squares*

ROTHKO

20 JANUARY
The Rothkos attend John F. Kennedy's inauguration in Washington and visit the installation of Rothko's work at the Phillips Collection.

18 JANUARY—12 MARCH
Mark Rothko opens at the Museum of Modern Art. The retrospective, spanning 1945—60, contains forty-eight works and the artist visits it regularly during its run. The exhibition travels to the Whitechapel Art Gallery in London, Amsterdam, Brussels, Basel, Rome and Paris.

Rothko provides detailed written instructions for the installation of his work at the Whitechapel Art Gallery and in early October sails to London to see the exhibition.

WORLD

Francis Crick and Sydney Brenner discover the structure of DNA.

17 JANUARY
President Eisenhower gives his final State of the Union Address.

4 FEBRUARY
James Meredith is denied admission to the University of Mississippi because of his race.

1 MARCH
President Kennedy establishes the Peace Corps.

MARCH
The United States sends military aid to Laos.

12 APRIL
Yuri Gagarin, a Soviet cosmonaut, becomes the first human in space.

17 APRIL
The Bay of Pigs Invasion of Cuba begins, but fails by 19 April. .

Clyfford Still moves to rural Maryland, severing ties with New York artists, who he believes to be corrupt, including Rothko.

8 MAY–3 JUNE
Ten American Painters at the Sidney Janis Gallery, including de Kooning, Gorky, Guston, Kline, Motherwell, Pollock, Rothko, Albers, Baziotes and Gottlieb

13 OCTOBER–31 DECEMBER
American Abstract Expressionists and Imagists at the Solomon R. Guggenheim Museum

DECEMBER
Claes Oldenburg opens *The Store*.

Rothko accepts a new commission for a series of murals for The Holyoke Center designed by Josep Lluís Sert at Harvard University, Cambridge, Massachusetts.

5 MAY
Alan Shepard becomes the first American in space.

13 AUGUST
Construction of the Berlin Wall begins, restricting movement between East Berlin and West Berlin.

30 OCTOBER
The Soviet Union detonates a 58-megaton hydrogen bomb, the largest ever man-made explosion, over Novaya Zemlya.

18 NOVEMBER
President Kennedy sends 18,000 troops to South Vietnam.

2 DECEMBER
In a broadcast speech, Cuban leader Fidel Castro declares that Cuba will adopt Communism.

11 DECEMBER
The Vietnam War officially begins.

1962

ART

Andy Warhol begins *Campbell's Soup Can* and *Marilyn* silkscreens.

Tony Smith, *Die*

Philip Leider and John Coplans co-found *Artforum* magazine.

Yayoi Kusama begins *Accumulations* series.

Anthony Caro, *Early One Morning*

Georg Baselitz, *The Great Piss-Up* (1962–3)

Herman Nitsch, Otto Mühl and Adolf Frohner, *The Blood Organ*, the founding event of Viennese Actionism

ROTHKO

By March, Rothko has relocated to a new studio at 1485 First Avenue and begins painting the murals commissioned for Harvard University.

Rothko's brother Albert is diagnosed with colon cancer. Rothko brings him to New York to be treated and sells paintings to pay for the medical bills.

In the late spring, Rothko suffers from health problems, including shingles, bronchitis and gout.

WORLD

Alfred Hitchcock, *The Birds*

Orson Welles, *The Trial*

7 FEBRUARY
The United States imposes an embargo against Cuba.

5 AUGUST
Marilyn Monroe dies.

7 MAY–2 JUNE
Ten American Painters at the Sidney Janis Gallery, including de Kooning, Gorky, Guston, Kline, Motherwell, Pollock, Rothko, Albers, Baziotes and Gottlieb

31 OCTOBER–1 DECEMBER
New Realists at Janis Gallery, including Oldenburg, Segal, Lichtenstein and Warhol

MAY
Rothko and his wife attend a state dinner for the arts at the White House.

24 OCTOBER
Rothko meets with the President of Harvard University to discuss the mural commission and shortly thereafter, the Board of Trustees accepts it.

Rothko, Gottlieb, Guston and Motherwell resign from the Janis Gallery in protest over *The New Realism*, an exhibition of Pop Art.

9 SEPTEMBER
Che Guevara returns from the Soviet Union declaring the supremacy of its political system.

10 SEPTEMBER
The United States Supreme Court upholds James Meredith's right to admission at the University of Mississippi.

OCTOBER
Johnny Carson takes over *The Tonight Show*.

22 OCTOBER
Soviet missiles are discovered in Cuba and President Kennedy demands their removal. Nikita Khrushchev agrees ending the Cuban Missile Crisis.

DECEMBER
11,000 United States troops and personnel in South Vietnam

1963

Andy Warhol moves to East 47th St. a.k.a. The Factory.

Claes Oldenburg, *Bedroom Ensemble*

Alex Katz, *Red Smile*

James Dine, *A Color Chart*

Hans Haacke, *Condensation Cube* (1963–5)

Ed Ruscha, *Twentysix Gasoline Stations*

Dan Flavin, *Diagonal of May 25, 1963*

Robert Morris, *Statement of Aesthetic Withdrawal*

Richard Artschwager, *Chair*

Joseph Beuys, *Filter Fat Corner*

9 APRIL–2 JUNE
Five Mural Panels Executed for Harvard University by Mark Rothko at the Solomon R. Guggenheim Museum

Rothko joins Marlborough Fine Arts Gallery, New York and London.

31 AUGUST
Rothko's second child, Christopher Hall Rothko is born.

Luciano Pavarotti debuts in London.

Sylvia Plath, *The Bell Jar*

Jean-Luc Godard *Le Mépris*

21 MARCH
Alcatraz Island Prison, San Francisco closes.

MARCH
Major civil rights voter-registration drive begins in Mississippi.

8 MAY
Large-scale demonstrations by Buddhists and pacifists against the South Vietnamese government.

11 JUNE
Buddhist monk Quang Duc sets fire to himself as an act of protest against Vietnamese President Ngo Dinh Diem's government.

14 MARCH–12 JUNE
Six Painters and the Object curated by Lawrence Alloway at the Solomon R. Guggenheim Museum, including Dine, Johns, Lichtenstein, Rauschenberg, Rosenquist and Warhol

7 OCTOBER–2 NOVEMBER
Eleven Abstract Expressionist Painters at the Sidney Janis Gallery, including de Kooning, Gorky, Gottlieb, Guston, Kline, Motherwell, Newman, Pollock, Rothko and Still

16–19 JUNE
Soviet cosmonaut Valentina Tereshkova becomes the first woman in space.

12 JUNE
Medgar Evers, secretary for the National Association for the Advancement of Colored People (NAACP) is murdered by a white supremacist in Mississippi.

1 JULY
The United States Postal Service introduces ZIP codes.

5 AUGUST
The United States, Soviet Union and Britain agree on the Nuclear Test Ban Treaty.

28 AUGUST
200,000 African Americans take part in a peaceful demonstration for civil rights in Washington. Martin Luther King delivers his 'I Have a Dream' speech on the steps of the Lincoln Memorial.

22 NOVEMBER
President Kennedy is assassinated. Two hours and nine minutes later Vice President Lyndon Johnson is sworn in as President.

1964

ART

Jo Baer, *Grayed-Yellow Vertical Rectangle* (1964—5)

James Rosenquist, *F-111* (1964—5)

Richard Hamilton, *Interior II*

Robert Rauschenberg, *Retroactive I*

Yoko Ono, *Cut Piece*

Carolee Schneemann, *Meat Joy*

Andy Warhol, *Thirteen Most Wanted Men*

Dan Flavin begins his 'monuments' to V. Tatlin.

Robert Rauschenberg is the first American artist to be awarded the Grand Prize for Painting at the XXXII Venice Biennale.

3 JANUARY—1 FEBRUARY
Four Environments by Four New Realists at the Sidney Janis Gallery

ROTHKO

JANUARY
Rothko travels to Harvard to supervise the installation of his murals at The Holyoke Centre.

FEBRUARY—MARCH
Rothko's first solo exhibition at Marlborough Fine Arts Gallery, London

17 APRIL
Dominique de Menil visits Rothko's studio and commissions a series of paintings for a proposed chapel at the University of St. Thomas, Houston, Texas.

WORLD

Physicists propose that atoms are comprised of quarks.

United States Surgeon General's report links smoking to lung cancer and heart disease.

Stanley Kubrick, *Doctor Strangelove or: How I Learned to Stop Worrying and Love the Bomb*

The Beatles and the Rolling Stones make their first tours of the United States.

Marshall McLuhan, *Understanding Media: The Extensions of Man*

8 JANUARY
President Johnson's State of the Union Address declares 'war on poverty'.

22 APRIL—18 OCTOBER
New York World's Fair, Flushing Meadow, Corona Park

22 APRIL—28 JUNE
*Painting and Sculpture of a Decade,
1954—1964*, at the Tate Gallery,
London, including *Rothko's No. 36
(Black Stripe)* (1958)

28 JUNE—6 OCTOBER
documenta 3, Kassel, curated by
Arnold Bode and Werner Haftmann

SEPTEMBER—OCTOBER
American Drawings at the Solomon R.
Guggenneim Museum, including Gorky,
Gottlieb, Guston, Kline, de Kooning,
Motherwell, Newman and Pollock

Rothko begins *Black-Form* paintings.

SUMMER
The Rothkos rent a cottage in
Amagansett, Long Island.

AUTUMN
Rothko moves to a new studio at 157 East
69th Street, a nineteenth-century carriage
house with a central skylight cupola.
Temporary walls of the same dimensions
as the Houston Chapel, a system of pulleys
and a parachute-like device for adjusting
light levels are installed.

2 JULY
The United States passes the landmark
Civil Rights Act protecting voting rights
and prohibiting racial, religious and
gender discrimination.

7 AUGUST
American Congress passes the Gulf of
Tonkin Resolution, which allows the
President to take all necessary measures
to repel any armed attack against United
States' forces.

1 OCTOBER
Former graduate student Jack Weinberg
is arrested at the University of California,
Berkeley, for refusing to show police
his identification card. The police car
carrying him is surrounded by up to 3,000
students for 32 hours, protesting against
the ban on political activities and
preventing the car from moving.

3 NOVEMBER
Re-election of Lyndon Johnson as the
United States President

1965

Robert Mangold, *Red Wall*

Ellsworth Kelly, *Red-Green-Blue*

Roy Lichtenstein, *Brushstroke*

Agnes Martin, *Morning*

Larry Bell, *Untitled*

Robert Morris, *Mirrored Cubes*

Donald Judd, 'Specific Objects' in *Arts Yearbook*

Michelangelo Pistoletto, *[Minus objects]* series (1965–6)

Shigeko Kubota, *Vagina Painting, 4 July 1965*

Eleanor Antin, *Blood of a Poet Box* (1965–8)

ROTHKO

15 JANUARY
Rothko receives a letter from Dominique de Menil expressing her support for the new commission.

Philip Johnson, preliminary architect of the Houston Chapel, is replaced by Howard Barnstone and Eugene Aubry.

Rothko spends the year working exclusively on the chapel paintings, which he feels will constitute his most important artistic statement.

WORLD

Allen Ginsburg coins the term 'Flower Power' at an anti-war rally.

Norman Mailer, *An American Dream*

24 JANUARY
Winston Churchill dies.

FEBRUARY
The United States start bombing North Vietnam.

21 FEBRUARY
Malcolm X is assassinated.

17 APRIL
15,000 students protest against the Vietnam War in Washington.

2 MAY
The first satellite is used for television transmission.

27 JUNE
An artists' petition with 500 signatures against the war in Vietnam is published in the *New York Times*.

23 FEBRUARY–25 APRIL
The Responsive Eye at The Museum of
Modern Art, an exhibition of Op Art

21 APRIL–30 MAY
*Three American Painters: Kenneth Noland,
Jules Olitski, Frank Stella* at the Fogg Art
Museum, Harvard

16 JULY–1 AUGUST
*The New York School: The First Generation
Paintings of the 1940s and 1950s* at the Los
Angeles County Museum of Art

28 MARCH
Rothko receives the Brandeis University
Creative Arts Award.

14–20 JUNE
The Ochre (Ochre and Red on Red) is
included in the White House Festival
of the Arts.

OCTOBER
Norman Reid, Director of the Tate
Gallery, visits Rothko and proposes that
the Tate acquire paintings for a dedicated
Rothko Room. The artist considers giving
the museum a group of more than thirty
works from his 1961–2 retrospective,
but decides instead to donate a selection
of Seagram murals. The donation was
partly motivated by the Tate's extensive
holdings of J.M.W. Turner, whom Rothko
greatly admired.

6 AUGUST
The United States passes the
Voting Rights Act.

15 AUGUST
The Indo-Pakistani war for the possession
of the Kashmir region begins.

27 AUGUST
Le Corbusier dies.

25 SEPTEMBER
President Johnson establishes the
National Endowment for the Arts.

3 OCTOBER
Cuba inaugurates a new Communist
Party and Central Committee.
Che Guevara resigns all his official
posts and his Cuban citizenship.

27 NOVEMBER
50,000 protesters encircle the
White House to demonstrate against
the Vietnam War.

1966

Donald Judd begins to work in modular series.

On Kawara begins date painting series.

Hanne Darboven begins calendar-based *Permutations*.

Joseph Kosuth, *Art as Idea as Idea* series (1966–8)

Mel Bochner, *36 Photographs and 12 Diagram*

Eva Hesse, *Hang Up*

Dan Graham, *Homes for America* (1966–7)

Bruce Nauman, *A Cast of the Space under My Chair* (1966–8)

John McCracken, *Untitled (Red Plank)*

Carl Andre, *Lever*

Richard Long, *Turf Circle, England*

Sol LeWitt, *Serial Project No.1 (ABCD)*

John Baldessari, *...no ideas have entered this work* (1966–8)

Martha Rosler, *Body Beautiful, or Beauty Knows No Pain* series (1966–72)

Yvonne Rainer, *The Mind is a Muscle* (1966–8)

Gustav Metzger, 'Destruction in Art Symposium'

ROTHKO

23 MARCH–19 JUNE
Rothko visits *Turner: Imagination and Reality* at the Museum of Modern Art and is greatly affected.

JUNE–AUGUST
The Rothko family travel to Europe. In Rome, they spend time with art-historian Peter Selz, curator of Rothko's 1961 retrospective at the Museum of Modern Art. They continue to tour Europe before travelling to London, where Rothko visits the Tate Gallery. The Rothkos sail back to New York on 11 August.

Rothko continues to work on the Chapel paintings.

WORLD

Theodor Adorno, *Negative Dialectics*

Jacques Lacan, *Ecrits*

Michel Foucault, *The Order of Things*

The new Metropolitan Opera House opens in Lincoln Center, New York.

13 JANUARY
Robert Weaver is appointed Head of the Department of Housing and Urban Development, becoming the first African-American to serve in the United States Cabinet.

31 JANUARY
The United States resumes bombing of North Vietnam after a thirty-seven-day pause.

3 FEBRUARY
Soviet space craft Lunar 9 makes the first soft landing on the moon.

13 JUNE
The Supreme Court establishes the Miranda Rule, which requires all suspects to be advised of their rights, including the right to remain silent.

Artists' Protest Committee erects
Peace Tower, Los Angeles.

Allan Kaprow, *Assemblage,
Environments & Happenings*

27 APRIL–12 JUNE
Primary Structures at the Jewish Museum,
New York, an exhibition of minimal art

JUNE
Robert Smithson 'Entropy and the New
Monuments' in *Artforum*

14 JUNE–31 JULY
Fifty Years of Modern Art: 1916–1966 at the
Cleveland Museum of Art, including three
paintings by Rothko

20 SEPTEMBER–8 OCTOBER
Eccentric Abstraction at the Fischbach
Gallery, New York, curated by Lucy
Lippard, including Hesse, Bourgeois and
Nauman among others

15 OCTOBER–20 AUGUST 1967
Two Decades of American Painting at the
Museum of Modern Art, including three
paintings by Rothko. The exhibition
travels to Tokyo, Kyoto, New Delhi,
Melbourne and Sydney.

JULY
Twenty-eight professional American
women establish the National Organization
for Women.

13 AUGUST
Chairman Mao Zedong launches the Great
Proletarian Cultural Revolution in China.

OCTOBER
The Black Panther Party is formed in
Oakland, California.

28 OCTOBER
Britain and France agree plans for the
Channel Tunnel.

1967

ART

Germano Celant coins the term 'Arte Povera'.

Michelangelo Pistoletto, *Venus of the Rags*

Daniel Buren develops vertical strip motif.

Bruce Nauman, *Dance or Exercise on the Perimeter of a Square* (1967–8)

Kenneth Noland, *Magnus*

Robert Bladen, *The X*

John Chamberlain, *Ultima Thule*

Robert Barry, *Red Square*

Michael Snow, *Wavelength*

Rita Donagh, *Contour*

Bridget Riley, *Late Morning*

VALIE EXPORT coins her name.

Alfred Barr, Director of Collections, retires from the Museum of Modern Art.

ROTHKO

APRIL
Rothko completes the fourteen paintings and six additional paintings for the Chapel, which are sent to Houston.

JUNE
Dominique de Menil and the chapel architects view the works, after which Rothko makes minor revisions. The eighteen paintings are then placed in storage until the chapel's completion in 1971.

Rothko accepts a one-month summer teaching position at the University of California and travels there with his family. Thereafter they visit Rothko's family in Portland, Oregon.

WORLD

Tom Stoppard, *Rosencrantz and Guildenstern Are Dead*

Guy Debord, *The Society of Spectacle*

The first pulsar star is discovered.

The minimum wage in the United States is raised to $1.40 per hour.

4 APRIL
Martin Luther King speaks at Riverside Church, New York, and makes his strongest statement to date against the Vietnam War.

15 APRIL
300,000 people attend an anti-war demonstration in New York.

21 April
Military coup in Athens establishes the regime of 'Greek Colonels'.

JUNE–AUGUST
'Summer of Love'

5–10 JUNE
The Six Day War between Israel and Arab States. 700,000 Palestinians flee to Jordan and Lebanon.

23 FEBRUARY—2 APRIL
Six Painters at the University of St. Thomas Art Department, including Mondrian, Guston, Kline, de Kooning, Pollock and Rothko

MAY
The National Endowment for the Arts *Art in Public Places* programme begins.

JUNE
Michael Fried, 'Art and Objecthood' and Sol LeWitt, 'Paragraphs on Conceptual Art' published in *Artforum*.

SUMMER
Artforum Earthworks special issue

30 AUGUST
Ad Reinhardt dies.

23—30 JULY
Major race riots in Detroit, Michigan

9 NOVEMBER
Rolling Stone magazine begins publication.

8 OCTOBER
Che Guevara is captured and executed in Higueira, Bolivia.

3 DECEMBER
First heart transplant is carried out by Dr Christiaan Barnard.

1968

Lawrence Weiner, *Statements*

Richard Serra, *Splashing*

Edward Kienholz, *The Portable War Memorial*

Tom Wesselman, *Great American Nude No.99*

Louise Bourgeois, *Fillette*

Walter de Maria, *50m³*

Dennis Oppenheim, *Annual Rings*

Sol LeWitt begins wall drawings.

N.E. Thing Co., *Portfolio of Piles*

Douglas Huebler, *Site Sculpture Project, New York Variable #1*

Art & Language is adopted as the collective name for Terry Atkinson, David Bainbridge, Michael Baldwin and Harold Hurrell.

Marcel Broodthaers begins his museum-based installations (1968–72).

ROTHKO

20 APRIL
Rothko suffers an aortic aneurysm caused by hypertension and is admitted to New York Hospital. He is unable to undergo surgery because of multiple health problems and stays in the hospital for three weeks. After being discharged on 8 May, he is confined to bed for another three weeks. His doctors recommend that he paint nothing over forty inches in height.

28 MAY
Rothko is inducted into the United States National Institute of Arts and Letters.

JULY
The Rothkos move to 621 Commercial Street in Provincetown near the Motherwells. Rothko paints a number of small works on paper, expressing a desire to create works like his watercolours of the 1940s.

Rothko writes to Norman Reid expressing his continued interest in donating works to the Tate Gallery.

Rothko begins holding a weekly Salon with younger artists, but feels frustrated with their responses to his work and he abandons the practice.

WORLD

Intel company is founded in California.

The first oil supertanker goes into service.

911 telephone emergency service is implemented for the first time in the United States.

500,000 American troops in Vietnam

Michel Foucault, *The Archaeology of Knowledge*

Stanley Kubrick, *2001, A Space Odyssey*

30 JANUARY
The beginning of the Tet Offensive in South Vietnam.

4 APRIL
Martin Luther King is assassinated, followed by demonstrations and riots in over 100 cities in the United States.

26 APRIL
Up to a million college and high-school students take part in a national student strike in the United States.

MAY
Violent clashes between students and the police begin in the Latin Quarter of Paris.

6 JUNE
Senator Robert Kennedy is assassinated.

JULY
The National Advisory Commission on Civil Disorders is created to investigate the causes of earlier race riots.

VALIE EXPORT, *Pat and Paw Cinema*

Seth Siegelaub curates *The Xerox Book*

Gregory Battcock publishes
Minimal Art: A Critical Anthology.

FEBRUARY
Lucy Lippard and John Chandler
publish 'The Dematerialization of Art'
in Art International.

MAY
Christo and Jeanne-Claude wrap
the Museum of Modern Art.

27 JUNE—6 OCTOBER
documenta 4, Kassel, curated by
Jean Leering and Arnold Bode

2 OCTOBER
Marcel Duchamp dies.

13 SEPTEMBER
Rothko draws up a new will with the
assistance of his accountant Bernard Reis
that divides his estate between his family
and The Mark Rothko Foundation.

AUTUMN
Rothko begins his *Brown and Gray*
works on paper.

LATE NOVEMBER
With the help of studio assistants,
Rothko begins an inventory of the more
than 800 works still in his possession.

21 AUGUST
Soviet Union troops invade
Czechoslovakia.

25—28 AUGUST
Riots at the Democratic National
Convention in Chicago

7 SEPTEMBER
New York-based group Radical Women
protest against the Miss America Pageant
in Atlantic City.

3 OCTOBER
Ten days before the Olympics in Mexico
City, students protesting against the
government are surrounded and fired at
by the army. More than 250 are killed and
approximately 1,000 wounded.

5 NOVEMBER
Richard Nixon is elected President and
appoints Henry Kissinger as National
Security Advisor.

1969

Lynda Benglis, *Odalisque (Hey, Hey Frankenthaler)*

Joan Jonas, *Mirror Piece I*

Robert Morris, *Continuous Project Altered Daily*

Richard Serra, *One Ton Prop (House of Cards)*

Joseph Beuys, *The Pack*

Barry Flanagan, *June 2, 1969*

Robert Smithson, *Asphalt Rundown*

Michael Heizer, *Double Negative* (1969–70)

John Baldessari, *Cremation Piece*

Joseph Kosuth, *'Art After Philosophy'*

Dan Graham, *Two Correlated Rotations*

Robert Barry, *Inert Gas Series*

Keith Arnatt, *Self-Burial*

Gilbert & George, *Our New Sculpture*

ROTHKO

1 JANUARY
Rothko leaves his wife Mell and moves into the studio on 69th Street in New York.

FEBRUARY
Rothko sells twenty-six more canvases and sixty-one works on paper to the Marlborough Gallery and signs an exclusive deal for the next eight years.

Rothko has a relationship with Rita Reinhardt, widow of artist Ad Reinhardt.

Rothko considers a commission for the UNESCO headquarters in Paris, where his paintings would hang alongside sculptures by Giacometti.

SPRING
Rothko begins painting the *Black on Gray* series.

9 JUNE
Rothko is awarded an Honorary Doctorate from Yale University.

12 JUNE
The Mark Rothko Foundation is incorporated, but its purpose is not made explicit. The directors are Rothko, Morton Feldman, Robert Goldwater, Morton Levine, Bernard Reis, Theodoros Stamos and Clinton Wilder.

WORLD

Arpanet, precursor to the internet, is developed by the United States Department of Defense.

The artificial human heart is developed.

81 million Americans own a television.

American forces suffer 10,000 casualties in Vietnam, the largest annual death toll to date.

16 JANUARY
Czech student Jan Palach publicly burns himself to death in Prague to protest against Soviet occupation and the suppression of freedom of speech.

9 FEBRUARY
First flight of the Boeing 747 jumbo jet.

1 APRIL
The activist phase of the Cultural Revolution in China subsides.

28 JUNE
The Stonewall Riots begin in Greenwich Village, a key moment in the history of the gay rights movement.

Jannis Kounellis, *Untitled [12 Horses]*

Georg Baselitz starts
upside-down paintings.

Cildo Meireles begins his *Insertions
into Ideological Circuits*.

Art Workers' Coalition (AWC) is formed.

Harold Szeeman curates *Live in Your Head:
When Attitudes Become Form. Works-
Concepts-Processes-Situations-Information*
at the Kunsthalle Bern and Institute of
Contemporary Arts, London.

Avalanche art magazine is formed.

APRIL
Robert Morris, 'Notes on Sculpture Part 4:
Beyond Objects' is published in *Artforum*.

18 OCTOBER 1969—1 FEBRUARY 1970
*New York Painting and Sculpture 1940—
1970* at The Metropolitan Museum of Art,
New York

30 SEPTEMBER
Rothko is diagnosed with
bilateral emphysema.

Rothko teaches several classes at Hunter
College, near his studio in New York.

EARLY NOVEMBER
Norman Reid visits Rothko to discuss the
installation of the proposed Rothko
Room at the Tate Gallery. Rothko donates
eight Seagram paintings to Tate in addition
to the mural donated in 1968.

DECEMBER
Rothko opens his studio to select members
of the New York art world to present his
new dark paintings for the first time.

JULY
President Nixon announces the first troop
withdrawals from Vietnam, but heavy
fighting persists throughout the summer.

20 JULY
While Michael Collins orbits the Moon, Neil
Armstrong and Edwin "Buzz" Aldrin
perform the first manned landing on the
lunar surface.

21—24 AUGUST
The Woodstock Festival takes place in
White Lake, New York.

3 SEPTEMBER
Ho Chi Minh, President of
North Vietnam dies.

3 SEPTEMBER
Life Magazine covers the atrocities
committed by United States troops in
the Vietnamese village of Song My.

15 OCTOBER
15 million people demonstrate against the
Vietnam War across the United States.

1970

ART

Michael Asher, *Pomona College Project*

Robert Smithson, *Spiral Jetty*

Hans Haacke, *MOMA-Poll*

Vito Acconci, *Step Piece*

Bas Jan Ader, *I'm Too Sad to Tell You*

Dan Graham, *Roll*

Joseph Beuys, *Felt Suit*

Giuseppe Penone, *Tree*

Adrian Piper, *Catalysis series*

Rebecca Horn, *Unicorn* (1970–2)

Bernd and Hilla Becher *Anonymous Sculptures: A Typology of Technical Construction*

Lucy Lippard forms the Ad Hoc Women Artists Committee to protest against the lack of female artists in the Whitney's Annual exhibition.

ROTHKO

25 FEBRUARY
Rothko commits suicide in the early morning in his studio. The Seagram paintings arrive in London the same day Rothko's death is announced.

28 FEBRUARY
Rothko is buried in a cemetery on the North Fork of Long Island.

26 MARCH–31 MAY
Mark Rothko at the Museum of Modern Art

WORLD

IBM develops the first floppy disc.

Germaine Greer, *The Female Eunuch*

TS Kuhn, *The Structure of Scientific Revolution*

JANUARY
President Nixon signs the National Environmental Policy Act.

18 FEBRUARY
A United States jury finds seven members of the Chicago 8 not guilty of conspiracy. Five are charged with intent to incite a riot.

10 APRIL
Paul McCartney announces that he is leaving the Beatles.

30 APRIL
American and South Vietnamese forces invade Cambodia.

9 APRIL—31 MAY
Robert Morris at the Whitney Museum of American Art. Morris closes the exhibition early to protest against the Vietnam War.

18 MAY
1,000 New York artists, dealers, museum officials, and other members of the art community meet at New York University, and agree to strike against war, repression, and racism.

22 MAY
The Whitney, the Jewish Museum, and a number of galleries close in sympathy with the New York Art Strike, while the Museum of Modern Art and the Solomon R. Guggenheim suspend their admission charges.

29 MAY
Eva Hesse dies at age thirty-four.

2 JULY—20 SEPTEMBER
Information at the Museum of Modern Art

28 MAY
The Rothko Room officially opens at the Tate Gallery.

26 AUGUST
Rothko's wife Mell dies at age forty-eight.

21 JUNE—15 OCTOBER
The Marlborough Gallery organises a memorial exhibition at the Museo d'Arte Moderna Ca' Pesaro, Venice, in conjunction with the XXXV Venice Biennale.

4 MAY
The United States National Guard shoot dead four anti-war demonstrators at Kent State University, Ohio.

24 OCTOBER
Salvador Allende is elected President of Chile.

9 NOVEMBER
Charles de Gaulle dies.

DECEMBER
The United States Supreme Court rules eighteen the minimum voting age.

Military coups in Somalia, Cambodia and Sudan.

The first tower of the World Trade Center is completed, becoming the world's tallest building.

Hans Namuth
Rothko in his 69th street studio, New York 1966

LIST OF EXHIBITED WORKS

Titles of works follow the principal titles listed by David Anfam, *Mark Rothko: The Works on Canvas*, catalogue raisonné, New Haven and London 1998 privileging the titles used by Rothko during his lifetime. In the case of the Seagram murals, these are listed as *Untitled* unless they carry a title specifically designated by Rothko for his 1961 retrospective or at a later stage such as in the deed of gift for the Tate murals. For the benefit of the reader, the list of paintings references the catalogue raisonné numbers while the works on paper reference Rothko's own inventory numbers.

Measurements are given in centimetres, height before width.

Four Darks in Red 1958
Oil on canvas
259.1 x 294.6
Whitney Museum of American Art, New York
Purchase, with funds from the Friends of the
Whitney Museum of American Art, Mr. and Mrs.
Eugene M. Schwartz, Mrs. Samuel A. Seaver
and Charles Simon
Anfam 611

Untitled 1958–9
Coloured crayons with graphite and touches
of pastel on red construction paper
9.9 x 45.8
National Gallery of Art, Washington
Gift of The Mark Rothko Foundation, Inc. 1986

Untitled 1958–9
Coloured crayons and traces of pastel
on red construction paper
10.6 x 45.7
National Gallery of Art, Washington
Gift of The Mark Rothko Foundation, Inc. 1986

Untitled 1958–9
Gouache on red construction paper
11.9 x 51
National Gallery of Art, Washington
Gift of The Mark Rothko Foundation, Inc. 1986

Untitled 1958–9
Gouache and watercolour on wove paper
10.7 x 42.9
National Gallery of Art, Washington
Gift of The Mark Rothko Foundation, Inc. 1986

Untitled 1958–9
Gouache and watercolour on red
construction paper
12.1 x 51.1
National Gallery of Art, Washington
Gift of The Mark Rothko Foundation, Inc. 1986

Sketch for "Mural No. 1" 1958
Mixed media on canvas
266.7 x 304.8
Kawamura Memorial Museum of Art, Sakura
Anfam 639

Sketch for "Mural No. 4" 1958
Mixed media on canvas
265.8 x 379.4
Kawamura Memorial Museum of Art, Sakura
Anfam 641

Untitled 1958
Mixed media on canvas
264.8 x 252.1
Kawamura Memorial Museum of Art, Sakura
Anfam 635

Black on Maroon 1958
Mixed media on canvas
228.6 x 207
Tate. Presented by the artist through the
American Federation of Arts 1969
Anfam 636

Black on Maroon
Sketch for "Mural No. 6" 1958
Mixed media on canvas
266.7 x 381.2
Tate. Presented by the artist through the American
Federation of Arts 1968
Anfam 642

Black on Maroon 1958
Mixed media on canvas
266.7 x 241.3
Tate. Presented by the artist through the
American Federation of Arts 1969
Anfam 644

Black on Maroon 1959
Mixed media on canvas
266.7 x 228.6
Tate Presented by the artist through the
American Federation of Arts 1969
Anfam 647

Untitled 1959
Mixed media on canvas
266.7 x 455.9
Kawamura Memorial Museum of Art, Sakura
Anfam 659

Untitled 1959
Mixed media on canvas
266.1 x 453.8
Kawamura Memorial Museum of Art, Sakura
Anfam 656

Red on Maroon
Mural, Section 2 1959
Mixed media on canvas
266.7 x 457.2
Tate. Presented by the artist through the
American Federation of Arts 1969
Anfam 657

Black on Maroon
Mural, Section 3 1959
Mixed media on canvas
266.7 x 457.2
Tate. Presented by the artist through the
American Federation of Arts 1969
Anfam 658

Red on Maroon
Mural, Section 4 1959
Mixed media on canvas
266.7 x 238.8
Tate. Presented by the artist through the
American Federation of Arts 1969
Anfam 660

Red on Maroon
Mural, Section 5 1959
Mixed media on canvas
182.9 x 457.2
Tate. Presented by the artist through the
American Federation of Arts 1969
Anfam 661

LIST OF EXHIBITED WORKS

Red on Maroon
Mural, Section 7 1959
Mixed media on canvas
182.9 x 457.2
Tate. Presented by the artist through the
American Federation of Arts 1969
Anfam 663

Untitled
Mural for End Wall 1959
Mixed media on canvas
265.4 x 288.3
National Gallery of Art, Washington
Gift of The Mark Rothko Foundation, Inc. 1985.38.5
Anfam 652

Untitled (Study for Seagram Mural) 1958–9
Gouache on paper
63.5 x 96.5
Collection of Christopher Rothko
2116.59

Untitled (Study for Seagram Mural) 1958–9
Gouache on paper
76.2 x 56
Collection of Christopher Rothko
2108.68

Untitled (Study for Seagram Mural) 1958–9
Gouache on paper
76.2 x 56
Collection of Kate Rothko Prizel
2107.68

Untitled (Study for Seagram Mural) 1958–9
Gouache on paper
60.3 x 47.6
Collection of Kate Rothko Prizel
Unnumbered

Untitled (Study for Seagram Mural) 1958–9
Gouache on paper
63.5 x 96.5
Collection of Kate Rothko Prizel
2115.59

Maquette for installation of Seagram
murals at Tate Gallery 1969
Cardboard
19.4 x 46.1 x 50.1
Tate Archive Collection

Maquette of *Black on Maroon* 1959 (T01166) 1969
Tempera on purple construction paper
10 x 8.5
Tate Archive Collection

Blank Maquette of approximate size for
***Black on Maroon* 1958** (T01031) 1969
Purple construction paper
10 x 14.2
Tate Archive Collection

Maquette of *Black on Maroon* 1959 (T01170) 1969
Tempera on purple construction paper
9 x 7.5
Tate Archive Collection

Maquette of *Red on Maroon* 1959 (T01167) 1969
Tempera on purple construction paper
6.5 x 17
Tate Archive Collection

Maquette of *Black on Maroon* 1959 (T01169) 1969
Tempera on purple construction paper
6.5 x 17
Tate Archive Collection

Maquette of *Red on Maroon* 1959 (T01163) 1969
Tempera on purple construction paper
10 x 17
Tate Archive Collection

Maquette of Red on Maroon 1959 (T01168) 1969
Tempera on purple construction paper
10 x 17
Tate Archive Collection

Blank Maquette 1969
Purple construction paper
10 x 10.5
Tate Archive Collection

Untitled 1964
Oil on canvas
228.6 x 175.3
Collection of Kate Rothko Prizel
Anfam 765

No. 1 1964
Mixed media on canvas
266.7 x 203.2
Kunstmuseum Basel
Anfam 773

No. 5 1964
Mixed media on canvas
228.6 x 175.3
Collection of Christopher Rothko
Anfam 777

No. 6 (?) 1964
Mixed media on canvas
236.2 x 193
National Gallery of Art, Washington
Gift of The Mark Rothko Foundation, Inc.
1986.43.140
Anfam 779

No. 7 1964
Mixed media on canvas
236.4 x 193.6
National Gallery of Art, Washington
Gift of The Mark Rothko Foundation, Inc.
1986.43.134
Anfam 780

No.8 1964
Mixed media on canvas
266.7 x 203.2
National Gallery of Art, Washington
Gift of The Mark Rothko Foundation, Inc.
1986.43.139
Anfam 781

Study for side-wall triptychs 1966
Graphite pencil on black paper with
traces of red crayon
16.5 x 26.4
The Menil Collection, Houston
Gift of The Mark Rothko Foundation, Inc.

Miniature model for entrance-wall
replacement panel c.1966
Collage of gouache on black paper
mounted on gouache on board
19.4 x 8.3
The Menil Collection, Houston
Gift of The Mark Rothko Foundation, Inc.

Study for side-wall triptychs 1966
Graphite pencil on black paper
17.1 x 26.4
The Menil Collection, Houston
Gift of The Mark Rothko Foundation, Inc.

Study for side-wall triptychs 1966
Graphite pencil on black paper
22.9 x 30.5
The Menil Collection, Houston
Gift of The Mark Rothko Foundation, Inc.

Study for side-wall triptychs 1966
Graphite pencil on black paper
16.5 x 26
The Menil Collection, Houston
Gift of The Mark Rothko Foundation, Inc.

Study for side-wall triptychs 1966
Graphite pencil on black paper
16.5 x 26
The Menil Collection, Houston
Gift of The Mark Rothko Foundation, Inc.

Untitled (Brown and Gray) 1969
Acrylic on paper
182.8 x 121.9
National Gallery of Art, Washington
Gift of The Mark Rothko Foundation, Inc. 1986
2097.69

Untitled (Brown and Gray) 1969
Acrylic on paper
152.9 x 122.2
National Gallery of Art, Washington
Gift of The Mark Rothko Foundation, Inc. 1986
2076.69

Untitled (Brown and Gray) 1969
Acrylic on paper
152 x 122.2
National Gallery of Art, Washington
Gift of The Mark Rothko Foundation, Inc. 1986
2077.69

Untitled (Brown and Gray) 1969
Acrylic on paper
152.8 x 122.3
National Gallery of Art, Washington
Gift of The Mark Rothko Foundation, Inc. 1986
2085.69

Untitled (Brown and Gray) 1969
Acrylic on paper
182.7 x 122.2
National Gallery of Art, Washington
Gift of The Mark Rothko Foundation, Inc. 1986
2082.69

Untitled (Brown and Gray) 1969
Acrylic on paper
182.5 x 122.2
National Gallery of Art, Washington
Gift of The Mark Rothko Foundation, Inc. 1986
2081.69

Untitled (Brown and Gray) 1969
Acrylic on paper
173 x 123.5
Tate. Presented by the Mark Rothko
Foundation 1986
2089.69

Untitled (Brown and Gray) 1969
Acrylic on paper
183.6 x 122.2
National Gallery of Art, Washington
Gift of The Mark Rothko Foundation, Inc. 1986
2099.69

Untitled 1969
Acrylic on canvas
137.8 x 173.4
National Gallery of Art, Washington
Gift of The Mark Rothko Foundation, Inc.
1986.43.165
Anfam 823

Untitled 1969
Acrylic on canvas
229.6 x 175.9
National Gallery of Art, Washington
Gift of The Mark Rothko Foundation, Inc.
1986.43.164
Anfam 815

Untitled 1969
Acrylic on canvas
177.2 x 297.2
Collection of Christopher Rothko
Anfam 826

Untitled 1970
Acrylic on canvas
172.7 x 152.4
The Museum of Contemporary Art, Los Angeles
Gift of The Mark Rothko Foundation, Inc.
Anfam 829

Untitled 1969
Acrylic on canvas
206.4 x 236.2
Collection of Kate Rothko Prizel
Anfam 825

Untitled 1969
Acrylic on canvas
172.7 x 152.7
Private Collection
Anfam 821

Untitled 1969
Acrylic on canvas
233.7 x 200.3
Collection of Christopher Rothko
Anfam 814

STUDIO PHOTOGRAPHS

Herbert Matter
Rothko in his 222 Bowery Street Studio 1960
Silver gelatin print
27.9 x 35.5
Courtesy Staley-Wise Gallery, New York
(fig. 5)

Herbert Matter
Rothko's 222 Bowery Street Studio 1960
(with *No. 61 Rust and Blue* 1953)
Silver gelatin print
20.3 x 25.4
Courtesy Staley-Wise Gallery, New York
(not illustrated)

Herbert Matter
Rothko's 222 Bowery Street Studio 1960
(with *No. 12, Black on Dark Sienna on Purple* 1960)
Silver gelatin print
27.9 x 35.5
Courtesy Staley-Wise Gallery, New York
(not illustrated)

Herbert Matter
Rothko's 222 Bowery Street Studio 1960
(with *No. 21* 1949)
Silver gelatin print
26.6 x 34.2
Private Collection
(not illustrated)

NOTES

SHADOWS OF LIGHT:
MARK ROTHKO'S LATE SERIES
ACHIM BORCHARDT-HUME

1 T.S. Eliot, *The Complete Poems and Plays*, London and Boston, Faber and Faber 1969, pp.85

2 Ian McKeever, *In Praise of Painting*. Three Essays, ed. and intro. Michael Tucker, Brighton 2005, p.62.

3 Robert Goldwater, 'Reflections on the Rothko exhibition', *Arts 35*, March 1961, pp.42–5.

4 See, for example, Ronald Alley, *Catalogue of the Tate Gallery's Collection of Modern Art*, Tate Gallery, London 1981, pp.657–63; Michael Compton, *Mark Rothko – The Seagram Mural Project*, Tate Liverpool 1988; Thomas Kellein, *Mark Rothko – Kaaba in New York*, exh. cat., Kunstmuseum Basel 1989.

5 Dan Rice interviewed by Arne Glimcher, 22 September 1978, first published in *Mark Rothko – The 1958–59 Murals: Second Series*, exh. cat., The Pace Gallery, New York 1978. The commissioning date is confirmed by James. E. B. Breslin, *Mark Rothko. A Biography*, Chicago and London 1993, p.373.

6 It is often assumed that Rothko cancelled the project following a dinner with his wife at The Four Seasons in autumn 1959. However, Compton 1988, p.17 cites an interview with Terry Frost which suggests that Rothko formally cancelled the contract as late as April 1960. Willem de Kooning remembers meeting Rothko at the Museum of Modern Art and that the latter 'was very happy. I had never seen him so happy about his work. It was the time that he took on a commission for The Four Seasons. The reason why he was happy – he made a contract; he was very careful. He made a contract so that he could get out of it.' See Joseph Liss, 'Willem de Kooning Remembers Mark Rothko', *Art News 78*, January 1979, pp.41–4.

7 Mark Rothko, undated manuscript, Mark Rothko Family Archive.

8 See, for instance, letter from Mary Alice Rothko to Ronald Alley, quoted in Alley 1981. According to the architects, there was never any room for such a misunderstanding of the venue's function; see letters from Philip Johnson and Phyllis Lambert to Ronald Alley, 25 September 1970, 30 March 1972 and 25 April 1972, Tate Gallery Archive.

9 Dan Rice recalls that 'one day Mark told me that he was going to take Mell [his wife] to dinner there [The Four Seasons] and look the place over. I had arrived early in the studio the morning after and he came through the door like a bull, as only Rothko could, in an absolute rage. He said explosively... "Anybody who will eat that kind of food for those kind of prices will never look at a picture of mine." Rice/Glimcher 1978.

10 John Fischer, 'Portrait of the Artist as an Angry Man', *Harper's Magazine*, July 1970, pp.16–23.

11 Werner Haftmann, *Mark Rothko*, exh. cat., Kunsthaus Zürich 1971, p.IX.

12 See also Dore Ashton, *About Rothko*, Da Capo Press, New York 1996, p. 155. Rothko's concept of 'place' bears certain similarities to that of Barnett Newman, which was rooted in the kabala and the idea of 'makom': 'One thing that I am involved in about painting is that painting should give man a sense of place: that he knows he's there, so he's aware of himself.' See Barnett Newman, *Selected Writings and Interviews*, ed. John P. O'Neill, Berkeley and Los Angeles 1992, pp.257–8 and 289–90.

13 In 1952, for instance, Rothko refused to participate in the Whitney Annual because he did not want his work to be shown together with that of other artists. He also refused subsequent invitations from the museum to partake in group shows in 1954 and 1957; see Breslin 1993, p.374.

14 Mark Rothko, 'A Symposium', *Interiors*, 10 May 1951.

15 Mark Rothko, 'The Romantics Were Prompted', Possibilities, no. 1, Winter 1948, p.84.

16 'A picture lives by companionship, expanding and quickening in the eyes of the sensitive observer. It dies by the same token. It is therefore a risky and unfeeling act *to send it out into the world* [my emphasis]. How often it must be permanently impaired by the eyes of the vulgar and the cruelty of the impotent who would extend their affliction universally.' *Tiger's Eye*, No. 2, 1947, p.44.

17 James E. B. Breslin Research Archive on Mark Rothko, 1900-1994, Getty Research Institute: Jackie and Dan Rice interview transcript (C2), 21 February 1986. 2003.m.23 Box 7 F3.

18 Curiously, one of the idiosyncrasies of Janis's gallery when it first opened in 1953 was that it had been designed to the specifications of a domestic space with carpeting throughout, which made for further continuities between the studio and gallery spaces. It is also worth pointing out that the room hosting four of his canvases at the Phillips Collection, one of the displays of his work with which Rothko seemed most content, enforced a similar intimacy between the viewer and the works.

19 Fischer 1970.

20 Haftmann 1971, p.VIII.

21 A selection of Rothko's *Multiform* paintings shown at Betty Parson's Gallery in 1949 were consecutively numbered rather than titled. However, so were many other *Multiform* works from this year, and given their internal differences it is unlikely that Rothko would have conceived of them as series as discussed in the present context.

22 See also John Coplans, *Serial Imagery*, exh. cat., Pasadena Art Museum 1968.

23 Rice/Glimcher 1978.

24 Ida Kohlmeyer, 'About Rothko', *Arts Quarterly*, 4, no. 4 (October/November/December 1982), p. 59; quoted in Bonnie Clearwater, *Mark Rothko. Works on Paper*, New York 1984, p.42

25 Rothko, for instance, made Elaine de Kooning rewrite an article on his work where the implied decorativeness of his work was one of the key issues of contention; see Breslin 1993, pp.387–9.

26 Dore Ashton, 'Art', *Arts and Architecture*, 75, no. 4, April 1958, p. 8, quoted in Clearwater 1984, p.42

27 See also John Klein, 'The Dispersal of the Modernist Series', *Oxford Art Journal*, vol. 21, no. 1, 1998, pp.123–35.

28 Ibid.

29 The growing ambition of the project is even more evident if one bears in mind the cost of materials. Dan Rice, for instance, recalls the extraordinary amount of costly pigment mixed in with rabbit glue that Rothko used for the first layer of the murals 'We were talking about mixing paint; at one point I had ... hundreds and hundreds of dollars worth of paint in this big thing, stirring it with this big stick, and he yelled at me from across the room, "Rice", and I turned around ... and the whole thing went over. We got down on our hands and knees, one with a piece of cardboard, the other with a dustpan and ladled it back into the vat.' Dan Rice interviewed by Mary Bustin and Jo Crook, 9 March 2000, Tate Conservation Department.

30 See also David Anfam, *Mark Rothko. The Works on Canvas. Catalogue raisonné*, Newhaven and London 1998, pp.89–92.

31 Rice/Glimcher 1978. At his MoMA retrospective Rothko listed five mural sections, giving rise to much speculation as to which of the other paintings might make up the missing two sections. However, rather than engage in such conjecture it may be more helpful to see the ambiguity and openness of Rothko's project as one of its essential qualities.

32 As Rothko was present for the installation and opening of his exhibition in London, it is most likely that it was his decision for the murals to be displayed in this way.

33 Rothko stipulated that large paintings should be hung as close to the floor as possible, with the exception of the murals, which were painted at a height of 4'6" above the floor. 'If it is not possible to raise them to that extent, any raising above three feet would contribute to their advantage and original effect.' Suggestions from Mr. Mark Rothko regarding the installation of his paintings, Mark Rothko 1961, Whitechapel Art Gallery, Whitechapel Archive.

34 Norman Reid remembered his discussions with Rothko: 'We tried out various arrangements of scaled down miniature paintings in the cardboard model of the room in the Tate which I had sent him some weeks ago. The tendency was for him to try to put too much in, and although I spent a long time with him trying out every possible combination of the pictures, including the one he has already given to the Tate, my own belief is that one cannot make more than a rough shot at an arrangement in this miniature form.' Norman Reid, Mark Rothko Gift: New York, 3 November 1969, Tate Gallery Archive.

35 Letter from Mark Rothko to Norman Reid, 4 September 1966, Tate Gallery Archive.

36 While Rothko stipulated, for instance, that the murals he donated to Tate should be shown in

NOTES

a room by themselves, he gave the option of showing a smaller selection.

37 Haftmann 1971, p.IX.
38 The penthouse of the Holyoke Center offered panoramic views that exposed Rothko's murals to strong sunlight, which accelerated the fading of unstable red pigment in the canvases, so that they soon changed colour. See also Marjorie B. Cohn (ed.), *Mark Rothko's Harvard Murals*, Cambridge MA 1988.
39 Rice/Breslin 1936.
40 See for instance Susan J. Barnes, *The Rothko Chapel: An Act of Faith,* Austin, Texas 1989; Sheldon Nodelman, *The Rothko Chapel Paintings: Origins, Structure, Meaning,* Houston and Austin 1997 David Anfam and Carol Mancusi-Ungaro, *Mark Rothko. The Chapel Commission,* exh. cat., The Menil Collection, Houston 1997; K. C. Eynatten, Kate Hutchins and Don Quintance (eds.), *Image of the Not-Seen: Search for Understanding,* The Rothko Chapel Art Series, Houston 2007.
41 Though there are nine paintings, they are consecutively numbered one to eight with number five confusingly appearing twice.
42 Anfam 1998 p.95 rightly raises the issue of the work's date. It is inscribed 1960 on the reverse but most likely Rothko erroneously assigned this date in the haste of cataloguing his oeuvre in 1969. The painting appears in Hans Namuth's 1964 photograph, which was taken in the East Hampton garage that Rothko then used as his studio, and it is extremely unlikely that Rothko would have shipped the work from his New York studio. The painting's close relationship to the *Black-Form* and the Chapel paintings further suggests the 1964 date.
43 Brian O'Doherty, 'Rothko's Endgame', *Mark Rothko. The Dark Paintings 1969–70,* exh. cat., Pace Gallery New York 1985, p.9.
44 Alighiero Boetti's *Nothing to See Nothing to Hide* dates to 1969. In 1978, it featured in a 16 mm film directed by Emidio Greco with the title projected onto the work. I would like to thank my colleague Mark Godfrey, for bringing this image to my attention.
45 Cited in Breslin 1993, p.430.
46 O'Doherty 1985, p.9.
47 Email correspondence between the author and Jonathan Ahearn, Rothko's studio assistant at the time. Ahearn confirms that by summer 1969 Rothko had fully embraced the presence of the white border as an integral part of the works. Clearwater 1984, p.54 cites a visit by the historian Irving Sandler during which Rothko stressed the importance of the border as part of the compositional scheme. This observation was confirmed by Sandler in a conversation with the author in July 2008.
48 *Untitled* 1959 is the only painting in the series not to have such a border, it having been painted out to extend the fields to the very edge of the canvas, an experiment that Rothko did not repeat.
49 Robert Goldwater, 'Rothko's Black Paintings', *Art in America,* no. 59, March–April 1971, pp.58–63, here p.62.

50 This event is vividly described by O'Doherty 1985.
51 See note 15.
52 Ashton 1996, p. 167.
53 Daniel Buren (trans, Thomas Repensek), 'The Function of the Studio', *October*, vol. 10, autumn 1979, pp.51–8, here p.53.

SEEING IN THE DARK
BRIONY FER

1 Charles Dickens, *Bleak House*, Hertfordshire 1993, p.3.
2 Ibid., p.3.
3 Jorge Luis Borges, 'Kafka and his Precursors', *The Total Library Non-fiction 1922–1986*, London and Harmondsworth 2000, p.365.
4 Maurice Merleau Ponty, 'Cézanne's Doubt', in *Sense and Non-Sense*, Evanston, Illinois 1964, p.20.
5 David Sylvester, 'Rothko', in *New Statesman*, 20 October, London, 1961, vol.62, no.1597, pp.573–574.
6 Mark Rothko, letter to Bryan Robertson, undated, Whitechapel Art Gallery Archive.
7 Ibid.
8 See Carol Mancusi-Ungaro's discussion in 'Material and Immaterial Surface: The Paintings of Rothko', in Jeffery Weiss et al., *Mark Rothko*, exh. cat., National Gallery of Washington 1998, pp.283–300.
9 I have discussed the Seagram series in more detail in *The Infinite Line: Re–making Art after Modernism*, Newhaven and London 2004, Chapter Two 'Picture', pp.5–26.
10 In an interview with Bruce Glaser, 'Reinhardt on Reinhardt', in *Art as Art*, p.21.
11 Reinhardt in a note written in 1955 on 'The Black-Square Paintings', ibid., p.82.
12 Ibid., p.95.
13 Ibid.
14 Henri Matisse, 'Black is a Colour', 1946, in David Batchelor (ed.), *Colour*, London 2008, p.97.
15 Even the best commentators on the late work, Barbara Novak and Brian O'Doherty, offer a symbolic interpretation of the wine colour of many of the late paintings as 'dionysiac' and of the darkness as testament to the artist's 'dramatic and tragic ambition'. See Weiss et al., 1998, p.269.
16 For a discussion of the radical shifts in conceptions of colour see David Batchelor, *Chromaphobia*, London 2000 and more recently, Ann Temkin (ed.), *Color Chart*, New York 2008.
17 Theodor Adorno, *Aesthetic Theory*, London 1997, p.59.
18 David Antin, 'The Existential Allegory of the Rothko Chapel', in *Seeing Rothko*, Los Angeles 2005 p.129.
19 J.G. Ballard, *Miracles of Life; Shanghai to Shepperton An Autobiography*, London 2008, p.298.

THE WORLD IN A FRAME
DAVID ANFAM

1 As Maurice Merleau-Ponty sagely observed, the seeing subject's embodiment means that we can never fully see ourselves; Merleau-Ponty, *The Visible and the Invisible* (trans. Alphonso Lingis), Evanston 1968, p.9.
2 David Anfam, 'To See, or Not To See', in K.C. Eynatten, Kate Hutchins and Don Quaintance (eds.), *Image of the Not-Seen: Search for Understanding*, Houston 2007, pp.65–6. Kirk Varnedoe, *Pictures of Nothing: Abstract Art Since Pollock*, Washington 2006, p.93, speculates that a sculpture by John McCracken inspired Kubrick.
3 With due acknowledgment of the seminal essay by Brian O'Doherty, 'Rothko's Endgame', in *Rothko: The Dark Paintings*, exh. cat., Pace Gallery, New York 1985.
4 Art that manipulates fictions of the end should not be mistaken for an end-driven art. On this distinction, see Frank Kermode, *The Sense of an Ending: Studies in the Theory of Fiction*, London, Oxford and New York 1966.
5 Rothko, letter of 1 February 1960 to Ronald Alley, Tate archives.
6 E.H. Gombrich, 'Expression and Communication', in *Meditations on a Hobby Horse*, London 1963, pp.56–69.
7 Anfam 2007, pp.66–9.
8 David Anfam, *Mark Rothko: The Works on Canvas – A Catalogue Raisonné*, New Haven, London and Washington 1998, cat. no.5.
9 Rothko, 'The Romantics Were Prompted, 1947', in Miguel López-Remiro, *Writings on Art: Mark Rothko*, New Haven and London 2006, p.59.
10 Rothko, 'Address to Pratt Institute, November [sic] 1958', in López-Remiro 2006, p.125.
11 Julia Kristeva, *Black Sun: Depression and Melancholia* (trans. Leon S. Roudiez), New York 1989, pp.97–103.
12 Rothko, letter of 4 September 1966, to Sir Norman Reid, Tate archives.
13 Elaine de Kooning, 'Two Americans in Action', *Art News Annual*, vol. 27, 1958, p.174.
14 Compare Lillian Lonngren, 'Abstract Expressionism in the American Scene', *Art International*, vol. 2, 1958, p.55: 'Black has become a new staple of Rothko's palette.'
15 Again, by a strange twist, *Open Window, Collioure* was first publicly shown at the UCLA Art Gallery, 5 January to 27 February 1966 – when Rothko was in the midst of the Chapel murals – and reproduced in color on p.66 of the catalogue (no.36). The show travelled to Chicago and Boston that year and received laudatory reviews from, inter alia, Clement Greenberg (my thanks to John Klein for this information). In any case, Rothko was deeply enamoured with Matisse.
16 Adolph Gottlieb also titled a 1965 painting *Black Light*.
17 David Batchelor, *Chromophobia*, London 2000, p.65.
18 Monochromatic in that the Seagrams take red through many tints, shades and admixtures

from dull orange, through purplish maroons to near-black.

19 John Fischer, 'The Easy Chair, Mark Rothko: Portrait of the Artist as an Angry Man', *Harper's Magazine*, vol. 241, July 1970, p.16.

20 Dore Ashton, *About Rothko*, Oxford and New York 1983, p.179.

21 Essentially, we may infer that Rothko is here staking a claim to practice the art of the real (significantly also the title of an exhibition held at the Museum of Modern Art in 1968).

22 Ad Reinhardt, 'Black', in Barbara Rose (ed.), *Art-as-Art: The Selected Writings of Ad Reinhardt*, Berkeley and Los Angeles 1975, p.98.

23 Rothko and Adolph Gottlieb, 'The Portrait and the Modern Artist, October 13, 1943', in López-Remiro, p.37; Leila Hadley Musham, *Alfred Jensen: Metaphysical and Primitive*, unpublished typescript, New York 1975, p.13. Rothko also told Jensen that 'when black is followed by a white square, it is an immediate success. The white square is very hard to get on and you have blackness if followed by black. You have to look forward. In going through blackness to arrive at white again, success follows the hard way' (Musham, p.10).

24 See James Meyer (ed.), *Minimalism*, London 2000, pp.14–16.

25 Rothko, unpublished sketchbook, labelled 'Fair Play Compositions', c.1954, Rothko archive.

26 Marjorie Phillips, *Duncan Phillips and His Collection*, Boston 1970, p.288.

27 On the connection with Leonardo's *The Ideal Proportions of the Human Figure* ('Vitruvian Man'), Rothko's abstraction and his earlier figurative work, see Anfam 2007, pp.70–1.

28 Elsewhere, I have proposed a range of cinematic qualities in Rothko's art; see Anfam 1998, pp.11–12, 13, 39, 61 and 77. Conceivably, therefore, Rothko's murals may also have some affinity with the rise of the enveloping technique of Cinerama in the United States from 1952 onwards.

29 It remains for the long-awaited catalogue raisonné of Rothko's works on paper to determine the precise chronological relationship between these 'light' acrylics and the 'dark' *Black on Grays*: which series came first or were they done simultaneously? Whatever, the chalky or ashen cast of these acrylics also harks back to Rothko's frigid palette in the late 1930s, as if alienation were here revisited for the last time, a revenant to be reckoned with.

30 The concept of the borders evidently derived from Rothko's noticing the exposed white that was left when he removed the tape used to attach his works on paper to his easels. The declarative border functions in the canvases – to borrow terms of reference from narrative theory—as a marker of the non-diegetic aspect of the image, framing its diegetic content (the black and grey per se) within.

31 On the other hand, Malcolm Morley, among others, had employed white borders as a distancing device during the 1960s. Rothko could have seen such Morleys at the

Guggenheim Museum's *The Photographic Image* (1966) and/or at the artist's shows at Kornblee Gallery (1967, 1969) – the first of which drew admiration from Barnett Newman. This is not to mention the importance of the border or frame to other artists such as Jo Baer and Robert Ryman.

32 Any debate as to what extent Rothko was ever a 'Minimalist' must flounder upon the thesis that 'Minimalism' was never a homogeneous movement, but rather a field of shifting discourse and positions. See James Meyer, *Minimalism: Art and Polemics in the Sixties*, New Haven and London 2001, pp.6–9.

33 Ashton 1983, p.155; 'Mark Rothko: Notes on the Seagram Mural Commission', in Oliver Wick (ed.), *Mark Rothko*, exh. cat., Palazzo delle Esposizione, Rome 2007, p.169.

34 Sheldon Nodelman, *The Rothko Chapel Paintings. Origins, Structure, Meaning*, Houston and Austin 1997, p.43. Previous major Modernist bids to integrate architecture, painting and so forth, had of course included, for example, the ambitions of the Bauhaus and Matisse's Chapel of the Rosary at Vence.

35 Arthur C. Danto, *Embodied Meanings: Critical Essays and Aesthetic Meditations*, New York 1994, pp.ix–x.

36 Ashton 1983, p.179; James E.B. Breslin, *Mark Rothko: A Biography*, Chicago and London 1993, p.469; Fischer 1970, p.21.

37 'Dan Flavin, Donald Judd, Frank Stella: New Nihilism or New Art? Interview with Bruce Glaser, 1964', in Meyer 2000, p.198.

38 Rothko, in Fischer 1970, p.21.

39 Rothko, in López-Remiro 2006, p.128.

40 Rothko, in Fischer 1970, p.16.

41 Still, in John P. O'Neill (ed.), *Clyfford Still*, exh. cat., Metropolitan Museum of Art, New York 1979, p.29.

42 Michel Foucault, *The Order of Things: An Archaeology of the Human Sciences*, New York 1970, p.387.

43 Dore Ashton, 'Rothko's Passion', *Art International*, vol. 22, February 1979, p.13.

44 Rothko, 'How to Combine Architecture, Painting, and Sculpture, 1951', in López-Remiro 2006, p.74.

45 Jean-Paul Sartre, 'New York, the Colonial City' in *Literary and Philosophical Essays* (trans. Annette Michelson), London 1955, p.121: 'In the numerical anonymity of the streets and avenues, I am simply anybody, anywhere.' For these and certain other ideas about spatiality, I am indebted to the cinema historian Edward Dimendberg and his remarkable study, *Film Noir and the Spaces of Modernity*, Cambridge 2004.

46 The bulging or extruded look of some of the internal elements, as in *Black on Maroon* (cat. x [T01163])and *Red on Maroon* [cat. x [T01169]), continues the impression that the paintings resemble screens and/or views through a fish-eye lens (which effect, intriguingly, was also to feature prominently in Frankenheimer's *Seconds*).

47 Rothko, in David Sylvester, 'The Ugly Duckling',

in Michael Auping (ed.), *Abstract Expressionism: The Critical Developments*, exh. cat., Buffalo and New York 1987, p.140. Given the chronology of Sylvester's involvement with the Abstract Expressionists, the remark is unlikely to pre-date the late 1950s. Another contemporary parallel here is with Ronald Bladen, who stated that 'I am concerned with that area of excitement belonging to natural phenomena such as a gigantic wave poised before it makes its fall'; Bladen [1970], in Thomas Kellein (ed.), *Ronald Bladen Sculpture*, New York 1998, p.18.

48 See the telling conclusions reached by Claude Cernuschi, 'The Mark Rothko Chapel in Houston: The Structure of Meaning or the Meaning of Structure', *Religion and the Arts*, vol. 3, 1999, pp.464–5, about the Chapel and the structural interpretation that it has elicited: 'if all pictorial, compositional, or configurational elements are balanced by other elements, if all forces are counteracted by opposing forces, then the ability of the spectator to gauge what is important becomes severely curtailed... Nodelman outlines so many forces and counterforces, connections and oppositions, similarities and dissimilarities, that, in the end, they tend to neutralize one another.'

49 Ulfert Wilke, diary notes, 6 May 1967, in Breslin 1993, p.469.

50 Judd, 'Nationwide Reports: Black, White, and Gray 1964', in Meyer 2000, p.202.

51 Another convention that artistic practice contemporary with the later Rothko's – starting with Jasper Johns in the mid-1950s and reaching an apogee in the 1960s – interrogated, rendered ironic and dismantled. See John Welchman, 'In and around the "Second Frame"', in Paul Duro (ed.), *The Rhetoric of the Frame: Essays on the Boundary of the Artwork* Cambridge 1996, pp.203–22.

52 Leon Battista Alberti, *On Painting* (trans. Cecil Grayson). London 1972, p.54. Alberti continued by establishing the 'centric point' in his rectangle; that is, a vanishing point. This prefigures the focal area(s) or nexus of attention that Rothko often situated near the middle of his abstractions. See, for example, the especially revealing star shape in the centre of the *Untitled* sketch for a Harvard Mural (1961) reproduced in Bonnie Clearwater, *Mark Rothko: Works on Paper*, New York 1984, p.58. Indeed, there may even be a whiff of Alberti's line illustrations about such a pen and ink drawing.

53 On Rothko and Vermeer, see Anfam 1998, pp.38–9.

54 Put another way, Vermeer is among those exceptional representational artists able to compose both in depth (that is, illusionistically) and across the painting's surface (abstractly). Similarly, the essence of Rothko's abstraction was to equivocate between deep space and a highly frontal surface emphasis.

55 'Scribble Book, ca. 1934', in López-Remiro 2006, p.10.

56 The questioner was the actor and film director, John Houston: see Nodelman 1997, pp.302 355, note 16.

NOTES

57 Although no evidence indicates that Rothko knew Erwin Panofsky's widely read essay 'Style and Medium in the Motion Pictures', the date and place of publication of the definitive version — in 1947 in the little magazine *Critique. A Review of Contemporary Art* (vol. 1, pp.5–28) — was provocatively close to Rothko's orbit. In particular, the most famous apothegm in Panofsky's text would have been music to Rothko's ears if he read it: the definition of cinema's possibilities as *'dynamization of space and, accordingly, spatialisation of time.'*

58 Rothko's involvement with perspective and spatiality is also explicable in terms set forth by Panofsky, specifically his proposal that perspective entails a 'rather bold abstraction from reality' that synthesises the objective and the subjective and 'expands human consciousness into a vessel for the divine'; see Panofsky, *Perspective as Symbolic Form* (trans. Christopher S. Wood), New York 1991, pp.29, 66, 72. Although Rothko could not have known Panofsky's text (Wood's was the first English translation thereof), Bernice Rose speculates that his ideas were widely circulated through the New York art world so that Rothko might have come into contact with them at second-hand. Rose, *Rothko: A Painter's Progress. The Year 1949*, exh. cat., PaceWildenstein, New York 2004, p.26, note 2.

59 The sense that some unseen drama is active beyond the figures' domain is a function of their rigid framework, the intimation of a world elsewhere that Gilles Deleuze called the 'out-of-field' (*hors-champ*) in his analysis of the cinematic image; see Deleuze, *Cinema 1: The Movement-Image* (trans. Hugh Tomlinson and Barbara Habberjam), Minneapolis 1986, pp.18ff.

60 Rothko 1958, in López-Remiro 2006, p.126.

61 On Munch and the early Rothko, see Anfam 1998, pp.35–6.

62 Anfam 1998 cat. nos. 96, 165, 166.

63 Rothko's involvement with empathy is but a short step away from the pathetic fallacy. Hence his admiration for Michelangelo Antonioni's film *The Red Desert* (1963), in which the characters' psychological states suffuse the desolate ambience. The key factor is that Rothko's far from up-to-date sources and influences (the theory of empathy derives from the nineteenth-century aesthetician Theodor Lipps) predisposed him to cutting-edge contemporary developments such as Antonioni's Existentialism. Nevertheless, some commentators continue to obscure the former with the latter: see, for example, Jeffrey Weiss, '*Temps Mort*: Rothko and Antonioni', in Wick 2007, pp.45–55.

64 See the far-reaching discussion in Ann Friedberg, *The Virtual Window: From Alberti to Microsoft*, Cambridge MA and London 2006.

65 Michel Butor, 'Rothko: The Mosques of New York', in Butor, *Inventory*, New York 1968, pp.268, 275: '[In the classic works] the margin is the painting itself as object ... [In the murals] the margins will move inside the painting. This apparition of the painting inside itself ... is one of the fundamental elements of contemporary art in its highest forms.' See also 'Dan Rice Interviewed by Arne Glimcher', in Thomas Kellein, *Mark Rothko: Kabaa in New York*, exh. cat., Kunsthalle, Basel 1989, p.23: 'The major difference that appeared in these paintings immediately and changed their character was that he simply turned the paintings on their side.'

66 Rothko [1953], in Breslin 1993, p.267; Rothko, in Harold Rosenberg, *The De-definition of Art*, London 1972, p.105.

67 See Jacques Lacan, 'The Mirror Stage as Formative of the Function of the *I* as Revealed in Psychoanalytic Experience', in Lacan, *Écrits: A Selection*, London 1989, pp.1–8, which hypothesises both the formation and dissolution of the 'I' in the mirror.

68 See Anfam 1998, pp.80–1, 87.

69 Here and in other works of the 1930s such as *Untitled* of 1936/37 (Anfam 1998, cat. no. 98), Rothko tapped into a cultural change in the United States during the early decades of the twentieth century, viz., the mass production of glass and mirrors that transformed shopping into a kaleidoscope of 'mirrors, illusions and human desires'. See Mark Pendergrast, *Mirror Mirror: A History of the Human Love Affair with Reflection*, New York 2003, pp.249–51.

70 See Pendergrast 2003, p.ix: 'The mirror appears throughout the human drama as a means of self-knowledge or elf-delusion.' As such, the mirror theme connects with Rothko's insistence on the ethical basis of art and, furthermore, with his Platonism and concomitant interest in reality and semblance.

71 Rothko, 'Fair Play Compositions', sketchbook, c.1954, Rothko archive.

72 Giorgio Vasari, *Lives of the Artists* (trans. George Bull), London 1987, pp.187–8.

73 See Christopher Rothko (ed.), Mark Rothko, *The Artist's Reality: Philosophies of Art*, New Haven and London 2005, passim. This manuscript dates from the second half of the 1930s and perhaps the first year or two of the 1940s.

74 See Hillel Schwartz, *The Culture of the Copy: Striking Likenesses, Unreasonable Facsimiles*, New York 1996. Especially telling in relation to Rothko's repetitions is Schwartz's quotation (p.288) of the philosopher Søren Kierkegaard, whose writings Rothko knew: 'Indeed, if there were no repetition, what then would life be? ... Repetition is reality, and it is the seriousness of life.' On Rothko's familiarity with Kierkegaard, see Ashton 1983, p.83 et passim. Regarding Rothko, Kierkegaard and repetition, see Anfam 1998, pp.79, 102, notes 129–37.

75 Andy Warhol, *The Philosophy of Andy Warhol: From A to B and Back Again*, New York 1975, p.7.

76 Richard Wollheim, 'Minimal Art', [1965] in Gregory Battcock (ed.), *Minimal Art: A Critical Anthology*, New York 1968, p.399. Wollheim's supposition (p.398) that Minimalist art destroys a more complex 'preimage' has a kind of correlative in Rothko's *Untitled* (1964, Anfam 1996, cat. no. 772). This extremely dark study for the Chapel paintings obliterates an initial wash of almost fluorescently bright crimson beneath its surface.

77 Mehring, in Lawrence Alloway, 'Systemic Painting', [1966] in Battcock 1968, p.56. Compare Rothko's statement, 'If a thing is worth doing once, it is worth doing over and over again – exploring it, probing it, demanding by this repetition that the public look at it'; Ida Kohlmeyer, 'About Rothko', *Arts Quarterly*, vol. 4, October–December 1982, p.59.

78 Of course, Rothko and Bacon shared the same dealer, Marlborough.

79 Samuel Beckett, *The Complete Dramatic Works*, London 2006, p.92.

80 Compare the title and *topos* of Beckett's play *Not I* (1970) and Rothko's remark, in Harold Rosenberg, *The De-definition of Art*, London 1972, p.105: 'I don't express myself in my painting. I express my not-self.'

81 Beckett [to Georges Duthuit], in A. Alvarez, *Beckett*, London 1973, p.17.

82 Beckett 2006, p.109.

83 Robert Motherwell, 'On Rothko, A Eulogy, 1970', in Dore Ashton and Joan Banach (eds.), *The Writings of Robert Motherwell*, Berkeley, Los Angeles and London, 2007, p.272. Once more, a contemporary parallel obtains with Rothko's words — in those of Mel Bochner: 'Art is, after all, Nothing [and] invisibility is an object'; Bochner, 'Primary Structures: A Declaration of a New Attitude as Revealed by an Important Current Exhibition', *Arts Magazine*, vol. 40, June 1966, p.34.

84 On the cinematic experience, framing and American art, see Kerry Brougher, *Art and Film Since 1945: Hall of Mirrors*, Los Angeles 1996, especially Kate Linker, 'Engaging Perspectives: Film, Feminism, Psychoanalysis, and the Problem of Vision', pp.248–51, on working within the limitations of a frame.

85 See Leo Braudy, *The World in a Frame: What We See in Films*, New York 1977. Braudy's theory of the 'closed' film, in opposition to the 'open' film, has great relevance to Rothko's universe. Braudy notes (p.71) that in the 'closed' films of Ingmar Bergman, God is expressed as emptiness and that this results in 'an inner frame once the frame of the divine has been removed' (p.74). There are acute parallels here with Rothko's belief that 'there are no gods' and his subsequent incorporation of the margin or framing edge inside the composition of the Seagram murals. Similarly, when 'open' and 'closed' systems collide in the same film, as they do in those of Antonioni and Francois Truffaut, the result is a merger of 'potentiality and stasis, the possibility of both open expansion beyond the frame and closed constriction within the frame' (p.101). This is the paradoxical dynamic of the late Rothko.

**ROTHKO AND THE
CINEMATIC IMAGINATION**
MORGAN THOMAS

Special thanks to Janet Blyberg at the National
Gallery of Art, Washington, D.C., and Robert
Blake (International Center of Photography,
New York) for their help during the research
for this essay. In addition, I gratefully
acknowledge the financial support provided by
the College of Arts, University of Canterbury,
in aiding this research.

1 Mark Rothko, quoted in James E. B. Breslin,
 Mark Rothko: A Biography, Chicago 1993, p.301.
2 André Bazin, 'Painting and Cinema' (undated),
 in André Bazin, *What is Cinema?*, trans.
 Hugh Gray, Berkeley and Los Angeles, 1967,
 pp.166, 169.
3 I draw here on the argument put forward by
 Roland Barthes, to the effect that the film
 still reveals the specifically 'filmic' to consist
 not in movement or animation as such, but in
 the 'framework of a permutational unfolding'
 ('The Third Meaning: Research Notes on some
 Eisenstein Stills', in Roland Barthes, *Image,
 Music, Text*, Stephen Heath, ed. and trans.,
 New York, 1977, p.67).
4 Mark Rothko, quoted in Dore Ashton,
 About Rothko, New York, 1983, p.179.
5 Stephanie Rosenthal, 'Mark Rothko: A Stage
 for Tragedy', in Rosenthal, *Black Paintings*,
 trans. Büro Sieveking, exh. cat., Ostfildern
 and Munich, 2006, p.60.
6 On the spread of the screen effect across
 different visual media during the twentieth
 century, see Quentin Bajac, 'Windows and
 Screens', in *Le Mouvement des Images*, exh. cat,
 Centre Pompidou, Paris, 2006, pp.31–36. On
 painting's relationship to photography, video
 and other technologies, particularly with regard
 to their surfaces, see Jeremy Gilbert-Rolfe,
 Beauty and the Contemporary Sublime,
 New York, 1999.
7 Samuel Weber, '*Deus ex Media*: Interview with
 Cassi Plate', in Samuel Weber, *Mass Mediauras:
 Form, Technics, Media*, ed. Alan Cholodenko,
 Sydney, 1996, p.157.
8 Ibid.
9 On the viewer's role in the projection of the
 cinematic image, see Vivian Sobchack, *The
 Address of the Eye: A Phenomenology of
 Film Experience*, Princeton, 1992, pp.175–203,
 and Keith Broadfoot and Rex Butler, 'The
 Illusion of Illusion', in *The Illusion of Life: Essays
 on Animation*, ed. Alan Cholodenko, Sydney,
 1991, pp.263–298.
10 André Bazin, 'The Evolution of the Language of
 Cinema', in *What is Cinema?*, p. 37. Bazin's focus
 on continuity and duration, which reflects his
 commitment to Italian neo-realist cinema, could
 be considered further in the context of the
 connection between Rothko and Michelangelo
 Antonioni, who visited Rothko's studio in 1962
 and linked his concerns with Rothko's. On this
 connection, see Jeffrey Weiss, '*Temps Mort*:
 Rothko and Antonioni', in Oliver Wick (ed.)

et al., *Mark Rothko*, exh. cat., Palazzo delle
 Esposizioni, Milan, 2008, pp.45–55.
11 André Bazin, 'The Ontology of the Photographic
 Image', in *What is Cinema?*, p. 15. On Bazin's
 realism, see Gilberto Perez, *The Material Ghost:
 Films and their Medium*, Baltimore, 1998.
12 'The Ontology of the Photographic Image', p.16.
13 For an analysis of the modulation of the
 image in cinema, see Gilles Deleuze, *Cinema
 2: The Time-Image*, trans. Hugh Tomlinson and
 Robert Galeta, Minneapolis, 1989, pp.27–28.
 Here cinematic modulation is said to involve
 a 'putting into variation of the mould, a
 transformation of the mould at each moment
 of its operation' (p.27). The modulation
 occurring in Rothko's serial paintings,
 which similarly works through variation and
 transformation, is of a different order from the
 serial but replicative modularity associated with
 Minimalist art in the 1960s.
14 Brian O'Doherty, 'Mark Rothko: The Tragic
 and the Transcendental', in *American Masters:
 The Voice and the Myth in Modern Art*,
 New York, 1982, pp.213–214.
15 Ibid.
16 Hubert Crehan, 'Rothko's Walls of Light',
 Arts Digest, November 1, 1954, p.19.
17 Ibid., p.5, p.9.
18 Ibid., p.19.
19 Frank Stella, *Working Space*, Cambridge,
 Massachusetts, and London, 1986, p.11.
20 Ibid
21 Mark Rothko, 'The Romantics Were Prompted',
 Possibilities 1 (1948), reprinted in Mark Rothko,
 Writings on Art, ed. Miguel López-Remiro,
 New Haven and London, 2006, pp.58-9.
22 Herbert Ferber, interview with Phyllis Tuchman,
 2 June, 1981 (Mark Rothko oral history project,
 Archives of American Art, reel 4937). My thanks
 to Michael Goldberg for information concerning
 Rothko's spotlights, and to Robert Blake for his
 advice about lighting shown in photographs of
 Rothko's later studios.
23 Yet sometimes the Seagram figures stand out
 on account of their thickness. Very thin paint
 predominates in Rothko's later paintings but his
 general procedure is to vary the consistency
 of paints. On Rothko's manipulation of painting
 materials, see Dana Cranmer, 'Painting Materials
 and Techniques of Mark Rothko: Consequences
 of an Unorthodox Approach', in *Mark Rothko
 1903–1970*, exh. cat., Tate Gallery, London,
 1996, pp.189–197, and Carol Mancusi-Ungaro,
 'Material and Immaterial Surface: The Paintings
 of Rothko', in Jeffrey Weiss (et al.), *Mark Rothko*,
 exh. cat., National Gallery of Art, Washington,
 1998, pp.282–300.
24 Hot lights, which Rothko appears to have been
 using in his studios of the 1960s if not earlier,
 are known for their warm (orange or reddish)
 light. Aluminium reflectors, one of which can
 be seen in a photograph taken in Rothko's First
 Avenue studio in 1964, cast a hard light that
 picks out surface textures, yet here the reflector
 is pointed up to the ceiling.
25 See John Fischer, 'Mark Rothko: Portrait of
 the Artist as an Angry Man' (first published in

Harper's, July 1970), reprinted in Mark Rothko,
 Writings on Art, p.131.
26 Heinrich Wölfflin, *Renaissance and Baroque*,
 trans. Kathrin Simon, London, 1966, p.46. My
 thanks to Achim Borchardt-Hume for bringing
 this connection to my attention.
27 Ibid., p.52.
28 On the basis of interviews with Rothko in the
 early 1950s, William Seitz uses the phrase
 'momentary stasis' to sum up Rothko's view
 of the relationships between the elements
 in his paintings (see William Seitz, *Abstract
 Expressionist Painting in America*, Cambridge,
 Massachusetts, 1983, p.102).
29 Matisse associated the unfolding of moments
 of perception in his painting with 'what I call
 the cinema of my sensibility' (quoted in Pierre
 Schneider, *Matisse*, trans. Michael Taylor and
 Bridget Strevens Romer, New York, 2002,
 p.374). Both he and Rothko are said to have
 loved the cinema.
30 See note 2.
31 See Roland Barthes, 'The Third Meaning:
 Research Notes on some Eisenstein Stills',
 pp.65–68.
32 Mark Rothko quoted in William Seitz,
 'Notes from an Interview by William Seitz,
 January 22, 1952', reprinted in Mark Rothko,
 Writings on Art, p.76.
33 This widely quoted remark was made by
 Frank Stella during an interview conducted
 in 1964 (Bruce Glaser, 'New Nihilism or New
 Art? Interview with Stella, Judd and Flavin',
 February, 1964, transcript of radio broadcast,
 reprinted in *Minimalism*, ed. James Meyer,
 London, 2000, p.198).
34 See Bruce Glaser, 'New Nihilism or New Art?
 Interview with Stella, Judd and Flavin', p.198.
35 See Clyfford Still, letter to Sidney Janis, 4 April,
 1955, quoted in Breslin, *Mark Rothko*, pp.343–
 344, and Barnett Newman, letter to Sidney
 Janis, 9 April, 1955, reprinted in John P. O'Neill
 (ed.), *Barnett Newman: Selected Writings and
 Interviews*, Chicago, 1990, pp.200–202.
36 In his talk at Pratt Institute, given in 1958,
 Rothko includes irony in his already ironic list
 of the 'ingredients' that go into a work of art.
 Irony, Rothko says, is a 'modern' ingredient
 ('Address to Pratt Institute', in Mark Rothko,
 Writings on Art, p.125).

THE SUBSTANCE OF THINGS
LESLIE CARLYLE, JAAP BOON,
MARY BUSTIN, PATRICIA SMITHEN

The authors gratefully acknowledge the
generous financial support of the Tate
International Council which enabled this
research. In addition they are particularly
grateful to Dr Joyce Townsend for her work
with the Rothko project team and to Dr Tom
Learner for his extensive preliminary work on
the analysis of Tate's paintings. Dr Bronwyn
Ormsby has also kindly assisted with the
analysis of paint samples. We are also grateful
to Dr Harriet Standeven for her assistance with

NOTES

the history of manufacture and use of lithol red pigment. Frank Hoogland and Jerre van der Horst (Molart Centre, AMOLF, Amsterdam) assisted in the experiments on the fading of lithol red and ultramarine mixtures.

1 Mark Rothko, 'Personal Statement', (1945) in David Porter, *Personal Statement, Painting Prophecy*, Washington, D.C. 1950, reprinted in Mark Rothko *Writings on Art*, ed. Miguel López-Remiro, New Haven and London, 2006, p.45.
2 Technical examination and documentation of the Tate Seagram Murals was carried out by Mary Bustin between 1998−2008 using a range of examination methods including the use of normal, raking and reflected raking light, ultraviolet and infrared radiation, and magnification. Dan Rice, interview with Mary Bustin and Jo Crook, 2000 (Tate Conservation Department); Dan Rice interviews: James E.B. Breslin Research Archive on Mark Rothko, 1900−1994; Getty Research Institute: Jackie and Dan Rice interview transcript (C2) 21 February 1986. 2003.m.23 Box 7 F3, William and Sally Scharf interview transcript (n.d.) Box 7 F28, and photocopy of handwritten notes, 'Interview- Dan Rice − Bonnie and Dana, November 1983', 2003.m.23 Box 7 F3. 'Bonnie and Dana' are Bonnie Clearwater and Dana Cranmer of the Rothko Foundation.
3 Studies were performed at Tate during 1998−2000 using pyrolysis gas chromatography mass spectrometry (PYGCMS) by Dr Tom Learner with Fourier transform infrared spectroscopy (FTIR) and high performance liquid chromatography (HPLC) on bulk microsamples by Dr Bronwyn Ormsby. Dr Joyce Townsend (Tate) analysed bulk microsamples by light microscopy, polarised light microscopy and elemental analysis using an energy dispersive X-ray detector inside a scanning electron microscope (SEM-EDX). She also made paint cross sections of selected samples that were analysed in the same way. These data sets were further interpreted by Dr Jaap Boon (Molart Centre AMOLF Amsterdam) in 2006−8.
4 Apart from reviewing existing information (see note 3) new analytical work was done in 2006 and 2007 on selected samples using direct temperature mass spectroscopy (DTMS), imaging FTIR, and SEM-EDX mapping to address questions regarding paint layering and selective surface degradation. Paint cross sections imaging was greatly enhanced using ion polishing at the Institute for Atomic and Molecular Physics in Amsterdam (AMOLF), see J.J. Boon and S. Asahina, in proceedings Microscopy and Microanalysis 2006, ed.P. Kotula et al. Cambridge, 2006, pp. 1322-1323. Non-contact 3-D high-resolution surface light microscopic studies were performed in collaboration with Dr E Leonhardt from Hirox Ltd (Lyon, France: /www.hirox-europe.com). The MOLAB team (University of Perugia, Italy: www.eu-artech.org) performed non-contact surface studies with fibre optic Fourier transform infrared spectroscopy. Near infrared

spectroscopy (FTIR-NIR with a sensitivity range in the region 5000-900 cm^{-1}), X-ray fluorescence spectroscopy (XRF) (for analysis of elements with Z >12 at a resolution of 130 eV) and UV-photography. These studies have cast new light on the material condition of the surface layers of paintings T01165, T01166, T01168, T01170 and T01031.
5 Rice/ Bustin/Crook 2000.
6 Ibid.
7 James E.B. Breslin Research Archive on Mark Rothko: Jackie and Dan Rice interview transcript (C2) 21 February 1986.
8 James E.B. Breslin Research Archive on Mark Rothko: William and Sally Scharf interview transcript (n.d.) 2003.
9 Dana Cranmer, 'Painting Materials and Techniques of Mark Rothko: Consequences of an Unorthodox Approach', in *Mark Rothko*, reprint ed., New York 2002, p.191. His technique for the Harvard murals is revealed in Marjorie Cohn (ed.), *Mark Rothko's Harvard Murals*, Center for Conservation and Technical Studies, Harvard University Art Museums, Cambridge, Mass. 1988. Rothko's later technique for the Rothko Chapel is explored by Carol Mancusi-Ungaro, 'Nuances of Surface in the Rothko Chapel Paintings', in *Mark Rothko: The Chapel Commission*, Houston 1996. Rothko's technique is also described comprehensively by Carol Mancusi-Ungaro, 'Material and Immaterial Surface: The Paintings of Rothko', in Jeffery Weiss (ed.), *Mark Rothko*, exh. cat., National Gallery of Art, Washington D.C. 1998, and by Mary Bustin, 'Rothko's Painting Technique', in Bonnie Clearwater (ed.), *The Rothko Book*, Tate Publishing, London 2006.
10 'He bought his canvas from an awning company so they would come in these enormous rolls, six foot, seven foot, eight foot, nine foot, ten foot.' Rice /Bustin/Crook 2000.
11 Leslie Carlyle and Ella Hendriks, 'A Visit to Claessens, Artists' Canvas Manufacturers', Chapter 3, Appendix IV, in *HART Report 2002−2005*, De Mayerene Programme. Copies available at Tate, Canadian Conservation Institute, Van Gogh Museum, Netherlands Institute for Cultural Heritage (ICN).
12 A canvas fibre with tinted paint from the reverse of T01170 was analysed. DTMS revealed the presence of mass spectrometric markers for animal glue and evidence of the synthetic colorant PR49:1 (lithol red). Ultramarine was observed by light microscopy and confirmed by EDX. The cotton fibres are characterised by a strong blue fluorescence.
13 Rice/Bustin/Crook 2000.
14 Rice recalled that Rothko insisted on taking his turn underneath; ibid.
15 Breslin's transcript identifies the egg mix as '[yolk and white]'; Breslin: Jackie and Dan Rice interview transcript (C2) 21 February 1986.
16 Ibid.
17 See notes 3 and 4.
18 Synthetic media like phenol-formaldehyde resin and the acrylates already have a higher molecular weight (as prepolymers) and do

not have to crosslink chemically from smaller molecular units such as those found in oils to form viscous matter. These paints are diluted with solvents so that drying by solvent evaporation occurs.
19 The artist Kenneth Noland has said: 'When you thinned Magna it held its intensity. If you thinned oil, it dispersed the pigments.' Kenneth Noland in a videotaped interview with Carol Mancusi-Ungaro and Leni Potoff at the Museum of Fine Art, Houston, 12 November 1993. Published in Jo Crook and Tom Learner, *The Impact of Modern Paints*, Tate Gallery Publishing, London 2000, p.27.
20 Rice/Bustin/Crook 2000.
21 Breslin: photocopy of handwritten notes, 'Interview − Dan Rice Bonnie and Dana, November 1983'
22 Rice mentioned the bags of raw pigment used by Rothko and he also recalled that Rothko and he 'would take turns in going out and buying dozens of eggs and he would just whomp them up in a bowl ... and mix them with water and paint it on'. Rice/ Bustin/Crook 2000. Egg alone or the mixed-media variant made of oil with dammar and egg were recommended in painting-technique books popular during Rothko's career such as Max Doerner's *The Materials of the Artist and Their Use in Painting*, first published in English in 1935 and Ralph Mayer's *The Artist's Handbook of Materials and Techniques*, first published 1940. Later on, Rothko was known to have used the oil, dammar and whole-egg recipe for the Houston murals (Mancusi-Ungaro 1996, p.26).
23 E.A. Apps, *Printing Ink Technology*, London, 1961; Harriet Standeven, 'The Historical and Technical Development of Gloss Housepaints, with reference to their use by twentieth-century artists', PhD thesis, Royal College of Art 2003.
24 Poly-*n*-butylmethacrylate resin is an acrylic solid that could be used as a paint vehicle when dissolved in solvent and mixed with pigments. Two companies manufactured this resin: Rohm and Haas, as Acryloid F-10 (Paraloid F10 in the UK) and E.I. Dupont de Nemours, as Lucite 44. George Stegmeir (retired technical manager, Grumbacher Artists Paints) reports that at the time Rothko was painting, artists and art students were purchasing F-10 and Lucite 44 from the suppliers and using these resins in combination with oils (personal correspondence July 2007). The use of Lucite 44 by Canadian artists was described by Marion Barclay in 'Materials Used in Certain Canadian Abstract Paintings of the 1950's', in Denise LeClerc (ed.), *The Crisis of Abstraction in Canada: The 1950's*, Ottawa: 1992, p.214. Leonard Bocour only started producing paint from this acrylic resin after it was brought to his attention by an artist in 1941. Paul Cummings, Oral History Interview with Leonard Bocour at his Apartment on Riverside Drive, New York 8 June 1978, http://www.aaa.si.edu/collections/oralhistories/transcripts/bocour78.htm
25 Jan Marontate, 'Synthetic Media and Modern Painting: A Case History in the

Sociology of Innovation', PhD thesis, University of Montreal 1996.

26 Rice/Bustin/Crook 2000.

27 A JEOL argon ion cross-section polishing system was used to create a surface superior to what can be achieved by hand polishing. The process takes place in a vacuum. Argon ions generated in an ion gun are accelerated to about 4 kV and shaped by a metal slit plate before they impinge on a silicon chip with the paint sample attached underneath. The ion beam cuts through the silica and sample in about 5 hours. Ion polishing results in a much sharper definition of the particles in the paint cross section because mechanical abrasion and distortion are avoided.

28 Leslie Carlyle, 'Historically Accurate Reconstructions of Oil Painters' Materials: An overview of the Hart Project 2002–2005', in J.J. Boon and E.S.B. Ferreira (eds), *NWO Reporting Highlights of the De Mayerne Programme: Research programme on molecular studies in conservation and technical studies in art history*, The Hague 2006 (www.nwo.nl/demayerne)

29 Work at Tate using PyGC-MS by Dr. Tom Learner in 1999 indicated the presence of lithol red in two paintings (T01164 and T01169, Tate Analytical Reports 2005). Further work in 2007 by Boon and co-workers in the MOLART group in Amsterdam compared several standard reference compounds of lithol red, which gave positive identification of the sulphated compound using electrospray mass spectrometric techniques. The compound is not always completely intact in the paint samples, as was shown by DTMS and evident after re-evaluation of all the existing PYGCMS data of the Seagram mural paintings at Tate. This reinterpretation of the data demonstrated the general occurrence of lithol red pigment in many of the paints.

30 Rothko's orientation of his canvases during painting is explored in C. Mancusi-Ungaro, 'Material and Immaterial Surface: The Paintings of Rothko', in Weiss 1998, and in J. Weiss, 'Dis-Orientation: Rothko's Inverted Canvases', in G. Phillips and T. Crow (eds), *Seeing Rothko*, Getty Research Institute, Los Angeles 2005, Tate Publishing, London 2006.

31 Rice/Bustin/Crook 2000.

32 Robert Motherwell, interviewed by Dominique de Menil and Susan Barnes, 10 May 1980, tape and transcript at the Menil Collection Archives, Houston.

33 Ralph Mayer, *The Artist's Handbook of Materials and Techniques*, New York (First published 1940), 1951 edition, p.228.

34 Analysis (PYGCMS) of a scraping from an area of glaze on T01168 with strong greenish yellow fluorescence reveals cholestatriene derived from cholesterol (a marker for egg yolk) next to a very strong protein signature for egg. The combination of egg yolk and egg protein points to the application of whole egg in this area. Fatty acid composition complies with an egg origin. No evidence for dammar

resin was found. This glaze is applied over red paint containing *n*-butylmethacrylate. Under ultraviolet light there is some pinkish fluorescence, which could be associated with a colourant described as PR49:1 (lithol red), which was found by PYGCMS analysis.

35 The appearance of a 'bloom' was noted by Michael Compton in his 'Introduction' to *Mark Rothko: The Seagram Mural Project*, Tate Gallery Liverpool 1988: 'They [the paintings] have suffered from a kind of bloom, apparently caused by the damar(sic) resin which Rothko mixed variously with oil, egg and turpentine, crystallising on the surface', p.15.

36 One of the authors, Mary Bustin, treated the painting in 1999 and retouched the repair, which no longer matched its surroundings. The original treatment by Roy Perry is described in Tate's conservation file T01165, *Red on Maroon* 1958.

37 The fugitive nature of lithol red was discussed in relation to Rothko's Harvard Murals by T. Hensick and P. Whitmore, 'Rothko's Harvard Murals', in Cohn 1988. pp.24–5. Although it was known that lithol red was fugitive in the paint industry and trade at the time Rothko was using it in the Seagram series, that information had not necessarily filtered through to artists, and they may not have been aware that this pigment was in their paint. While advocating caution in its use, Doerner also noted 'lithol fast scarlet G … [is], according to Dr. Wagner, sufficiently lightproof for artists' colors', 1934, p.92. (also 1949 edn. p.92). Mayer noted that it was found under the trade name of 'Harrison Red' and, 'When first made, it was much recommended because it was an advance in permanence over the older aniline lakes, but it is not sufficiently light-proof to be used for permanent painting' (1951 edn, p.51). He further noted that it was 'used in industrial paints and in printing inks; not for permanent painting' (1951 edn, p.53).

38 Analysis by DTMS, GCMS and nanospray-electrospray-MS of surface paint drips on the right edge of T01165 shows dammar resin constituents (e.g. ocotillone), associated with normally aged (thirty to fifty years) dammar varnish (G.A. van der Doelen, and J. J. Boon (2000), Artificial ageing of varnish triterpenoids in solution. *Journal of Photochemistry and Photobiology A: Chemistry*, 134: pp.45–57). However, at the surface of T01165, degraded remnants of dammar resin are found (hexakisnor-dammaran-3,20-dione and 30-oxo-25,26,27-trosnor-dammarano-24,20-lactone). Similarly, on the surface of T01166 some evidence for 30-oxo-25,26,27-trisnor-dammarano-24,20-lactone from degraded dammar was observed in a scraping. This points to more advanced dammar resin degradation than would be expected considering the age of the paintings. Stereomicroscopy of the surface glaze of T01165 reveals a very broken up degraded layer with only synthetic ultramarine and some transparent paint extenders. Very rarely a trace of red pigment (lithol red PR49:1) can be seen by fluorescence microscopy.

In contrast, the drip sample from the right tacking margin of T01165, which would be more protected from light, contains abundant lithol red pigment. The role of ultramarine blue in catalysing breakdown of organic paint vehicle has been explored by Keune et al 'Comparative study of the effect of traditional pigments or artificially aged oil paint systems using complementary analytical techniques', in J. Bridgland (ed.), *ICOM-CC 15th Triennial Meeting Preprints*, London 2008, where it was shown with ultramarine oil paint reconstruction experiments that the oil becomes severely deteriorated; the oil constituents are heavily oxidised and there is loss of binding medium.

39 As part of Tate's most recent investigations, experiments with lithol red in dichloromethane solution with or without ultramarine were conducted at the Molart Centre AMOLF according to the technique described by Novotná et al in 2003 (Photo-degradation of indigo in dichloromethane solution. J. Coloration Technology, 119: pp.1–7). Lithol red alone in a saturated solution disappeared (and could no longer be detected by DTMS and nanospray-ESIMS) after thirty-two days of light exposure (equivalent to approximately five years of normal museum lighting). Lithol red in solution with synthetic ultramarine under the same conditions degraded more quickly. All solutions after each light exposure period were kept in the dark at low temperature (-18°C) after flushing with argon. All lithol red solutions with ultramarine were completely discoloured after thirty-two days except the initial solution, which had aged to an equivalent of twenty-two days of light exposure without ultramarine (equivalent of three years of museum lighting). Synthetic ultramarine plays an important role as catalyst of lithol red degradation in the dark, implying that light exposure is not the only factor for the loss of lithol red to occur. Its combination with ultramarine is a crucial factor in the loss of lithol red from the glazes and the paints.

40 In this case, where the haze is not as evident, a scraping was analysed by DTMS, which revealed only a proteinaceous substance (evidence for peptide bonds associated with protein was also seen by MOLAB using FTIR). Elsewhere on this painting markers for degraded dammar (ocotillone and hexakisnor-dammaran-3,20-dione) were observed, indicating that Rothko had used both protein-based media as well as dammar resin at the surface of the painting, which may account for the variable haze effect.

41 Carole Mancusi-Ungaro comprehensively describes the dilemmas and ethical problems encountered when treating some of Rothko paintings in 'Embracing Humility in the Shadow of the Artist', in Mark Leonard (ed.), *Personal Viewpoints: Thoughts about Paintings Conservation*, Los Angeles 2003, pp.83–94.

BIBLIOGRAPHY
FIONA BAKER AND SOPHIA EASEY

BOOKS

Robert Fulton Porter : *A critique of criticism : the mature paintings of Mark Rothko*. Dissertation, Ann Arbor, Mich. : Xerox University Microfilms, 1974; 169p.; bibl. (pp.150–169).

Lee Seldes : *The legacy of Mark Rothko*. London : Secker & Warburg, 1978; 372p. 8p. of plates; bibl. (pp.357–360).

Dore Ashton : *About Rothko*. New York : OUP, 1983; 225p., 8p. of plates; bibl. (pp.203–207). (new edition publ. 1996).

Bonnie Clearwater : *Mark Rothko : works on paper*. New York : Hudson Hills Press in association with Mark Rothko Foundation and the American Federation of Arts, 1984; 144p., 122 illus. (96 col.); introd. by Dore Ashton (pp.9–13), biog. (pp.136–139), bibl. (pp.140–141).

Marjorie B. Cohn (ed.) : *Mark Rothko's Harvard murals*. Cambridge, Mass. : Harvard University Art Museums, 1988; 62p., illus. (some col.).

Susan J. Barnes : *The Rothko Chapel : an act of faith*. Houston : Rothko Chapel, 1989; 126p. illus. (some col.); ports., bibl. (pp.110–115).

Anna Chave : *Mark Rothko : subjects in abstraction*. New Haven, London : Yale University Press, 1989; 229p., 24p. of plates; bibl. (pp.217–224).

Rachel Warren : *The murals of Mark Rothko : a question of environment*. University of Edinburgh, History of Art MA dissertation, 1991; bibl. (pp.43–46).

Marc Glimcher : *The art of Mark Rothko : into an unknown world*. London : Barrie & Jenkins, 1992; 164p., 56 plates; ports. biog. (pp.163–165).

James E. B. Breslin : *Mark Rothko : a biography*. Chicago ; London : University of Chicago, 1993; 700p., 52p. of plates; bibl. (pp.562–563).

Diane Waldman : *Mark Rothko : in New York. New York* : Guggenheim Museum, 1994; 142p., illus. (mostly col.), ports., bibl. (pp.138–142).

Dore Ashton : *About Rothko*. New York : Da Capo Press, 1996; 225p., 8p. of plates; bibl. (pp.203–207). (New edition of work first publ. in 1983).

Sheldon Nodelman : *The Rothko Chapel paintings: origins, structure, meaning*. Houston : Menil Foundation ; Austin : University of Texas Press, 1997; 359p., illus. (some col.), ports.

Recortes de prensa de la exposicion Mark Rothko [del 23.9.87 a 3.1.1998]. Madrid : Fundación Juan March, 1998.

David Anfam : *Mark Rothko : the works on canvas : catalogue raisonné*. New Haven ; London ; Washington : Yale University Press in association with the National Gallery of Art, 1998; 708p., illus. (some col.), ports., bibl. (pp.681–696).

Mary Bustin : *The Rothko Room : talk to the ABPR on the conservation of the Tate's Seagram Murals, 11th July 2001*. London : The Author, 2001; [15] leaves of typescript, text of a Powerpoint presentation to the Association of British Picture Restorers.

Jacob Baal-Teshuva : *Mark Rothko 1903–1970 : pictures as drama*. Cologne ; London : Taschen, 2003; 96p., illus.; biog., bibl. (p.96).

Youssef Ishaghpour : *Rothko : une absence d'image : lumière de couleur*. Tours : Farrago Editions, 2003; 127p.

Mark Rothko : *The artist's reality : philosophies of art*. New Haven, London : Yale University Press, 2004; 136p., col. illus.; ed. and with introd. by Christopher Rothko (pp.xi–xxxi).

Bonnie Clearwater : *The Rothko book*. London : Tate Publishing, 2006; 222p.; biog., colls., bibl. (pp.214–216).

Glen Phillips and Thomas Crow : *Seeing Rothko*. London, Los Angeles : Tate Publishing in association with Getty Research Institute, 2006, 2005; 290p., illus. (some col.), ports.; bibl. (pp.263–271).

Mark Rothko : *Writings on art*. New Haven, London : Yale University Press, 2006; 172p.; ed. by Miguel López-Remiro, introd. (pp.ix–xvi), annotations and biog. (pp.159–168).

Julia Davis : *Mark Rothko : the art of transcendence*. Maidstone : Crescent Moon, 2007; 101p., illus. (4 col.; [52]p. of black and white plates); bibl. (pp.97–101).

K.C. Eynatten, Kate Hutchins, Don Quaintance (eds.) : *Image of the not-seen : search for understanding : the Rothko Chapel Art series*. Houston : The Rothko Chapel, 2007. Lecture Series presented by the Chapel, Jan. – June 2005; illus., (some col.); port., introd. by Christopher Rothko (pp.13–15), bibl. (pp.140–141).

Riccardo Venturi : *Mark Rothko : lo spazion e la sua disciplina* : Milan : Electa, 2007; 221p., illus. (some col.).

SECTIONS OF BOOKS

Irving Sandler : 'Mark Rothko', Chap. 13 in *Abstract Expressionism : the triumph of American painting*. London : Pall Mall Press, 1970; pp. 175–184, *et passim*, illus (some col.).

Brian O'Doherty : 'Mark Rothko : the tragic and the transcendental', in *American Masters : the voice and the myth*. New York : Random House, 1974; pp.150–185, illus. (some col.).

Robert Rosenblum : *Modern painting and the northern romantic tradition : Friedrich to Rothko*. London : Thames and Hudson, 1975; *passim.*, illus.

Laurie Adams : 'The matter of Mark Rothko, deceased' in *Art on trial : from Whistler to Rothko*. New York : Walker, 1976; pp.169–210, *et passim*, illus.

Sheldon Nodelman : *Marden, Novros, Rothko : painting in the age of actuality*. Houston : Institute for the Arts, Rice University ; Seattle : University of Washington Press, 1978; *passim*, illus.

Ronald Alley : 'Mark Rothko', in *Catalogue of the Tate Gallery's collection of Modern Art other than works by British artists*. London : Tate Gallery ; Sotheby Parke Bennet, 1981; pp.657–663.

Annette Cox : *Art as politics : the Abstract Expressionist avant-garde and society*. Ann Arbor, Mich. : UMI Research Press, [1982]; *passim*.

Peter Selz : 'Mark Rothko', in *Art in a turbulent era*. Ann Arbor, Mich. : UMI Research Press, 1985; pp.257–264.

Frederick R. Brandt : 'Mark Rothko', in *Late 20th-century art : selections from the Sydney and Frances Lewis Collection at the Virginia Museum of Fine Arts*. Richmond : Virginia Museum of Fine Arts, 1985; pp.168–169, 1 col. illus.

Barbara Rose : *American painting : the twentieth century*. Geneva : Skira ; New York : Rizzoli, 1986; *passim.*, 1 col. illus.

Leo Bersani : 'Rothko : blocked vision' in *Arts of impoverishment : Beckett, Rothko, Resnais*. Cambridge, Mass. ; London : Harvard University Press, 1993; pp.93–145, *et passim*, illus. (some col.).

Clement Greenberg : the collected essays and criticism : Modernism with a vengeance 1957–1969, vol. 4. Chicago ; London : University of Chicago Press, 1993; particularly 'After Abstract Expressionism' (pp.121–134), *passim*.

'Mark Rothko : 1903–1970', in *Selected works from Kawamura Memorial Museum of Art*. Kawamura Memorial Museum of Art, 1995; pp.187–191, 7 col. illus.

Walter Hops : 'The Rothko Chapel', in *The Menil Collection : a selection from the Paleolithic to the modern era*. New York : Harry N. Abrams, 1997; pp.314-317, 2 col. illus.

BIBLIOGRAPHY

Sean Scully : 'Against the dying of his own light : mystery and sadness in Rothko's work' (pp.11–23; originally published in the *Times Literary Supplement*, 6 Nov. 1998, no. 4988); and Bernd Klüser : 'Über die Schwierigkeit des Einfachen : Bemerkungen zu den Bildern von S. Scully, M. Rothko und B. Newman' (pp.85–92; English translation by James F. Parry, 'Notes on the pictures of S. Scully, M. Rothko, B. Newman', pp.47–53), in *Sean Scully : Barcelona paintings and recent editions 1999–2000*. Munich : Galerie Bernd Klüser, 1999.

John Golding : 'Newman, Rothko, Still and the reductive image' and 'Newman, Rothko, Still and the abstract sublime', in *Paths to the absolute : Mondrian, Malevich, Kandinsky, Pollock, Newman, Rothko and Still*. London : Thames & Hudson, 2000; pp.153–194, 195–232, *et passim*, illus. (some col.).

Frances Colpitt (ed.) : *Abstract art in the late twentieth century*. Cambridge : Cambridge University Press, 2002; *passim*.

'Mark Rothko : 1903–1970', in *Leeum, Samsung Museum of Art : modern art*. Seoul : Samsung Museum of Modern Art, [2004]; pp.312–313, 1 col. illus.

Briony Fer : *The infinite line : re-making art after Modernism*. New Haven, London : Yale University Press, 2004; pp.5–25, *et passim*, illus.

Roger Kimball : 'Inventing Mark Rothko', Chap. 2 in The rape of the masters : how political correctness sabotages art. San Francisco : Encounter Books, 2004; pp.55–71, illus.

'Robert Motherwell : on Mark Rothko', Chap. 5 in Denise Green : *Metonymy in contemporary art : a new paradigm*. Minneapolis : University of Minnesota Press, 2005; pp.64–73.

Charles Harrison : 'Rothko', Chap. 11, Part V 'Painting the unseen', in *Painting the difference : sex and spectator in modern art*. Chicago ; London : University of Chicago Press, 2005; pp.209–230, illus.

Ellen G. Landau : *Reading Abstract Expressionism : context and critique*. New Brunswick, New Jersey, London : Rutgers University Press, 2005; particularly introd. (pp.1–121) and Lawrence Alloway 'Residual sign systems in Abstract Expressionism' (pp.313–323), *passim*.

William H. Libaw : 'Embodiment without bodies: Mark Rothko', Chap. 21 in *Painting in a world transformed : how modern art reflects our conflicting responses to science and change*. Jefferson N.C. ; London : McFarland & Co., 2005; pp.131–134, illus.

Thomas Crow : 'Unknowing parallels : the last artistic thoughts of Mark Rothko and Eva Hesse', in Karen Painter and Thomas Crow : *Late thoughts : reflections on artists and composers at work*. Los Angeles : Getty Publications, 2006; pp.55–61, 4 col. illus., port.

Simon Schama : 'Rothko : the music of beyond in the city of glitter', in *Simon Schama's power of art*. London : BBC Books, 2006; pp.396–439, illus. (mostly col.)

SOLO EXHIBITION CATALOGUES

Mark Rothko (54 works). Museum of Modern Art, New York, 18 Jan. – 12 Mar. 1961. 44p., illus. (some col.); text by Peter Selz, biog. (pp.7–8), bibl. (pp.40–41), exhibs. (pp.41–42).

[Mark Rothko] A retrospective exhibition : paintings 1945 – 1960 (48 works). Whitechapel Art Gallery, London, Oct. – Nov. 1961; 25p. illus.; biog. (pp.6–7), exhibs. (pp.7–10), bibl. (pp.10–13), text by Peter Selz and Robert Goldwater.

Mark Rothko (48 works). Stedelijk Museum, Amsterdam, 24 Nov. – 27 Dec. 1961; [12]p., illus.; port. biog.

Mark Rothko (49 works). Kunsthalle Basel, 3 Mar. – 8 Apr. 1962; [20]p., 8 leaves of plates (4 col.); port., text by Peter Selz and Robert Goldwater, biog., exhibs.

Mark Rothko (13 works). Marlborough, London, Feb. – Mar. 1964; [36]p., 13 col. plates; biog., exhibs., bibl.

Mark Rothko (27 works). Museo d'Arte Moderna Ca' Pesaro, Venice, 21 June – 15 Oct. 1970; [64]p., 27 col. plates; biog., exhibs., colls.

Mark Rothko : [retrospective exhibition] (62 works). Kunsthaus, Zurich, 21 Mar. – 9 May 1971; exhibition touring to Nationalgalerie Berlin, 26 Mar. 19 July 1971; Museum Boymans-Van Beuningen, Rotterdam, 20 Nov. 1971 – 2 Jan. 1972 ; 115p., illus. (col. plates); text by Werner Haftmann, biog., bibl., exhibs., colls.

Salute to Mark Rothko : [loan exhibition of paintings] (17 works). Yale University Art Gallery, New Haven, 6 May – 20 June 1971; [4]p., 1 col. illus.; text by Andres Carnduff Ritchie.

Mark Rothko (42 works). Musée National d'Art Moderne, Paris, 23 Mar. – 8 May 1972; 41p., illus. (col.); biog. (pp.xxi–xxii), bib . (pp.xxiii–xxviii), exhibs. (pp.xxix–xxxi).

Mark Rothko : the 1958–1959 murals (10 works). Pace Gallery, New York, 28 Oct. – 25 Nov. 1978; [12]p. and 10 leaves of colour plates; introd. by Arnold Glimcher.

Mark Rothko, 1903-1970: A Retrospective (198 works). Solomon R. Guggenheim Museum, New York, 27 Oct. 1978–14 Jan. 1979; 296p., illus.; text by Diane Waldman, biog. (pp.265–279), exhibs. (pp.280–291), bibl. (pp.292–295). (Published simultaneously in London and New York).

Mark Rothko : paintings 1948–1967 (13 works). Pace Gallery, New York, 1 – 30 Apr. 1983; 41p., 13 col. plates; port., introd. by Irving Sandler (pp.5–13).

Mark Rothko : subjects. High Museum of Art, Atlanta, 15 Oct. [1983] – 26 Feb. [1984]; 31p., illus. (some col.); text by Anna Chave, biog. (pp.30–31).

Mark Rothko : works on paper (86 works). National Gallery of Art, Washington, 6 May – 5 Aug. 1984; [8]p., illus.; ports, biog (pp.[5–6]), bibl. (p.[8]).

Mark Rothko : the dark paintings 1969–70 (15 works). Pace Gallery, New York, 29 Mar. – 27 Apr. 1985; 32p., illus. (some col.); text by Brian O'Doherty (pp.5–9).

Mark Rothko, 1903–1970 (93 works). Tate Gallery, London, 17 June – 1 Sept. 1987; 205p., illus, 93 col. plates; ports., bibl. (pp.199–202).

Mark Rothko (52 works). Fundación Juan March, Madrid, 23 Sept. 1937 – 3 Jan. 1988; [120]p., illus. (some col.); ports., text by Michael Compton, biog.

Mark Rothko, 1903–1970 : Retrospektive der Gemälde (66 works). Museum Ludwig, Cologne, 30 Jan. – 27 Mar. 1988; 213p., illus., 66 col. plates; biog. (pp.65–72), bibl. (pp.207–209).

Mark Rothko : the Seagram Mural Project (27 works). Tate Gallery Liverpool, 28 May 1988 – 12 Feb. 1989; 32p., illus. (some col.); text by Michael Compton, bibl. (p.17). (Exhibition guide also produced).

Mark Rothko : Kaapa in New York (38 works). Kunsthalle Basel, 19 Feb. – 7 May 1989; 94p., illus. (mostly col.); port., introd. by Michael Compton 'Introduction to the Seagram Mural Project ' (pp.9–22), text by Thomas Kellein (pp.31–48).

Mark Rothko : the last paintings (11 works). Pace Gallery, New York, 18 Feb. – 19 Mar. 1994; 35p., col. illus.; port., text by Brian O'Doherty, bibl. (p.35).

Mark Rothko (56 works). Kawamura Memorial Museum of Art; Sakura City, 1995; exhibition touring to Maragame Genichiro-Inokuma Museum of Contemporary Art, 11 Nov. – 24 Dec. 1995; Nagoya City Art Museum, 4 Jan. – 12 Feb. 1996; Museum of Contemporary Art, Tokyo, 17 Feb. – 24 Mar. 1996; 225p., 43 illus., 56 col. plates; biog. (pp.192–196); bibl. (pp.197–203).

Mark Rothko in Cornwall (3 works). Tate Gallery St. Ives, 4 May – 3 Nov. 1996; 14p. 3 col. illus.; port.

Mark Rothko : the Chapel Commission (39 works, including 1 not shown in exhibition). Menil Collection, Houston, 13 Dec. 1996 – 29 Mar. 1997; 32p., illus. (some col.); port., introd. by Paul Winkler (p.5).

Mark Rothko (116 works). National Gallery of Art, Washington, 3 May – 16 Aug. 1998; Exhibition touring to Whitney Museum of Art, New York, 10 Sept. – 29 Nov. 1998; Musée d'Art Moderne de la Ville de Paris, 8 Jan. – 18 Apr. 1999; 376p., illus. (some col.); ports., biog. (pp.333-350).

Mark Rothko (68 works). Musée d'Art Moderne de la Ville de Paris, 14 Jan. – 18 Apr. 1999; exhibition also held at Gallery of Art, Washington, 3 May – 16 Aug. 1998, Whitney Museum of Art, New York, 10 Sept. – 29 Nov. 1998; 291p. illus. (68 col. plates); biog. (pp.251–272), bibl. (pp.287–289).

Mark Rothko (84 works). Fundacío Joan Miró, Barcelona, 25 Nov. 2000 – 28 Jan. 2001; 223p., illus. (some col.); biog. (pp.155–162).

Mark Rothko (102 works). Fondation Beyeler, Basle, 18 Feb. – 29 Apr. 2001; 203p., illus (mostly col.); ports., biog. pp.(185–193), bibl. (pp.195–202).

Mark Rothko : paredes de luz (60 works). Guggenheim Museum, Bilbao, 8 June – 24 Oct. 2004; 175p., illus. (mostly col.); ports., biog. (pp.157–173).

Mark Rothko : Arbeiten auf Papier 1930–1969 = Mark Rothko : works on paper 1930–1969 (62 works). Galerie Beyeler, Basle, 7 June – 20 Aug. 2005; 66p., illus (mainly col.); ports.

The art of Mark Rothko : selections from the National Gallery of Art, Washington (27 works). Leeum, Samsung Museum of Art, Seoul, 22 June – 10 Sept. 2006; 68p., col. illus.; port., biog. (pp.84–85).

Mark Rothko (38 works). Tel Aviv Museum of Art, 29 Mar. – 30 June 2007; 238p., col. illus.; ports., ed. by Mordechai Omer and Christopher Rothko, introd by Christopher Rothko (pp.9–10), includes essays by Christopher Rothko 'Mark Rothko and the quiet dominance of form' (pp.11–27), John Gage 'Rothko: color as subject' (pp.43–56), Natalie Kosoi 'Nothingness made visible: the case of Rothko's paintings' (pp.57–66), Mordechai Omer 'Cycles of faith: Rothko, Kierkegaard and the sacrifice of Isaac' (pp.67–89), biog. compiled by Ahuva Israel (pp.91–108).

Rothko (100 works). Palazzo delle Esposizioni, Rome, 6 Oct. 2007 – 6 Jan. 2008; ed. by Oliver Wick, biog. (pp.211–220), bibl. (pp.221–232).

Mark Rothko: Retrospektive (115 works). Kunsthalle der Hypo-Kulturstiftung, Munich, 8 Feb. – 27 Apr. 2008 and Hamburger Kunsthalle, 16 May – 24 Aug. 2008; 218p., col. illus.; ports., ed. by Hubertus Gassner, Christiane Lange and Oliver Wick, biog. (pp.196–206), bibl. (pp.208–210).

GROUP EXHIBITIONS

Lipton, Rothko, Smith, Tobey : 29th Biennale Venezia 1958 : Stati Uniti d'America (10 works by MR). Venice Biennale, 1958; [53]p., illus.; text 'Mark Rothko' by Sam Hunter.

The Sidney Janis Painters : Albers, Baziotes, Gorky, Gottlieb, Guston, Kline, de Kooning, Motherwell, Rothko, Pollock (2 works by MR). John & Mable Ringling Museum of Art, Sarasota, 8 Apr. – 7 May 1961; 34p., illus., biog. (p.34).

Six painters : Mondrian, Guston, Kline, de Kooning, Pollock, Rothko (9 works by MR). University of St. Thomas, Art Department, Houston, Feb. – Apr. 1967; 67p., illus. (some col.).

Six peintres Americains : Gorky, Kline, de Kooning, Newman, Pollock, Rothko (1 work by MR). Knoedler & Cie, Paris, Oct. 1967; 38p., illus.

Twenty-five years of American painting, 1948–1873 (2 works by MR). Des Moines Art Center, 6 Mar. – 22 Apr. 1973; [54]p., illus. (some col.), bibl.

Landscapes, interior and exterior : Avery, Rothko and Schueler (3 works by MR). Cleveland Museum of Art, 9 July – 31 Aug. 1975; [30]p., illus. (some col.), biog., bibl., exhibs.

American art at mid-century : the subjects of the artist (8 works by MR). National Gallery of Art, Washington, 1 June 1978 – 14 Jan. 1979; 296p., illus. (some col.), biog. (pp.244), essay by Eliza E. Rathbone 'Mark Rothko : the brown and gray paintings' (pp.242-266).

Zeichen des Glaubens : Geist der Avantgard : Religiose Tendenzen in der Kunst des 20 Jahrhunderts (6 works by MR). Orangerie des Schloss Charlottenberg, Berlin, 31 May – 13 July 1980; 55p, illus.

Ten Americans from Pace (2 works by MR). Wildenstein Gallery, London, 18 June – 18 July 1980; [32]p., illus. (some col.).

Klassiche Moderne = Classical Moderns (1 work by MR). Galerie Gmurzynska, Cologne, May – Aug. 1981; 272p., illus. (some col.).

American Abstract Expressionists (5 works by MR). City Art Centre and Fruitmarket Gallery, Edinburgh, 13 Aug. – 12 Sept. 1981; 12p., illus. (mostly col.).

Peintres du silence : Julius Bissier, Giorgio Morandi, Ben Nicholson, Mark Rothko, Mark Tobey, Italo Valenti (2 works by MR). Musée Jenisch, Vevey, 13 Sept. – 22 Nov. 1981; 88p. illus. (some col.); biog. (p.72).

Amerikanische Malerei 1930-1980 (4 works by MR). Haus der Kunst, Munich, 14 Nov. 1981 – 31 Jan. 1982; 301p., illus. (some col.), biog. (pp.275–276).

The Richard and Jane Lang Collection (4 works by MR). Art Museum, Seattle, 2 Feb. – 1 Apr. 1984; 65p., illus. (some col.).

An American Renaissance : painting and sculpture since 1940 (1 work by MR). Museum of Art, Fort Lauderdale (Fla.), 12 Jan. – 30 Mar. 1986, 296p., illus. (some col.), bibl. (pp.255–260).

Beuys, Klein, Rothko (13 works by MR). Anthony d'Offay Gallery, London, 5 June – 3 July 1987; 87p., illus. (some col.), ports.

Beuys, Klein, Rothko / exposición organizada por la Galería Anthony d'Offay, Londres (10 works by MR). Fundación Caja de Pensiones, Madrid, 17 Sept. – 8 Nov. 1987; 95p. illus. (some col.); ports.

Abstract Expressionism : the critical developments (8 works by MR). Albright-Knox Art Gallery, Buffalo, 1987, 19 Sept. – 29 Nov. 1987; 302p., illus. (some col.), bibl. (pp.292–293).

Old masters – new visions : El Greco to Rothko, from the Phillips Collection, Washington D.C. (2 works by MR). Australian National Gallery, Canberra, 3 Oct. – 6 Dec. 1987; 85p., illus.

Another world : Mito Annual '93 (3 works by MR). Art Tower Mito Contemporary Art Center, Mito, 21 Nov. 1992 – 3 Mar. 1993; 2v. illus. (some col.); ports., biog. (vol.2 p.52).

Konzept : Farbe : Albers, Dienst, Erben, Gecelli, Geiger, Graubner, Jawlensky, Jochims, Lohse, Minnich, Nay, Poliakoff, Rothko, Saro, Zeniuk (1 work by MR). Galerie Karin Fesel, Düsseldorf, 1993; 131p., illus. (some col.); ports.

I love yellow (3 works by MR). Galerie Beyeler, Basle, June – Sept. 1996; 60p., col. illus.

Bonnard, Rothko : color and light (13 works by MR). PaceWildenstein, New York, 19 Feb. – 22 Mar. 1997; 69p., col. illus.

Greenberg Van Doren Gallery : selected works (2 works by MR). Greenberg Van Doren Gallery, St. Louis, 1998; 86p, col. illus.

The New York School : de Kooning, Gorky, Kline, Newman, Pollock. Rothko, Smith, Still (1 work by MR). Gagosian Gallery, New York, 17 Mar. – 25 Apr. 1998; 16p., col. illus.

Art in the 20th century : modern masterpieces from the Collection of the Stedelijk Museum, Amsterdam (1 work by MR). City Art Gallery, Wellington, 4 Apr. – 5 July 1998; 144p., col. illus., biog. (p.139).

À rebours : la rebelión informalista, 1939–1968 (3 works by MR). Centro Atlántico de Arte Moderno, Las Palmas, 20 Apr. – 13 June 1999; 386p., illus. (mostly colour); ports., biog. (p.369).

BIBLIOGRAPHY

Cézanne und die Moderne : Picasso, Braque, Léger, Mondrian, Klee, Matisse, Giacometti, Rothko, De Kooning, Kelly (1 work by MR) Fondation Beyeler, Basle, 10 Oct. 1999 – 9 Jan. 2000; 137p., illus. (mostly col.); text by Gottfried Boehm, biog. (p.136.)

The legacy of a collector : the Panza di Biumo Collection at the Museum of Contemporary Art, Los Angeles (7 works by MR). Museum of Contemporary Art, Los Angeles, 12 Dec. 1999 – 30 Apr. 2000; 251p., illus. (mostly col.); port., biog. (pp.235–236), bibl. (pp.236–237).

Cross-currents in modern art : a tribute to Peter Selz (2 works by MR). Achim Moeller Fine Art, New York, 2 Feb. – 3 Mar. 2000; 78p., illus. (some col.), ports., bibl. (pp.66-75).

Expressionismo Abstracto : orba sobre papel : Colección the Metropolitan Museum of Art New York (9 works by MR). Fundación Juan March, Madrid, 9 May – 2 July 2000; 159p., col. illus.

On the sublime : Mark Rothko, Yves Klein, James Turrell (5 works by MR). Deutsche Guggenheim Berlin, 7 July – 7 Oct. 2001; 135p. illus. (some col.); ports.

A century of drawing : works on paper from Degas to LeWitt (5 works by MR). National Gallery of Art, Washington, 18 Nov. 2001 – 17 Apr. 2002; 316p., illus. (mostly col.); particularly pp.250–255.

Claude Monet : … up to digital impressionism (3 works by MR). Fondation Beyeler, Basle, 28 Mar. - 4 Aug. 2002; 251p., illus. (mainly col.); 'The Monet revival and New York School abstraction', by Michael Leja pp.133–159.

Coming to light : Avery, Gottlieb, Rothko : Provincetown summers 1957 – 1961 (7 works by MR). Knoedler & Company, New York, 2 May – 15 Aug. 2002; 107p., illus. (mostly col.), 'Avery, Gottlieb and Rothko : The Provincetown summers', pp.10–12, Christopher Rothko 'Mark Rothko and the quiet dominance of form' (pp.18–19), bibl. (pp.105–107).

Seeking transcendence : Edvard Munch , Mark Rothko, Ann Hamilton, Robert Irwin, Wolfgang Laib (4 works by MR). Art Gallery of Western Australia, Perth, 13 Feb. – 24 Apr. 2005; 20p., col. illus.

Black paintings (16 works by MR). Haus der Kunst, Munich, 15 Sept. 2005 – 14 Jan. 2007; 203p., illus. (some col.), bibl. (pp.104–105), biog. (p.98).

The perception of the horizontal (1 work by MR). Museion, Bolzano, 17 Sept. 2005 – 8 Jan. 2006; 96p., illus. (mostly col.).

Ecole de New York : Expressionisme abstrait américain : œuvres sur papier : William Baziotes, Adolph Gottlieb, Hans Hofmann, Franz Kline, Willem de Kooning, Robert Motherwell, Jackson Pollock, Richard Pousette-Dart, Mark Rothko, David Smith, Jack Tworkov (1 work by MR). Editions Nice Musées, 8 Dec 2005 – 5 Mar. 2006; 87p. illus. (some col.); ports., bibl. (p.87).

Dream museum : the Osaka collections (2 works by MR). National Museum of Art, Osaka, 16 Jan. – 25 Mar. 2007; 159p. illus. (mostly col.).

Declaring space : Mark Rothko, Barnett Newman, Lucio Fontana, Yves Klein (6 works by MR). Modern Art Museum of Fort Worth, 30 Sept. 2007 – 6 Jan. 2008; 176p., illus. (some col.), bibl. (p.170).

The abstraction of Landscape : from northern romanticism to Abstract Expressionism (5 works by MR). Fundación Juan March, Madrid, 5 Oct. 2007 – 13 Jan. 2008; 271p. illus. (some col.); chap. 4 'The spirit of landscape and total abstraction: from Newman to Rothko' (pp.161–199).

Color as field : American painting 1950–1975 (1 work by MR). Denver Art Museum, 9 Nov. 2007 – 3 Feb. 2008; 127p., illus. (mostly col.), ports., biog. (pp.13–114).

AUDIO-VISUAL

An introduction to the humanities [programme 30] : Rothko : the Seagram Murals. Milton Keynes : Open University, 1999; 30 min., col., narrated by Charles Harrison.

Simon Schama's power of art : Rothko [Programme 8]. London : BBC2, 2006; 30 min., col., broadcast 8 Dec. 2006.

Centurians : [assessment of the painter Mark Rothko]. London : BBC Radio 7, 2007; 15 min. Unedited off-air sound recording from 21 Nov. 2007, with contributions by George Segal, Richard Cook and Charles Harrison.

ARTICLES, REVIEWS, ETC.

1960
Ashton Dore : 'Perspective de la peinture américaine' in Cahiers d'Art, 1960, no. 33–35, pp. 203–220.

H. Harvard Arnason and Sir Herbert Read : 'Dialogue on Modern U.S. painting', in Art News, May 1960, vol. 59, no. 1, pp.33–35.

Georgine Oeri : 'Tobey and Rothko', in Baltimore Museum of Art News, Winter 1960, 23, no. 2, pp.2–8.

1961
Georgine Oeri : 'Marc Rothko', in Quadrum, 1961, no. 10, pp.65–74, 189.

E.C. Goossen : 'Rothko : the omnibus age', in Art News, Jan. 1961, vol. 59, no. 9, pp.38–49, 60–61.

Robert Rosenblum : 'The Abstract Sublime', in Art News, Feb. 1961, vol. 59, no. 10, pp.38–41, 56–58.

Max Kozloff : 'Mark Rothko's new retrospective', in Art Journal, Spring 1961, vol. 20, no. 3, pp.148–149.

Robert Goldwater :'Reflections on the Rothko exhibition', in Arts, Mar. 1961, vol. 35, no. 6, pp.42–45.

Stuart Preston : 'Current and forthcoming exhibitions : New York [review of Museum of Modern Art exhib.], in Burlington Magazine, Mar. 1961, vol. 103, no. 696, p.116.

Irving Hershel Sandler : 'New York letter', in Art International, Mar. 1961, vol. 5, no. 2, pp.40–41.

Peter Selz : 'Mark Rothko', in L'Oeil, April 1961, no. 76, pp.36-43, 82.

I.H.S [Irving Hershel Sandler] : 'Ten Americans' [review of Janis exhib.], in Art News, Summer 1961, vol. 60, no. 4, p.10.

Henry Geldzahler : 'Heller : new American-type collector', in Art News, Sept. 1961, vol. 60 no. 3, pp.28–31.

'A spiritual experience : paintings by Mark Rothko' [review of Whitechapel exhib.], in The Times, 13 Oct. 1961, p.18.

Keith Sutton : 'Round the London art galleries' [review of Whitechapel exhib.], in The Listener, 19 Oct. 1961, vol. 66, no. 1699, p.616.

David Sylvester : 'Rothko', in New Statesman, 20 Oct. 1961, vol. 62, no. 1597, pp.573–574.

Jane Harrison : ''Mark Rothko' [review of Whitechapel exhib.], in Arts Review, 21 Oct – 4 Nov. 1961, vol. 13, pp.2, 18.

A. Brookner : 'Current and forthcoming exhibitions' [review of Whitechapel exhib.], in Burlington Magazine, Nov. 1961, vol. 103, no. 704, p.477.

'Rothko : painter of walls of light' [review of Whitechapel exhib.], in The Times, 7 Nov. 1961, no. 55232, p.15.

1962
Michael Butor : 'The mosques of New York, or the art of Mark Rothko', in New World Writing, 1962, vol.21, pp.7-25.

Lawrence Alloway : 'Notes on Rothko', in Art International, Summer 1962, vol. VI, no. 5–6, pp.90–94.

1964
Pierre Rouve : 'Rothko : Marlborough New London' [review of Marlborough exhib.], in *Arts Review*, 22 Feb. — 7 Mar. 1964, vol. 16, no. 3, pp. 3, 17, 22.

Keith Roberts : 'Current and forthcoming exhibitions : London' [review of New London Gallery exhib.], in *Burlington Magazine*, Apr. 1964, vol. 106, no. 733, p.194.

G. S. Whittet : 'London commentary : fresh facets in mature artist's work' [review of Marlborough exhib.], in *Studio International*, May 1964, vol. 167, no. 853, p.216.

1965
Max Kozloff : 'The problem of color-light in Rothko', in *Artforum*, Sept. 1965, vol. IV, no. 1, pp.38—44.

1967
'The Times diary ; Rothko's gift to the Tate', in *The Times*, 11 Apr. 1967, p.10.

1970
'Obituary : Mark Rothko : American pioneer of Abstract Expressionist painting', in *The Times*, 27 Feb. 1970, p.10.

Thomas B. Hess : 'Editorial : Mark Rothko, 1903 — 1970', in *Art News*, Apr. 1970, vol. 69, no. 2, pp.29, 66—67.

'Suicide de Mark Rothko', in *Connaissance des Arts*, Apr. 1970, no. 218, p.29.

Max Kozloff : 'Mark Rothko (1903 — 1970)', in *Artforum*, Apr. 1970, vol. 8, no. 8, pp.88—89.

Hilary Spurling : 'Emperor Rothko', in *The Times*, 4 June 1970, p.13.

R.C. Kenedy : 'Mark Rothko', in *Art International*, Oct. 1970, vol. 14, no. 8, pp.45—49.

Brian O'Doherty : 'Rothko', in *Art International*, Oct. 1970, vol. 14, no. 8, pp.30—44.

Thomas B. Hess : 'Rothko : a Venetian souvenir', in *Art News*, Nov. 1970, vol. 69, no. 7, pp.40—41, 72—74.

Alastair Gordon :In the Galleries : the Rothko Room', in *Connoisseur*, Dec. 1970, vol. 175, no. 706, pp.30—44.

1971
Dominique de Ménil : 'The Rothko Chapel', in *Art Journal*, Spring 1971, vol. 30, no. 3, pp.249—251.

Robert Goldwater : 'Rothko's Black Paintings' in *Art in America*, Mar.— Apr. 1971, vol. 59, no. 2, pp.58—63.

Thomas B. Hess : 'Editorial : can art be used?', in *Art News*, Apr. 1971, vol. 70, no. 2, p.33.

Jean-Patrice Marandel : 'Une chapelle oecuménique au Texas' in *L'Oeil*, May 1971, no. 197, pp.16—19.

Dore Ashton : 'The Rothko Chapel in Houston', in *Studio International*, June 1971, vol. 181, no. 934, pp.273—275.

'Rothko Chapel dedicated in Houston', in *Connoisseur*, July 1971, no. 713, p.225.

Gregory Battock : 'New York one' [Rothko Chapel], in *Art and Artists*, July 1971, vol. 6, no. 4, issue no. 64, pp. 58—59.

1972
Guy Burn : 'Rothko : Rietveld' [review of Hayward exhib.], in *Arts Review*, Feb. 1972, vol. 24, no. 3, p.78.

James Burr : London galleries : Caliban and calm', in *Apollo*, Feb. 1972, vol. 95, no. 120, p.139.

Peter Campbell : 'Art : three [review of Hayward exhib.], in *The Listener*, 17 Feb. 1972, vol. 87, no. 2238, p.225.

Christopher Neve : 'Pictures must be miraculous : Rothko at the Hayward Gallery', in *Country Life*, 17 Feb. 1972, vol. 151, no. 3897, p.391.

Richard Cork : 'UK commentary' [review of Hayward exhib.], in *Studio International*, Mar. 1972, vol. 183, no. 942, pp.120—121.

Keith Roberts : 'Current and forthcoming exhibitions : London' [review of Hayward exhib.], in *Burlington Magazine*, Mar. 1972, vol. 114, no. 828, pp.190, 193.

Andrew Causey : 'Rothko through his paintings', in *Studio International*, Apr. 1972, vol. 183, no. 943, pp.149—155.

Frank Bowling : 'Problems of criticism V', in *Arts Magazine*, May 1972, vol. 46, no. 7, pp.37—38.

1973
Brian O'Doherty : 'The Rothko Chapel', in *Art in America*, Jan.—Feb. 1973, vol. 61, no. 1, pp.14—16, 18, 20.

Charles Harrison : 'Abstract Expressionism II', in *Studio International*, Feb. 1973, vol. 185, no. 952, pp.58—60.

Budd Hopkins : 'Budd Hopkins on Budd Hopkins', in *Art in America*, July—Aug. 1973, vol. 61, no. 4, pp.91—93.

Lawrence Alloway : 'Residual sign systems in Abstract Expressionism', in *Artforum*, Nov. 1973, vol. 12, no. 3, pp.36—42.

1974
Les Levine : 'Dallas has the airport but Houston's got the art, Lone Star Four : Mrs John de Menil in the Rothko Chapel', in *Arts Magazine*, Mar. 1974, vol. 48, no. 6, pp.30—33.

Wallace Putnam : 'Mark Rothko told me', in *Arts Magazine*, Apr. 1974, vol. 48, no. 7, pp.44—45.

1975
Janet Kutner : 'Brice Marden, David Novros, Mark Rothko : the urge to communicate through non-imagistic painting', in *Arts Magazine*, Sept. 1975, vol. 50, no. 1, pp.61—63.

1976
Ann Holmes : 'The Rothko Chapel six years later', in *Art News*, Dec. 1976, vol. 75, no. 10, pp.35—37.

1977
Dore Ashton : 'Oranges and lemons : an adjustment', in *Arts Magazine*, Feb. 1977, vol. 51, no. 6, p.142.

1978
Donald B. Kuspit : 'Symbolic pregnance in Mark Rothko and Clifford Still', in *Arts Magazine*, Mar. 1978, vol. 52, no. 7, pp.120—125.

Malcolm N. Carter : 'Art , money and the troubles of Mark Rothko', in *Horizon*, Oct. 1978, vol.21, no.10, pp.20—29.

Peter Fuller : 'The legacy of Mark Rothko', in *Art Monthly*, Oct. 1978, no. 20, pp.3—5.

Robert Hughes : 'The Rabbi and the moving blur : at the Guggenheim Museum, a Rothko Retrospective', in *Time*, Nov. 1978, vol.112, no. 19, pp.8—16.

Ann Holmes : 'The Rothko Chapel : a gentle glow', in *Art News*, Dec. 1978, vol. 77, no. 10, pp. 109, 111—112.

1979
Michael Merz : 'Ich sammle keine Kunst, ich sammle Geld : Geschichten um der Rothko-Prozess', in *Du*, 1979, no. 4, pp.4—6.

Barbara Cavaliere : 'Mark Rothko' [review of Pace Gallery exhib.], in *Arts Magazine*, Jan. 1979, vol. 53, no. 5, p.20.

Eric Gibson : 'Mark Rothko' [review of the Guggenheim exhib.], in *Art International*, Jan. 1979, vol. 22, no. 8, p.42.

Donald Goddard : 'Rothko's journey into the unknown', in *Art News*, Jan 1979, vol. 78, no. 1, pp.36—40.

Joseph Liss : 'William de Kooning remembers Mark Rothko : "his house had many mansions"' [interview], in *Art News*, Jan 1979, vol. 78, no. 1, pp.41—44.

Stephen Polcari : 'Mark Rothko', in *Arts Magazine*, Jan. 1979, vol. 53, no. 5, p.3.

John T. Spike : [review of the Guggenheim exhib.], in *Burlington Magazine*, Jan. 1979, vol. 121, no. 910, pp.636—4.

BIBLIOGRAPHY

Denis Thomas : 'If it sells it's art' [review of *The legacy of Mark Rothko* by Lee Seldes], in *The Listener*, 18 Jan. 1979, pp.143–144.

Barbara Cavaliere : 'Notes on Rothko', in *Flash Art*, Jan.–Feb. 1979, no. 86–87, pp.32–38.

Dore Ashton : 'Rothko's passion' in *Art International*, Feb. 1979, vol. 22, no. 9, pp.6–13.

Konstartin Bazarov : 'The legacy of Mark Rothko by Lee Seldes' [book review], in *Art and Artists*, Feb. 1979, vol. 13, no. 10, pp.46–48.

T. Fujieda : 'Special feature : Mark Rothko', in *Mizue*, Mar. 1979, no. 888, pp.6–57. Text in Japanese.

Fred Hoffman : 'Glimpses of the transcendent' [review of the Guggenheim exhib. on tour at the Museum of Fine Arts], in *Artweek*, 17 Mar. 1979, vol. 10, no. 11, pp. 1, 16.

Peter Schjeldahl : 'Rothko and belief', in *Art in America*, Mar.–Apr. 1979, vol. 67, no. 2, pp.78–85.

Nina Bremer : 'New York, the Solomon R. Guggenheim Museum exhibition : Mark Rothko, 1903–1970, retrospective exhibition October 27, 1978 – January 14, 1979', in *Pantheon*, Apr. 1979, vol.37, pp.20–29.

Jean-Luc Bordeaux : 'Rothko', in *Connaissance des Arts*, May 1979, no. 327, pp.114–119.

'Rothko' [review of the Guggenheim exhib. on tour at the County Museum of Art, Los Angeles], in *L'Oeil*, Sept. 1979, no. 290, p.69.

Stephen Polcari : 'The intellectual roots of Abstract Expressionism : Mark Rothko', in *Arts Magazine*, Sept. 1979, vol. 54, no. 1, pp.124–134.

John and Natasha Stodder : 'Rothko on film' [review of film *In search of Rothko* by Courtney Sale], in Artweek, 15 Sept. 1979, vol. 10, no. 29, p.16.

1981
Evan R. Firestone : 'Color in Abstract Expressionism : sources and background for meaning', in *Arts Magazine*, Mar. 1981, vol. 55, no. 7, pp.140-143.

Ann Gibson : 'Regression and color in Abstract Expressionism : Barnett Newman, Mark Rothko and Clyfford Still', in *Arts Magazine*, Mar. 1981, vol. 55, no. 7, pp.144–153.

'More solid foundation' [on Rothko foundation], in *Art News*, Sept. 1981, vol. 80, no. 7, pp.20, 22.

1983
'Rothko', in *Bulletin of the Walker Art Centre*, Minneapolis, Jan. 1983, p.1.

Valentine Tatransky [review of the Pace Gallery exhib. 1983] : 'Kenneth Noland : as great as ever', in *Arts Magazine*, June 1983, vol. 57, no. 10, p.119.

Howard Singerman : 'Tainted image : Rothko on tv [review of *The Rothko Conspiracy*], in *Art in America*, Nov. 1983, vol. 71, pp.11–13.

Peter Schjeldahl : 'Mystifying the mysterious' [review of *About Rothko* by Dore Ashton], in *Art in America*, Dec. 1983, vol. 71, no. 11, p.15.

1984
Carla Hall : 'Celebrating the art of Rothko' [review of the National Gallery of Art exhib. 1984], in *Washington Post*, 4 May 1984, Section B, pp.1, 8.

Pamela Kessler : 'Fade to gray : Mark Rothko at National', in *Washington Post*, 4 May 1984, p.39.

Paul Richard : Rothko on paper : gazing at eternity' [review of the National Gallery of Art exhib. 1984], in *Washington Post*, 13 May 1984, Section H, pp.1, 5.

'Mark Rothko : works on paper' [review of the National Gallery of Art exhib.], in *Museum News*, June 1984, vol. 62, no. 5, pp.71–72.

Waldemar Januszczak : 'Elusive art' [review of *About Rothko* by Dore Ashton], in *Guardian*, 23 Aug. 1984, p.8.

Michael Brenson : 'Rothko at the Guggenheim' [review of the National Gallery of Art exhib. 1984 on tour at the Guggenheim], in *New York Times*, 7 June 1985, pp.1, 24.

Stephen Gardiner : 'New academic?' [review of *About Rothko* by Dore Ashton], in *The Listener*, 16 Aug. 1984, p.26.

1985
Michael Brenson : 'Mark Rothko : the dark paintings 1969–70 [review of Pace exhib.], in *New York Times*, 12 Apr. 1985.

Michael Brenson : 'The museum scene : no time off for doldrums : Rothko at the Guggenheim, in *New York Times*, 7 June 1985.

Bonnie Clearwater : 'How Rothko looked at Rothko', in *Art News*, Nov. 1985, vol. 84, no. 9, pp.100–103.

Robin Duthy : 'The fortunes of Rothko : immensely admired his paintings are not always easy to sell', in *Connoisseur*, Nov. 1985, vol. 215, no. 886, pp.174–185.

Irvin Molotsky : 'Six Rothko murals to hang at the National', in *New York Times*, 10 Nov. 1985, p.81.

James Burr : 'Further book reviews' [review of *Works on paper* cat.], in *Apollo*, Dec. 1985, vol. 122, no. 286, pp.504, 506.

1986
Claude R. Cernuschi : Mark Rothko's mature paintings : a question of content', in *Arts Magazine*, May 1986, vol. 60, no. 9, pp.54–57.

Bill Berkson : 'San Francisco : Mark Rothko', [review of *Works on paper* exhib.], in *Artforum*, Oct. 1986, vol. 25, no. 2, pp.139–140.

Barry Schwabsky : 'The real situation : Philip Guston and Mark Rothko at the end of the Sixties', in *Arts Magazine*, Dec. 1986, vol. 61, no. 4, pp.46–47.

Eugene Victor Thaw : 'The Abstract Expressionists', in *The Metropolitan Museum of Art Bulletin*, Winter 1986/1987, vol. 44, pp.3–56.

1987
David Lee : 'Brush with fame and death', in *The Times*, 13 June 1987, p.50.

Waldemar Januszczak : 'Bright light in the dark' [review of Tate exhib.], in *Guardian*, 20 June 1987, p.9.

William Packer : 'Sensations of light' [review of Tate exhib.], in *Financial Times*, 23 June 1987, p.21.

Marina Vaizey : 'Hovering on clouds of many colours' [review of Tate exhib.], in *Sunday Times*, 28 June 1987, p.51.

Larry Berryman [review of Tate exhib.], in *Arts Review*, July 1987, vol. 39, no. 13, p.448.

John Russell Taylor : 'Magisterial progression' [incl. review of Tate exhib.], in *The Times*, 1 July 1987, p.18.

Richard Cork : 'Pictures as dramas' [review of Tate exhib.], in *Listener*, 2 July 1987, pp.38–39.

Richard Boston : 'A bit on the side' [review of Tate exhib.], in *Guardian*, 3 July 1987, p.21.

Laure Meyer [review of Tate exhib.], in *L'Oeil*, July/Aug. 1987, no. 384/5, p.83.

Rupert Martin : 'Mark Rothko and the American sublime', in *Artseen*, [Aug.] 1987, no.19, pp.6–8.

Peter Fuller : 'Mark Rothko, 1903 – 1970' [review of Tate exhib.], in *Burlington Magazine*, Aug. 1987, vol. 129, no. 1013, pp.545–547.

David Anfam : 'Mark Rothko at the Tate Gallery', in *Art International*, Autumn 1987, no. 1, pp.96–99.

Robin Stemp : 'Mark Rothko at the Tate Gallery', in *The Artist*, Sept. 1987, vol. 102, no. 9, pp.32–33.

1988
Katy Deepwell, Juliet Steyn : 'Readings of the Jewish artist in late Modernism', in *Art Monthly*, Feb. 1988, no. 113, pp.6–9.

Stephen Polcari : 'Mark Rothko : heritage, environment and tradition', in *Smithsonian Studies in American Art*, Spring 1988, vol. 2, no. 2, pp.32–63.

Amine Haase : 'Mark Rothko : Joseph Marioni' [review of Museum Ludwig exhib.], in *Kunstforum International*, Apr.– May. 1988, vol. 94, pp.262–265.

Eric Gibson : 'The other Rothko scandal', in *New Criterion*, Oct. 1988, vol. 7, no. 2, pp.85–88.

Charles Giuliano : 'Blaming the victim', in *Art News*, Nov. 1988, vol.87, no. 9, p.38.

Haun Saussy [review of Harvard exhib.], in *Arts Magazine*, Nov. 1988, vol. 63, no. 3, p.96.

J.R.R. Christie, Fred Orton : 'Writing on a text of the life', in *Art History*, Dec. 1988, vol. 11, no. 4, pp.545–546.

1989
Anna Chave : 'Mark Rothko : subjects in abstraction', in *Art and Design*, 1989, vol. 5, no. 11–12, pp.42–49.

Hilton Kramer : 'Was Rothko an abstract painter?', in *New Criterion*, Mar. 1989, vol. 7, no. 7, pp.1–5.

Patrick Heron : 'Can Mark Rothko's work survive?', in *Modern Painters*, Summer 1989, vol, 2, no. 2, pp.36–37, 39.

Andrew Decker : 'Rothko's legacy', in *Art News*, Sept. 1989, vol. 88, no. 7, pp.41, 43.

Terry Atkinson : 'Rothko : convention and deconstruction', in *Art Monthly*, Nov. 1989, no. 131, pp.10–12, 14, 16.

1990
Jonathan Harris : 'Militant monographs' [review of Mark Rothko : subjects in abstraction], in *Oxford Art Journal*, 1990, vol. 13, no. 1, pp.101–105.

David Anfam : [review of *Mark Rothko : subjects in abstraction*], in *Burlington Magazine*, July 1990, vol. 132, no. 1048, pp.502–503.

Xavier Girard : 'Le temple du monochrome', in *Beaux-Arts Magazine*, Dec. 1990, no. 85, pp.118–121.

1992
Anthony O'Hear : 'The real or the Real? Chardin or Rothko?', in *Modern Painters*, Spring 1992, vol. 5, no. 1, pp.58–62.

1993
Vincent J. Bruno : 'Mark Rothko and the Second Style: the art of the color-field in Roman murals', in *Studies in the History of Art*, 1993, vol. 43, pp.62–93.

Paola Serra Zanetti : 'Rothko o la tragedia di un solitario', in *Arte*, Jan. 1993, vol. 23, no. 236, pp.52–7.

Robin Cembalest : 'Rothko revealed' [the Rothko murals at Cambridge Mass.], in *Art News*, Apr. 1993, vol. 92, no. 4, p.42.

1994
Eric Gibson : 'Lives of the artist' [review of *Mark Rothko : a biography*], in *New Criterion*, Jan. 1994, vol. 12, no. 5, pp.69–75.

Julia Neuberger : 'The man the past never left alone', in *The Times*, 10 Jan. 1994, p.32.

Roberta Smith : 'Gallery view : for Rothko it wasn't all black despair', in *New York Times*, 6 Mar. 1994, p.41.

Brian Sewell : 'Barren fields' [review of *Mark Rothko : a biography*], in *Art Review*, Apr. 1994, no. 46, pp.34–36.

T.J. Clark : 'In defense of Abstract Expressionism', in *October*, Summer 1994, no. 69, pp.22–48.

Steven Johnson : 'Rothko Chapel and Rothko's Chapel', in *Perspectives of New Music*, Summer 1994, vol. 32, no. 2, pp.6–53.

Stephen Henry Madoff : 'Mark Rothko' [review of Pace Gallery exhib.], in *Art News*, Summer 1994, vol. 93, no. 6, p.176.

Hayden Herrera : 'Biography' [review of *Mark Rothko : a biography*], in *Art in America*, July 1994, vol. 82, no. 7, pp.29, 31.

1996
Rachel Barnes : 'Leaving a mark' [interview with Patrick Heron on the occasion of the St. Ives exhib.], in *Art Review*, May 1996, vol. 48, pp.28, 30.

Adrian Searle : 'When Mr Gloom came to play' [review of St. Ives exhib.], in *Guardian*, 14 May 1996.

Michael Compton : 'The big picture' [on the occasion of the St. Ives exhib.], in *Tate*, Summer 1996, no. 9, pp.49–51.

Günther Englehard : 'Abstraktion : Mark Rothko', in *Art : das Kunstmagazin*, July 1996, vol. 7, pp.14–27.

Simon Morley : 'Yanks : Tobey and Rothko in England' [review of St. Ives exhib.], in *Art Monthly*, July/Aug. 1996, no. 198, pp.9-12.

Emma E. Roberts : 'St Ives. Mark Rothko' [review of St. Ives exhib.], in *Burlington Magazine*, Oct. 1996, vol. 138, no. 1123, pp.702–703.

1997
Frances Colpitt : 'Outtakes from the Chapel' [review of Menhil exhib.], in *Art in America*, June 1997, vol. 85, no. 6, pp.98–99.

Stephen Polcari : 'Houston. Mark Rothko' [exhibition review], in *Burlington Magazine*, July 1997, vol. 139, no. 1132, pp.505–507.

Richard Coles : 'The Rothko Chapel : religious art without God' [review of *The Rothko Chapel paintings : origins, structure, meaning* by Sheldon Nodelman], in *Art Newspaper*, July–Aug. 1997, p.45.

Klaus Kertess : 'Mark Rothko : Menil Collection' [review of Menil exhib.], in *Artforum*, Oct. 1997, vol. 36, no. 2, p.96.

1998
Claude Cernuschi : 'Mark Rothko from alpha to omega', in *Archives of American Art Journal*, 1998, vol. 38, no. 1–2, pp.39–45.

Robert Rosenblum : 'Isn't it romantic' [review of Washington exhib.], in *Artforum*, May 1998, vol. 36, no. 9, pp.24–29.

Kenneth Baker : 'Shedding light on Rothko's light' [review of Washington exhib.], in *Art Newspaper*, June 1998, p.24.

Bryan Robertson : 'About Rothko', in *Modern Painters*, Autumn 1998, vol. 11, no. 3, pp.24–29.

Michael Kimmelman : 'Rothko's gloomy elegance in retrospect', in *New York Times*, 18 Sept. 1998, pp.31, 34.

Anna C. Chave : 'Washington and New York : Mark Rothko' [review of Washington and New York exhibs.], in *Burlington Magazine*, Oct. 1998, vol. 140, no. 1147, pp.712–714.

Rex Weil : 'Mark Rothko' [review of Washington exhib.], in *Art News*, Oct. 1998, vol. 97, no. 9, p.152.

Dore Ashton : 'Rothko's mystery remains' [review of cat. raisonné], in *Modern Painters*, Winter 1998, pp.109-110.

Mario Naves : 'Mark Rothko at the Whitney', in *New Criterion*, Nov. 1998, vol. 17, no. 3, pp.52–54.

Tom Rosenthal : 'Pictures that defy walls', in *Times Higher Education Supplement*, 20 Nov. 1998.

Daniel Arasse : 'La solitude de Mark Rothko' [review of Paris exhib.], in *Art Press*, Dec. 1998, no. 241, pp.27–35.

Hervé Vanel : 'Artiste du yo-yo', in *L'Oeil*, Dec. 1998/ Jan. 1999, no. 502, pp.34–41.

1999
Jean-Louis Andral : 'Mark Rothko : peinture classique' [review of Paris exhib.], in *Connaissance des Arts*, Jan. 1999, no. 557, pp.32–39.

Itzhak Goldberg : 'Rothko : la couleur métaphysique' [review of Paris exhib.], in *Beaux Arts Magazine*, Jan. 1999, no. 176, pp.62–69.

Mark Rothko : revue de presse [bound photocopied press reviews of exhibition held at Musée d'Art Moderne de la Ville de Paris, 14 Jan. – 18 Apr. 1999]. Paris : Musée d'Art Moderne de la Ville de Paris, 1999.

Phillipe Piguet : 'Mark Rothko : a celebration of the sublime' [review of Paris exhib.], in *Cimaise*, Jan./ Feb. 1999, vol. 46, no. 257, pp.9–16.

BIBLIOGRAPHY

Donald Kuspitt : 'Mark Rothko : the works on canvas' [review of cat. raisonné], in *New Art Examiner*, Feb. 1999, vol. 26, no. 5, pp.62–63.

Barry Schwabsky : 'Mark Rothko : Whitney Museum of American Art; Jackson Pollock : Museum of Modern Art', in *New Art Examiner*, Feb. 1999, vol. 26, no. 5, p 47.

Waldemar Januszczak : 'Somewhere inside the rainbow' [review of Paris exhib.], in *Sunday Times*, 14 Feb. 1999.

Phyllis Tuchman : 'Rothko rising' [review of Washington exhib.], in *Art Journal*, Spring 1999, vol. 58, no. 1, pp.110–112.

Doris Von Drathen : 'Mark Rothko' [review of Paris exhib.], in *Kunstforum International*, Mar.–Apr. 1999, no. 144, p.140.

John Golding : 'Mark Rothko : the works on canvas : a catalogue raisonné', in *Burlington Magazine*, June 1999, vol. 141, no. 1155, p.365.

Sheldon Nodelman : 'Rediscovering Rothko' [review of Washington exhib.], in *Art in America*, July 1999, vol. 87, no. 7, pp.58–65, 106.

Sean Scully : 'Bodies of light' [review of Washington exhib.], in *Art in America*, July 1999, vol. 87, no. 7, pp.66–70, 111.

Eric Lum : 'Pollock's promise: toward an Abstract Expressionist architecture', in *Assemblage*, Aug. 1999, no. 39, pp.62–93.

Alan Shipway : 'Anni mirabilis' [review of cat. raisonné], in *Art Book*, Sept. 1999, vol. 6 no. 4, pp 8–9.

Yve-Alain Bois : 'The big pictures' [review of cat. raisonné], in *Artforum*, Oct. 1999, vol. 38, no. 2, pp.20–23.

2000
Janet Tyson : 'Unveiled : the Rothko Chapel', in *Art Newspaper*, July–Aug. 2000, p.32.

Michael Compton : 'Paths to the absolute' [review of book by John Golding], in *Tate*, Winter 2000, no. 23, pp.81–82.

2001
Adrian Searle : 'The ghost in the gallery' [review of Fundación Joan Miró exhib.], in *Guardian*, 9 Jan. 2001, p.12.

Sanda Miller : 'Paths to the absolute' [review of book by John Golding], in *Art History*, Feb. 2001, vol. 24, no. 1, pp.159–160.

Yves Kobry : 'Mark Rothko : les plongées sensorielles' [review of Beyeler exhib.], in *Beaux Arts Magazine*, Mar. 2001, no. 202, p.36.

Michael White [review of book by John Golding], in *Burlington Magazine*, Mar. 2001, vol. 143, no. 1176, pp.169–70.

David Anfam : 'Paths to the absolute : Mondrian, Malevich, Kandinsky, Pollock, Newman, Rothko, Still' [review of book by John Golding], in *Apollo*, May 2001, vol. 153, no. 471, pp.56–57.

Mary Krienke : 'Mark Rothko Fondation Beyeler, Basel' [exhib. review], in *Art News*, May 2001, vol. 100, no. 5, p.203.

Patricia Railing : 'Paths to the absolute' [review of book by John Golding], in *Art Book*, June 2001, vol. 8, no. 3, pp.38–40.

Reinhard Ermen : 'Mark Rothko : eine vertiefte Beziehung zwischen Bild und Betrachter Fondation Beyeler, Riehen/Basel', in *Kunstforum International*, June–July 2001, no. 155, pp.425–428.

'From Rothko to wrappings' [review of Berlin exhib.], in *Art Newspaper*, Sept. 2001, p.37.

Charles Harrison : 'The difficulty with Rothko' [review of cat. raisonné], in *Art History*, Sept. 2001, vol. 24, no. 4, pp.598–601.

David Anfam : 'Review : on the sublime. Berlin', in *Burlington Magazine*, Oct. 2001, vol. 143, no. 1183, pp.650–651.

2002
S.E. Canning : 'What's on : coming to light : a very Gottlieb Rothko', in *Art Newspaper*, July–Aug. 2002, p.4.

Nathan Kernan : 'Review : Recent and Contemporary Art. New York' [review of Knoedler exhib.], in *Burlington Magazine*, Aug. 2002, vol. 144, no. 1193, pp.519–521.

Jonathan Jones : 'Feeding fury' [Seagram murals at the Tate], in *Guardian*, 7 Dec. 2002, p.36.

2004
Ann Hindry : 'Mark Rothko la réalité de l'artiste', in *Art Press*, 2004, no. 307, p.58.

Diedre Stein Greben : 'Rothko's reality' [review of *The artist's reality : philosophies of art*], in Art News, Oct. 2004, vol. 103, no. 9, p.74.

Iain Gale : 'Book review : Mark Rothko, the artist's reality : look at the smaller picture', in *Scotland on Sunday*, 28 Nov. 2004, p.8.

2005
Bérénice Geoffroy-Schneite, Itzhak Goldberg and Emmanuelle Lequeux : 'Pigments : de Lascaux à Rothko', in *Beaux Arts Magazine*, Apr. 2005, no. 250, pp.56–63.

Henry Meyric Hughes : 'Rothko's year in provenance' [review of *The artist's reality : philosophies of art*], in *The Times Literary Supplement*, 8 Apr. 2005, p.29.

Natalie Kosoi : 'Nothingness made visible : the case of Rothko's paintings', in *Art Journal*, Summer 2005, vol. 64, no. 2, pp.20–31.

Sheldon Nodelman : 'Reading Rothko' [review of *The artist's reality : philosophies of art*], in *Art in America*, Oct. 2005, vol. 95, no. 9, pp.45, 47, 49, 51.

Patricia Railing : 'Book review : the Artist's Reality', in *Art Book*, Nov. 2005, vol. 12, no. 4, pp.30–31.

2006
John Banville : 'A room full of violence', in *Daily Telegraph*, 6 May 2006, p.4.

Laura Barnett : 'Following Rothko's vision' [review of Rothko re-installation at Tate], in *Daily Telegraph*, 6 May 2006, p.4.

Dushko Petrovich : 'Rothko the writer, in *The Boston Globe*, 18 June 2006, p.C3.

Joachim Hauschild : 'Der Blick verliert sich im Dunkeln' [review of Munich exhib.], in *Art : das Kunstmagazin*, Sept. 2006, no. 9, p.97.

Johannes Meinhardt : 'Black paintings : ein epochaler Bruch', in *Kunstforum International*, Dec. 2006, no. 183, pp.364–365.

2007
Margarita Tupitsyn : 'Black paintings' [review of Munich exhib.], in *Artforum*, Jan. 2007, vol. 45, no. 5, pp.256–266.

Kyle MacMillan : 'Life with Rothko : a son remembers his artist father', in *The Denver Post*, 7 Jan. 2007, p.F03.

David Usborne : 'Dark star : the tortured genius of Mark Rothko', in *Independent Extra*, 15 May 2007.

Tim Cornwell : 'A searing intellect that burned brightly before fading to black', in *The Scotsman*, 17 May 2007, p.35.

Ann Landi : 'How Rothko came into his own' [review of *The Rothko Book* by Bonnie Clearwater], in *Art News*, June 2007, vol. 106, no. 6, p.104.

Rachel Spence : 'Journey into the depths : Rothko's early visions of myth and darkness are uncovered in a new retrospective in Rome', in *Financial Times*, 27 Oct. 2007, p.16.

2008
Frances Colpitt : 'Spatial overtures' [review of Forth Worth exhib.], in *Art in America*, Jan. 2008, no. 1, pp.58–61.

Sheldon Nodelman : 'The unknown Rothko', in *Art in America*, Feb. 2008, no. 2, pp.98–105.

PHOTOGRAPHIC CREDITS

COPYRIGHT CREDITS

Artworks on canvas by Mark Rothko
© 1998 by Kate Rothko Prizel and
Christopher Rothko

Artworks on paper by Mark Rothko
© 2008 by Kate Rothko Prizel and
Christopher Rothko

Writings by Mark Rothko
© 2004 by Kate Rothko Prizel and
Christopher Rothko

Photographs by Mark Rothko
© 2008 by Kate Rothko Prizel and
Christopher Rothko

Francis Bacon © Estate of Francis Bacon.
All rights reserved, DACS 2008

Stan Brakhage © Stan Brakhage Estate

Alighiero Boetti © Alighiero Boetti DACS 2008

Rudy Burckhardt © ARS, NY and DACS,
London 2008

Marcel Duchamp © Succession Marcel Duchamp /
ADAGP, Paris and DACS, London 2008

Jasper Johns © Jasper Johns / VAGA, New York /
DACS, London 2008

Henri Matisse © Succession H Matisse / DACS 2008

Edvard Munch © Munch Museum/Munch – Ellingsen
Group, BONO, Oslo / DACS, London 2008

Hans Namuth © 1991 Hans Namuth Estate

Ad Reinhardt © ARS, NY and DACS, London 2008

Ed Ruscha © Ed Ruscha

Robert Ryman © Robert Ryman

Ezra Stoller © Esto. All rights reserved

PHOTOCREDITS

Photo by Dean Beasom p. 105

© Jaap Boon fig. 43, fig. 47, fig. 52a, fig. 52b,
fig. 52d

Photo: Martin Bühler p. 149

Photo: Christopher Burke p. 137, p. 138, p. 139,
p. 140, p. 141, p. 147, p. 151, p. 185, p. 189, p.193

Image courtesy Christie's p. 191

Photo CNAC/MNAM, Dist.RMN –
© Philipe Megeat fig. 26

Courtesy Center for Creative Photography,
University of Arizona fig. 40, p. 225

Photo: Brian Forrest p. 187

Photo by Jim Frank fig. 29

© The Frick Collection, New York fig. 28

© J. Paul Getty Trust fig. 39, fig. 46

© Imaging Department / President and Fellows
of Harvard College fig. 12

Photo: Paul Hester p. 158–163

Photo by Hickey-Robertson fig. 13, fig. 14

Image created by Hirox Ltd fig. 42a, fig. 42b

Kawamura Memorial Museum of Art, Sakura,
Japan p. 98

Image probably by Morton Levine, courtesy Oliver
Wick and Robert Bayer fig. 16

Alexander Liberman Photographic Collection and
Archive Research Library, The Getty Institute, Los
Angeles, Califorina fig. 39, fig. 46, p. 195

© Herbert Matter fig. 5

Image created by MOLAB fig. 45, fig. 51b

© 2008. Digital images, The Museum of Modern Art,
New York / Scala, Florence fig. 8, fig. 22

National Gallery of Art, Washington fig. 2, p. 99

National Portrait Gallery, Smithsonian
Institution fig. 11, p. 231

Photo: Tim Nighswander fig. 7

RIBA Library Photographs Collection fig. 4

Rothko Chapel, Houston, Texas fig. 13, fig. 14

© 1990, Photo Scala, Florence fig. 38

© 1960 Shamley Productions, Inc. fig. 36

Photo: Rob Shelley p. 99

© Tate Gallery Archive fig. 10

© Tate Photography 2008 fig. 20, fig. 30, fig. 44,
fig. 48, fig. 49, fig. 50, fig. 51a, fig. 52c

Photo by Tate Photography / J Fernandes p. 143–5

Photo: Tate Photography / Marcus Leith and
Marcella Leith p. 98

Von der Haydt-Museum Wuppertal fig. 35

Photo © Osamu Watanabe p. 98

© Whitechapel Gallery, Whitechapel
Archives fig. 9, fig. 18

INDEX

Page numbers in *italic* refer to plates.

SUPPORTING TATE

Tate relies on a large number of supporters — individuals, foundations, companies and public sector sources — to enable it to deliver its programme of activities, both on and off its gallery sites. This support is essential in order for Tate to acquire works of art for the Collection, to support learning and exhibition programmes, care for the Collection in storage and enable art to be displayed, both digitally and physically, inside and outside Tate. Your donation will make a real difference and enable others to enjoy Tate and its Collection both now and in the future. There are a variety of ways in which you can help support Tate and also benefit as a UK or US taxpayer. Please contact us at:

Development Office
Tate
Millbank
London SW1P 4RG

Tel: 020 7887 8945
Fax: 020 7887 8098

American Patrons of Tate
1285 6th Avenue (35th fl)
New York, NY 10019
USA

Tel: 001 212 882 5675
Fax: 001 212 882 5571

Donations, of whatever size, are gratefully received, either to support particular areas of interest, or to contribute to general activity costs.

Gifts of Shares
We can accept gifts of quoted share and securities. All gifts of shares to Tate are exempt from capital gains tax, and higher rate taxpayers enjoy additional tax efficiencies. For further information please contact the Development Office.

Gift Aid
Through Gift Aid you can increase the value of your donation to Tate as we are able to reclaim the tax on your gift. Gift Aid applies to gifts of any size, whether regular or a one-off gift. Higher rate taxpayers are also able to claim additional personal tax relief. Contact us for further information and to make a Gift Aid Declaration.

Legacies
A legacy to Tate may take the form of a residual share of an estate, a specific cash sum or item of property such as a work of art. Legacies to Tate are free of inheritance tax, and help to secure a strong future for the Collection and galleries.

Offers in lieu of tax
Inheritance Tax can be satisfied by transferring to the Government a work of art of outstanding importance. In this case the amount of tax is reduced, and it can be made a condition of the offer that the work of art is allocated to Tate. Please contact us for details.

Membership Programmes
Tate Members enjoy unlimited free admission throughout the year to all exhibitions at Tate, as well as a number of other benefits such as exclusive use of our Members' Rooms and a free annual subscription to *Tate Etc*. Whilst enjoying the exclusive privileges of membership, you are also helping secure Tate's position at the very heart of British and modern art. Your support actively contributes to new purchases of important art, ensuring that the Tate's Collection continues to be relevant and comprehensive, as well as funding projects in London, Liverpool and St Ives that increase access and understanding for everyone.

Tate Patrons
Tate Patrons share a strong enthusiasm for art and are committed to giving significant financial support to Tate on an annual basis. The Patrons support the acquisition of works across Tate's broad collecting remit, as well as other areas of Tate activity such as conservation, education and research. The scheme provides a forum for Patrons to share their interest in art and to exchange knowledge and information in an enjoyable environment. United States taxpayers who wish to receive full tax exempt status from the IRS under Section 501 (c) (3) are able to support the Patrons through the American Patrons of Tate. For more information on the scheme please contact the Patrons office.

Corporate Membership
Corporate Membership at Tate Modern, Tate Liverpool and Tate Britain offers companies opportunities for corporate entertaining and the chance for a wide variety of employee benefits. These include special private views, special access to paying exhibitions, out-of-hours visits and tours, invitations to VIP events and talks at members' offices.

Corporate Investment
Tate has developed a range of imaginative partnerships with the corporate sector, ranging from international interpretation and exhibition programmes to local outreach and staff development programmes. We are particularly known for high-profile business to business marketing initiatives and employee benefit packages. Please contact the Corporate Fundraising team for further details.

Charity Details
The Tate Gallery is an exempt charity; the Museums & Galleries Act 1992 added the Tate Gallery to the list of exempt charities defined in the 1960 Charities Act. Tate Members is a registered charity (number 313021). Tate Foundation is a registered charity (number 1085314).

American Patrons of Tate
American Patrons of Tate is an independent charity based in New York that supports the work of Tate in the United Kingdom. It receives full tax exempt status from the IRS under section 501(c)(3) allowing United States taxpayers to receive tax deductions on gifts towards annual membership programmes, exhibitions, scholarship and capital projects. For more information contact the American Patrons of Tate office.

SUPPORTING TATE

Mr and Mrs John Botts
Frances and John Bowes
Ivor Braka
Mr and Mrs James Brice
The British Land Company plc
Donald L Bryant Jr Family
Melva Bucksbaum
Cazenove & Co
The Clore Duffield Foundation
Edwin C Cohen
The John S. Cohen Foundation
Ronald and Sharon Cohen
Sadie Coles
Carole and Neville Conrad
Giles and Sonia Coode-Adams
Douglas Cramer
Alan Cristea Gallery
Thomas Dane
Michel and Hélène David-Weill
Julia W Dayton
Pauline Denyer-Smith and Paul Smith
Sir Harry and Lady Djanogly
The Drapers' Company
English Heritage
English Partnerships
The Eranda Foundation
Esmée Fairbairn Charitable Trust
Donald and Doris Fisher
Richard B. and Jeanne Donovan Fisher
The Fishmongers' Company
Friends of the Tate Gallery
Bob and Kate Gavron
Giancarlo Giammetti
Alan Gibbs
Mr and Mrs Edward Gilhuly
Helyn and Ralph Goldenberg
The Horace W Goldsmith Foundation
The Worshipful Company of Goldsmiths
Lydia and Manfred Gorvy
Noam and Geraldine Gottesman
Pehr and Christina Gyllenhammar
Mimi and Peter Haas
The Worshipful Company
 of Haberdashers
Hanover Acceptances Limited
The Headley Trust
Mr and Mrs André Hoffmann
Anthony and Evelyn Jacobs
Jay Jopling
Mr and Mrs Karpidas
Howard and Linda Karshan
Peter and Maria Kellner
Madeleine Kleinwort
Brian and Lesley Knox
Pamela and C Richard Kramlich
Mr and Mrs Henry R Kravis
Irene and Hyman Kreitman
The Kresge Foundation
Catherine and Pierre Lagrange
The Lauder Foundation – Leonard
 and Evelyn Lauder Fund
Leathersellers' Company
 Charitable Fund
Agnès and Edward Lee
Lex Service Plc
Ruth and Stuart Lipton
Anders and Ulla Ljungh

The Frank Lloyd Family Trusts
Mr and Mrs George Loudon
Viviane and James Mayor
Ronald and Rita McAulay
The Mercers' Company
The Meyer Foundation
The Millennium Commission
Anthony and Deirdre Montagu
The Monument Trust
Mori Building, Ltd
Mr and Mrs M D Moross
Guy and Marion Naggar
Peter and Eileen Norton, The Peter
 Norton Family Foundation
Maja Oeri and Hans Bodenmann
Sir Peter and Lady Osborne
William A Palmer
Mr Frederik Paulsen
The Pet Shop Boys
The Nyda and Oliver Prenn Foundation
The Rayne Foundation
John and Jill Ritblat
Barrie and Emmanuel Roman
Lord and Lady Rothschild
The Dr Mortimer and Theresa
 Sackler Foundation
Ruth and Stephan Schmidheiny
Mr and Mrs Charles Schwab
David and Sophie Shalit
Belle Shenkman Estate
William Sieghart
Peter Simon
Mr and Mrs Sven Skarendahl
London Borough of Southwark
The Foundation for Sports and the Arts
Mr and Mrs Nicholas Stanley
The Starr Foundation
The Jack Steinberg Charitable Trust
Charlotte and Dennis Stevenson
Hugh and Catherine Stevenson
John Studzinski
David and Linda Supino
The Government of Switzerland
Carter and Mary Thacher
Helen Thorpe
Insinger Townsley
The 29th May 1961 Charitable Trust
David and Emma Verey
Dinah Verey
The Vintners' Company
Clodagh and Leslie Waddington
Robert and Felicity Waley-Cohen
Gordon D Watson
The Weston Family
Mr and Mrs Stephen Wilberding
Michael S Wilson
Poju and Anita Zabludowicz
and those donors who wish to
remain anonymous

FOUNDING CORPORATE PARTNERS
AMP
BNP Paribas
CGU plc
Clifford Chance
Energis Communications
Freshfields Bruckhaus Deringer

GKR
GLG Partners
Goldman Sachs
Lazard Brothers & Co., Limited
Lehman Brothers
London & Cambridge
 Properties Limited
London Electricity plc, EDF Group
Mayer, Brown, Rowe & Maw
Pearson plc
Prudential plc
Railtrack PLC
Reuters
Rolls-Royce plc
J. Sainsbury Plc
Schroders
UBS
UBS Warburg
Wasserstein, Perella & Co., Inc.

TATE MODERN BENEFACTORS
AND MAJOR DONORS
Abstract Select Limited
AFAA/Culturesfrance
Alexander and Bonin Publishing,
 Inc., New York
The American Fund for the Tate Gallery
American Patrons of Tate
The Annenberg Foundation
The Art Fund
Art Mentor Foundation Lucerne
Arts Council England
The Estate of Miss Arline Bage
Jill and Jay Bernstein
Anne Best
The Charlotte Bonham-Carter
 Charitable Trust
Louise Bourgeois
The Deborah Loeb Brice Foundation
Melva Bucksbaum and Raymond Learsy
PHG Cadbury Charitable Trust
Charities Advisory Trust
Henry Christensen III
The Ernest Cook Trust
Alastair Cookson
The Dr V J Daniel Bequest
Julia W Dayton
Dedalus Foundation, Inc.
Marie and Joe Donnelly
Carla Emil and Richard Silverstein
The Eranda Foundation
Marilyn and Larry Fields
Doris and Donald G Fisher
Jeanne Donovan Fisher
The Estate of Richard B Fisher
Sir Evelyn and Lady Lynn Forester
 de Rothschild
Glenn R Fuhrman
Kathy Fuld
Liz Gerring and Kirk Radke
The Getty Foundation
Ralph Goldenberg
The Horace W Goldsmith Foundation
Noam and Geraldine Gottesman
The Paul Hamlyn Foundation
Heritage Lottery Fund
Kraus Family Foundation

The Samuel H Kress Foundation
The Leche Trust
London Borough of Southwark
Alison and Howard Lutnick
The Estate of Sir Edwin Manton
Becky and Jimmy Mayer
The Andrew W Mellon Foundation
Mondriaan Foundation, Amsterdam
The Henry Moore Foundation
Paul and Alison Myners
Guy and Marion Naggar
National Heritage Memorial Fund
Hartley Neel
Richard Neel
Ophiuchus SA
Outset/Frieze Art Fair Acquisitions
 Fund for Tate 2008
Yana and Stephen Peel
Catherine Petitgas
PF Charitable Trust
The Polish Cultural Institute
Pro Helvetia, Swiss Arts Council
Public Sector Research
 Exploitation Fund
Beatriz Quintella and Luiz Augusto
 Teixeira de Freitas
Emily Rauh Pulitzer
Robert Rennie and Carey Fouks
David Roberts
The Sandra Charitable Trust
John Schaeffer and Nevill Keating
 Pictures Ltd
Anna Marie and Robert Shapiro
Juliet Lea Hillman Simonds Foundation
The Steel Charitable Trust
Tate International Council
Tate Members
Tate Patrons
Terra Foundation for American Art
The Mary Joy Thomson Bequest
The Sir Jules Thorn Charitable Trust
Paulo Vieira
Nina and Graham Williams
Reba and David Williams
Poju and Anita Zabludowicz
and those donors who wish to
remain anonymous

PLATINUM PATRONS
Mr Shane Akeroyd
Beecroft Charitable Trust
Rory and Elizabeth Brooks
Lord Browne of Madingley
John and Susan Burns
Melanie Clore
Pieter and Olga Dreesmann
Tania Fares
Ruth Finch
Mrs Wendy Fisher
The Flow Foundation
Hugh Gibson
The Charles S. and Carmen de Mora
 Hale Foundation
The Hayden Family Foundation
John A Smith and Vicky Hughes
Maria and Peter Kellner
Judith Licht

Mr and Mrs Eskandar Maleki
Panos and Sandra Marinopoulos
Paul and Alison Myners
Mr David Roberts
Simon and Virginia Robertson
Sally and Anthony Salz
Mr and Mrs Jake Shafran
Poju and Anita Zabludowicz
and those who wish to
remain anonymous

GOLD PATRONS
Mrs Ghazwa Mayassi Abu-Suud
Chumsri and Luqman Arnold
Arpad Busson
Sir Trevor Chinn CVO and Lady Chinn
Alastair Cookson
Christian Dinesen
Yelena Duncan
Nanette Gehrig
Candida and Zak Gertler
Lady Hollick
Anne-Marie and Geoffrey Isaac
Claire Livingstone
Fiona Mactaggart
Elena Bowes Marano
Gina Marcou
Sir Robert McAlpine Ltd.
Mr Donald Moore
Catherine and Franck Petitgas
Pilar Ordovás
Yana Peel and Stephen Peel
Mathew Prichard
Ramzy and Maya Rasamny
Mr and Mrs James Reed
Mrs Rosario Saxe-Coburg
Carol Sellars
Sophie and David Shalit
Maria and Malek Sukkar
Jolana and Petri Vainio
Michael and Jane Wilson
Manuela and Iwan Wirth
Caroline Wiseman
Barbara Yerolemou
and those who wish to
remain anonymous

SILVER PATRONS
Agnew's
Helen Alexander
Ryan Allen & Caleb Kramer
Alia Al-Senussi
Toby and Kate Anstruther
Mr and Mrs Zeev Aram
Edward Ariowitsch Foundation
Mr Giorgio Armani
Kiran Arora
Edgar Astaire
Daphne Warburg Astor
Mrs Jane Barker
Mr Oliver Barker
Victoria Barnsley
Jim Bartos
Mr and Mrs Paul Bell
Alex and Angela Bernstein
Madeleine Bessborough
Janice Blackburn

Mr and Mrs Anthony Blee
Elena Bonanno di Linguaglossa
Sir Alan Bowness, CBE
Mrs Lena Boyle
Mr and Mrs Floyd H Bradley
Ivor Braka
Mr Simon Alexander Brandon
Viscountess Bridgeman
The Broere Charitable Foundation
Mr Dan Brooke
Ben and Louisa Brown
Michael Burrell
Mrs Marlene Burston
Mr Charles Butter
Canvas Magazine
Mrs Timothy Capon
Peter Carew
Francis Carnwath
Ms Veronica Cazarez
Lord and Lady Charles Cecil
John and Christina Chandris
Frank Cohen
Dr. Judith Collins
Mr and Mrs Paul Collins
Terrence Collis
Mr and Mrs Oliver Colman
Carole and Neville Conrad
Giles and Sonia Coode-Adams
Mr and Mrs Paul Cooke
Cynthia Corbett
Mark and Cathy Corbett
Sidney and Elizabeth Corob
Ms Pilar Corrias
Gül Coskun
Mr and Mrs Bertrand Coste
James Curtis
Sir Howard Davies
Sir Simon Day
Anne Chantal Defay Sheridan
Simon C Dickinson Esq
James Diner
Joan Edlis
Lord and Lady Egremont
Maryam Eisler
Mrs Amanda Eliasch
John Erle-Drax
Stuart and Margaret Evans
Gerard Faggionato
Mrs Heather Farrar
Mrs Margy Fenwick
Mr Bryan Ferry
The Sylvie Fleming Collection
Joscelyn Fox
Eric and Louise Franck
Elizabeth Freeman
Stephen Friedman
Julia Fuller
Mr and Mrs Albert Fuss
Gapper Charitable Trust
Mrs Daniela Gareh
Patrick Gibson
Mr David Gill and Mr Francis Sultana
Mr Mark Glatman
Nicholas and Judith Goodison
Paul and Kay Goswell
Penelope Govett
Gavin Graham

Martyn Gregory
Sir Ronald Grierson
Mrs Kate Grimond
Richard and Odile Grogan
Miss Julie Grossman
Pehr and Christina Gyllenhammar
Louise Hallett
Andrea Hamilton Photography
Mrs Sue Hammerson OBE
Samantha Hampshire
Richard Hazlewood
Michael and Morven Heller
Mr Iain Henderson Russell
Patsy Hickman
Robert Holden
James Holland-Hibbert
Mr Jonathan Horwich
John Huntingford
Soren Jessen
Mr Michael Johnson
Mr and Mrs Peter Johnson
Mr Chester Jones
Jay Jopling
Tracey Josephs
Mrs Gabrielle Jungels-Winkler
Andrew Kalman
Mr Cyril Karaoglan
Dr. Martin Kenig
Mr David Ker
Mr and Mrs Simon Keswick
David Killick
Mr and Mrs Paolo Kind
Mr and Mrs James Kirkman
Brian and Lesley Knox
Kowitz Trust
The de Laszlo Foundation
Simon Lee
Sally Leeson
Zachary R. Leonard
Mr Jeffrey Leung
Mr Gerald Levin
Leonard Lewis
Ina Lindemann
Anders and Ulla Ljungh
Mr Gilbert Lloyd
George Loudon
Mark and Liza Loveday
Thomas Loyd
The Mactaggart Third Fund
Marillyn Maklouf
Mr M J Margulies
Marsh Christian Trust
Janet Martin
Mr and Mrs Y Martini
Matthew Mellon
Dr. Rob Melville
Michael Meynell
Mrs Michelle Michell
Mr Alfred Mignano
Victoria Miro
Jan Mol
Houston Morris
Mrs William Morrison
Mr Stamatis Moskey
Mr Guy and The Hon Mrs Naggar
Richard Nagy, London
Ms Angeliki Nikolakopoulou

Michael Nyman
Julian Opie
Desmond Page
Maureen Paley
Dominic Palfreyman
Michael Palin
Cornelia Pallavicini
Stephen and Clare Pardy
Eve Pilkington
Lauren Papadopoulos Prakke
Oliver Prenn
Susan Prevezer QC
Mr and Mrs Ryan Prince
Valerie Rademacher
Will Ramsay
Mrs Phyllis Rapp
Mr and Mrs Philip Renaud
Sir Tim Rice
Lady Ritblat
Tim Ritchie
David Rocklin
Chris Rokos
Frankie Rossi
Mr James Roundell
Mr Alex Sainsbury and Ms Elinor Jansz
The Hon Michael Samuel
Cherrill and Ian Scheer
Sylvia Scheuer
Charles Schneer
Amir Shariat
Neville Shulman CBE
Andrew Silewicz
Simon and Rebecca Silver
Mr and Mrs David T Smith
Stella Smith
Louise Spence
Digby Squires Esq.
Mr and Mrs Nicholas Stanley
Mr Timothy and the Hon. Mrs Steel
Lady Stevenson
Lucy Sun
The Swan Trust
Robert and Patricia Swannell
Mr James Swartz
The Lady Juliet Tadgell
Sir Anthony and Lady Tennant
Christopher and Sally Tennant
Soren S K Tholstrup
Mrs Lucy Thomlinson
Margaret Thornton
Emily Tsingou and Henry Bond
TWResearch
Melissa Ulfane
Petri and Jolana Vainio
Mrs Cecilia Versteegh
Gisela von Sanden
Mr Christopher V Walker
Audrey Wallrock
Offer Waterman
Mr and Mrs Mark Weiss
Jack Wendler
Miss Cheyenne Westphal
The Cecilia Wong Trust
Anna Zaoui
and those who wish to
remain anonymous